Signs & Symbols in Christian Art

BY

GEORGE FERGUSON

With Illustrations from Paintings of the Renaissance

OXFORD UNIVERSITY PRESS
London Oxford New York

OXFORD UNIVERSITY PRESS
Oxford London Glasgow
New York Toronto Melbourne Wellington
Nairobi Dar es Salaam Cape Town
Kuala Lumpur Singapore Jakarta Hong Kong Tokyo
Delhi Bombay Calcutta Madras Karachi

This Book is Affectionately Dedicated to
RUSH H. KRESS

First published by Oxford University Press, New York, 1954
First issued as an Oxford University Press paperback, 1961
This reprint, 1981

CONTENTS

THE REASON WHY

My seven-year-old daughter was looking at a color reproduction of Tiepolo's Madonna and the Goldfinch. It had just been sent to me by Col. H. A. McBride, Administrator of the National Gallery of Art in Washington. She asked, 'What does the goldfinch in the child's hand mean?'

This question, which my daughter asked several years ago, was the beginning of this book. It began a search for the sources of information from which one could find simple and adequate meanings to aid in the understanding of the symbols which were so widely used in religious paintings.

We discovered that there had been a great deal written on religious symbolism, particularly of the Renaissance period. There was one obvious difficulty; the information was widely scattered. No thorough work which included the entire field of religious symbolism had been attempted for many years. After consultation with many persons having an interest in and knowledge of Christian art, we decided that a fresh approach might prove of great interest and help. We then determined to provide this study of religious symbolism and illustrate it with Renaissance paintings of religious subjects.

This book is the result of our exciting adventure in this field during the past five years. We commend it to you with the comments of its first reviewer. We asked a girl of twelve to read the manuscript. Her comment expresses far better than anything we could write the feeling we hope will be shared by every reader.

'*Symbolism and its meaning in Christian art is a subject on which few books have been written. This book is very simple to read and to anyone who is interested in art it will be a great asset to their library. I found this book extremely interesting and charmingly written. The choice of words and the charming descriptions make it extremely enjoyable. I like the section about animals and birds best. I also like the wonderful descriptions of different symbols of animals, birds, and butterflies, also insects. Another lovely section was written on flowers and another on the Old Testament. I shall be very interested to see this book when it comes out because it seems so unique and is so interesting.*'

I wish to express my extreme appreciation to the author, the Reverend George Ferguson, Rector of Saint Philip's In The Hills, Tucson, Arizona. He has given the readers a fresh and unique presentation of the story of symbolism in Christian art. It is hoped that your interest will being you a renewed insight into the universality of the Christian religion. We who are the children of the Christian heritage should be grateful that our religion can, as in previous ages, stimulate our thoughts, words, and daily actions.

RUSH H. KRESS

AN INTRODUCTION

The Christian asserts that man is created in the image of God. He declares that God has given man a soul, capable of reaching up into Heaven itself and inspiring the human mind to its noblest achievement, the quest after God.

It is this spiritual aspiration that lifts man to his greatest heights. No words have ever been found that are adequate to give it satisfactory expression. There is a reason for this. God has given the soul the privilege of enjoying a continuous awareness of the realities of life. These realities may be described as the never-ending experiences man has with truth, beauty and goodness. These experiences are so vital and moving that man has a constant urge to impart them to others. It is in this act of sharing them that he gives witness to the truth that he is indeed made in the image of God.

There is a language for these experiences. It is a very simple and beautiful language which man has known and used since the beginning of time. It is called the language of the sign and the symbol, the outward and visible form through which is revealed the inward and invisible reality that moves and directs the soul of a man. Let us take one simple example. Are there any words that truly express human love? Yet the touch of a hand, the light of the eyes, the radiance of a face—these symbols of love are far more expressive than any words. Or sorrow— how can its depths be made known? A single tear coursing down the cheek reveals what words could never express. Then again, goodness— can anyone adequately describe it? Of course not. We know it as an act, or a hundred acts, a bent of the soul that has ruled a mind to think and a body to labor in kindness and gentleness and in sacrifice of self in the service of others. These are symbols that men have always understood. There are no words for them. Because the experiences of the soul with life's deepest realities are made known through them, they are a truly universal language. These signs and symbols are the language of the soul.

We have stated that inward realities are made known by the use of the sign and the symbol. In common practice they are used interchangeably. A sign is a symbol; a symbol is a sign. However, without becoming technical, there is a distinction that should be made between

them which may be of assistance. A sign *represents*. It points to something, and takes its character from what is done with it. The cross represents the Christian faith and points to Christ's Crucifixion. A symbol *resembles*. It has acquired a deeper meaning than the sign, because it is more completely identified with what it represents, and its character is derived from what is known by it. The lamb, the sacrificial animal of the Jewish faith, was offered upon the altar as a propitiation for sin. Christ was identified as the Lamb of God because the offering of Himself upon the Cross resembled this act of atonement. The Cross symbolizes God's love for man in the sacrifice of His Son for the sins of the world.

It is in Christian symbolism that the universality of this unspoken language reaches its fullness. We can understand its development as the natural response of the Christian to his world. Christian man, in his quest after God, attaches to well-known words, actions, or things, a mystical and spiritual meaning. In this manner divine truth is recognized and a deeper insight is given to man's ability to understand God's presence in all creation. It was because the Christian Church believed the Christ to be the Saviour of all men that she used the universal language of the sign and the symbol. She was convinced that it was her task to redeem the world, and all men, under God's plan as it was now revealed in His Son. Therefore, she did not hesitate to borrow from every available source in her effort to further this commission. The sign and the symbol, particularly those most common in the realm of human experience, were given a Christian and spiritual meaning.

This book does not attempt to go beyond the age of the Renaissance in its description of religious symbolism. We have only gathered together the most generally and commonly recognized signs and symbols of this great age which, by the very nature of the religious art of the Renaissance, gave them a definitive form from which there has been little deviation. The artists of the Renaissance, under the patronage of the Church, introduced little that was new. They crystallized and ordered Christian symbolism as it had been known and experienced through the entire Christian era. It has come down to us chiefly because it was the perfecting in art form of the common experience of Christian man.

The early Christian saw God in everything. In God he 'lived and moved and had his being.' It followed quite naturally that, in his eyes,

everything was symbolical of God. How the Christian attached religious and spiritual meaning to all that he observed is the story that this book seeks to tell. It was for this reason that we decided to include several sections that do not belong, strictly speaking, under the heading of signs and symbols, particularly those on The Old Testament, St. John the Baptist, The Virgin Mary, and Jesus Christ. The material included in these sections is that which was most commonly portrayed by the Renaissance painters. In selecting the scenes of highest imagery for their portrayals, they broadened the scope of the field in which the signs and the symbols naturally emerged in definitive form. In other instances, such as the sections on Religious Dress, Religious Objects, and Artifacts, the symbolism was not inherent in the things described. It emerged through the use and association and identification in the mind of the Christian, as he attributed symbolical meaning to these things.

This is 'The Reason Why,' as Mr. Rush H. Kress has expressed the motive in his foreword. His interest and enthusiasm have been constant and happy companions in the writing of this book. I am grateful for his consent that the illustrations for this volume should be from the extensive Samuel H. Kress Collection of Renaissance art. All Biblical quotations are from the Authorized King James Version.

The assistance that has been accorded me by the staff of the Kress Foundation has been invaluable. Mr. John Walker, Director of the National Gallery of Art, Washington, D.C., has been a constant friend and advisor. The co-operation of his staff has been unfailing. Mr. Andreas Andersen, Professor of Art at the University of Arizona, was a valued colleague during the years of preparation. Mr. Mark Voris, Assistant Professor of Art at the University of Arizona, and Miss Enid Bell executed the line drawings. I wish to express my thanks to Miss Jean Card for her assistance in the preparation of this book.

<div align="right">

GEORGE FERGUSON

</div>

SECTION I

Animals, Birds, and Insects

Ape. In Christian art, the figure of the ape has been used to symbolize sin, malice, cunning, and lust. It may also symbolize the slothful soul of man: blind, greedy, sinful. Satan is sometimes portrayed in the form of an ape, and, when he is shown as an ape in chains, the idea of sin conquered by faith and virtue is conveyed. The ape sometimes appears, together with other animals, in the scenes of the Visitation of the Magi.

Ass. The ass is frequently portrayed in Renaissance paintings, particularly in pictures of the Sacrifice of Isaac, the Nativity, the Flight into Egypt, and the Entry of Christ into Jerusalem. The most familiar portrayal is in the Natavity scenes, where the ass regularly appears. The ass and the ox symbolize that the humblest and least of the animal creation were present when Jesus was born and that they recognized Him as the Son of God. Their presence at the birth of Christ refers to the prophecy of Isaiah 1: 3, 'the ox knoweth its owner, and the ass his master's crib.' A legend of St. Anthony of Padua may perhaps be connected with this interpretation. The saint had tried in vain to convert a Jew. He finally lost his patience and exclaimed that it would be easier to make a wild ass kneel before the Sacrament than to make the Jew see the truth of his argument. The Jew then challenged him to make the experiment. To the wonder of the people present, the wild ass did kneel, and a number of the Jews and unbelievers were converted to Christianity.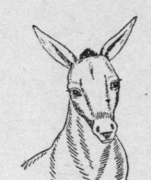
As a domestic animal, the ass appears in other legends of the saints. A typical legend, to be found in the life of St. Jerome, tells of the donkey that carried wood for the monastery.

Basilisk. The basilisk is a fabulous animal, half cock and half snake. And according to legend, the basilisk could kill merely by its glance. In early symbolism, the basilisk was commonly accepted as the symbol of the Devil or the Antichrist, an interpretation based upon a passage from Psalm 91: 13, which reads in the Douay version: '. . . thou shalt tread upon the adder and the basilisk and trample under foot the lion and the dragon.' These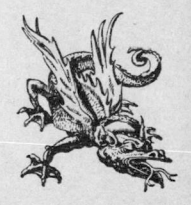

four animals were interpreted by St. Augustine as four aspects of the Devil, who was trodden down by the triumphing Christ. Though a well-established symbol, and often represented in the Middle Ages, the basilisk rarely appears in Italian paintings of the Renaissance.

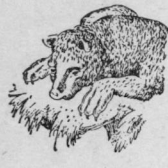

Bear. The bear, as a wild animal, has symbolized cruelty and evil influence. In the Old Testament it is used to represent the Kingdom of Persia, which brought death and corruption into the world, and was finally destroyed by God (Daniel 7: 5). Two bears are said to have appeared from the woods and eaten the children who mocked the prophet Elisha because of his baldness (II Kings 2: 24).

Bear cubs were believed to be born shapeless, their form being given to them by the mother bear. This legendary act became a symbol of Christianity, which reforms and regenerates heathen people. It is in this sense that a number of legends concerning the taming of a bear by a saint may be interpreted. Typical is the story of St. Euphemia, who, when thrown to the wild animals in the arena, was worshiped, rather than eaten, by the bear.

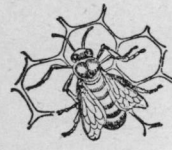

Bee. The bee, because of its industrious habits, has become the symbol of activity, diligence, work, and good order. Also, because the bee produces honey, it has come to be accepted as a symbol of sweetness and religious eloquence. Thus, the beehive is a recognized attribute of St. Ambrose and of St. Bernard de Clairvaux, for their eloquence is said to have been as sweet as honey. The beehive is similarly the symbol of a pious and unified community. St. Ambrose compared the Church to a beehive, and the Christian to the bee, working ardently and forever true to the hive. As a producer of honey, which is a symbol of Christ, and for the virtue of its habits, the bee has been used to symbolize the virginity of Mary.

Since, according to ancient legend, the bee never sleeps, it is occasionally used to suggest Christian vigilance and zeal in acquiring virtue. (See Beehive, in Section XIV.)

Birds. In the earliest days of Christian art, birds were used as symbols of the 'winged soul.' Long before any attempt was made by the artist to identify birds according to species, the bird form was employed to suggest the spiritual, as opposed to the material.

The representation of the soul by a bird goes back to the art of ancient Egypt. This symbolism may be implied in the pictures of the Christ Child holding a bird in His hand or holding one tied to a string. St. Francis of Assisi is often represented preaching to the birds.

Blackbird. The black feathers and the melodious song of the blackbird made it a symbol of the darkness of sin and the alluring temptations of the flesh. In this sense, it is often seen in scenes from the life of St. Benedict, who had to make such a great struggle against the temptations of the flesh. Legend relates that one day, while St. Benedict was at prayer, the Devil appeared to him in the form of a blackbird, seeking to divert his attention from his devotions. The saint, however, recognized the bird as the Devil and vanquished him with the sign of the Cross.

Bull. The bull, indicating mere brute strength, is sometimes shown kneeling at the feet of St. Sylvester, who performed the miracle of bringing a dead bull back to life. A bull of brass is the attribute of St. Eustace, who was martyred with his family by being incarcerated in a brazen bull under which a great fire was lighted. (See Ox.)

Butterfly. The butterfly is sometimes seen in paintings of the Virgin and Child, and is usually in the Child's hand. It is a symbol of the Resurrection of Christ. In a more general sense, the butterfly may symbolize the resurrection of all men. This meaning is derived from the three stages in its life as represented by the caterpillar, the chrysalis, and the butterfly, which are clearly symbols of life, death, and resurrection.

Camel. This animal came to symbolize temperance, probably because the camel could go without drinking for such long periods of time. The camel, as the means of travel in the Orient, was not only a beast of burden but the sign of royalty and dignity. The trappings with which he was harnessed were often rich and costly. The camel was, therefore, commonly used in Renaissance art to help provide Oriental settings for Biblical themes. This was especially true in scenes depicting the Visit of the Wise Men at the Manger in Bethlehem.

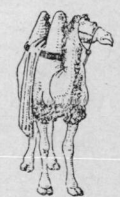

Camel's hair is the invariable symbol of St. John the Baptist,

from the Biblical description of his dress, 'And John was clothed with camel's hair, and with a girdle of a skin about his loins ...' (Mark 1 : 6).

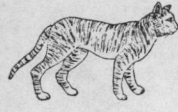

Cat. The cat, because of its habits, was taken as a symbol of laziness and lust. There is also the legend about the 'cat of the Madonna' (*gatta della Madonna*) which tells that at the birth of Christ a cat gave birth to a litter of kittens in the same stable. This cat is usually shown with a cross-shaped marking on her back.

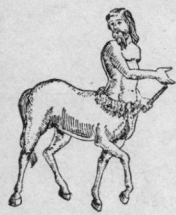

Centaur. This fabled creature had the body of a horse and the head and bust of a human being. The figure has been used in Christian art to symbolize savage passions and excesses, especially the sin of adultery. The beast has also been used to represent brute force and vengeance; to symbolize the heretic; and to show man divided against himself, torn between good and evil. The centaur was sometimes depicted carrying a bow and arrow to symbolize the fiery darts of the wicked.

The centaur frequently appears in paintings of the life of St. Anthony Abbot because, according to legend, this fabulous animal pointed out to the saint the way to reach St. Paul the Hermit in the desert.

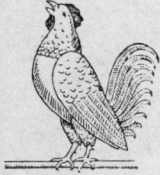

Cock. The cock, because of its crowing early in the morning, is used as an emblem of watchfulness and vigilance. In paintings when the cock stands near the figure of St. Peter, it expresses his denial and subsequent repentance. In this connection, the cock also has become one of the symbols of the Passion. This is based upon Christ's response to Peter's avowal of loyalty, 'Verily, verily, I say unto thee, the cock shall not crow till thou hast denied me thrice ...' (John 13 : 38).

Crane. The crane is a symbol of vigilance, loyalty, good life and works, and good order in the monastic life. All these favorable meanings are derived from the legendary habits of this bird. It is supposed that each night the cranes gather in a circle around their king. Certain cranes are selected to keep watch, and must, at all cost, avoid falling asleep. To this end, each guardian crane stands on one foot, while raising the other. In the raised foot it holds a stone which, should the crane fall asleep, would drop on the other foot and so awaken it.

Dog. The dog, because of his watchfulness and fidelity, has been accepted as the symbol of these virtues. There are many examples of the faithful dog, such as the dog of Tobias, and the dog of St. Roch, who brought bread to the saint and remained at his side. As a symbol of faithfulness in marriage, the dog is often shown at the feet or in the lap of married women. A dog with a flaming torch in its mouth is a symbol of St. Dominic.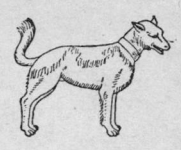
Black-and-white dogs were sometimes used as symbols of the Dominicans (Domini canes, 'dogs of the Lord'), who wore black-and-white habits.

Dolphin. The dolphin is portrayed in Christian art more frequently than any other fish. Generally, it has come to symbolize resurrection and salvation. Considered to be the strongest and swiftest of the fishes, it was often shown bearing the souls of the dead across the waters to the world beyond. Depicted with an anchor or a boat, it symbolized the Christian soul, or the Church, being guided toward salvation by Christ. It frequently represented the whale in the story of Jonah. This, in turn, led to the use of the dolphin as a symbol of the Resurrection and also, though more rarely, as a symbol of Christ.

Dove. The dove, in ancient and Christian art, has been the symbol of purity and peace. In the story of the flood, the dove, sent out from the ark by Noah, brought back an olive branch to show that the waters had receded and that God had made peace with man (Genesis 8).
In the law of Moses, the dove was declared to be pure and for this reason was used as an offering for purification after the birth of a child. Often Joseph carries two white doves in a basket in scenes of the Presentation of Christ in the Temple. 'And when the days of her purification according to the law of Moses were accomplished, they brought him to Jerusalem, to present him to the Lord . . . And to offer a sacrifice according to that which is said in the law of the Lord, A pair of turtledoves, or two young pigeons' (Luke 2: 22, 24). As an emblem of purity the dove sometimes appears on top of Joseph's rod to show that he was chosen to be the husband of the Virgin Mary. The dove was seen by the father of St. Catherine of Siena above her head while she was in prayer.
The most important use of the dove in Christian art, however, is

as the symbol of the Holy Ghost. This symbolism first appears in the story of the baptism of Christ. 'And John bare record, saying, I saw the Spirit descending from heaven like a dove, and it abode upon him' (John 1: 32). The dove, symbolic of the Holy Ghost, is present in representations of the Trinity, the Baptism, and the Annunciation to Mary. Seven doves are used to represent the seven spirits of God or the Holy Spirit in its sevenfold gifts of Grace. This refers to the prophecy of Isaiah 11: 1, 2, 'And there shall come forth a rod out of the stem of Jesse, and a branch shall grow out of his roots: and the spirit of the Lord shall rest upon him, the spirit of wisdom and understanding, the spirit of counsel and might, the spirit of knowledge and of the fear of the Lord.'

The dove is also connected with the lives of several saints. It is the attribute of St. Benedict because he saw the soul of his dead sister Scholastica fly up to Heaven in the shape of a white dove. The dove is also used as an attribute of St. Gregory the Great, for the dove of the Holy Spirit perched upon St. Gregory's shoulder while he wrote.

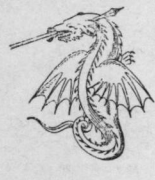

Dragon (Serpent). The dragon, or serpent, was selected by the painters of the Renaissance to symbolize the Devil. The dragon as the enemy of God is vividly portrayed in Revelation 12: 7-9, 'And there was war in heaven: Michael and his angels fought against the dragon; and the dragon fought and his angels, and prevailed not; neither was their place found anymore in heaven. And the great dragon was cast out, that old serpent, called the Devil, and Satan, which deceiveth the whole world: he was cast out into the earth, and his angels were cast out with him.' The dragon, expelled from Heaven, continues his war against God. Thus, he is depicted as the devouring monster who angrily destroys his victims.

The dragon is the attribute of St. Margaret, and of St. Martha, both of whom are said to have fought, and vanquished, a dragon. It is also the attribute of a number of other saints, including St. George of Cappadocia, who slew the dragon 'through the power of Jesus Christ.' The dragon appears with the Apostle Philip, St. Sylvester, and the Archangel Michael, who is often shown with a dragon under foot, in token of his victory over the powers of darkness.

The serpent, symbolizing the Devil and Satan, is depicted as

the tempter of Adam and Eve. 'And the Lord God said unto the Woman, What is this that thou hast done? And the woman said, The serpent beguiled me, and I did eat' (Genesis 3 : 13). Thus, the serpent represents in general the wily tempter that betrays man into sin. The serpent is sometimes portrayed at the foot of the Cross to signify that the evil power responsible for man's fall has been overcome by the power of Christ, who died that man might be redeemed. (See Adam and Eve, in Section V).

Eagle. The eagle may generally be interpreted as a symbol of the Resurrection. This is based upon the early belief that the eagle, unlike other birds, periodically renewed its plumage and its youth by flying near the sun and then plunging into the water. This interpretation is further borne out by Psalm 103: 5, '. . . thy youth is renewed like the eagle's.'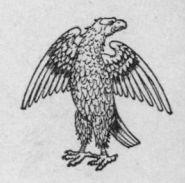

The eagle is also used to represent the new life begun at the baptismal font and the Christian soul strengthened by grace. 'But they that wait upon the Lord shall renew their strength; they shall mount up with wings as eagles . . .' (Isaiah 40: 31). The eagle is said to have the ability to soar until it is lost to sight, and still retain its ability to gaze into the blazing mid-day sun. For this reason, it has come to symbolize Christ. In a more general sense, it symbolizes those who are just; or stands for the virtues of courage, faith, and contemplation. More rarely, when it is depicted as a bird of prey, the eagle suggests the demon who ravishes souls, or the sins of pride and worldly power.

The eagle also symbolizes generosity. It was believed that the eagle, no matter how great its hunger, always left half its prey to the birds that followed.

The eagle is the particular attribute of St. John the Evangelist. The vision of Ezekiel 1 : 5, 10, '. . . out of the midst thereof came the likeness of four living creatures . . . as for the likeness of their faces, they four had the face of a man, and the face of a lion . . . the face of an ox . . . the face of an eagle,' was interpreted as referring to the four evangelists. Because St. John, in his Gospel, soared upward in his contemplation of the divine nature of the Saviour, the eagle became his symbol.

In a more general sense, the eagle came to represent the inspiration of the gospels. It is from this symbolic interpretation that the lectern, from which the gospels are read, is often given the form of a winged eagle.

Egg. The egg is the symbol of hope and resurrection. This meaning is derived from the manner in which the small chick breaks from the egg at its birth.

Ermine. This small animal, because of the whiteness of its fur and the legend that it preferred death to impurity, is used to symbolize purity.

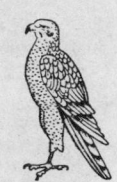

Falcon. There are two kinds of falcons in religious symbolism: the wild and the domestic. The wild falcon symbolized evil thought or action, while the domestic falcon represented the holy man, or the Gentile converted to the Christian faith. As the favorite hunting bird, the domestic falcon was often represented during the Renaissance in pageants and courtly scenes, and was often held by a page in the company of the Magi.

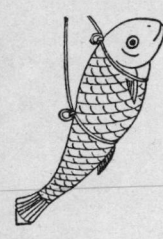

Fish. The most frequent use of the fish is as a symbol of Christ. This is because the five Greek letters forming the word 'fish' are the initial letters of the five words: 'Jesus Christ God's Son Saviour' ($I\chi\theta\acute{v}\varsigma$). In this sense, the fish symbol was frequently used in Early Christian art and literature. The fish is also used as a symbol of baptism, for, just as the fish cannot live except in water, the true Christian cannot live save through the waters of baptism.
In Renaissance imagery, the fish is given as an attribute to Tobias because the gall of a fish restored the sight of his father Tobit; it is also given as an attribute to St. Peter, an allusion to his being a fisherman; and to St. Anthony of Padua, who preached to the fish.

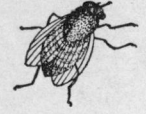

Fly. The fly has long been considered a bearer of evil or pestilence. In Christian symbolism the fly is a symbol of sin. It sometimes appears in pictures of the Virgin and Child to convey the idea of sin and redemption. The fly as a bringer of disease was sometimes shown with the goldfinch, a 'saviour-bird' against disease.

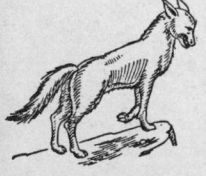

Fox. Traditionally the symbol of cunning and guile, the fox also symbolized the Devil. Though it was shown frequently in sculpture during the Middle Ages, it was for the most part confined to book illustration during the Renaissance.

Frog. Because of his continuous croaking and the fact that a rain of frogs was one of the plagues of Egypt (Exodus 8), the frog has been given a devilish significance, and has sometimes been likened to heretics. Usually in paintings it conveys the repulsive aspect of sin. More loosely, it is interpreted as a symbol of those who snatch at life's fleeting pleasures; hence it represents worldly things in general.

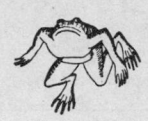

Giraffe. In the Renaissance the giraffe was depicted more because of its strange appearance and its rarity among animals in Europe than for any symbolic meaning.

Goat. In Early Christian art, the goat was taken as a symbol of the damned in the Last Judgment. This interpretation is based upon a long passage in the Bible (Matthew 25: 31-46) which relates how Christ upon His coming, shall separate the believing from the unbelieving, as the shepherd separates the sheep from the goats. In the Renaissance the goat was usually shown in order to distinguish the sinners from the righteous.

Goldfinch. The goldfinch is fond of eating thistles and thorns, and since all thorny plants have been accepted as an allusion to Christ's crown of thorns, the goldfinch has become an accepted symbol of the Passion of Christ. In this sense, it frequently appears with the Christ Child, showing the close connection between the Incarnation and the Passion.

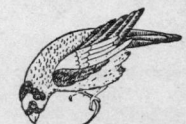

Goose. Since the time of the Romans, the goose has been a symbol of providence and vigilance. The legend of the Capitoline geese that saved Rome from the invasion of the Gauls is well known.

In Christian art the goose is sometimes given as an attribute to St. Martin of Tours, because a goose is supposed to have revealed his hiding place to the inhabitants of Tours, who had come to call the saint to be their bishop.

Grasshopper (Locust). The grasshopper, or locust, was one of the plagues visited upon the Egyptians because the Pharaoh's heart was hardened against the Word of the Lord. Accordingly, the grasshopper when held by the Christ Child is a symbol of the conversion of nations to Christianity. This meaning is also

derived from Proverbs 30: 27, 'The locusts have no king, yet go they forth all of them by bands,' a passage early interpreted as referring to the nations formerly without Christ for their King. St. John the Baptist was said to have fed on locusts.

Griffin. This fabulous creature, usually depicted with the head and wings of an eagle and the body of a lion, is used with two different and opposite meanings; on the one hand to represent the Saviour; on the other, because it is a combination of the preying of the eagle and the fierceness of the lion, to symbolize those who oppress and persecute the Christians.

Hare (Rabbit). The hare, itself defenseless, is a symbol of men who put the hope of their salvation in the Christ and His Passion. It is also a well-known symbol of lust and fecundity. A white hare is sometimes placed at the feet of the Virgin Mary to indicate her triumph over lust.

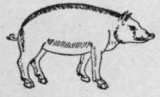

Hog. The hog is used to represent the demon of sensuality and gluttony. The hog is frequently shown as one of the attributes of Anthony Abbot, who is reputed to have vanquished this demon.

Horse. In ancient mythology the horse was the emblem of the sun, as the ox was that of the moon. In the Renaissance, however, the horse was most often depicted as a symbol of lust. This interpretation is based on Jeremiah 5: 8, 'They were as fed horses in the morning: every one neighed after his neighbor's wife.'

Lamb. The lamb, as a symbol of Christ, is one of the favorite, and most frequently used, symbols in all periods of Christian art. Many scriptural passages give authority for this symbolism. A typical reference is John 1: 29, 'The next day John seeth Jesus coming unto him, and saith, Behold the Lamb of God, which taketh away the sin of the world!'

The Holy Lamb is often depicted with a nimbus, standing upon a small hill from which four streams of water flow (Revelation 14:1). The hill represents the Church of Christ, the mountain of God's house. The streams represent the four Holy Gospels, the four rivers of Paradise, ever flowing and refreshing the pastures of the Church on earth.

In pictures where Christ is shown as the rescuing shepherd, the lamb is also used to symbolize the sinner. This subject, usually called the Good Shepherd, is very frequent in Early Christian art, but was seldom used in the Renaissance.

During the Renaissance the lamb was often depicted in representations of the Holy Family with the Infant St. John. Here, the lamb alludes to St. John's mission as the forerunner of Christ, and his recognition of Christ as the Lamb of God at the time of His Baptism. This meaning is indicated by the portrayal of St. John the Baptist pointing to a lamb which he usually holds in his left hand.

The lamb (Latin, *agnus*) is given as an attribute to St. Agnes, who was martyred because she declared herself to be the bride of Christ and refused to marry. It is also found as an attribute of St. Clement, who was guided by a lamb to the spot where he found water.

Lark. The lark, because it flies high and sings only when in flight toward Heaven, has been taken as the symbol of the humility of priesthood.

Leopard. The leopard is a symbol of sin, cruelty, the Devil, and the Antichrist. It sometimes appears in representations of the Adoration of the Magi to show that the Incarnation of Christ was necessary for redemption from sin.

Lion. The lion is used in Renaissance art with various meanings, depending upon the circumstances. In general, the lion is emblematic of strength, majesty, courage, and fortitude. Legendary natural history states that young lions are born dead, but come to life three days after birth when breathed upon by their sire. Thus, the lion has become associated with the Resurrection, and is the symbol of Christ, the Lord of Life.

The lion is one of the four animals that appear in the prophecy of Ezekiel. He is the symbol of the Evangelist Mark because St. Mark in his Gospel dwells most fully upon the Resurrection of Christ and proclaims with great emphasis the royal dignity of Christ. The winged lion is invariably the attribute of St. Mark, and appears also as the emblem of Venice, because this city was under the protection of St. Mark. St. Jerome is also closely identified with the lion. It is said that the saint removed a painful

thorn from the paw of a lion, who thereupon became his close and faithful friend.

It was a medieval belief that the lion slept with its eyes open. For this reason, he also became a symbol of watchfulness. In rarer instances the lion, because of its pride and fierceness, was used as a symbol of the Prince of Darkness, this interpretation being supported by Psalm 91:13, 'Thou shalt tread upon the lion and adder . . .' This passage is interpreted as Christ triumphing over the Devil. In addition, lions appear as attributes of St. Mary of Egypt, St. Euphemia, St. Onuphrius, and St. Paul the Hermit.

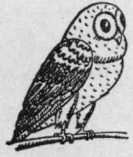

Owl. The owl, since it hides in darkness and fears the light, has come to symbolize Satan, the Prince of Darkness. As Satan deceives humanity, so the owl is said to trick other birds, causing them to fall into the snares set by hunters. The owl also symbolizes solitude and, in this sense, appears in scenes of hermits at prayer. Its most ancient gift, however, is that of wisdom, and, with this meaning, it is sometimes shown with St. Jerome.

In another sense, the owl is an attribute of Christ, who sacrificed Himself to save mankind, 'To give light to them that sit in darkness and in the shadow of death . . .' (Luke 1: 79). This explains the presence of the owl in scenes of the Crucifixion.

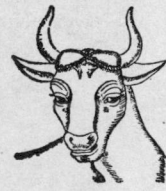

Ox. The ox, a sacrificial animal of the Jews, was often used in Renaissance painting to represent the Jewish nation. It is also used as a symbol of patience and strength. Almost invariably, the ox and the ass appear together in paintings of the Nativity. (See Ass.) In the writings of some of the early Christian fathers, the ox is accepted as a symbol of Christ, the true sacrifice. The symbol is similarly used to represent all who patiently bear their yoke while laboring in silence for the good of others. The winged ox is the attribute of St. Luke because of his emphasis upon the sacrificial aspects of our Lord's atonement as well as upon His divine priesthood.

Partridge. In a good sense, the partridge is used as a symbol of the Church and of truth; but it is ordinarily symbolic of deceit and theft, and in a more general sense, of the Devil: 'As the partridge sitteth on eggs, and hatcheth them not; so he that getteth riches, and not by right, shall leave them in the midst of his days, and at his end shall be a fool.' (Jeremiah 17:11).

Peacock. In Christian art the peacock is used as the symbol of immortality. This symbolism is derived from the legendary belief that the flesh of the peacock does not decay. It is with this meaning that it appears in scenes of the Nativity. The 'hundred eyes' in the peacock's tail are sometimes used to symbolize the 'all seeing' Church. The peacock's habit of strutting and displaying the beauty of its feathers has caused it also to become a symbol of worldly pride and vanity. A peacock's feather is often an attribute of St. Barbara, in reference to Heliopolis, the city of her birth.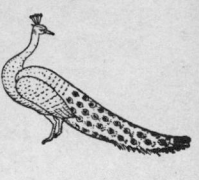

Pelican. According to legend, the pelican, which has the greatest love of all creatures for its offspring, pierces its breast to feed them with its own blood. It is on the basis of this legend that the pelican came to symbolize Christ's sacrifice on the Cross, because of His love for all mankind. In this sense, it also symbolizes the Eucharistic Sacrament. This interpretation is supported by Psalm 102: 6, 'I am like a pelican of the wilderness,' which is an accepted allusion to Christ. The pelican is sometimes shown nesting on the top of the Cross.

Phoenix. The phoenix was a mythical bird of great beauty which lived in the Arabian wilderness. Its life span was said to be between three hundred and five hundred years. Periodically, it burned itself upon a funeral pyre; whereupon, it would rise from its own ashes, restored to all the freshness of youth, and would enter upon another cycle of life. The phoenix was introduced into Christian symbolism as early as the first century, when the legend of this bird was related by St. Clement in his first Epistle to the Corinthians. In Early Christian art, the phoenix constantly appears on funeral stones, its particular meaning being the resurrection of the dead and the triumph of eternal life over death. The phoenix later became a symbol of the Resurrection of Christ, and commonly appears in connection with the Crucifixion. In another sense, the phoenix stands for faith and constancy. Though popular in the art of the Middle Ages, the phoenix is rare in Italian Renaissance paintings.

Ram. Because the ram is the leader of the herd, sometimes it was used as a symbol for Christ. Also, in the same way that the ram fights with the wolf and vanquishes him, so Christ battles

with Satan and is victorious. The ram, the animal God caused to be placed in a thorny bush so that Abraham might sacrifice it in place of his son Isaac, represents Christ crowned with thorns and sacrificed for mankind. In a general sense, the ram is used as a symbol for strength.

Rat (Mouse). The rat, or the mouse, because of its destructiveness, is symbolic of evil. It is rarely seen in Renaissance art, except as an attribute of St. Fina.

Raven. According to a Jewish legend, the raven was originally white, but its feathers turned black when it failed to return to the ark, from which Noah had sent it to find out if the flood had abated. Because of the blackness of its plumage, its supposed habit of devouring the eyes and the brain of the dead, and its liking for spoiled flesh, the raven was selected as a symbol of the Devil, who throws the soul into darkness, invades the intelligence, and is gratified by corruption. The raven appears in a more favorable light in relation to certain saints. It is the attribute of St. Vincent because God sent a raven to guard his sacred remains. The raven is also the attribute of St. Anthony Abbot and St. Paul the Hermit because it brought them a loaf of bread each day when they lived together in the desert. The raven, as symbolizing solitude, is associated with these hermit saints.

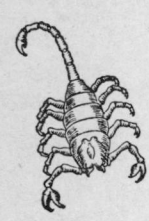

Scorpion. The scorpion is one of the symbols of evil. The sting of the tail of the scorpion is poisonous and causes great agony to a person who is stung. It is often mentioned in the Bible, '. . . and their torment was the torment of a scorpion, when it striketh a man' (Revelation 9: 5). Because of the treachery of its bite, the scorpion became a symbol of Judas. As a symbol of treachery, the scorpion appears on the flags and shields held by the soldiers who assisted at the Crucifixion of Christ.

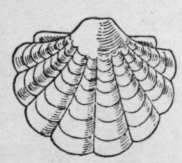

Shell. The shell, notably the cockleshell, or the scallop shell, is generally used in Christian art to signify pilgrimage. The scallop shell is used specifically as an attribute of St. James the Great. It is generally supposed to allude to the countless pilgrimages that were made to his celebrated shrine at Compostella in Spain. St. Roch is customarily painted in the dress of a pilgrim with a cockleshell in his hat.

Snail. The snail was believed to be born from the mud, and to feed upon it. It was, therefore, interpreted as the symbol of the sinner, and of laziness, because it made no effort to seek food, but ate what it found at hand.

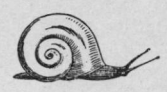

Sparrow. Considered to be the lowliest among all birds, the sparrow came to be used as a symbol of the lowly, the least among all people, who were, nevertheless, under the protection of God the Father; for even the sparrow came to earth only through the will of God, and received from Him its means of life.

Spider. The spider is used symbolically, first to represent the miser, for it bleeds the fly as the miser bleeds the poor; second, to represent the Devil, for the Devil prepares his traps as the spider does its web; and third, to represent the malice of evil-doers whose webs will perish like those of the spider. The cobweb is a symbol of human frailty.

Stag. The stag takes its symbolic significance from Psalm 42:1, 'As the hart panteth after the water brooks, so panteth my soul after thee, O God.' Thus, the stag has come to typify piety and religious aspiration. Similarly, because the stag seeks freedom and refuge in the high mountains, it has been used to symbolize solitude and purity of life.
The stag, as the attribute of St. Eustace and St. Hubert, is shown with a crucifix between its horns. The stag without the crucifix is an attribute of St. Julian the Hospitator.

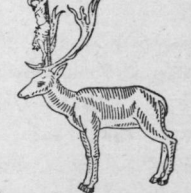

Stork. The stork is a symbol of prudence and vigilance, piety, and chastity. It was associated with the Annunciation because, as the stork announces the coming of spring, the Annunciation to Mary indicated the Advent of Christ. It is possible that the present north European tradition that new-born babies are carried to their mothers by storks may be derived from the association of this bird with the Annunciation.

Swallow. In the Renaissance the swallow was a symbol of the Incarnation of Christ. For this reason, it appears in scenes of the Annunciation and of the Nativity, nestling under the eaves or in holes in the wall. It was thought that the swallow hibernated in

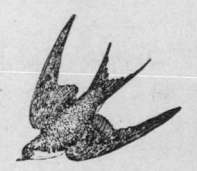

the mud during the winter, and its advent in the spring was looked upon as a rebirth from the death-like state of winter. For this reason it also became a symbol of resurrection.

Unicorn. The unicorn, according to the myth, was a small animal, similar in size to a kid, but surprisingly fierce and swift, with a very sharp, single horn in the center of its forehead. Supposedly no hunter could capture the animal by force, but it could be taken by means of a trick. The hunter was required to lead a virgin to the spot frequented by the unicorn and to leave her alone there. The unicorn, sensing the purity of the maiden, would run to her, lay its head in her lap, and fall asleep. Thus its capture would be effected. For obvious reasons the unicorn was early accepted as the symbol of purity in general and of feminine chastity in particular. The legend was interpreted by Christian writers as an allegory of the Annunciation and the Incarnation of Christ, born of a Virgin.

Thus, the unicorn is usually an attribute of the Virgin Mary, but also of St. Justina of Padua and of St. Justina of Antioch, who retained their purity under great temptation.

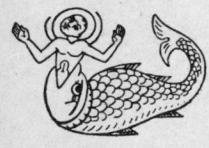

Whale. According to ancient legend, the huge body of the whale was often mistaken by mariners for an island, and ships anchored to its side were dragged down to destruction by a sudden plunge of the great creature. In this way, the whale came to be used as a symbol of the Devil and of his cunning, and the whale's open mouth was often depicted to represent the open gates of Hell.

The whale also appears in the Biblical story of Jonah, who was swallowed by a whale and disgorged three days later. Allegorically, the experience of Jonah is likened to Christ in the sepulchre and His Resurrection after three days. Unfamiliarity with the appearance and habits of the whale, and even with the identification of the Biblical sea-monster as such, prevented the artists of the Italian Renaissance from painting naturalistic whales. Rather, Jonah's monster was, to them, either something in the way of a dragon, a great shaggy fish, or a dolphin.

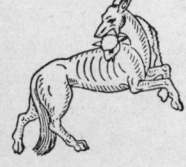

Wolf. The wolf is sometimes used as an attribute of St. Francis of Assisi. This is based on the famous story of the wolf of Gubbio. A wolf that had been doing great damage was being hunted by the

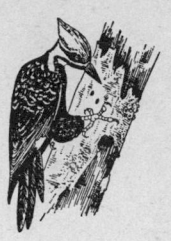

people of Gubbio, when St. Francis encountered it. He addressed it as 'Brother Wolf,' and protected it as a fellow creature who knew no better, and set about to reform it.

Woodpecker. The woodpecker is usually symbolic of the Devil, or of heresy, which undermines human nature and leads man to damnation.

SECTION II

Flowers, Trees, and Plants

Acacia. The acacia is a symbol of the immortality of the soul.

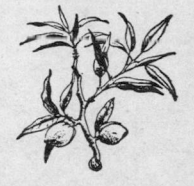

Almond. The almond is a symbol of divine approval or favor. This symbolism is based upon Numbers 17:1–8, in which it is told how Aaron was chosen to be the priest of the Lord through the miracle of his budding rod: '. . . and, behold, the rod of Aaron for the house of Levi was budded, and brought forth buds, and bloomed blossoms, and yielded almonds.' It is with reference to this passage that the almond became a symbol of the Virgin Mary. (See Mandorla, in Section XI.)

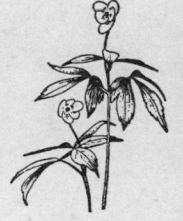

Anemone. In pagan mythology, the anemone was a symbol of sorrow and death. Such a belief was based upon the legend of Adonis, who was believed to have died on a bed of anemones, which then turned from white to red. Christian symbolism has also attributed to the anemone the suggestion of illness. The anemone may be depicted in scenes of the Crucifixion, or in conjunction with the Virgin Mary to show her sorrow for the Passion of Christ. The red spots on the petals symbolize the blood of Christ, for it is said that anemones sprang up on Calvary the evening of the Crucifixion. In the early days of the Church, the triple leaf of this plant was used to symbolize the Trinity.

Apple. In Latin, the word for apple and the word for evil, *malum*, are identical. It is for this reason that the legend has grown

up that the Tree of Knowledge in the Garden of Eden, the fruit of which Adam and Eve were forbidden to eat, was an apple tree (Genesis 3: 3). In pictures of the tempting of Eve by the serpent in the Garden of Eden, Eve is generally shown with an apple in her hand, offering it to Adam. The apple may also be symbolic of Christ, the new Adam, who took upon himself the burden of man's sin. For this reason, when the apple appears in the hands of Adam it means sin, but when it is in the hands of Christ, it symbolizes the fruit of salvation. Such interpretation is based upon the Song of Solomon 2: 3, 'As the apple tree among the trees of the wood, so is my beloved among the sons. I sat down under his shadow with great delight, and his fruit was sweet to my taste.' This passage has been interpreted as an allusion to Christ.
As Christ is the new Adam, so, in tradition, the Virgin Mary is considered to be the new Eve, and, for this reason, an apple placed in the hands of Mary is also considered an allusion to salvation. Three apples are an attribute of St. Dorothea.

Aspen. There are two early legends about the aspen tree. One relates that the Cross was made from the aspen, and that, when the tree realized the purpose for which it was being used, its leaves began to tremble with horror and have never ceased. The other legend is that, when Christ died on the Cross, all the trees bowed in sorrow except the aspen. Because of its pride and sinful arrogance the leaves of the aspen were doomed to continual trembling.

Bramble. The bramble was believed to be the burning bush in which the angel of the Lord appeared to Moses, '. . . the bush burned with fire, and the bush was not consumed' (Exodus 3: 2). The bramble has become a symbol of the purity of the Virgin Mary, who bore the flames of divine love without being consumed by lust.

Bulrush. The bulrush is a lowly, thickly clustered, common plant, growing near the water. Because of these characteristics, it has become a symbol for the multitude of the faithful who lead a humble life and abide by the teaching of the Church, the source of living waters. This explanation found support in Job 8:11, 'Can the rush grow up without mire? Can the flag grow without water?' Also, since the infant Moses (and Moses is taken as the

forerunner of Christ) was found in the bulrushes, they have come to be connected with the place whence salvation came.

Carnation. The red carnation is a symbol of pure love. According to a Flemish custom, a variety of carnation, the pink, was worn by the bride upon the day of her wedding, and the groom was supposed to search her and find it. From this custom, the pink has become a symbol of marriage. Newlyweds are often shown carrying a pink in their hands.

Cedar. The cedar tree, particularly the cedar of Lebanon, is a symbol of Christ: '... his countenance is as Lebanon, excellent as the cedars' (Song of Solomon 5: 15). The stately form of the cedar caused it to be identified with the concepts of beauty and majesty. The prophet Ezekiel used the cedar as a symbol of the Messiah and His Kingdom. '... I will also take of the highest branch of the high cedar ... and will plant it upon an high mountain and eminent' (Ezekiel 17: 22).

Cherry. The red, sweet fruit of the cherry symbolizes the sweetness of character which is derived from good works. It is often called the Fruit of Paradise. A cherry, held in the hand of the Christ Child, suggests the delights of the blessed.

Chestnut. The chestnut in its husk is surrounded by thorns, but is unharmed by them. For this reason it is a symbol of chastity, because this virtue is a triumph over the temptations of the flesh, symbolized by the thorns.

Clover. The clover, with its three leaves, is an obvious symbol of the Trinity. According to legend, clover was given as an example of the Trinity by St. Patrick, when he evangelized Ireland, and thus the clover, or shamrock, has become the emblem of Ireland. Another name for the three-leaved clover is 'trefoil.'

Cockle. The cockle is a common weed that often invades the tilled fields and intermingles with the planted grain. It symbolizes wickedness invading the good field of the Church. 'Let thistles grow instead of wheat, and cockle instead of barley' (Job 31: 40).

Columbine. The form of this flower has been likened to a white dove, and, for this reason, columbine has been used to symbolize the Holy Ghost. Columbine is derived from the Latin word for dove, *columba*. Seven blooms on a stalk were symbolic of the seven gifts of the Spirit, according to the prophecy of Isaiah 11 : 2, 'And the spirit of the Lord shall rest upon him, the spirit of wisdom and understanding, the spirit of counsel and might, the spirit of knowledge and of the fear of the Lord.'

Cyclamen. This plant was early dedicated to the Virgin Mary. The red spot at the heart of the flower signifies the bleeding sorrow in Mary's heart. The cyclamen is sometimes called 'bleeding nun.'

Cypress. The cypress, even in pagan times, was associated with death. It is found in many cemeteries, both Christian and pagan. Carvings depicting the cypress are found on many Christian tombs. There were several reasons for associating the cypress with death; for example, it has dark foliage and, once cut, it never springs up again from its roots.

Daisy. Toward the end of the fifteenth century the daisy came to be used in paintings of the 'Adoration' as a symbol of the innocence of the Christ Child. Apparently, the sweet simplicity of the daisy was felt to be a better symbol of His innocence than the tall, stately lily.

Dandelion. One of the 'bitter herbs', the dandelion, was used as a symbol of the Passion, and as such appears, among other flowers, in paintings of the Madonna and Child, and of the Crucifixion.

Elm. The elm alludes to the dignity of life. Its all-encompassing growth and the spreading of its great branches in every direction symbolizes the strength which is derived by the devout from their faith in the Scriptures.

Fern. The fern conceals its grace, delicacy, and beauty in the shadowed glens of the forest. Because the charm of this plant is seen only by the honest searcher, the fern symbolizes solitary humility, frankness, and sincerity.

Fig. The fig tree is sometimes used, instead of the apple tree, as the Tree of Knowledge in the Garden of Eden. The leaf of the fig tree appears in the story of the Fall in Genesis 3 : 7, 'And the eyes of them both were opened, and they knew that they were naked; and they sewed fig leaves together and made themselves aprons.' From this allusion to its leaf, the fig has become a symbol of lust. Its many seeds have made it also a symbol of fertility.

Fir. The fir tree is a symbol of the elect in Heaven, who despise lowly desires. It also symbolizes people who excel in the virtue of patience.

Fruit. Fruit is often used to suggest the twelve fruits of the Spirit: love, joy, peace, long-suffering, gentleness, goodness, faith, meekness, patience, modesty, temperance, and chastity.

Gourd. The gourd is prominent in the story of Jonah, and, because of this association with him, has come to symbolize the Resurrection (Jonah 4). When painted together with an apple, the gourd, as the symbol of the Resurrection, is the antidote for the apple, the symbol of evil, or death.

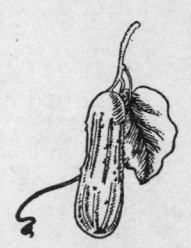

The gourd was used by pilgrims as a flask to carry water. It is the special attribute of St. James the Great, and of the Archangel Raphael and is sometimes given to Christ, who, dressed as a pilgrim, joined the two Apostles on their way to Emmaus. Frequently, in art the gourd resembles a cucumber.

Grain. Wheat, a well-known Eucharistic symbol, is used to suggest the human nature of Christ. This interpretation is based upon John 12 : 24, 'Verily, verily, I say unto you, except a corn of wheat fall into the ground and die, it abideth alone; but if it die, it bringeth forth much fruit.' Ears of grain and bunches of grapes are used to symbolize the bread and wine of Holy Communion.

Grapes. Bunches of grapes with ears of grain were sometimes used to symbolize the wine and bread of Holy Communion. In general, the grape, like the Eucharistic wine, is a symbol of the Blood of Christ. Representations of labor in the vineyard sometimes signify the work of good Christians in the vineyard of the

Lord; the grape vine or leaf is used as an emblem of the Saviour, the 'true vine.' (See Vine).

Hyacinth. The hyacinth is sometimes regarded as a symbol of Christian prudence, peace of mind, and the desire for Heaven. Its symbolism is derived from pagan mythology, being based upon the legend of the beautiful youth, Hyacinthus, who was accidentally killed by Apollo, while playing with the discus. Apollo then caused the hyacinth to spring from the youth's blood.

Hyssop. This plant, which grows in solitary places among stones, is used to symbolize penitence and humility. Due to its purgative qualities, it is also taken to symbolize innocence regained and, hence, baptism. 'Purge me with hyssop, and I shall be clean: wash me, and I shall be whiter than snow' (Psalm 51: 7).

Ilex (Holly). The ilex, or holly oak, is an evergreen which, because of its thorny leaves, is regarded as a symbol of Christ's crown of thorns. It is also said to have been the tree of the Cross and, therefore, is symbolic of the Passion of Christ. A legend relates that all the trees, when they heard that Christ was to be crucified, agreed not to allow their wood to be defiled for this purpose. When the axe touched them, they all splintered into a thousand fragments. Only the ilex remained whole and permitted itself to be used as the instrument of the Passion. It is often found in paintings of St. Jerome meditating on the Passion, or of St. John the Baptist, who, by acclaiming Christ the Lamb of God, foretold His Passion.

Iris. The iris, a rival of the lily as the flower of the Virgin, first appears as a religious symbol in the works of the early Flemish masters, where it both accompanies and replaces the lily in pictures of the Virgin. This symbolism stems from the fact that the name 'iris' means 'sword lily', which was taken as an allusion to the sorrow of the Virgin at the Passion of Christ. Spanish painters adopted the iris as the attribute of the Queen of Heaven and also as an attribute of the Immaculate Conception. (See Lily).

Ivy. Symbolically, the ivy has always been closely identified with death and immortality. Because it is forever green, it is a symbol of fidelity and eternal life.
The ivy, which clings to its support, is also a symbol of attachment and undying affection.

Jasmine. The white color and sweet scent of the jasmine make it a symbol of the Virgin Mary. As a secondary meaning, it may signify grace, elegance, and amiability.

Lady's Bed-Straw. This lowly plant received its common name from the legend that some pieces of it were mingled with the straw in the manger where the Infant Christ was laid.

Laurel. The laurel symbolizes triumph, eternity, and chastity. The victor in ancient contests was crowned with a wreath of laurel. St. Paul contrasts this wreath with the imperishable wreath with which the victorious Christian is crowned (I Corinthians 9: 24–27). This, with the fact that laurel leaves never wilt but preserve their green foliage, makes it symbolic of eternity. Its association with chastity is probably derived from the pagan symbolism that the laurel was consecrated to the Vestal Virgins, who vowed perpetual chastity.

Lemon. The lemon is a symbol of fidelity in love, and, as such, is often associated with the Virgin Mary.

Lily. The lily is a symbol of purity, and has become the flower of the Virgin. Originally, in Christian symbolism, the lily was used as the attribute of the virgin saints. The lily among thorns has become a symbol of the Immaculate Conception of the Virgin, in token of the purity she preserved amid the sins of the world. One incident in the life of the Virgin, the Annunciation, is particularly associated with lilies. In many of the scenes of the Annunciation painted during the Renaissance, the Archangel Gabriel holds a lily, or a lily is placed in a vase between the Virgin and the Announcing Angel. Because of this, the lily has become an attribute of the Archangel Gabriel.
Occasionally, the Infant Christ is represented offering a spray of lilies to a saint. Here the lily symbolizes the virtue of chastity. As a symbol of chastity, the lily is the attribute of several saints,

among them St. Dominic, St. Francis, St. Anthony of Padua, St. Clare, and St. Joseph.

The fleur-de-lis, a variety of lily, is the emblem of royalty. The fleur-de-lis was chosen by King Clovis as an emblem of his purification through baptism, and this flower has since become the emblem of the kings of France. For this reason, the flower is an attribute of St. Louis of France and St. Louis of Toulouse, both of them members of the royal house of France. The fleur-de-lis was also the emblem of the city of Florence. As an attribute of royalty, the fleur-de-lis appears on crowns and sceptres of kingly saints, and is given to the Virgin Mary as Queen of Heaven.

Lily of the Valley. The lily of the valley is one of the first flowers of the year and announces the return of spring. For this reason it has become a symbol of the Advent of Christ. For the whiteness of its flowers and the sweetness of its scent it is a symbol of the Virgin Mary, especially of her Immaculate Conception. The latter meaning is based upon Song of Solomon 2:1, 'I am the rose of Sharon, and the lily of the valleys.'

Myrtle. The evergreen myrtle has from very early times been used as the symbol of love. In Roman mythology the myrtle was considered sacred to Venus, the goddess of love. In Christian symbolism the myrtle is an allusion to the Gentiles who were converted by Christ. This interpretation is based upon Zechariah 1: 8, 'I saw by night, and behold a man riding upon a red horse, and he stood among the myrtle trees that were in the bottom; and behind him there were horses, red, speckled, and white.' This passage was interpreted as showing Christ, the man riding upon the red horse amid the Gentiles and followed by the hierarchies of martyrs and confessors.

Narcissus. The symbolism of the narcissus, which represents selfishness and self-love, coldness, and indifference, refers to the Greek legend of the youth, Narcissus, who fell in love with his own image when he saw it in the water and drowned while trying to embrace it. After his death, the youth was changed into a flower, the narcissus.

This flower is sometimes depicted in scenes of the Annunciation or of Paradise to show the triumph of divine love, sacrifice, and eternal life over death, selfishness, and sin.

Oak. Long before the Christian era, the ancient Celtic cult of the Druids worshiped the oak. As was often the case with pagan superstitions, the veneration of the oak tree was absorbed into Christian symbolism and its meaning changed into a symbol of Christ or the Virgin Mary. The oak was one of the several species of trees that were looked upon as the tree from which the Cross was made. (See Ilex, Aspen.)
Because of its solidity and endurance, the oak is also a symbol of the strength of faith and virtue, and of the endurance of the Christian against adversity.

Olive. The olive is a true Biblical tree, a tree 'full of fatness' which yields great quantities of oil. Its rich yield symbolized the providence of God toward His children. 'The trees went forth . . . to anoint a king over them; and they said unto the olive tree. Reign thou over us. But the olive tree said unto them, Should I leave my fatness, wherewith by me they honour God and man . . .?' (Judges 9: 8–9).
The olive branch has always been regarded as a symbol of peace, and appears as such in allegorical paintings of Peace. It will be recalled that when Noah was in the ark during the flood, he sent forth a dove to find out whether the waters had receded from the earth. 'And the dove came in to him in the evening; and, lo, in her mouth was an olive leaf plucked off: so Noah knew that the waters were abated from off the earth' (Genesis 8: 11). In this passage, the olive branch is symbolic of the peace God made with men. A dove with an olive twig in its beak is often used to indicate that the souls of the deceased have departed in the peace of God. As a token of peace, an olive branch is carried by the Archangel Gabriel to the Virgin Mary in scenes of the Annunciation. This symbolism was especially favored by painters of the Sienese school; they wished to avoid the representation of the lily, the customary symbol of the Annunciation, because it was also the emblem of Florence, the declared enemy of Siena.

Orange. The orange tree is regarded as a symbol of purity, chastity, and generosity. Thus it is occasionally depicted in paintings of the Virgin Mary. The orange tree was sometimes used instead of the apple tree or the fig tree in scenes showing the fall of man. When it is seen in representations of Paradise, it alludes to the fall of man and his redemption. The white flower is also

used to suggest purity, and for this reason orange blossoms are the traditional adornment of brides.

Palm. Among the Romans, the palm frond was traditionally the symbol of victory. This meaning was carried into Christian symbolism, where the palm branch was used to suggest the martyr's triumph over death. Martyrs are often depicted with the palm either in place of or in addition to the instruments of their martyrdom. Christ is often shown bearing the palm branch as a symbol of His triumph over sin and death. More often, it is associated with His triumphant entry into Jerusalem. 'On the next day much people that were come to the feast, when they heard that Jesus was coming to Jerusalem, took branches of palm trees, and went forth to meet him, and cried, Hosanna; Blessed is the King of Israel that cometh in the name of the Lord' (John 12: 12–13).

A palm-tree staff is the attribute of St. Christopher, in reference to the legend that he uprooted a palm tree to support himself on his travels. After carrying Christ across the river, he thrust the staff into the ground, whereupon it took root and bore fruit. A dress made of palm leaves is an attribute of St. Paul the Hermit.

Pansy. Though rarely depicted in the Renaissance, the pansy is a symbol of remembrance and meditation.

Peach. The peach is symbolic of the silence of virtue and of a virtuous heart and tongue. Sometimes it appears in paintings of the Virgin and Child, in place of the apple, to symbolize the fruit of salvation.

Pear. The pear frequently appears in connection with the Incarnate Christ, in allusion to His love for mankind.

Plane Tree. The plane tree, which spreads its branches high and wide, has become a symbol of charity, firmness of character, and moral superiority. It is more specifically a symbol of the charity of Christ.

Plantain. The plantain, often seen in Renaissance paintings, is a common and lowly plant which thrives along roads and pathways. It became known as 'way bread' and a symbol of the 'well-trodden path' of the multitude that seek the path to Christ.

Plum. The plum is symbolic of fidelity and independence. However, it was most frequently used in Renaissance painting for decorative purposes.

Pomegranate. In Christian symbolism, the pomegranate as a rule alludes to the Church because of the inner unity of countless seeds in one and the same fruit.

In pagan mythology, it was an attribute of Proserpina and symbolized her periodical return to earth in the spring. From this pagan symbolism of the return of spring and rejuvenation of the earth was derived the second symbolism of the pomegranate in Christian art, that of hope in immortality and of resurrection. The pomegranate, because of its many seeds, was also a symbol of fertility.

Poppy. The poppy is a symbol of fertility, sleep, ignorance, extravagance, and indifference. It is sometimes depicted in allusion to the Passion of Christ because of its blood-red color and its meaning of sleep and death.

Reed. The reed is one of the symbols of the Passion, for, on the Cross, Christ was tendered a sponge soaked in vinegar on the end of a reed. It thus symbolizes the humiliation of greatness. It is also used to represent the just, who dwell on the banks of the waters of grace. The small cross carried by St. John the Baptist is commonly made of reeds.

Rose. Traditionally, among the ancient Romans, the rose was the symbol of victory, pride, and triumphant love. It was the flower of Venus, goddess of love.

In Christian symbolism, the red rose is a symbol of martyrdom, while the white rose is a symbol of purity. This interpretation has been current since the earliest years of Christianity. St. Ambrose relates how the rose came to have thorns. Before it became one of the flowers of the earth, the rose grew in Paradise without thorns. Only after the fall of man did the rose take on its thorns to remind man of the sins he had committed and his fall from grace; whereas its fragrance and beauty continued to remind him of the splendor of Paradise. It is probably in reference to this legend that the Virgin Mary is called a 'rose without thorns,' because of the tradition that she was exempt from the consequences of original sin.

In Renaissance art, a garland of roses is often an allusion to the rosary of the Blessed Virgin. (See Rosary, in Section XIII.)

Wreaths of roses worn by angels, saints, or by human souls who have entered into heavenly bliss, are indicative of heavenly joy.

In accordance with a very ancient custom dating as far back as the time of Pope Gregory I, the sending of a golden rose by the Pope to people of distinction is a symbol of special papal benediction. An apron full of roses is an attribute of St. Elisabeth of Hungary, while a basket of roses and apples is used to identify St. Dorothea of Cappadocia.

Strawberry. The strawberry is the symbol of perfect righteousness, or the emblem of the righteous man whose fruits are good works. When shown with other fruits and flowers, it represents the good works of the righteous or the fruits of the spirit. It is in line with this meaning that the Virgin is sometimes shown clad in a dress decorated with clusters of strawberries. The strawberry is occasionally shown accompanied by violets to suggest that the truly spiritual are always humble.

Thistle. The thistle is the symbol of earthly sorrow and sin because of the curse pronounced against Adam by God, in Genesis 3 : 17-18, '. . . cursed is the ground for thy sake; in sorrow shalt thou eat of it all the days of thy life; thorns also and thistles shall it bring forth to thee; and thou shalt eat the herb of the field.' The thistle is a thorny plant, and because of its connection with thorns in the passage quoted above, it has also become one of the symbols of the Passion of Christ, and particularly of His crowning with thorns. (See Thorn.)

Thorn. Thorns and thorn branches signify grief, tribulation, and sin. According to St. Thomas Aquinas, thorn bushes suggest the minor sins, and growing briars, or brambles, the greater ones. The crown of thorns with which the soldiers crowned Christ before the Crucifixion was a parody of the Roman emperor's festal crown of roses. The tonsure of the priest is a reverent allusion to this thorny crown.

The crown of thorns, when shown in connection with saints, is a symbol of their martyrdom. St. Catherine of Siena is often depicted with the stigmata and the crown of thorns which she received from Christ.

Tree. The tree has played an important part in Christian symbolism. In general, the tree is a symbol of either life or death, depending upon whether it is healthy and strong, or poorly nourished and withered. Genesis 2:9 describes how the Lord planted the Garden of Eden: 'And out of the ground made the Lord God to grow every tree that is pleasant to the sight, and good for food; the tree of life also in the midst of the garden, and the tree of knowledge of good and evil.' Genesis continues to relate that the fall of man resulted from Adam's partaking of the fruit of the Tree of Knowledge. There is a legend that, after the death of Adam, the Archangel Michael instructed Eve to plant a branch of the Tree of Knowledge on his grave. From this branch grew the tree which Solomon moved to the Temple garden. It was later discarded and thrown into the pool of Bethesda. There it remained until it was taken out to be fashioned into the Cross. (See Solomon and the Queen of Sheba, in Section V.)
The flowering tree is used as an attribute of St. Zenobius, with reference to the legend of the dead tree that burst into leaf at the touch of the saint's dead hand.

Tree of Jesse. The genealogy of Christ, according to the Gospel of St. Matthew, is frequently shown in the form of a tree which springs from Jesse, the father of David, and bears, as its fruit, the various ancestors of Christ. Usually the tree culminates with the figure of the Virgin bearing her Divine Son in her arms. The representation of the Tree of Jesse is based upon the prophecy of Isaiah 11:1-2, 'And there shall come forth a rod out of the stem of Jesse, and a Branch shall grow out of his roots: And the spirit of the Lord shall rest upon him . . .' The presence of the Crucified Christ in the Tree of Jesse is based on a medieval tradition that the dead tree of life may only become green again if the Crucified Christ is grafted upon it and revives it with His blood. The presence of the Virgin Mary alone at the top of the Tree of Jesse alludes to her Immaculate Conception. In place of a tree, sometimes the vine, a Eucharistic symbol, can be found.

Vine. The vine is one of the most vivid symbols in the Bible and is used to express the relationship between God and His people. The vine sometimes refers to the vineyard as being the protected place where the children of God (the vines) flourish under the tender care of God (the Keeper of the Vineyard). 'For the

vineyard of the Lord of hosts is the house of Israel, and the men of Judah his pleasant plant' (Isaiah 5: 7). The vine was used as the symbol of the Church of God, in which, alone, this relationship exists.

The vine as the emblem of Christ follows from His words expressing the new relation between God and man through Him. 'I am the true vine, and my Father is the husbandman . . . I am the vine, ye are the branches: He that abideth in me, and I in him, the same bringeth forth much fruit: for without me ye can do nothing . . . Herein is my Father glorified, that ye bear much fruit; so shall ye be my disciples' (John 15: 1, 5, 8).

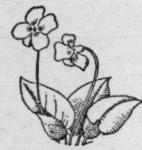

Violet. The violet is a symbol of humility. St. Bernard describes the Virgin Mary as the 'violet of humility.' It is also used to denote the humility of the Son of God in assuming human form. White violets are an attribute of St. Fina, whose resting place, after her death, was found covered by these flowers. (See also Strawberry.)

Wheat. Wheat is used to suggest the bounty of the earth, but, in relation to Holy Communion, it symbolizes the bread of the Eucharist. (See Grain.)

Willow. The willow continues to flourish and to remain whole, no matter how many of its branches are cut. Therefore, it has come to be a symbol of the gospel of Christ, which remains intact, no matter how widely it is distributed among the peoples of the world.

SECTION III

Earth and Sky

Ashes. In Christian symbolism, ashes are the symbol of penitence. On Ash Wednesday, the first day of Lent, ashes placed on the forehead express the penitential nature of the season. The ashes are from the palms of the previous Palm Sunday. Ashes also represent the death of the human body and symbolize the shortness of earthly life.

Carbuncle. The deep blood-red of the carbuncle is significant of blood and suffering, hence the stone is considered to be symbolic of Christ's Passion and of martyrdom. Five carbuncles are sometimes shown on the Cross to symbolize the five wounds received by Christ during the Crucifixion.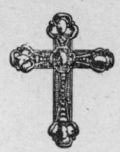

Clouds. Clouds in the heavens are the natural veil of the blue sky, and are, therefore, used as the symbol of the unseen God. A hand emerging from a cloud is the most common symbol of Divine Omnipotence.

Coral. Coral was used as a charm against the 'evil eye,' and, as such, was commonly hung about the neck of children. In pictures of the Christ Child it denotes protection against evil.

Darkness. Physical darkness is the symbol of spiritual darkness. The Devil is the Prince of Darkness. In his realm, all is dark; while in the realm of God, all is light.

Dawn. Dawn is the symbol of the Blood of Christ. Through the shedding of His Blood, the darkness of sin was overcome, and the dawn of eternal salvation made the world light. It is with this meaning that, in paintings of the Resurrection, Christ sometimes appears clothed in the rose color of dawn. Dawn is also the symbol of the Advent of Christ.

Earth. The earth, which produces plants and trees and furnishes a habitation for man, is often used as a symbol for the Church, which feeds man with spiritual faith and offers him shelter. Thus, the earth, in which the Cross was planted, sometimes conveys this symbolic meaning.

East. East, being the direction in which the sunrise appears, is symbolic of Christ, the Sun of the Universe.

Fire and Flames. Fire and flames are symbolic of both martyrdom and religious fervor. Flames of fire are an attribute of St. Anthony of Padua, the patron saint of protection against fire. St. Laurence sometimes wears a burning tunic, in reference to his torture on a gridiron. Fire or flames may appear as attributes to signify the fervor of such saints as St. Anthony Abbot and St.

Agnes. Fire itself is sometimes personified as a monster vomiting flames; or by a salamander, which, according to legend, can live in fire without being burned. In paintings of Pentecost, flames on the heads of the Apostles signify the presence of the Holy Ghost. They also signify the torments of Hell. (See Heart, Section IV.)

Fountain. The fountain is one of the attributes of the Virgin Mary, who was regarded as 'the fountain of living waters.' This Interpretation is based on the famous passage in Song of Solomon 4:12ff., and upon Psalm 36: 9, which reads, 'For with thee is the fountain of life: in thy light shall we see light.' The fountain is also the attribute of St. Clement, who miraculously found water in the desert for his followers.

Garden. The enclosed garden is a symbol of the Immaculate Conception of the Virgin Mary. The symbol is borrowed from the Song of Solomon 4: 12, 'A garden inclosed is my sister, my spouse; a spring shut up, a fountain sealed.'

Gold. The precious metal, gold, is used as the symbol of pure light, the heavenly element in which God lives. It is also used as a symbol of worldly wealth and idolatry. This is based on the story of Aaron (Exodus 32), who, in the absence of Moses, fashioned a golden calf which was to be worshiped instead of the true God.

Harbor. The harbor, according to some authorities, is a symbol of eternal life, and the ships making for the harbor are likened to souls in search of Heaven.

Honey. The purity and sweetness of honey have made it a symbol of the work of God and the ministry of Christ. Paradise, the reward of the faithful in their labors for Christ, is known as 'the land of milk and honey.'

Ivory. Ivory has two outstanding qualities: the whiteness of its color and the firmness of its texture. From these qualities come the symbols of purity and moral fortitude. Ivory, is, on occasion, a symbol of Christ, in reference to the incorruptibility of His body in the tomb. This is in all probability the origin of the custom of carving crucifixes from ivory.

Light. Light is symbolic of Christ, in reference to His words in John 8: 12, 'Then spake Jesus again unto them, saying, I am the light of the world: he that followeth me shall not walk in darkness, but shall have the light of life.'

North. North has always been considered as the region of cold and night. In the early centuries of the Church, the barbarians lived to the north. The reading of the gospel from the north end of the altar symbolized the Church's desire to convert the barbarians to Christ.

Oil. Oil is the symbol of the Grace of God. It is used in the sacraments of baptism, confirmation, ordination, and unction.

Pearl. The pearl, as the 'most precious jewel,' is used as a symbol of salvation, which is worth more than all the treasures of earth. 'The Kingdom of Heaven,' said Christ, according to Matthew 13: 45, 'is like unto a merchant man, seeking goodly pearls; who, when he had found one pearl of great price, went and sold all that he had, and bought it.' Elsewhere in Matthew the pearl represents the word of God: 'Give not that which is holy unto the dogs, neither cast ye your pearls before swine, lest they trample them under their feet . . .' (Matthew 7: 6).

Pitch. Pitch, because of its color and clinging quality, is a symbol of evil. 'Black as pitch' is a familiar phrase used to denote a sinful state or condition.

Rainbow. The rainbow is a symbol of union and, because it appeared after the Flood, it is also the symbol of pardon and of the reconciliation given to the human race by God. In art, the rainbow is used as the Lord's throne, and in representations of the Last Judgment, Christ is often seated upon it. '. . . behold, a throne was set in heaven, and one sat on the throne . . . and there was a rainbow round about the throne.' (Revelation 4: 2, 3).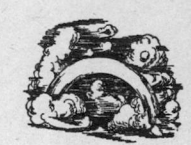

Rivers. According to ancient tradition, there were four sacred rivers: the Pison, the Gihon, the Tigris, and the Euphrates. These rivers were believed to be the four rivers of Paradise, flowing from a single rock, and as such were used as symbols of the four gospels flowing from Christ.

Rocks. Rocks are a symbol of the Lord. This meaning is derived from the story of Moses, who smote the rock from which a spring burst forth to refresh his people. Christ is often referred to as a rock from which flow the pure rivers of the gospel. St. Peter, too, is referred to as a rock, the cornerstone of the Church, because of Christ's statement: '. . . that thou art Peter, and upon this rock I will build my church . . .' (Matthew 16: 18).

Salt. Salt is the symbol of strength and superiority. Christ, in the Sermon on the Mount, called His disciples 'the salt of the earth' (Matthew 5: 13). Since salt protects food from decay, it is sometimes used as a symbol of protection against evil and, in this context, is sometimes placed in the mouth of the child being baptized.

Silver. Because of its whiteness and because it is a precious metal tested by fire, silver has become the symbol of purity and chastity. Silver also is symbolic of the eloquence of the evangelist. These concepts are based upon Psalm 12: 6, which states: 'The words of the Lord are pure words: as silver tried in a furnace of earth, purified seven times.' (See Coins and Money, in Section XIV.)

Smoke. Smoke has come to suggest vanity and all that is fleeting because it rises into the air only to disappear. Symbolically, it is a reminder of the shortness of this life and the futility of seeking earthly glory. The anger and wrath of God were ofttimes indicated by smoke. 'O God, why has thou cast us off for ever? Why doth thine anger smoke against the sheep of thy pasture? (Psalm 74:1).

South. South, as one of the cardinal points, is the seat of light and warmth; it is therefore associated with the New Testament, especially the Epistles.

Star. The star, lighting the darkness of the heavens at night, is a symbol of divine guidance or favour. The Star of the East, often seen in pictures of the Magi, was the star that guided the wise men to Bethlehem and stood in the sky over the manger where Christ was born. Twelve stars may symbolize the twelve tribes of Israel and the twelve Apostles. The Virgin of the Immaculate Conception and the Queen of Heaven is crowned with twelve

stars (Revelation 12:1). One star is a symbol of the Virgin in her title 'Stella Maris,' Star of the Sea. A star on the forehead is one of the attributes given to St. Dominic, while a star on the breast is an attribute of St. Nicholas of Tolentino.

Stones. Stones are symbols of firmness. They are used as an attribute of St. Stephen, who was stoned to death. St. Jerome is frequently portrayed at prayer beating his breast with a stone.

Sun and Moon. The sun is symbolic of Christ, this interpretation being based on the prophecy of Malachi 4: 2: 'But unto you that fear my name shall the Sun of righteousness arise with healing in his wings.' The sun and moon are used as attributes of the Virgin Mary, referring to the 'woman clothed with the sun, and the moon under her feet' (Revelation 12: 1). The sun and moon are often represented in scenes of the Crucifixion to indicate the sorrow of all creation at the death of Christ. St. Thomas Aquinas is sometimes depicted with a sun on his breast.

Time. In Renaissance art, Father Time, the personification of time, is generally represented as a nude figure with wings. His most common attributes are the scythe or sickle, but sometimes an hourglass, a snake or dragon biting its tail, or the zodiac is substituted. In many cases, the figure walks with crutches to suggest extreme age.

Water. Water is a symbol of cleansing and purifying. In this sense it is used in the sacrament of baptism, symbolizing the washing away of sin and the rising to newness of life. It also denotes innocence, as when Pilate publicly washed his hands, saying, 'I am innocent of the blood of this just person' (Matthew 27: 24). More rarely, water suggests trouble or tribulation: 'Save me, O God; for the waters are come into my soul . . . I am come into deep waters, where the floods overflow me' (Psalm 69: 1, 2). The water, mixed with wine, in the Eucharist has come to denote Christ's humanity, the wine representing His divinity.

Well. The well or fountain is the symbol of baptism, of life and rebirth. The flowing fountain symbolizes the waters of eternal life. The sealed well or fountain is a symbol of the virginity of Mary. (See Fountain.)

West. As one of the four cardinal points, the west signifies the seat of darkness and the abode of demons. To those sitting in the darkness, the rose window high up on the western side of the church was said to make the light of the gospel visible.

Wings. Wings are the symbol of divine mission. That is why the angels, archangels, seraphim, and cherubim are painted with wings. The emblems of the four evangelists, the lion of St. Mark, the ox of St. Luke, the man of St. Matthew, and the eagle of St. John, are all depicted as winged creatures.

SECTION IV

The Human Body

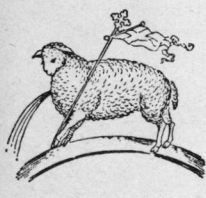

Blood. By its very nature, blood is the symbol of life and of the human soul. Christ, the Son of God, shed His blood upon the Cross to redeem mankind from its sins. 'And he took the cup, and gave thanks, and gave it to them, saying, Drink ye all of it; for this is my blood of the New Testament, which is shed for many for the remission of sins' (Matthew 26: 27, 28). Red, the color of blood, has become the common attribute of all those martyrs who died rather than deny Christ.

Breasts. The female breasts are the symbol of motherhood, and its attributes of love, nourishment, and protection. The Virgin as mother gives her breast to the Child. Two breasts on a platter are used as an attribute of St. Agatha, who, as part of her martyrdom, had her breasts torn by pincers or shears.

Ear. The human ear has come to be one of the symbols of the betrayal of Christ and thus of the Passion. In John 18:10, at Christ's arrest by the servants of Caiaphas, it is related how '. . . Simon Peter having a sword drew it, and smote the high priest's servant and cut off his right ear.'

Eye. Because of the many scriptural references to the eye of God, the eye has come to symbolize the all-knowing and ever-present

God. 'The eyes of the Lord are over the righteous, and his ears are open to their prayers' (I Peter 3:12). In Proverbs 22: 12, it is written: 'The eyes of the Lord preserve knowledge, and he over-throweth the words of the transgressor.' In the later period of Renaissance painting, the Eye of God surrounded by a triangle is used to symbolize the Holy Trinity. The eye within the triangle, surrounded by a circle and radiating rays of light, is used to suggest the infinite holiness of the Triune God. A pair of eyes, often on a platter, are the attribute of St. Lucy.

Foot. The human foot, because it touches the dust of the earth, is used to symbolize humility and willing servitude. The woman in the house of the Pharisee who washed Christ's feet with her tears did so as a token of her humility and penitence, and her sins were forgiven (Luke 7: 38). Christ Himself washed the feet of His disciples at the Last Supper (John 13: 5). It is on the basis of this act that it has become the tradition for bishops to perform the ceremony of washing feet on Maundy Thursday.

Hair. Loose, flowing hair is a symbol of penitence. Its origin is closely allied to the episode related in Luke 7: 37–38, 'And, be-hold, a woman in the city, which was a sinner, when she knew that Jesus sat at meat in the Pharisee's house . . . stood at his feet behind him weeping, and began to wash his feet with tears, and did wipe them with the hairs of her head . . .' This Biblical story led to the custom of the hermits, and all those doing penance, of letting their hair grow long.
In ancient times, unmarried women wore their hair loose and long. This is the reason that the virgin saints are frequently por-trayed with long, flowing hair. Long hair worn by men may sometimes symbolize strength, an allusion to the story of Samson.

Hand. In the early days of Christian art, Christians hesitated to depict the countenance of their God, but the presence of the Almighty was frequently indicated by a hand issuing from a cloud that hid the awe-inspiring and glorious majesty of God, which 'no man could behold and live' (Exodus 33: 20). The origin of this symbol rests in the frequent scriptural references to the hand and the arm of the Lord, symbols of His almighty power and will. The hand is sometimes shown closed or grasping

some object, but is often shown open with three fingers extended, the symbol of the Trinity, with rays of light issuing from it. The hand is frequently, but not always, invested with the nimbus. The hand raised, palm outward, is symbolical of the blessing of God.

The hand also plays an important role in the Passion of Christ. The open hand recalls the mocking of Christ in the Common Hall, for He was slapped in the face there. The hand closed over straws recalls the tradition that lots were drawn to see whether Christ or Barabbas should be released.

A hand pouring money into another hand, or a hand holding a bag of money, is an allusion to the betrayal by Judas. Finally, hands over a basin allude to the episode of Pilate's washing his hands of responsibility for Christ's Crucifixion. The clasping of hands, as in the marriage ceremony, has the symbolic meaning of union.

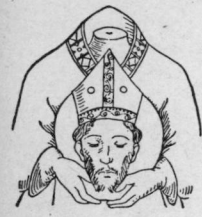

Head. The head, as the uppermost and chief part of the body, is sometimes used to represent the whole man. It also represents the seat of life and, being the chief member of the body, has rule and control over all of the other members. Thus Christ is the spiritual head of His Church not only in eminence and influence but in that He communicates life and strength to every believer.

The head is used as a symbol in relation to a number of Biblical persons. A severed head in the hands or at the feet of a male figure is an attribute of David, who, after striking down Goliath the Philistine with a stone from his sling, struck off the Philistine's head with a sword. Judith is portrayed with a severed head in her hands, in allusion to her killing of Holofernes. Salome is frequently depicted carrying the head, often haloed, of John the Baptist on a platter. A head on a platter is sometimes employed as an attribute of St. John the Baptist.

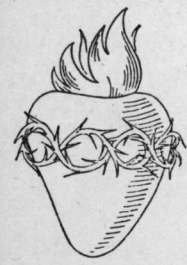

Heart. The heart was considered to be the source of understanding, love, courage, devotion, sorrow, and joy. Its deep religious meaning is expressed in I Samuel 16: 7, 'But the Lord said unto Samuel, Look not on his countenance, or on the height of his stature . . . for the Lord seeth not as man seeth; for man looketh on the outward appearance, but the Lord looketh on the heart.' The human heart, when carried by a saint, is symbolic of love and piety. The flaming heart suggests the utmost religious fervor.

The heart pierced by an arrow symbolizes contrition, deep repentance, and devotion under conditions of extreme trial. The flaming heart and, occasionally, the pierced heart are used as attributes of St. Augustine, symbolizing God's guidance of his zeal. The heart with a cross is an attribute of St. Catherine of Siena, with reference to the legend that, in response to her prayers, the Saviour one day appeared to her and replaced her heart with His own. The heart is also used as an attribute of St. Bernardino of Siena.

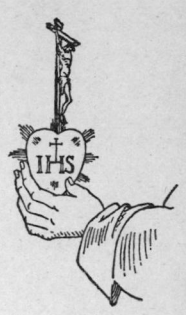

Nudity. The portrayal of the human body in its nakedness had great teaching to support its various representations. At the time of the Renaissance, there were four clearly defined, symbolic types of nudity.

Nuditas naturalis: The natural state of man as he is born into the world. 'For we brought nothing into this world, and it is certain we can carry nothing out' (I Timothy 6: 7). Man's recognition of this fact should lead him to '. . . follow after righteousness, godliness, faith, love, patience, meekness' (I Timothy 6: 11).

Nuditas temporalis: The lack of worldly goods and possessions. While this is the natural state of man at his birth, it can also be the result of the trials and difficulties of life which cause a man to live in a condition of poverty. This lack of worldly goods can be voluntary, however, and assumed 'to the glory of God,' as in the case of those who have willingly surrendered all temporal things in order to serve God completely.

Nuditas virtualis: This is the use of nudity as the symbol of purity and innocence. It represents those in this world who, though engaged in the activities of life, nevertheless are not overcome by the evil and temptation which surround them. It represents the high and the desirable quality of the virtuous life.

Nuditas criminalis: This use of nudity is the opposite of *nuditas virtualis*. It is symbolic of lust, vanity, and the absence of all virtues.

The difference between these last two types of nudity might be explained as the quest for Eternal Bliss as opposed to the pursuit after Transient Bliss. Titian's picture of 'Sacred and Profane Love' is said by some to point out this contrast. Eternal Bliss, *nuditas virtualis*, is personified by a woman whose nudity denotes her contempt for perishable, earthly things. A flame in her right hand symbolizes the love of God. Transient Bliss, *nuditas*

criminalis, is depicted by a woman richly clothed and adorned with glittering jewels. In her hands she holds a vessel of gold and gems, symbolizing vanity and the love of riches and pleasures of this world.

In portraying truth as a virtue, it is usually represented by the figure of a naked woman.

Skeleton. The human skeleton is, for obvious reasons, used as a symbol of death. Frequently, the skeleton is shown bearing in one hand a scythe, a symbol of the cutting short of life, and in the other hand an hourglass, a symbol of the swift passage of time.

Skull. The skull is used as a symbol of the transitory nature of life on earth. It suggests, therefore, the useless vanity of earthly things. The skull is sometimes used as an attribute of penitent saints, such as St. Mary Magdalene, St. Paul, St. Jerome, and St. Francis of Assisi. Hermits are usually shown with a skull to suggest their contemplation of death. When a cross is represented with the skull, it suggests their meditation upon eternal life after death.

In some Renaissance pictures, the Cross is shown with a skull and crossbones at its foot, referring to the Cross on Golgotha, 'the place of a skull.' There is a legend that the Cross rested upon the skull and bones of Adam, suggesting that through the Cross all men may rise to eternal life. 'And so it is written, The first man Adam was made a living soul; the last Adam was made a quickening spirit' (I Corinthians 15: 45).

Stigmata. The word 'stigmata' is the plural of the word 'stigma,' which means a mark, usually of disgrace or infamy. Stigmata are marks said to have been supernaturally impressed upon certain persons of high religious character in the semblance of the five wounds suffered by Christ upon the Cross. In Christian art, the stigmata are used particularly as the attribute of St. Catherine of Siena and of St. Francis of Assisi, because marks are reported to have appeared on both of them.

SECTION V

The Old Testament

Introduction. The great interest of the Renaissance painters was centered in Christ, the Virgin, and the saints of the Church. The belief that the events and personalities of the Old Testament foreshadowed events in the life of Christ led, however, to many representations of Old Testament scenes and episodes. The natural appeal of the dramatic quality of the Old Testament stories had encouraged the use of the more familiar themes. The portrayal of the great Old Testament characters who, in their offices, were considered as the forerunners of the Christian revelation was a part of the witness of the action of God in human events and human history which had its fulfillment in Christ. In Renaissance art, the following Old Testament themes were most popular.

The Creation. Many subjects which portrayed the story of the Creation were found in the first chapters of Genesis. 'And the earth was without form, and void; and darkness was upon the face of the deep. And the Spirit of God moved upon the face of the waters' (Genesis 1: 2). On the first day, God created light and divided the light from darkness, thus creating Day and Night. On the second day, God divided the waters and created the firmament, which He called Heaven. On the third day, He created the land, which He called Earth, and endowed it with plants, flowers, and trees. On the fourth day, God created the lights of Heaven, including the sun, the moon, and the stars. On the fifth day, He created the birds of the air and creatures that inhabit the waters. Finally, on the sixth day, God created the beasts of the earth and Man himself. 'And God said, Let us make man in our image, after our likeness ...' (Genesis 1: 26). 'And on the seventh day God ended his work which he had made; and he rested on the seventh day from all his work which he had made. And God blessed the seventh day, and sanctified it' (Genesis 2: 2, 3).

Adam and Eve. The most common scenes from the story of Adam and Eve are the following:
The Creation of Adam: The creation of Adam, the first man, is thus described in Genesis 2: 7, 'And the Lord God formed man of the dust of the ground, and breathed into his nostrils the breath of life; and man became a living soul.'
The Creation of Eve: After God had created Adam, He decided that man

needed a helpmeet in addition to the birds and the beasts. He therefore 'caused a deep sleep to fall upon Adam . . . and he took one of his ribs, and closed up the flesh instead thereof; and the rib, which the Lord had taken from man, made he a woman, and brought her unto the man. And Adam said, This is now bone of my bones and flesh of my flesh: she shall be called Woman, because she was taken out of Man' (Genesis 2: 21ff.).

The Temptation of Eve: In the Garden of Eden, where God had placed Adam and Eve, He had planted 'the tree of the knowledge of good and evil,' and He warned Adam on penalty of death not to eat the fruit of this tree. But the serpent, 'more subtil than any beast of the field,' came to the woman Eve and tempted her to eat of the fruit of the tree, telling her that if she did so her eyes would be opened and she would be like the gods, knowing good and evil (Genesis 3: 1ff.). Being tempted, Eve ate the forbidden fruit and gave some also to Adam, her husband. 'And the eyes of them both were opened, and they knew that they were naked; and they sewed fig leaves together, and made themselves aprons' (Genesis 3: 7).

The Expulsion of Adam and Eve: Because Adam and Eve had disobeyed His command, and fearing that they might now eat also the fruit of the Tree of Life that grew in the Garden of Eden and become as gods, the Lord laid certain punishments upon Adam and Eve and banished them from the Garden of Eden. Because of the sin of Eve, He decreed that thereafter all women should bear their children in pain and should be subject to man. Because Adam had likewise sinned, the Lord decreed that henceforth man should earn his bread by the sweat of his brow. And He declared to Adam: '. . . dust thou art, and unto dust shalt thou return' (Genesis 3: 19).

Adam and Eve Toiling on Earth: A common representation of Adam and Eve shows them after their expulsion from the Garden of Eden toiling on earth in fulfillment of the Lord's decree that man shall earn his bread by the sweat of his brow.

The Sacrifice of Abel: The first child born to Adam and Eve was Cain, who became a tiller of the soil. His younger brother Abel, however, became a shepherd. And it was Abel who brought one of the first offspring of his flock as an offering to the Lord, '. . . and the Lord had respect unto Abel and to his offering' (Genesis 4: 4). This sacrifice by Abel was thought to foretell the Crucifixion, since Jesus, 'the Lamb of God,' was similarly sacrificed.

The Killing of Abel by Cain: Cain also made an offering to the Lord, 'But unto Cain and to his offering he [the Lord] had not respect. And Cain was very wroth, and his countenance fell' (Genesis 4: 5). In his anger, Cain came upon his brother Abel in the field and slew him. In punishment for this crime, the Lord made Cain a fugitive and a vagabond and set a mark upon him so that all should know him.

Noah. The prophet Noah was a direct descendant of Adam and Eve through their third son, Seth. In the days of Noah, 'God saw that the wickedness of man was great in the earth,' and He determined to destroy man, whom He had created (Genesis 6: 5ff.). Noah alone found grace in the eyes of the Lord. So the Lord instructed Noah to build an ark, '. . . and thou shalt come into the ark, thou, and thy sons, and thy wife, and thy son's wives with thee. And of every living thing of all flesh, two of every sort shalt thou bring into the ark, to keep them alive with thee; they shall be male and female' (Genesis 6: 18, 19).

The Building of the Ark: Often represented in art is the scene in which Noah is building the ark in accordance with the specific instructions given to him by God. 'The length of the ark shall be three hundred cubits, the breadth of it fifty cubits, and the height of it thirty cubits. A window shalt thou make to the ark . . . and the door of the ark shalt thou set in the side thereof; with lower, second, and third stories shalt thou make it' (Genesis 6: 15, 16).

The Flood: Also frequently portrayed is the great flood itself which the Lord loosed upon the earth and which 'prevailed upon the earth for an hundred and fifty days.' Noah and his family and the animals that he had taken with him rode out the flood safely in the ark. And the Lord at last felt that His cleansing of the earth had been accomplished and He caused the rains to cease and the waters to subside. When the waters fell, the ark of Noah came to rest upon the mountains of Ararat. To discover whether the earth was again habitable, Noah sent forth a raven, which did not return. He then sent forth a dove, which at first found no resting place. On being sent forth a second time, it returned bearing an olive leaf in its beak (Genesis 8: 11). So Noah knew that the flood was subsiding. This experience of Noah in the ark has been compared to the baptism of Christ.

The Sacrifice of Noah: In thankfulness for being saved from the flood, 'Noah built an altar unto the Lord; and took of every clean beast, and of every clean fowl, and offered burnt offerings on the altar' (Genesis 8: 20.).

The Drunkenness of Noah: Another scene from the life of Noah frequently represented depicts the unworthy action of his youngest son Ham, who spied upon his father in his tent after Noah had partaken too generously of wine. He thus dishonoured his parent by gazing upon his nakedness. When Noah awoke and learned what his son had done, he cursed him, saying: '. . . a servant of servants shall he be unto his brethren' (Genesis 9: 25).

Abraham. Of the descendants of Noah, it was Abraham who was chosen by the Lord to depart from the place of his birth and to go forth into the land of Canaan (Genesis 12: 1ff.). The events in the life of Abraham most commonly portrayed are:

Hagar and Ishmael: Sarah, the wife of Abraham, finding that she was unable to bear a child, told her husband to take as another wife her handmaiden, Hagar, that he might have children (Genesis 16). Of this union a son was born who was named Ishmael.

The Apparition of the Three Angels: When he was far advanced in years, Abraham received a visitation from the Lord, who announced that Abraham and Sarah should at last be blessed with a son of their own. At first Abraham would not believe this, thinking that both he and his wife were too old. Some time later, as Abraham sat in the door of his tent, three men appeared before him. Perceiving that they were angels of the Lord, he hastened to do them honor. They, too, prophesied that he and his wife would be granted a son (Genesis 18: 2ff.). At the appointed time the Lord appeared to Sarah, as He had promised, and she bore a son to Abraham who was named Isaac (Genesis 21: 1–3). Since, on the occasion of the visitation of the three angels, Abraham addressed them in the singular, this scene has been considered an allusion to the Trinity.

Abraham and Melchizedek: Some time after Abraham had established himself in the land of Canaan, he learned that his nephew Lot, who resided in the city of Sodom, had been taken prisoner and all his goods had been seized in an attack upon that city. Upon hearing this news, Abraham armed his followers and pursued the raiders. When he caught up with them, he attacked them by night and defeated them, bringing back all the captives and the goods that had been stolen. When Abraham returned triumphant, Melchizedek, king of Salem and high priest, came out to meet the victor, bringing him bread and wine. And Melchizedek blessed Abraham, saying: 'Blessed be Abraham of the most high God, possessor of heaven and earth.' Abraham, in turn, paid one-tenth of the spoils of battle as tithes to Melchizedek. The writer of the Epistle to the Hebrews (Hebrews 7: 1ff.) relates this episode to the sacrifices of Christ and to Christ's priesthood.

The Sacrifice of Isaac: The scene from the life of Abraham most commonly portrayed concerns the story of how he, being tested by the Lord, would have sacrificed his son Isaac at the Lord's behest. At the crucial moment, when Abraham was about to slay his son, the Lord intervened, saying: 'Lay not thine hand upon the lad, neither do thou anything unto him: for now I know that thou fearest God, seeing thou has not withheld thy son, thine only son from me' (Genesis 22). This episode has been interpreted in the light of Christ's Passion; for just as Abraham was prepared to sacrifice his son to obey the will of God, so Christ sacrificed Himself at the behest of His Father. And as Isaac carried the wood for his pyre to the place of his intended sacrifice, so Christ bore His Cross to Golgotha.

Lot, his Wife, and Daughters: The Lord had determined to destroy the wicked

cities of Sodom and Gomorrah. But, because of Lot's goodness, the Lord decided to save Lot, his wife, and two daughters. 'When the morning arose, then the angels hastened Lot, saying, Arise, take thy wife, and thy two daughters, which are here; lest thou be consumed in the iniquity of the city . . . look not behind thee . . . lest thou be consumed . . . but his wife looked back from behind him, and she became a pillar of salt' (Genesis 19). After this tragedy to his wife, Lot went to dwell with his two daughters in a mountain cave. There, because there were no men for them to marry and because Lot himself was without a wife, the daughters conspired together to seduce their father. By plying him with wine, they were able to bemuse him so that, without realizing what he was doing, he received them each in turn into his bed, and they bore him sons, Moab and Ammon.

Isaac and Rebekah: Abraham, being far advanced in years, was anxious that his son Isaac should marry and should take as wife, not a daughter of the land of Canaan, but a woman of the land of his birth, which was Chaldea. Accordingly, Abraham sent a trusted servant to select a wife for Isaac. Approaching the city of Nahor, the servant prayed for guidance in his choice of a proper wife for Isaac, that she be the one who gave him and his camels drink. The prayer was answered and the servant selected the damsel Rebekah, who he brought back to Canaan. Isaac, meditating in the fields at eventide, saw the camels approach. 'And Rebekah lifted up her eyes, and when she saw Isaac, she lighted off the camel. For she had said unto the servant. What man is this who walketh in the field to meet us? And the servant had said, It is my master; therefore she took a vail, and covered herself . . . And Isaac brought her into his mother Sarah's tent, and took Rebekah, and she became his wife' (Genesis 24: 64ff.).

Jacob.

Of her marriage with Isaac, twin sons were born to Rebekah, Jacob and Esau. Esau was a great hunter and the favorite of his father. Jacob, 'a plain man, dwelling in tents,' was his mother's favorite.

The Blessing of Jacob: Isaac, now old, his eyesight failing, sensed that death was near. He called Esau to him, saying: 'Take me some venison; and make me savoury meat, such as I love, and bring it to me that I may eat; that my soul may bless thee before I die.' But Rebekah, overhearing, sought means by which her favorite might receive his father's blessing, rather than Esau. In Esau's absence, she dressed Jacob in Esau's clothes and covered Jacob's hands and neck with goat skin, for Esau was 'a hairy man.' Then she prepared savory meat and sent Jacob with it to his father. Isaac, in his blindness, was uncertain who had come. 'The voice is Jacob's voice,' he said, 'but the hands are the hands of Esau.' Deceived because the hands he touched were hairy, Isaac blessed Jacob, giving him authority over his brother and all their tribe (Genesis 27).

The Dream of Jacob: Often represented in paintings of the Renaissance is the dream that came to Jacob on his journey to Haran in search of a wife. Stopping at night along the roadside, he took stones for his pillow and lay down to sleep. 'And he dreamed, and behold a ladder set up on the earth, and the top of it reached to heaven: and behold the angels of God ascending and descending on it' (Genesis 28: 12). Then the Lord addressed Jacob, saying: 'I am the Lord God of Abraham thy father, and the God of Isaac: the land whereupon thou liest, to thee will I give it, and to thy seed.' When Jacob awoke, he realized that the Lord had been with him, and he took the stones of his pillow and constructed a pillar and, pouring oil upon it, called the place Bethel. Moreover, he made a vow that, if God remained with him, 'this stone, which I have set for a pillar, shall be God's house: and of all that thou shalt give me I will surely give the tenth unto thee' (Genesis 28: 22).

Jacob Wrestling with the Angel: Jacob had further evidence of God's favor toward him on the occasion of his journey to meet Esau, his estranged brother. Retiring for the night, 'Jacob was left alone; and there wrestled a man with him until the breaking of the day.' The angel did not prevail over Jacob. 'And he said, Let me go, for the day breaketh. And he said, I will not let thee go, except thou bless me. And he said unto him, What is thy name? And he said, Jacob. And he said, Thy name shall be called no more Jacob, but Israel: for as a prince hast thou power with God and with men, and hast prevailed. And Jacob asked him, and said, Tell me, I pray thee, thy name, and he said, Wherefore is it that thou dost ask after my name? And he blessed him there. And Jacob called the name of the place Peniel: for I have seen God face to face, and my life is preserved' (Genesis 32: 24–32).

Joseph. Joseph was the son of Jacob and his favorite wife, Rachel. Jacob 'loved Joseph more than all his children, because he was the son of his old age: and he made him a coat of many colours.' This coat was meant to show that Joseph, unlike his brothers, who were workmen for their father, was permitted to remain in his father's house and enjoy special privileges. 'And when his brethren saw their father loved him [Joseph] more than all his brethren, they hated him, and could not speak peaceably unto him.' One day Jacob sent Joseph to see whether all went well with his brothers and the flocks they were tending. 'And when they saw him afar off, even before he came near unto them, they conspired against him to slay him . . . And it came to pass, when Joseph was come unto his brethren, that they stripped Joseph out of his coat, his coat of many colours that was on him; and they took him, and cast him into a pit . . . and they drew and lifted up Joseph out of the pit, and sold Joseph to the Ishmeelites for twenty pieces of silver: and they brought Joseph into Egypt . . . [his brothers] took Joseph's coat, and

killed a kid of the goats, and dipped the coat in the blood . . . and they brought it to their father . . . And he knew it, and said, It is my son's coat . . . And Jacob rent his clothes . . . and mourned for his son many days' (Genesis 37). The sale of Joseph to the Ishmeelites by his brothers has been compared to the Betrayal of Christ by Judas, who sold his Master for thirty pieces of silver.

Of the later events in the life of Joseph, those most frequently represented in art are the following:

Joseph and Potiphar's Wife: Joseph was taken into Egypt, where he became a servant to Potiphar, a captain in the guard of Pharaoh. He worked so faithfully that he was made overseer of his master's estate. But Potiphar's wife fell in love with Joseph and would have tempted him to sin. One day, Joseph was forced to escape from her approaches by slipping out of his coat and leaving it in her hands. Angry at Joseph's disregard of her, Potiphar's wife used his coat as evidence that he had made improper advances to her (Genesis 39).

Pharaoh's Dream: Joseph was cast into prison by Potiphar because of false charges by his wife. While there, Joseph helped one of the servants of Pharoah by interpreting his dreams. Some two years later Pharaoh himself had a dream which troubled him. He dreamed first that he saw seven fine fat cattle come down to a stream and drink. These were followed by seven lean, half-starved cattle that ate up the seven fat cattle. Again, he dreamed that he saw seven fine ears of corn spring up on one stalk. Thereafter, seven poor ears sprang up and they devoured the seven fat ears. When Pharaoh could obtain no satisfactory explanation of this dream from those around him, his servant persuaded him to send for Joseph, who interpreted the dream to mean that there would be seven years of plenty in the land of Egypt, followed by seven years of famine. As a result of Joseph's advice, the harvests of the seven good years were stored against the ensuing famine, and the people of Egypt were saved from disaster (Genesis 40 and 41).

Joseph and His Brethren: The famine that afflicted Egypt affected also the land of Canaan, where Joseph was born. Jacob, Joseph's father, sent his sons to Egypt to buy corn in order that his people might not starve. Meanwhile, Joseph had been made governor of all Egypt. When his brothers appeared before him they failed to recognize him. The meeting of Joseph and his brothers and their eventual reunion has frequently been depicted (Genesis 42–47).

Moses. After the death of Joseph, the Israelites multiplied greatly and became powerful in the land of Egypt. Fearful of the growing strength of the Israelites, the king of Egypt ordered that all male children of the tribe should be put to death at infancy. But one of the Israelite women was determined to

save her son. After three months, when it was no longer possible to hide him in her home, she placed him in a wicker basket and left it 'in the flags by the river's brink' (Exodus 2: 3). The child's sister then stationed herself near the spot to see what would take place. She saw the daughter of Pharaoh come down to bathe and discover the infant. The princess realized that the baby was a child of the Israelites but, because he wept, she had compassion on him. The child's sister seized the opportunity to approach the princess, and offered to find a woman to nurse the baby. In this way, the child's mother was permitted to take care of her own son. 'And the child grew, and she brought him unto Pharaoh's daughter, and he became her son. And she called his name Moses' (Exodus 2: 10).

Many other scenes from the life of Moses have been subjects of Renaissance paintings. Among them are the following:

Moses and the Crown of Gold: While Moses, as a child, was still living in the court of Pharaoh, the king one day playfully set a crown upon his head. There was an idol in the center of the crown and the child threw the crown to the floor. The wise men of the court were called upon to interpret this omen. Some thought it signified that Moses would eventually overthrow the king. Others, however, saw in the incident merely a childish whim. To settle the question, it was decided to subject the child to a test. Two platters were placed before him; one heaped with burning coals, and the other with cherries. It was agreed that, if Moses chose the hot embers, he should be saved. Guided by the Lord, Moses seized a handful of the burning coals and, screaming, put his hand into his mouth. Legend says that as a consequence his tongue was burned, and that thereafter he had speech difficulties. This story, based on a Hebrew legend, was often illustrated by Italian painters.

Moses and the Midianites: As a young man, Moses became increasingly aware of the cruel oppression of the Israelites by the Egyptians. In defending one of his people he killed an Egyptian overseer. Fleeing to save his life, he found refuge in the land of Midian. One day, as Moses sat by a well, the seven daughters of the priest of Midian came to water their father's sheep. When some local shepherds tried to drive the girls away, Moses helped them and saw that their sheep were properly watered. Hearing of this, the priest took Moses into his home. Moses later married one of his daughters, Zipporah (Exodus 2: 11ff.).

Moses and the Burning Bush: One day, while Moses was tending the sheep of his father-in-law Jethro, he chanced to come to Horeb, the mountain of God. 'And the angel of the Lord appeared unto him in a flame of fire out of the midst of a bush: and he looked, and behold, the bush burned with fire, and the bush was not consumed' (Exodus 3: 2). When Moses paused to see why the fire did not consume it, God called to him out of the midst of the bush.

It was then that the Lord told Moses that he was chosen to return to the land of Pharaoh and 'bring forth my people the children of Israel out of Egypt.'
The Plagues of Egypt: In accordance with the will of the Lord, Moses, together with Aaron, returned to Egypt and pleaded with Pharaoh to release the people of Israel from their bondage. But the heart of Pharaoh was hardened, and, instead of releasing the Israelites, he increased their burdens (Exodus 5: 7ff.). Then Moses, with the help of the Lord, brought upon Egypt a series of disasters. Moses first smote the waters of the rivers of Egypt with his rod. The rivers were turned to blood and the fish died. He next caused the land to be overrun by a plague of frogs. Next Moses smote the dust and turned it into a plague of lice that afflicted man and beast. When Pharaoh still refused to relent, Moses caused a plague of flies to swarm over the land. Next he brought a pestilence upon the cattle of Egypt, and all cattle except that of the Israelites died in the fields. As this failed to move the king, Moses caused a plague of boils to afflict the Egyptians and, following this, a great storm of hail and lightning to destroy the crops in the fields. But Pharaoh still refused to bow before the will of God, so Moses set upon Egypt a plague of locusts which devoured everything that was green in the land. Then Moses stretched forth his hand and for three days the land of Egypt was enveloped in darkness. Finally, Moses warned Pharaoh that, if he would not free the people of Israel, the firstborn child of every Egyptian family would be struck dead. But Pharaoh still refused to listen, so the Lord '. . . smote all the firstborn in the land of Egypt, from the firstborn of Pharaoh that sat on his throne unto the firstborn of the captive that was in the dungeon; and all the firstborn of cattle' (Exodus 12: 29). But children of the people of Israel were spared, for the Lord '. . . passed over the houses of the children of Israel in Egypt, when he smote the Egyptians . . .' (Exodus 12: 27). As the result of this ultimate disaster, Pharaoh permitted the people of Israel to leave Egypt.
The Passage of the Red Sea. Even though Pharaoh at last permitted the people of Israel to depart from Egypt, his pride would not suffer them to go freely, and he gathered together his warriors and chariots to pursue them. The army of the Egyptians came upon the Israelites on the shores of the Red Sea. The people of Israel were very much afraid. 'And Moses stretched out his hand over the sea; and the Lord caused the sea to go back by a strong east wind all that night, and made the sea dry land, and the waters were divided. And the children of Israel went into the midst of the sea upon the dry ground: and the waters were a wall unto them on their right hand, and on their left' (Exodus 14: 21, 22).
The Destruction of Pharaoh and His Army: When the army of Pharaoh, still in pursuit, sought to follow the Israelites across the Red Sea, Moses again stretched forth his hand over the sea, 'And the waters returned, and covered

the chariots, and the horsemen, and all the host of Pharaoh that came into the sea after them; there remained not so much as one of them' (Exodus 14: 28). 'Thus the Lord saved Israel that day out of the hand of the Egyptians; and Israel saw the Egyptians dead upon the sea shore' (Exodus 14: 30).

The Gathering of Manna: During the wanderings of the children of Israel after their escape from Egypt, they found themselves lost in the wilderness and without food. But the Lord gave help. '. . . in the morning the dew lay round about the host. And when the dew that lay was gone up, behold, upon the face of the wilderness there lay a small round thing, as small as the hoar frost on the ground. And when the children of Israel saw it, they said one to another, it is manna: for they wist not what it was. And Moses said unto them, This is the bread which the Lord hath given you to eat' (Exodus 16: 13ff.). The Israelites gathered the manna and were fed, and it was on manna that they subsisted during the forty years they wandered before coming to Canaan.

Moses and the Rock of Horeb: After the children of Israel had come out of the wilderness, they first pitched their tents in a place called Rephidim, but there was no water and they were very thirsty. When Moses called upon the Lord for help, the Lord said: 'Go on before the people, and take with thee of the elders of Israel; and thy rod, wherewith thou smotest the river, take in thine hand, and go. Behold, I will stand before thee there upon the rock in Horeb; and thou shalt smite the rock, and there shall come water out of it, that the people may drink. And Moses did so in the sight of the elders of Israel' (Exodus 17: 5, 6).

Moses Receiving the Ten Commandments: One of the most famous and most frequently represented scenes from the life of Moses is the one in which Moses, at the command of the Lord, ascended Mt. Sinai and there received from the Lord the two tablets of stone, upon which His commandments were written (Exodus 31: 18).

Moses and the Golden Calf: While Moses was absent upon Mt. Sinai receiving the commandments of the Lord, the people of Israel came to Aaron, saying, '. . . make us gods, which shall go before us; for as for this Moses, the man who brought us up out of this land of Egypt, we wot not what is become of him' (Exodus 32: 1). So Aaron gathered together the jewelry of the people and fashioned from it a golden calf which he gave to the people to worship. But when Moses, returning from Mt. Sinai, saw the idol, he was enraged and cast the tablets of the Lord upon the ground and broke them. Then he seized the golden calf and destroyed it (Exodus 32: 20).

Moses and the Brazen Serpent: During the course of their wanderings, the people of Israel came to the land of Edom. They were much discouraged because of the long and difficult way that they had traveled. There were

murmurings against God and against Moses and, in punishment, the Lord sent a scourge of fiery serpents that bit the people, and many of them died. But Moses prayed for the people, and the Lord said: '. . . make thee a fiery serpent, and set it upon a pole: and it shall come to pass, that every one that is bitten, when he looketh upon it, shall live. And Moses made a serpent of brass, and put it upon a pole, and it came to pass, that if a serpent had bitten any man, when he beheld the serpent of brass, he lived' (Numbers 21: 8). In this way the faith of the children of Israel was restored.

Joshua. Following the death of Moses, Joshua became leader of all the people of Israel. Under his command they crossed the River Jordan into the land of Gilead, the land 'flowing with milk and honey' which the Lord had promised them. From his military exploits the Renaissance painters singled out for special attention the story of Jericho.

The Fall of Jericho: Having crossed the Jordan, the Israelites found themselves before the walls of the city of Jericho, which they besieged. The Lord appeared to Joshua and told him how the city might be taken. Each day, for six days, the Israelites marched silently once around the walls of the city, bearing with them the Ark of the Covenant. On the seventh day, following the Lord's command, they circled the city seven times: 'And it came to pass at the seventh time, when the priests blew with the trumpets, Joshua said unto the people, Shout; for the Lord hath given you the city . . . So the people shouted when the priests blew with the trumpets: and it came to pass, when the people heard the sound of the trumpet, and the people shouted with a great shout, that the wall fell down flat, so that the people went up into the city, every man straight before him, and they took the city' (Joshua 6: 16ff.).

Samson. During the years following the death of Joshua, the Israelites slipped from the paths of virtue. In punishment, the Lord delivered them first into the hands of the Midianites and then into the hands of the Philistines. At last, however, the Lord relented and ordained that there should be born to one of the women of Israel a son, who 'shall begin to deliver Israel out of the hands of the Philistines' (Judges 13: 5). The boy was named Samson, and he was of great strength. It is told how Samson in his youth slew a lion with his bare hands and how, later, he slew a thousand Philistines with the jawbone of an ass. The following scenes from his life are most commonly portrayed:

Samson and Delilah: It chanced that Samson fell very much in love with a woman of the Philistines named Delilah. Hearing of this, the leaders among the Philistines urged Delilah to use her wiles; to discover from Samson the secret of his great strength, so that he might be deprived of it and overcome. Thrice Delilah, with words of love, sought to beguile Samson into revealing

his secret. It was not until the third attempt that Samson finally confessed that the source of his mighty strength lay in his hair which, since birth, had never been cut. Causing Samson to sleep, she 'called for a man, and she caused him to shave off the seven locks of his head; and she began to afflict him, and his strength went from him' (Judges 16: 19). Thus was Samson delivered into the hands of the Philistines.

Death of Samson: The Philistines, who had seized Samson, first blinded him, then placed fetters upon him, and finally imprisoned him at Gaza. They forgot, however, that Samson's hair would grow again. Some time later, Samson was haled from his prison cell to a great gathering of the Philistines, who wished to make sport of him. Because he was blinded, Samson was led into the house by a youth. Samson asked the lad to lead him to the pillars supporting the roof, in order that he might have something to lean against. Feeling the pillars under his hand, Samson, with a great effort, tore them down and the roof of the building collapsed upon all who were present. Samson himself was killed and '. . . the dead which he slew at his death were more than they which he slew in his life' (Judges 16: 30). The allegorical figure of Fortitude is sometimes portrayed with a column or pillar, in reference to this act of Samson's.

Ruth. Well known in Renaissance art is the figure of Ruth, the woman of Moab, who, when her husband and her father-in-law both died, insisted upon remaining with her mother-in-law, Naomi, saying: '. . . intreat me not to leave thee, or to return from following after thee: for whither thou goest, I will go; and where thou lodgest, I will lodge: thy people shall be my people, and thy God my God' (Ruth 1: 16).

Ruth and Boaz: When Naomi returned to Bethlehem, the town of her birth, Ruth accompanied her. In order that they might have food, Ruth went into the field to glean the grain which remained after the reapers had passed. The field to which she went belonged to Boaz, a man of great wealth and of the same family as Naomi. Seeing Ruth standing in the field, Boaz fell in love with her and did her great kindness. That night Ruth came to Boaz on the threshing floor, after the threshing was over, and made herself known to him. Boaz then determined to exercise his right as her kinsman to claim her. This he did, and of their marriage was born a son, Obed, who was the father of Jesse, who in turn became the father of David the King.

David. In the days following the death of Samson, while the Israelites were still embattled against the Philistines, Samuel, the son of Hannah, came to be recognized as a true prophet of the Lord. The people of Israel appealed to Samuel that he appoint one of their people to be their king. The first to be

chosen by Samuel as king of the Israelites was the great warrior, Saul. He fought mightily against the enemies of Israel, but because of his idolatries, the Lord turned against him and rejected him as king of the Israelites. It was then that the Lord directed Samuel how he should find David, son of Jesse, and make him king over all Israel. The events in the life of David most commonly depicted in Renaissance painting include the following:

The Anointing of David: Having rejected Saul as king of Israel, the Lord instructed the prophet Samuel to fill his horn with oil '. . . and go, I will send thee to Jesse the Bethlehemite: for I have provided me a king among his sons' (1 Samuel 16: 1). At Bethlehem, Jesse brought forth each of his sons, in turn, and presented them to Samuel; each was rejected. Finally, David, the youngest, was brought from the field where he had been guarding the sheep. Then the Lord said to Samuel, '. . . Arise, anoint him: for this is he. Then Samuel took the horn of oil, and anointed him in the midst of his brethren: and the spirit of the Lord came upon David from that day forward . . .' (I Samuel 16: 12, 13).

David Playing the Harp: This scene is based upon the passage in I Samuel 16: 23, which reads: 'And it came to pass, when the evil spirit from God was upon Saul, that David took an harp, and played with his hand: so Saul was refreshed, and was well, and the evil spirit departed from him.'

David and Goliath: The heroic battle between David and Goliath, the champion of the Philistines, is described at length in 1 Samuel 17. The account concludes: 'And David put his hand into his bag, and took thence a stone, and slang it, and smote the Philistine in his forehead, that the stone sunk into his forehead: and he fell upon his face to the earth. So David prevailed over the Philistine with a sling and with a stone, and smote the Philistine, and slew him; but there was no sword in the hand of David. Therefore David ran, and stood upon the Philistine, and took his sword, and drew it out of the sheath thereof, and slew him, and cut off his head therewith. And when the Philistines saw their champion was dead, they fled' (1 Samuel 17: 49ff.).

The Triumphs of David: Two triumphal scenes from the life of David are frequently portrayed in art. The first depicts the return of David and Saul after their victory over the Philistines and is based on the passage from 1 Samuel 18: 6ff., which reads: 'And it came to pass as they came, when David was returned from the slaughter of the Philistine, that the women came out of all cities of Israel, singing and dancing, to meet king Saul, with tabrets, with joy, and with instruments of musick. And the women answered one another as they played, and said, Saul hath slain his thousands, and David his ten thousands. And Saul was very wroth . . .' Because of jealousy, Saul, thereafter, was set against David.

The second scene of triumph occurred after the death of Saul and after David

had been chosen king by all the tribes of Israel. Soon after he became king, David was again forced to fight the Philistines, whom he defeated in two great battles. He then gathered together his chosen followers and went to Judah to recapture the Ark of God, which had been in the hands of the Philistines. This he brought back triumphantly to Jerusalem, which he had made both the political and the religious capital of the state (II Samuel 6). The entrance of David himself into Jerusalem has been interpreted as foretelling Christ's entry into that city prior to the Passion.

David Dancing before the Ark: In describing the passage of the Ark of God into Jerusalem, it is recounted that 'David went and brought the ark of God from the house of Obed-edom into the city of David with gladness. And it was so, that when they that bare the ark of the Lord had gone six paces, he sacrificed oxen and fatlings. And David danced before the Lord with all his might . . .' (II Samuel 6: 12ff.).

David and Bathsheba: Bathsheba, whom David first saw from the roof of his palace and coveted, was the wife of another, and it was not until David had contrived to have her husband killed in battle that he was able to marry her. And, as the Old Testament states, '. . . the thing that David had done displeased the Lord' (II Samuel 11: 27).

The Penitence of David: In punishment for having caused the death of Uriah the Hittite, the husband of Bathsheba, and for marrying his widow, the Lord caused the first-born child of David and Bathsheba to fall mortally ill. In great repentance for his act, David admitted that he had sinned against the Lord. He was forgiven, but the child died. Following his repentance, a second child was born to David and Bathsheba, who was named Solomon (II Samuel 12).

Solomon. Solomon, the son of David and Bathsheba, who succeeded David as king of Israel, was renowned for his great wisdom. Among the episodes of his life that have been the subject of art, the best known are the following:

The Judgment of Solomon: Two women came to Solomon in dispute over a child, each claiming that the child belonged to her. To settle the dispute, Solomon called for a sword and said, '. . . divide the living child in two, and give half to the one, and half to the other' (I Kings 3: 25). Then the true mother, because she loved the infant so much and did not wish to see it die, said, 'O my lord, give her the living child, and in no wise slay it. But the other said, Let it be neither mine nor thine, but divide it.' From these words, Solomon was able to identify the real mother and to restore the child to her.

Solomon and the Queen of Sheba: So famous did Solomon become for his wisdom that the Queen of Sheba came to Jerusalem, with a great train of followers, to put his wisdom to the test. She asked him many questions, and to

each Solomon gave a sound and accurate answer. Greatly impressed, the Queen departed after giving Solomon many precious gifts. Solomon, in turn, '. . . gave unto the queen of Sheba all her desire, whatsoever she asked, beside that which Solomon gave her of his royal bounty' (1 Kings 10: 13).

There is a legend that on the occasion of the Queen of Sheba's visit to Jerusalem, she was confronted with a wooden bridge across a stream. She became immediately aware of the miraculous quality of the wood, and knelt before it. It seems that when Adam died, his son, Seth, planted a branch on the grave of his father. This branch grew into a mighty tree and was still flourishing at the time of Solomon. (See Tree, Section II.) Solomon admired its beauty and ordered that it should be used as a pillar in the Temple. But the wood was not suitable in size. When it was discarded, it was thrown across a brook as a bridge. Legend further states that the Queen of Sheba warned Solomon that from this wood would be built the cross that would destroy the people of Israel. To prevent this, Solomon had the wood buried deep below the ground. But, in subsequent years, a well was dug at this self-same spot, and the waters of it became miraculously endowed because of their contact with the wood. At the time of Christ, the wood floated to the top of the water and was used to build the Cross on which Christ was crucified.

Esther. Esther was the Hebrew maiden who, through the efforts of her cousin, Mordecai, was chosen as queen by the great King Ahasuerus, who reigned 'from India even unto Ethiopia, over an hundred and seven and twenty provinces.' The story of Esther and Mordecai is told in the Book of Esther, and several scenes from this account were used in Renaissance painting.

The Affliction of Mordecai: Mordecai aroused the anger of one Haman, a favorite of King Ahasuerus, with the result that Haman persuaded the king to issue an edict commanding the death of all Jews within his territories. To this the king agreed, not aware that Esther, his queen, was a Jewess. When Mordecai heard of the king's edict, he '. . . rent his clothes, and put on sackcloth with ashes, and went out into the midst of the city, and cried with a loud and a bitter cry' (Esther 4: 1).

Esther and Ahasuerus: Hearing from Mordecai what the king had decreed with respect to the Jews, Esther went to Ahasuerus to intercede on behalf of her people. 'And it was so, when the king saw Esther the queen standing in the court, that she obtained favour in his sight: and the king held out to Esther the golden sceptre that was in his hand. So Esther drew near, and touched the top of the sceptre. Then said the king unto her, What wilt thou, queen Esther? and what is thy request? it shall be even given thee to the half of the kingdom' (Esther 5: 2, 3). In the Apocryphal expansion of the Book of

Esther (Esther 15: 10ff.) it is indicated that, in touching her with his sceptre, Ahasuerus freed Esther from his decree, that anyone who dared to come into his royal presence without being summoned should be condemned to death. *Mordecai Honored by Ahasuerus*: In examining the records of his reign, Ahasuerus discovered the great service that Mordecai had rendered him and realized that Mordecai had not been properly rewarded. It so chanced that Haman, Mordecai's enemy, was present at the court, and the king asked him, '. . . What shall be done unto the man whom the king delighteth to honour? Haman, believing that it was he himself whom the king wished to honor, replied, '. . . Let the royal apparel be brought which the king useth to wear, and the horse that the king rideth upon, and the royal crown which is set upon his head: And let this apparel and horse be delivered to the hand of one of the king's most noble princes, that they may array the man withal whom the king delighteth to honour, and bring him on horseback through the streets of the city, and proclaim before him, Thus shall it be done to the man whom the king delighteth to honour.' And the king said, '. . . do even so to Mordecai the Jew . . .' and Haman did as the king instructed (Esther 6: 6ff.).

Jonah. It was Jonah who was chosen by the Lord to go down to the city of Nineveh to preach against the wickedness of the people. But Jonah was afraid and sought to flee from the presence of the Lord. Of the story of Jonah the following scenes are most frequently represented in art:
Jonah Cast into the Sea: In his flight, Jonah took ship at Joppa, hoping to reach Tarshish. 'But the Lord sent out a great wind into the sea, and there was a mighty tempest in the sea, so that the ship was like to be broken' (Jonah 1: 4). To the others on the vessel, Jonah finally confessed that it was because of the anger of the Lord against him that the storm had come upon them, and he counseled them to cast him into the sea. When at last they did so, 'the sea ceased from her raging.'
Jonah Preserved from the Sea: The Lord did not intend that Jonah should drown and '. . . had prepared a great fish to swallow up Jonah. And Jonah was in the belly of the fish three days and three nights' (Jonah 1: 17). From the belly of the fish, Jonah, in his extremity, prayed to the Lord, declaring his willingness to bow to the Lord's will. 'And the Lord spake unto the fish, and it vomited out Jonah upon the dry land' (Jonah 2: 10). This is the basis for assigning to Jonah, as a pictorial attribute, a great fish or whale.
Jonah and the Gourd: In compliance with the bidding of the Lord, Jonah went to the city of Nineveh. There he warned the people that because of their wickedness the city would be destroyed within forty days. In repentance the king of Nineveh declared a great fast, and the people of the city clad

themselves in sackcloth and covered themselves with ashes. Seeing this, the Lord forgave Nineveh, but Jonah was angry because the Lord did not fulfil his prophecy. After Jonah had stationed himself outside the city to see what would take place, the Lord caused a great gourd to grow so that Jonah would be shaded from the sun, and Jonah was greatly pleased. But in the night the Lord sent a worm to destroy the gourd, and again Jonah was overcome with anger. 'Then said the Lord, Thou has had pity on the gourd, for the which thou hast not laboured, neither madest it grow; which came up in a night, and perished in a night: And should not I spare Nineveh, that great city, wherein are more than sixscore thousand persons that cannot discern between their right hand and their left hand; and also much cattle?' (Jonah 4: 10, 11). Jonah is often represented resting in the shadow of the gourd.

Stories from the Apocrypha. In addition to the scenes from the Old Testament already described, which were an inspiration for many paintings of the Renaissance, the artistic representations of that period also include several well-known scenes from the Old Testament Apocrypha, which formed a part of the sacred literature of the Alexandrian Jews. Most commonly depicted are the following:

Tobias and the Angel: Tobit, an upright man, and suffering from a severe affliction of his eyes, was making preparations for his death. He asked his son, Tobias, to journey into Media to collect certain moneys due him. Accompanied by his faithful dog, Tobias set forth. Uncertain of the way, he sought a companion who could guide him. He chanced to meet the Archangel Raphael who, unrecognized by Tobias, agreed to accompany him on his journey. During their travels they came to the river Tigris. Tobias went down to the river to bathe, whereupon '. . . a fish leaped out of the river, and would have devoured him. Then the angel said unto him, Take the fish. And the young man laid hold of the fish, and drew it to land' (Tobit 6: 2, 3). Following the instructions of the angel, Tobias then roasted the fish that they might eat, but saved the heart, the liver, and the gall, for, said the angel, '. . . touching the heart and the liver, if a devil or an evil spirit trouble any, we must make a smoke thereof before the man or the woman, and the party shall be no more vexed. As for the gall, it is good to anoint a man that hath whiteness in his eyes, and he shall be healed.' Tobias' journey, under the continual guidance of Raphael, was a happy one. He collected the money due his father. He cured Sara, with whom he had fallen in love and married, of an evil spirit. Upon returning home he restored his father's sight. It was not until the joy of this deeply religious family was complete that the Archangel Raphael revealed himself. '. . . by the will of our God I came; wherefore praise him forever . . . Now therefore give God thanks: for I go

up to him that sent me; but write all these things which are done in a book. And when they arose, they saw him no more' (Tobit 12: 18, 20, 21).

Judith and Holofernes: In the days when Nebuchadnezzar, king of Babylonia, ruled in the city of Nineveh, he determined upon a great conquest and called to him Holofernes, chief captain of his armies. 'Thou shalt go against all the west country, because they disobeyed my command,' said the king, and Holofernes 'mustered the chosen men for the battle, as his lord had commanded him' (Judith 2: 6ff.). In due course, the army of the Babylonians came to the land of Israel, but the people of Israel had been warned of the invasion and had fortified themselves to resist. First of the citadels of the Israelites to be besieged was the city of Bethulia. Rather than take the city by assault, Holofernes decided to overcome it by cutting off its water supply. Soon the people in the city were in despair and were preparing to surrender. But a beautiful widow of the city named Judith asked permission of the city governors to save them all. After praying to the Lord for help, she decked herself in her finest raiment and went out to deliver herself to the Babylonians. In their camp, she demanded to be brought to Holofernes, for she declared that she knew of a way by which the city might be taken. Holofernes was impressed by her beauty and her intelligence, and for three days she was permitted to remain in the camp, going out at night to pray. On the fourth day, Holofernes prepared a great banquet for his officers, and Judith was invited to attend. As the evening progressed, Holofernes became more and more overcome by wine. At last all his guests and servants departed, leaving him alone in his tent with Judith. Stupefied by the wine, Holofernes became unconscious. Then Judith seized his sword and '. . . approached his bed, and took hold of the hair of his head, and said, Strengthen me, O Lord God of Israel, this day. And she smote twice upon his neck with all her might, and she took away his head from him' (Judith 13: 7). Because the Babylonians were accustomed to seeing her leave the camp at night, she was able to depart, taking with her the head of the great captain. In the morning, when the death of Holofernes was discovered, the Babylonians were dismayed, and the warriors of Israel were able to defeat them utterly.

Susanna and the Elders: According to the Apocryphal story, Susanna was the beautiful wife of a citizen of Babylon. She was as good as she was beautiful, but because of her beauty, two elders of the community fell in love with her and determined to possess her. Together they hid in her garden and, as she was about to bathe, unattended even by her maid servants, they sprang out of hiding and demanded that she give herself to them. They threatened that if she refused they would bear false witness against her and swear that they had discovered her in the act of adultery. In spite of their threats Susanna repulsed them, whereupon the two elders cried out against her. She was

brought to the place of judgment and condemned to death for her sin. But as she was being led away to her execution, a youth by the name of Daniel 'cried with a loud voice' and insisted that she had not been given a fair trial. The trial was resumed, and Daniel, by separating the two witnesses against her, caused them to give conflicting evidence, thus proving that both were lying. As a result, Susanna was exonerated, and the two elders were condemned to suffer the fate they had sought to bring upon their innocent victim.

SECTION VI

St. John the Baptist

John the Baptist, as the forerunner of Christ, was one of the most frequently depicted saints in Renaissance painting. According to St. Mark, 'John did baptize in the wilderness, and preach the baptism of repentance for the remission of sins' (Mark 1:4). Mark also states that 'John was clothed with camel's hair, and with a girdle of a skin about his loins; and he did eat locusts and wild honey.' The following events from the story of John the Baptist are the most familiar.

Zacharias in the Temple. In the days when Herod was king in Judea there lived a certain priest of the Israelite faith whose name was Zacharias and whose wife was named Elisabeth. Both these righteous people were distressed because they were childless and, since they were advanced in years, they had little hope that a child would be given to them. But one day, as Zacharias was burning incense in the temple, the Archangel Gabriel appeared to him saying, '. . . Fear not, Zacharias: for thy prayer is heard; and thy wife Elisabeth shall bear thee a son, and thou shalt call his name John' (Luke 1:13). Zacharias could not at first believe the message of the angel. He asked for a sign as proof and was temporarily struck dumb.

The Birth and Naming of John. As Gabriel had foretold, Elisabeth became pregnant with child. While she still was carrying the infant John she received a visit from her cousin, Mary of Nazareth, who had learned through the Annunciation Angel of Elisabeth's good fortune. The scene of the meeting of the two prospective mothers is commonly known as the *Visitation*. (See the Virgin Mary, in Section VII.) In due course, Elisabeth's son was born.

Her family and neighbors would have named the child after his father, but Elisabeth insisted that the infant be called John. To settle the matter, they appealed to Zacharias, the father, who, because he was dumb, '. . . asked for a writing table, and wrote, saying, His name is John. And they marvelled all' (Luke 1: 63). Thus did John the Baptist come by his name, and at the same instant his father regained his speech and praised the Lord. Renaissance artists often combined the Birth and the Naming of St. John into one composition.

St. John in the Wilderness. According to legend, St. John took leave of his parents as a mere child and went to dwell in the desert. We have some representations of Christ and St. John meeting as children in the wilderness. As a young man sojourning in the wilderness, John one day experienced a divine revelation, urging him to become a preacher of the gospel of baptism for the remission of sins. 'These things were done in Bethabara beyond Jordan, where John was baptizing' (John 1: 28).

St. John Preaching. After his revelation, John came into the country near the River Jordan preaching, 'As it is written in the book of the words of Esaias the prophet, saying, The voice of one crying in the wilderness, Prepare ye the way of the Lord, make his paths straight' (Luke 3: 4). The power of his message of the need of repentance for sin caused many of the people to receive baptism at the hands of John. But when some questioned whether John himself was the Christ, the Redeemer, whose coming had been fore-told, 'John answered, saying unto them all, I indeed baptize you with water; but one mightier than I cometh, the latchet of whose shoes I am not worthy to unloose: he shall baptize you with the Holy Ghost and with fire' (Luke 3: 16). Subsequently, Jesus Himself came to John and was baptized by him. This scene is a major composition in all representations of the St. John cycle, as it is for that of Christ's ministry. (See The Baptism of Christ, in Section VIII).

St. John in Prison. Because of his preaching and, above all, because he had publicly dared to reproach Herod, the king, for his sins, John was seized by the soldiers of Herod and cast into prison. While in prison, John heard of some of the miracles that Jesus had performed and sent two of his disciples to ask whether Jesus was the true Christ. It was then that Jesus said of John, 'This is he, of whom it is written, Behold, I send my messenger before thy face, which shall prepare thy way before thee. Among those that are born of women there is not a greater prophet than John the Baptist . . .' (Luke 7: 27, 28).

The Feast of Herod. The major sin which John had charged against Herod was that, contrary to the law, he had married Herodias, the wife of his deceased brother. Herodias would have had John put to death at once, but Herod was afraid, realizing that John was a just and holy man. Some time after John had been imprisoned, Herod held a great feast on the occasion of his birthday to which he asked all the dignitaries of his court. To entertain his guests, Salome, daughter of Herodias, came in and danced before them. So much did Salome and her dancing please Herod and the assembled company that he promised to make her a gift of whatever she might ask. 'And she went forth, and said unto her mother, What shall I ask? and she said, The head of John the Baptist' (Mark 6: 24).

The Beheading of John the Baptist. In accordance with the promise that he had made to Salome, '. . . the king sent an executioner, and commanded his head to be brought: and he went and beheaded him in the prison, And brought his head in a charger, and gave it to the damsel: and the damsel gave it to her mother' (Mark 6: 27, 28). Pictures of Salome bearing the head of John the Baptist are distinguishable from pictures of Judith bearing the head of Holofernes by the charger in the former, and by the halo with which the head of John is almost invariably crowned.

The Burial of John the Baptist. The final scene in the cycle of John the Baptist is his burial. When his disciples heard of the execution of John, they came and took his body and laid it in a tomb (Mark 6: 29). (See The Saints, in Section X).

SECTION VII

The Virgin Mary

No other figure, except that of Christ Himself, was so often portrayed in Renaissance art as the Virgin Mary. Broadly speaking, representations of the Virgin fall into two major categories. On the one hand are the large number of pictures that use as subject matter the life of the Virgin. These are basically narrative. Their sources are the New Testament record and the rich tradition which centered about her who, as the mother of the Saviour, was 'blessed among women.' Distinct from this group are those paintings of the Virgin which may be termed devotional. (See The Trinity, the Madonna, and Angels; Section IX.) The paintings of this second group were created to

emphasize the outstanding characteristics of Mary as the Divine Mother. The events in the life of the Virgin Mary most commonly represented are the following.

The Legend of Joachim and Anna. Joachim and Anna were the parents of the Virgin Mary. They were of the royal house of David. Their one great sorrow was that they were childless. On a certain feast day, Joachim brought double offerings to the temple, which the high priest refused to accept. According to the law, Joachim was not permitted to make these sacrifices because he had not fathered a child in Israel. Sorrowfully he went out into the wilderness and fasted for forty days and nights. Anna remained at home and, on the last day of the religious festival, went into her garden to pray. There an angel appeared to her, telling her that her prayer had been heard and that she would give birth to a child who would become blessed throughout the world. Meanwhile, another angel had come to Joachim, as he was tending his sheep in the mountains, and comforted him with promises. When Joachim returned home it befell as the angels had promised. Anna gave birth to a daughter, whom she named Mary. That Mary was conceived by divine intervention is connected with the religious concept of Immaculate Conception, which holds that Mary was herself free from original sin and, therefore, worthy to be the mother of the Saviour. Among the scenes from this legend frequently represented are those in which Joachim, with a sacrificial lamb in his arms, is rejected at the temple; Anna receiving the message of the angel; and Joachim being advised by the angel that he will become a father.

The Nativity of the Virgin. The scene of the birth of Mary generally shows Anna, the mother of the child, reclining in bed, receiving the ministrations of her handmaidens and the congratulations of her friends and neighbors. The bedchamber is usually richly decorated in keeping with the reputed wealth of the family.

The Presentation of the Virgin. When Anna, mother of Mary, prayed in her garden for a child, she promised that if her prayer was answered she would dedicate her child to the service of God. In keeping with this promise, when the child Mary was three or four years old, Anna took her to the temple to begin her service to the Lord. Legend states: 'And being placed before the altar, she danced with her feet, so that all the house of Israel rejoiced with her, and loved her.'

The Childhood of Mary. Mary remained in the temple until she was fourteen years of age. Various pictures have been painted of her life during those

years. She is sometimes represented teaching her companions to spin or to embroider and is sometimes attended by angels.

The Marriage of the Virgin. When the Virgin Mary was fourteen years old and having lived for some ten years in the temple, she was informed by the priests that she should be married. She replied that this was impossible because her life was dedicated to God. But the high priest, Zacharias, declared that he had received a revelation from an angel, who told him to assemble the marriageable men and to have each bring to the temple his rod or staff. These were to be left in the temple overnight when, it was promised, a sign would be given to indicate which of the suitors for Mary's hand was favored by the Lord. All was done according to the directions of the angel, and in the morning it was found that the staff of Joseph, the carpenter of Nazareth, had blossomed. He was, therefore, chosen as the husband of Mary. Several of the episodes in this story appear in art.

The marriage ceremony itself is often depicted in front of the temple, with many people present. The priest, standing in the middle, joins the hands of the bride and groom. Mary generally stands at his right, attended by a group of maidens. Joseph stands at his left, and behind Joseph is the crowd of rejected suitors. At times Joseph is shown putting a ring on Mary's finger.

The Annunciation. The Annunciation is the title of those pictures that depict the Archangel Gabriel coming to the Virgin Mary to announce to her that she will give birth to Christ. The scene is described in the Gospel according to St. Luke: 'And the angel came in unto her, and said, Hail, thou that art highly favoured, the Lord is with thee: blessed art thou among women . . . thou shalt conceive in thy womb, and bring forth a son, and shalt call his name Jesus' (Luke 1: 28ff.). The scene is usually laid in Mary's house. The Virgin frequently holds a book and appears to have been interrupted in her reading. In other portrayals, the Virgin is kneeling in prayer when Gabriel appears. In earlier Renaissance paintings, Gabriel carries the wand, or sceptre, as the herald of God. In later representations he carries the lily, as the symbol of the purity of the Virgin. The presence of God the Holy Ghost is symbolized by the dove.

The Dream of Joseph. Joseph, the husband of Mary, when he found that she was with child, was greatly disturbed. But, '. . . being a just man, and not willing to make her a publick example, was minded to put her away privily. But while he thought on these things, behold, the angel of the Lord appeared unto him in a dream, saying, Joseph, thou son of David, fear not to take unto thee Mary thy wife: for that which is conceived in her is of the

Holy Ghost. And she shall bring forth a son, and thou shalt call his name Jesus: for he shall save his people from their sins' (Matthew 1: 19ff.).

The Visitation. This is the title given to those paintings that depict the visit of the Virgin Mary, who was already with child, to her cousin, Elisabeth, who had been advised through the Archangel Gabriel that she would give birth to John the Baptist. It was Elisabeth who first perceived the true character of Jesus, for she said to Mary: 'And whence is this to me, that the Mother of my Lord should come to me?' (Luke 1: 43). In these pictures, Elisabeth can easily be distinguished from Mary, for she is much older, and she is usually shown making a gesture of welcome. Sometimes they are painted embracing each other.

The Nativity. The Nativity is the scene of the birth of Christ (Luke 2). The time is midnight, as a rule, and the place a stable in the town of Bethlehem, there being no room available at the local inn. The figures usually included in paintings of the Nativity are the Virgin Mary, the Infant Jesus, Joseph, an ox, and an ass. The ox and ass are depicted on the basis of the passage from the first chapter of Isaiah, which reads, 'The ox knoweth his owner, and the ass his master's crib.' Often the Annunciation to the Shepherds appears in the background of pictures of the Nativity.

The Purification. According to the religious law of the people of Israel, it was ordained that, after giving birth to a man-child, a mother must go through a period of purification for thirty-three days. '. . . she shall touch no hallowed thing, nor come into the sanctuary, until the days of her purifying be fulfilled' (Leviticus 12: 4). Mary, the mother of Christ, being of the Israelite faith, obeyed the law. 'And when the days of her purification according to the law of Moses were accomplished, they brought him to Jerusalem, to present him to the Lord: and to offer sacrifice according to that which is said in the law of the Lord, A pair of turtle doves, or two young pigeons' (Luke 2: 22, 24). This scene is sometimes called 'Purification of the Virgin.' Usually however, the emphasis in this scene is placed upon Jesus, rather than upon His mother, and the scene is then entitled 'Presentation in the Temple.'

Pentecost. One of the last scenes in which the Virgin Mary appeared was on the occasion of the Feast of Pentecost, following Christ's Ascension. There were gathered together in Jerusalem a number of Christ's followers, including the Apostles, Mary the mother of Jesus, and other women. While they were all together, 'suddenly there came a sound from heaven as of a rushing

mighty wind, and it filled all the house where they were sitting. And there appeared unto them cloven tongues like as of fire, and it sat upon each of them. And they were all filled with the Holy Ghost, and began to speak with other tongues, as the Spirit gave them utterance' (Acts 2: 2–4). (See The Holy Ghost, in Section IX.)

The Dormition (Death) and Assumption of the Virgin. These two episodes are so frequently portrayed together that they are presented under one heading. Legend states that after the Crucifixion of Christ, His mother lived with the Apostle John, though she re-visited many of the places associated with the life of her Son. Finally, in her loneliness, she prayed to be delivered from life. She was visited by an angel who promised that within three days she should enter Paradise where her Son awaited her. The angel then presented her with a palm branch which she in turn handed to St. John with the request that it be borne before her at her burial. Mary also requested of the angel that all the Apostles be present at her death, and this wish was granted. Paintings of the death of Mary therefore usually show the Apostles gathered about her deathbed, with Peter at the head of the bed and John at its foot.

The account of Mary's death further states that, in the night, the house was suddenly filled with a great sound, whereupon Jesus Himself appeared, accompanied by a host of angels. The soul of Mary then left her body and was received into the arms of her Son, Who carried it into Heaven. Mary's body remained on earth and was buried by the Apostles. Three days later, however, Jesus decreed that the soul of His Mother should be reunited with her body, and that both should be transported to Heaven. The full story of the Death and Assumption of the Virgin calls for at least six pictorial representations: first, the scene in which the angel announces her death and presents her with the palm branch; second, Mary saying farewell to the Apostles; third, Mary's death and the assumption of her soul into Heaven; fourth, bearing her body to the sepulchre; fifth, the entombment; and, sixth, the assumption of Mary's reunited body and soul.

St. Thomas and the Virgin's Girdle. This legend relates that the Apostle, St. Thomas, was absent when the Virgin's body and soul were reunited and transported to Heaven, and he refused to believe in her bodily assumption. He demanded that her grave be opened so that he might see whether her body still remained within. Finding the grave empty, he looked toward Heaven and there beheld the Virgin in her bodily form, slowly being transported upward. To convince him of her assumption, Mary flung down to Thomas the belt, or girdle, from her dress.

The Coronation of the Virgin. The last scene in the cycle of the Virgin Mary is that in which she is received into Heaven by her Divine Son, and is crowned by Him as Queen of Heaven. The Coronation of the Virgin was believed to have been foreshadowed by that episode in the life of Solomon in which, after the death of David and the coronation of Solomon as king of the Israelites, his mother, Bathsheba, came to him to ask a favor. 'And the king rose up to meet her, and bowed himself unto her, and sat down on his throne, and caused a seat to be set for the king's mother; and she sat on his right hand' (I Kings 2: 19). Narrative pictures of the Coronation of the Virgin may often be distinguished from allegorical pictures of the Queen of Heaven by the appearance in them of events from the last days of the Virgin on earth, including the deathbed, the tomb, and the Apostles and friends on earth weeping for her.

SECTION VIII

Jesus Christ

As in the case of the Virgin Mary, a distinction should be made between those paintings of the Renaissance period which portray the events in the life of Christ from a narrative standpoint and the very large number of paintings of the Saviour that are of devotional character. The life cycle of Jesus, as recounted in the gospels of St. Matthew, St. Mark, St. Luke, and St. John, was presented in pictorial form by the great artists of the Renaissance, time and time again. In addition, many thousands of pictures of Christ were painted that had no narrative significance, but were intended to convey the spiritual quality and significance of the Son of God as the Saviour of Mankind. Of the narrative scenes from the life of Christ, those commonly depicted are described below.

The Nativity. Paintings which portray the birth of Jesus are almost without number. The Nativity portrays the Holy Family in the stable at Bethlehem. The Christ Child is lying in a manger or upon the straw. The Virgin kneels in adoration before Him. Joseph, in his wonderment, stands at one side. The ox and the ass, in the background, gaze quietly at the scene before them.

The Annunciation to, and the Adoration of, the Shepherds. In the story of the birth of Christ, as told by St. Luke, it is recounted that there were

in the fields near Bethlehem certain shepherds who were watching their
flocks. On the night when Christ was born, '. . . lo, the angel of the Lord
came upon them, and the glory of the Lord shone round about them: and
they were sore afraid. And the angel said unto them, Fear not: for, behold, I
bring you good tidings of great joy . . . For unto you is born this day in the
city of David a Saviour, which is Christ the Lord. And this shall be a sign
unto you; Ye shall find the babe wrapped in swaddling clothes, lying in a
manger. And suddenly there was with the angel a multitude of the heavenly
host praising God, and saying, Glory to God in the highest, and on earth
peace, good will toward men' (Luke 2: 9ff.). This scene has been depicted fre-
quently, and it is usually entitled 'Annunciation to the Shepherds.' Following
the Annunciation, the shepherds went into the town of Bethlehem and there
found Jesus lying in a manger, as the angel had predicted. The pictures show-
ing the shepherds worshiping the Christ Child in the stable are commonly
entitled 'Adoration of the Shepherds.'

The Presentation at the Temple, and the Circumcision. After Jesus was
born, all the requirements of the law of Moses with respect to an infant son
were fulfilled, including His Presentation at the Temple and His Circumci-
sion (Luke 2). At the Circumcision, which took place eight days after birth,
the Virgin Mary would not be present. In the Renaissance this scene is fre-
quently shown together with the Purification of the Virgin. The scene in
which Mary and Joseph bring the Infant Jesus to the temple is depicted often
in Renaissance art, and is called 'Presentation in the Temple.' It is recounted
that, in the temple, when Jesus was brought there by His parents, there was a
man of Jerusalem named Simeon, to whom it had been revealed that he
would not die until he had seen the Lord's Christ. Upon seeing Jesus, Simeon
took the Child in his arms and said, 'Lord, now lettest thou thy servant
depart in peace, according to thy word: For mine eyes have seen thy salva-
tion' (Luke 2: 29, 30). Also present in the temple was '. . . one Anna, a pro-
phetess . . . and she coming in that instant gave thanks likewise unto the
Lord . . .' (Luke 2: 36, 38).

The Magi. St. Matthew in his version of the Gospel tells of the wise men
from the East who came to Jerusalem at the time of Christ's birth and in-
quired for Him who had been born King of the Jews. Herod, the king of
Judea, sent them to seek Jesus in Bethlehem, and a star went before them
showing them the way. Pictures portraying the rich caravan of the three wise
men, or Magi, journeying toward Bethlehem are commonly entitled
'Journey of the Magi.' When the wise men found Mary with her Son,
in Bethlehem, they fell down and worshiped Him and presented Him

with gifts of gold, frankincense, and myrrh. The scene in which the wise men worship the Infant Christ is called 'Adoration of the Magi.' The Magi are sometimes represented as kings because of the passage from the Psalms which reads, 'The kings of Tarshish and of the isles shall bring presents . . . all kings shall fall down before him: all nations shall serve him' (Psalm 72: 10, 11). The Church's season celebrating the Visitation of the Magi is Epiphany, which means the Manifestation of Christ to the Gentiles. This signifies the spreading of Christianity to all lands, to all peoples, for all ages. Thus the Magi, to whom tradition has given the names Caspar, Melchior, and Balthasar, are frequently represented as youth, middle age, and old age. One of them is usually dark-skinned. Their gifts to the Christ Child have a symbolic meaning: gold to a King, frankincense to One Divine, myrrh, the emblem of death, to a Sufferer. To the Christian, these gifts represent the offering to Christ of wealth and energy, adoration, and self-sacrifice.

The Flight into Egypt and the Massacre of the Innocents. When Herod, the king, heard that a child had been born who would become King of the Jews, he was angry, and sought to find the child in order that it might be destroyed. But an angel appeared to Joseph, the husband of Mary, and warned him to take the Infant Jesus and flee into Egypt to escape from Herod (Matthew 2: 13). This Joseph did, and the scene depicting the journey of the Holy Family is termed 'Flight into Egypt.' Paintings of this scene generally show the Virgin Mary riding upon an ass, with the Infant Jesus in her arms, while Joseph leads the ass. Sometimes the Holy Family is shown resting by the side of the road during the long journey into Egypt. Occasionally, they are shown leaving Bethlehem while the massacre of the young children, decreed by Herod in order to destroy the Christ Child, is taking place. This slaughter is known as the 'Massacre of the Innocents' (Matthew 2: 16).

The Return from Egypt. The Holy Family remained in Egypt for several years. After the death of King Herod, an angel appeared to Joseph, telling him that it was now safe for him to return with Jesus to Israel (Matthew 2: 19). Paintings of the return journey are entitled the 'Return from Egypt.' Usually these pictures are easily distinguished from those of the 'Flight into Egypt' because Jesus is depicted as a small boy instead of an infant.

The Dispute in the Temple. After the return from Egypt, the Holy Family lived in the village of Nazareth. When Christ was twelve years old, His family took Him to Jerusalem for the feast of the Passover. As the family was on the return journey, they found that Christ was not with them. Hurrying back to Jerusalem, they found Jesus in the temple, surrounded by

several doctors, or Jewish Rabbis, with whom he was in deep discussion (Luke 2: 41ff.). This scene is usually called the 'Dispute in the Temple,' or 'Christ among the Doctors.'

The Baptism of Christ. John the Baptist was preaching in the wilderness of Judea, prophesying the coming of the Saviour. Many came out to him from Jerusalem and other places in Judea and were baptized by him in the River Jordan. 'Then cometh Jesus from Galilee to Jordan unto John, to be baptized of him. But John forbad him, saying, I have need to be baptized of thee, and comest thou to me? And Jesus answering said unto him, Suffer it to be so now: for thus it becometh us to fulfil all righteousness. Then he suffered him. And Jesus, when he was baptized, went up straightway out of the water: and, lo, the heavens were opened unto him, and he saw the Spirit of God descending like a dove, and lighting upon him: And lo a voice from heaven, saying, This is my beloved Son, in whom I am well pleased' (Matthew 3: 13ff.).

The Temptation. After Jesus had been baptized by John the Baptist, He went into the wilderness, where He prayed and fasted for forty days and forty nights. As a result of His fast He was very hungry, and at this moment the Devil appeared to Him, saying, '. . . If thou be the Son of God, command that these stones be made bread.' But Jesus replied, '. . . Man shall not live by bread alone, but by every word that proceedeth out of the mouth of God.' Again the Devil sought to tempt Him, this time by taking Him to the top of the temple in the holy city. There he urged Jesus to cast Himself down, assuring Him that if He were indeed the Son of God, the Lord would send angels to see that Jesus was not hurt. Again, however, Jesus resisted, saying, '. . . Thou shalt not tempt the Lord thy God.' Finally, the Devil took Jesus to the top of a high mountain and there showed Him all the wealth of the world, which he offered as a bribe if Christ would forsake God and worship Satan. To this Jesus replied, '. . . Get thee hence, Satan: for it is written, Thou shalt worship the Lord thy God, and him only shalt thou serve' (Matthew 4: 1-11). Paintings of the Temptation may show any one of these three scenes.

The Calling of the First Two Apostles. Frequently portrayed in art is the episode in which Christ called His first disciples. 'And Jesus, walking by the sea of Galilee, saw two brethren, Simon called Peter, and Andrew his brother, casting a net into the sea: for they were fishers. And he said unto them, Follow me, and I will make you fishers of men. And they straightway left their nets and followed him' (Matthew 4: 18ff.).

The Tribute Money. During His ministry in Judea, Christ came to the city of Jerusalem and taught in the temple. This aroused the anger of the priests, who set spies upon Jesus and sought to convict Him of treason through His own words. In an effort to trap Him, the spies asked Jesus if it were lawful for them to pay tribute to Caesar. In answer, Jesus asked them to show Him a penny and inquired whose image the penny bore. When the spies confirmed that the penny bore the image of Caesar, Jesus replied in His memorable words, '. . . Render therefore unto Caesar the things which be Caesar's, and unto God the things which be God's' (Luke 20: 25). On the basis of these words, no charge could be placed against Jesus and His enemies were discomfited. On another occasion, when Christ and His disciples came to Capernaum, they that received tribute money came to Peter and asked him if his Master paid tribute. Knowing of this, Christ instructed Peter, and told him, '. . . go thou to the sea, and cast an hook, and take up the fish that first cometh up; and when thou hast opened his mouth, thou shalt find a piece of money: that take, and give unto them for me and thee' (Matthew 17: 27).

The Sermon on the Mount. After Christ had begun His ministry, the fame of His preaching spread and there were many who came to listen to His words. One of the most famous occasions of Christ's preaching to the multitudes was the time He went into the mountain to address them (Matthew 5ff.). This scene is entitled 'The Sermon on the Mount.'

Supper in the House of Simon. In the city of Capernaum, Jesus was asked by a Pharisee, named Simon, to enter his house and eat. While Jesus sat at meat, a woman of the city entered and began to wash His feet with her tears, to wipe them with her hair, and to kiss them. Simon the Pharisee was astounded, for he believed that if Jesus were a true prophet, He would realize that the woman was of low character and would refuse her touch. But Jesus said, 'Her sins, which are many, are forgiven; for she loved much: but to whom little is forgiven, the same loveth little.' To the woman Jesus said, 'Thy faith hath saved thee; go in peace' (Luke 7: 36ff.).

Supper in the House of Levi. Also in the city of Capernaum, Jesus had supper one night in the house of Levi, a collector of customs. Many of the publicans and sinners who had followed Him came in and sat down at the table with Him. Seeing this, the scribes and Pharisees inquired of His disciples why He was willing to sit at table with people of such bad character. Hearing their question, Jesus replied, '. . . They that are whole have no need of the physician, but they that are sick: I come not to call the righteous, but sinners to repentance' (Mark 2: 17).

Cleansing of the Temple. St. John describes in his Gospel (2: 13ff.) the famous scene when Jesus drove the money changers and merchants from the temple in Jerusalem. '. . . And Jesus went up to Jerusalem, and found in the temple those that sold oxen and sheep and doves, and the changers of money sitting: and when he had made a scourge of small cords, he drove them all out of the temple, and the sheep, and the oxen; and poured out the changers' money, and overthrew the tables; And said unto them that sold doves, Take these things hence; make not my Father's house an house of merchandise.'

Christ and the Woman of Samaria. During a journey from Judea to Galilee, Jesus came to a city of Samaria and paused to refresh Himself at a well. 'There cometh a woman of Samaria to draw water: Jesus saith unto her, Give me to drink . . . Then saith the woman of Samaria unto him, How is it that thou, being a Jew, asketh drink of me, which am a woman of Samaria? for the Jews have no dealings with the Samaritans' (John 4: 7, 9). As a result of their conversation, she recognized Him as the Messiah and brought many of the Samaritans from the city to see Him. Christ remained with them for two days, and many of the citizens were converted to faith in Him.

The Woman Taken in Adultery. While Christ was preaching in the temple, the scribes and the Pharisees brought to Him a woman who had sinned greatly. They said that, according to the law of Moses, the woman should be stoned, but they asked Jesus what was His opinion. In this manner they sought to trap Him in order that He might be accused before the Law. At first Jesus, seeming not to have heard them, stooped down and wrote with His finger upon the ground. When the question was repeated, however, Jesus replied, 'He that is without sin among you, let him first cast a stone at her . . . And they which heard it, being convicted by their own conscience, went out one by one . . . and Jesus was left alone, and the woman standing in the midst . . . he said unto her, Woman, where are those thine accusers? hath no man condemned thee? She said, No man, Lord. And Jesus said unto her, Neither do I condemn thee: go, and sin no more' (John 8: 7ff.).

The Parable of the Good Samaritan. This parable, one of the most famous Biblical stories and a favorite subject of artistic interpretation, is told in the words of Christ Himself, as reported by St. Luke. It seems that a certain lawyer questioned Jesus, asking how he might assure himself of eternal life. It was his understanding, he said, that to achieve eternity one must love God with all one's heart and soul, and must love one's neighbor like one's self. But, he asked, how is one to identify one's neighbor? To this Jesus replied in the form of a parable, saying, '. . . A certain man went down from Jerusalem

to Jericho, and fell among thieves, which stripped him of his raiment, and wounded him, and departed, leaving him half dead. And by chance there came down a certain priest that way: and when he saw him, he passed by on the other side. And likewise a Levite, when he was at the place, came and looked on him, and passed by on the other side. But a certain Samaritan, as he journeyed, came where he was: and when he saw him, he had compassion on him, And went to him, and bound up his wounds, pouring in oil and wine, and set him on his own beast, and brought him to an inn, and took care of him. And on the morrow when he departed, he took out two pence, and gave them to the host, and said unto him, Take care of him; and whatsoever thou spendest more, when I come again, I will repay thee. Which now of these three, thinkest thou, was neighbour unto him that fell among the thieves? And he said, He that shewed mercy on him. Then said Jesus unto him, Go, and do thou likewise' (Luke 10: 30ff.).

The Parable of the Prodigal Son. Another of the familiar parables of Christ is that of the son who asked his father to give him outright his portion of the family estate. When the father acceded to his request, the son took his portion and, journeying in distant lands, squandered everything he had. Later, in poverty and humiliation, the son repented and returned to his father, saying, '. . . Father, I have sinned against heaven, and in thy sight, and am no more worthy to be called thy son.' But the father embraced him and clothing him in fine raiment, ordered that a feast be held and a fatted calf killed, in rejoicing for his return. The boy's elder brother, who had stayed at home working faithfully for his father, protested over the generous treatment accorded to his brother, who, he declared, had done nothing to deserve it. To this the father replied, '. . . Son, thou art ever with me, and all that I have is thine. It was meet that we should make merry, and be glad; for this thy brother was dead, and is alive again; and was lost, and is found' (Luke 15: 11ff.).
This parable was Christ's answer to the scribes and Pharisees who were shocked that Christ had been willing to share His meal with the publicans and sinners who had come to listen to Him.

The Marriage at Cana. The first miracle performed by Christ was at a wedding in the town of Cana to which He and His mother, Mary, and His disciples were invited. 'And when they wanted wine, the mother of Jesus saith unto him, They have no wine' (John 2: 3). Jesus then gave instructions that six waterpots of stone be filled with water and that these be carried to the governor of the feast. When the governor tasted the contents of the waterpots, he discovered that all were filled with the finest wine.

The Draught of Fishes. St. Luke gives a somewhat different version from St. Matthew and St. Mark of the calling of Simon Peter, the first Apostle. According to St. Luke, Jesus was preaching to the people beside the lake of Gennesaret when, to escape the pressure of the crowd, He stepped into one of the local fishing boats which happened to belong to Simon Peter. After Jesus had stopped preaching, He told Simon Peter to push off from land and let down his net. Simon protested that no one had caught any fish that day, but, nonetheless, complied with Christ's request. To his astonishment, the net came up so filled with fish that Simon had to call upon his partners, James and John, and the other fishermen, to help him bring the catch ashore. Simon Peter was astonished at this miracle and fell on his knees before Jesus, Who said, '. . . Fear not; from henceforth thou shalt catch men. And when they had brought their ships to land, they forsook all, and followed him' (Luke 5: 1–11). Another 'Miraculous Draught of Fishes' took place when, after His Resurrection, Christ appeared to His disciples after they had fished in vain throughout the night in the sea of Tiberias (John 21).

The Healing at the Pool of Bethesda. In the city of Jerusalem there was a famous pool, called the pool of Bethesda, which was reputed to have healing powers for the blind, the lame, and those otherwise afflicted. One day, as He stood beside the pool, Jesus observed an old man, an invalid for many years. Jesus asked the suffering man if he did not wish to be cured. The man replied, '. . . Sir, I have no man, when the water is troubled, to put me into the pool: but while I am coming, another steppeth down before me. Jesus saith unto him, Rise, take up thy bed and walk. And immediately the man was made whole and took up his bed, and walked' (John 5: 7–9). Because this incident took place on the Jewish Sabbath, the Jews were aroused against Jesus and sought to kill him.

The Loaves and the Fishes. Jesus went up into a mountain near the Sea of Galilee, and a great crowd followed Him. Among them were many lame, blind, dumb, and maimed, who cast themselves at Jesus' feet and were cured. Then Jesus called His disciples to Him and said, '. . . I have compassion on the multitude, because they continue with me now three days, and have nothing to eat: and I will not send them away fasting, lest they faint in the way' (Matthew 15: 32). When the disciples asked how so large a gathering was to be fed, since all the food available was seven loaves and a few little fishes, Jesus commanded the crowd to sit on the ground. He then broke the loaves and the fishes into pieces which He handed to the disciples and which they, in turn, passed to the hungry multitude. By this means, some four thousand men, women, and children were fed.

Christ Walking Upon the Water. One evening, Christ ordered His disciples to cross over the Sea of Galilee before Him. A great wind arose that threatened to swamp the boat. Late in the night '. . . Jesus went unto them, walking on the sea . . . the disciples . . . cried out for fear . . . Jesus spake unto them, saying, Be of good cheer, it is I, be not afraid' (Matthew 14: 25ff.). When Jesus came into the ship the wind ceased.

St. Matthew adds the further detail that, having received permission, Peter attempted to walk out toward Christ but, losing courage, he began to sink. Immediately Jesus stretched out His hand and saved him. The scene with this addition is known as 'The Navicella.'

The Raising of Lazarus. While Jesus was on a journey, His friend Lazarus, brother of Mary and Martha, was taken ill. Word of the illness was sent to Jesus, but He did not at once return to Bethany, where Lazarus lived. After several days, however, He sensed that Lazarus had died, and, when He returned to Bethany, this truth was confirmed to Him by Mary and Martha. To them Jesus said that, if they would have faith, their brother would be restored to them. He then asked to be taken to the grave where Lazarus was buried. After the grave had been opened, Jesus called upon God and then, in a loud voice, said, 'Lazarus, come forth.' At these words, Lazarus emerged from the grave, still wrapped in graveclothes. Jesus said, 'Loose him, and let him go.' This was done, and Lazarus was restored to life. By this means, many of the Jews who had witnessed the miracle were converted to belief in Christ (John 11). A figure frequently portrayed in paintings of the raising of Lazarus is that of a man who holds his hand to his nose. This figure is to recall the warning of Martha, 'Lord, by this time he stinketh: for he hath been dead four days.'

The Transfiguration. After the return of the disciples from their first missionary journey and their recognition of Jesus as the Son of God, He took Peter, John, and James up into a mountain to pray. There, before their eyes, Christ was transfigured. His garments became shining white with a heavenly radiance, and there appeared and talked with Him the prophets Moses and Elias. Then Peter offered to build on that site three shrines: one for Jesus, one for Moses, and one for Elias. But, as Peter spoke, '. . . there came a cloud, and overshadowed them . . . and there came a voice out of the cloud, saying, This is my beloved Son: hear him' (Luke 9: 34ff.).

Christ's Passion. The last events of Christ's earthly life, from His entry into Jerusalem to His burial, are collectively called The Passion. The Passion scenes most frequently depicted include the following:

The Entry into Jerusalem: After journeying through Judea, preaching to the people, Christ came at last to the Mount of Olives, just outside Jerusalem. He had already told His disciples that He would be seized in Jerusalem and be put to death. But this knowledge did not cause Him to hold back, and He made His preparations to enter the city. He instructed two of the disciples to go into Jerusalem and to bring an ass that they would find there. When the ass was brought to Christ, the disciples spread their garments on its back and Christ mounted and rode toward the city. The people came out to meet Him, spreading palm branches before Him and crying out, '. . . Blessed is he that cometh in the name of the Lord . . . Hosanna in the highest' (Mark 11: 9ff.). In paintings of Christ's entry into Jerusalem, it is common to find the figure of a man who has climbed a tree, obviously for the purpose of seeing over the heads of the crowd. The figure is intended to represent Zacchaeus, the publican, who did in fact climb a tree to see Jesus 'because he was little of stature.' Historically, this incident is inaccurate in relation to the entry into Jerusalem, for, according to St. Luke, it took place in Jericho when Jesus was passing through that town just prior to His entry into Jerusalem.

Christ Washes the Feet of the Disciples: Christ entered into Jerusalem a few days before the feast of the Passover. Christ realized that His time had come and that He would be betrayed by Judas Iscariot. After the Last Supper with His disciples, He rose from the table, 'and laid aside his garments; and took a towel, and girded himself. After that he poureth water into a bason, and began to wash the disciples' feet, and to wipe them with the towel wherewith he was girded' (John 13: 4ff.). Christ then explained to the disciples that He had set them an example of humility which they should follow, for, 'Verily, verily, I say unto you, The servant is not greater than his lord; neither he that is sent greater than he that sent him' (John 13: 16).

The Last Supper: This famous scene depicts the last meal that Christ had with His disciples before His betrayal by Judas Iscariot. It was at this meal that Christ broke bread and handed it to His disciples. 'And as they were eating, Jesus took bread, and blessed it, and brake it, and gave it to the disciples, and said, Take, eat; this is my body. And he took the cup, and gave thanks, and gave it to them, saying, Drink ye all of it; For this is my blood of the new testament, which is shed for many for the remission of sins' (Matthew 26: 26ff.). This ceremony, as instituted by Christ, in anticipation of His death, is the basis for the Christian rite of Communion.

In paintings of the Last Supper, the traitor Judas Iscariot is generally shown sitting apart from the other disciples, or springing up from the table, as Christ says, 'But, behold, the hand of him that betrayeth me is with me on the table' (Luke 22: 21). John, who sits at Christ's right hand, is frequently shown with his head resting on the table, or sometimes against Christ,

because he is identified with the unnamed disciple 'whom Jesus loved,' described in John 13: 23.

The Agony in the Garden: After the Last Supper, Christ, knowing of the betrayal by Judas, retired with His disciples to a place called Gethsemane. There He took Peter, James, and John a little apart with Him. He asked them to wait for Him and watch, while He went by Himself to commune with God. After He prayed, He returned to find the three disciples asleep and said, '. . . What, could ye not watch with me one hour?' (Matthew 26: 40). Twice more, Christ left the disciples to watch while He reconciled His soul to death, and each time, when He returned, He found the disciples sleeping. When He returned the third time, He said, '. . . Sleep on now, and take your rest: behold, the hour is at hand, and the Son of man is betrayed into the hands of sinners' (Matthew 26; 45). Paintings of the Agony in the Garden almost always show the figures of the three sleeping disciples. St. Luke adds that while He was praying, 'there appeared an angel unto him from Heaven, strengthening him' (Luke 22: 43). The angel is sometimes included in paintings of this scene.

The Betrayal: As Christ and His disciples were leaving the garden of Gethsemane, a multitude appeared, armed with swords and staves. To betray his Master, Judas identified Him to the servants of the priests by kissing Him (Mark 14: 44ff.). To protect Jesus, Simon Peter drew his sword and smote off the ear of Malchus, a servant of the high priest. But Christ said, '. . . Put up thy sword into the sheath: the cup which my Father hath given me, shall I not drink it?' (John 18: 10ff.).

Christ before Caiaphas: After His seizure, Christ was taken before the high priest, Caiaphas, where the scribes and the elders were assembled. There He was accused of blasphemy (Mark 14: 53ff.).

The Denial of Peter: After Christ had been seized by the servants of the high priest, He was brought to the palace, and there the council sought to find witnesses against Him, in order that He might be put to death. Meanwhile, Peter had followed at a distance and was in the palace of the high priest, sitting with the servants while Christ was being accused. As Peter sat there, first a maid, then others in the palace recognized him and accused him of being a follower of Jesus. But, as Christ had foretold, '. . . Verily, I say unto thee, That this day, even in this night, before the cock crow twice, thou shalt deny me thrice' (Mark 14: 30). Peter three times declared that he did not know the man who had been taken prisoner. Then, upon hearing a cock crow for the second time, Peter remembered the words of Christ and wept, realizing that he had been unfaithful to his beloved Master.

Christ before Pilate: The morning after Christ had been accused before Caiaphas, the high priest, He was bound and brought before the governor,

Pontius Pilate. Here He was accused by the chief priests and elders, who wished Him put to death. It was the custom, in connection with the Passover, for the governor to release one prisoner at the request of the people. Pilate asked whether he should release Christ. The priests and elders persuaded the people to ask for the release of another prisoner, Barabbas. When Pilate asked what should be done with Christ, the crowd demanded He be crucified. 'When Pilate saw that he could prevail nothing, but that rather a tumult was made, he took water, and washed his hands before the multitude, saying, I am innocent of the blood of this just person: see ye to it' (Matthew 27: 24).

The Flagellation: After Pilate had reluctantly bowed to the demands of the mob and had released Barabbas, he delivered Jesus to the soldiers to be scourged and crucified (Matthew 27: 26).

The Mocking of Christ: After Christ had been scourged, He was taken by soldiers into the Common Hall, where His garments were stripped from Him. The soldiers then threw a scarlet (or purple) robe about Him, crowned Him with a crown of thorns, put a reed in His hand as a mock symbol of power, and jeered at Him, saying: 'Hail, King of the Jews' (Mark 15: 15ff.).

'Ecce Homo': Very famous among the paintings of the Passion is that which is entitled 'Ecce Homo' (Behold the Man). After the mocking of Christ in the Common Hall, Pilate had Him brought forth before the people, '. . . and saith unto them, Behold, I bring him forth to you, that ye may know that I find no fault in him. Then came Christ forth, wearing the crown of thorns, and the purple robe. And Pilate saith unto them, Behold the man!' (John 19: 4, 5).

The Road to Calvary: The Evangelists Matthew, Mark and Luke relate that, as Christ was led away to be crucified, '. . . as they came out, they found a man of Cyrene, Simon by name: him they compelled to bear his cross' (Matthew 27: 32). It is only the Evangelist John who says that Christ was compelled to bear His own Cross. 'And he bearing his cross went forth into a place called the place of a skull, which is called in the Hebrew Golgotha' (John 19: 17). The general portrayal of The Road to Calvary, following the version of St. John, shows Christ bearing His Cross on His shoulders.

The Stations of the Cross: In religious art, Christ's journey to Calvary is usually divided into fourteen scenes or Stations. These are:

1. Jesus is condemned to Death
2. Jesus receives His Cross
3. Jesus falls the First Time under His Cross
4. Jesus meets His Afflicted Mother
5. Simon of Cyrene helps Jesus to carry His Cross

6. Veronica wipes the Face of Jesus
7. Jesus falls the Second Time
8. Jesus speaks to the Women of Jerusalem
9. Jesus falls the Third Time
10. Jesus is stripped of His Garments
11. Jesus is nailed to the Cross
12. Jesus dies on the Cross
13. Jesus is taken down from the Cross
14. Jesus is laid in the Sepulchre

The Crucifixion: All four versions of the Gospel describe the crucifying of Christ, but these accounts vary considerably in detail. In paintings of the Crucifixion, therefore, it is not unnatural that a number of different aspects and variations of the scene should be represented. In general, it is agreed that after Christ had been brought to Golgotha (Calvary), He was stripped of His clothes and crucified, His Cross being erected between those of two thieves who were crucified at the same time. Then Pilate caused a sign to be made which read, 'Jesus of Nazareth The King of the Jews', and this was affixed to Christ's Cross. After the Crucifixion, the soldiers present cast lots for Christ's coat that '. . . was without seam, woven from the top throughout.' While Christ was on the Cross, the crowd mocked Him, asking why, if He were King of Israel, He could not save Himself. Both St. Matthew and St. Mark say that the thieves who were crucified with Christ likewise cursed Him. St. Luke reports that one of them rebuked the other, saying, '. . . we receive the due reward of our deeds: but this man hath done nothing amiss.' He then said to Christ, '. . . Lord, remember me when thou comest into thy kingdom.' After Christ had been hanging on the Cross for many hours, He was thirsty. Thereupon one of those present filled a sponge with vinegar and placed it on a reed and held it to Christ's mouth. The Gospels all agree that a number of women were present at the Crucifixion, among whom Mary, the mother of Christ, Mary, the mother of St. James the Less, and Mary Magdalene are named. St. John alone indicates that he, too, was present and that, just before Christ died, He commended His mother to John's care. It was after Christ's death on the Cross that one of the soldiers pierced the side of the Saviour with a spear and '. . . forthwith came there out blood and water.' This soldier is commonly identified with the centurion who, on witnessing the Crucifixion, became convinced of Christ's divinity. And when he '. . . saw that he so cried out and gave up the ghost, he said, Truly this man was the Son of God.' In Christian tradition, this centurion has been given the name St. Longinus.

The Descent from the Cross: All four of the Evangelists have described how Christ's body was taken down from the Cross and how Joseph of Arimathea, a wealthy lawyer, went to Pilate and begged for Christ's body, a request which was granted. St. John alone, however, mentions the presence of Nicodemus, who joined with Joseph in wrapping the body of Christ in linen, together with spices of myrrh and aloes, '. . . as the manner of the Jews is to bury' (John 19: 40). This scene is frequently called 'The Deposition.'

The Pietà: This is the title commonly given to representations of the Virgin, Mary Magdalene, and others lamenting over the body of Christ after the Crucifixion.

The Entombment: This scene describes the actual burial of Christ by Joseph of Arimathea. Some versions also show Nicodemus present at the burial, in accordance with the Gospel of St. John. The place of burial was a new tomb, hewn out of rock. St. Matthew states that it was a tomb that Joseph had prepared in anticipation of his own death. After the entombment, the sepulchre was closed by a great stone, which sealed it.

The Resurrection. The Gospels do not describe the actual Resurrection of Christ from the tomb, but it is abundantly illustrated in art. Christ is arrayed in a white or golden garment. He often carries the banner of the Resurrection. The soldiers guarding the tomb have fallen into a deep sleep. Angels may be present. The soldiers set to guard the tomb and the question of their sleeping are discussed by St. Matthew (Matthew 27: 62ff.; 28: 11ff.). The Gospels vary as to who it was that first discovered that the Resurrection of Christ had taken place. St. Matthew states that it was Mary Magdalene and Mary, the mother of James, who came to the sepulchre early in the morning, and there were told by an angel that Christ had risen. St. Mark states that these two, together with the girl Salome, came to the tomb and found the great stone that sealed it already rolled away. Entering the sepulchre, they found an angel, who told them that Christ had risen. In the same connection, St. Luke mentions the two Marys and several other women. St. John specifically states that it was Mary Magdalene who came at an early hour to the tomb, and was astonished to find that the stone which closed the sepulchre had been removed. She then hastened to Peter and John to tell them that the body of Christ had been taken away. Both disciples rushed to the tomb and found that the sepulchre was indeed empty. All of them departed, with the exception of Mary Magdalene. Weeping, she alone remained at the tomb. Finally, bending down, she looked into the sepulchre. Two angels, clothed in white, were sitting there; one, where the head of Christ had been; the other, at the place of His feet. Then, suddenly, Mary saw the figure of Christ

standing beside her. However, she did not recognize Him until after He had spoken her name.

The Appearances. According to the Gospels, Christ appeared several times to His disciples and others after the Resurrection, and these appearances have been the subject of many important paintings of the Renaissance. The Appearances most frequently portrayed are the following:
Noli Me Tangere (Touch Me Not): The first person to whom Christ is reported to have appeared is Mary Magdalene, when she went to His tomb. She did not recognize Jesus, whom she supposed to be the gardener, until He spoke her name. 'Jesus saith unto her, Mary. She turned herself, and saith unto him, Rabboni; which is to say, Master. Jesus saith unto her, Touch me not; for I am not yet ascended to my Father' (John 20: 16, 17).
The Road to Emmaus: St. Luke tells how two of the disciples on the day of the Resurrection went to the village of Emmaus. As they journeyed '. . . they talked together of all these things which had happened. And it came to pass, that, while they communed together and reasoned, Jesus himself drew near, and went with them. But their eyes were holden that they should not know him' (Luke 24: 14ff.).
The Supper at Emmaus: When the two disciples and Jesus, whom they had not recognized, approached the village of Emmaus, He indicated that He would continue on the way. 'But they constrained him, saying, Abide with us: for it is toward evening and the day is far spent. And he went in to tarry with them. And it came to pass, as he sat at meat with them, he took bread, and blessed it, and brake, and gave to them. And their eyes were opened, and they knew him; and he vanished out of their sight' (Luke 24: 28ff.).
The Incredulity of Thomas: According to St. John, Christ appeared to the disciples on the evening of the Resurrection, the first day of the week. Thomas was absent. When later he returned and was told of Christ's appearance, he said, '. . . Except I shall see in his hands the print of the nails, and put my finger into the print of the nails, and thrust my hand into his side, I will not believe.' Thomas was present when, eight days later, Jesus again appeared to the disciples. 'Then saith he to Thomas, Reach hither thy finger, and behold my hands; and reach hither thy hand, and thrust it into my side: and be not faithless but believing. And Thomas answered and said unto him, My Lord and my God' (John 20: 25ff.).

The Ascension. St. Luke, in his Gospel and in The Acts of the Apostles, gives accounts of the Ascension of Christ. It was largely from these accounts that Renaissance artists drew their inspiration for paintings of this scene. 'And he led them out as far as Bethany, and he lifted up his hands, and blessed

them. And it came to pass, while he blessed them, he was parted from them, and carried up into heaven' (Luke 24: 50, 51). 'And while they looked stedfastly toward heaven as he went up, behold, two men stood by them in white apparel: Which also said, Ye men of Galilee, why stand ye gazing up into heaven? this same Jesus, which is taken up from you into heaven, shall so come in like manner as ye have seen him go into heaven' (Acts 1: 10, 11). 'And they worshipped him, and returned to Jerusalem with great joy: And were continually in the temple, praising and blessing God. Amen' (Luke 24: 52, 53).

The World Beyond. The Church's teaching about the four last things: Death, Judgment, Heaven, and Hell, was quite widely portrayed by Renaissance painters. The themes most commonly used were the following:

Christ in Limbo or the Descent into Hell: According to the Christian Creeds, after the Crucifixion and Burial of Christ, He descended into Hell. Hell, or Limbo, is portrayed in Renaissance painting as a cavelike place, crowded with those who await His coming. When its gates are shown, they are being trampled beneath Christ's feet. When the Devil is represented, he is a small, black, and cowering figure. In contrast, Christ is large and commanding, dressed in gleaming garments and carrying the banner of the Resurrection. Adam, the first man, stands at the entrance to greet Him. Next to him stands Eve, and among the crowd behind them can usually be seen the crowned figures of David, Moses, and St. John the Baptist.

The Last Judgment: The Nicene Creed, the statement of Christian belief, asserts that Christ shall return in glory to judge both the living and the dead. In art, the Last Judgment has been shown, from the simple Biblical scene of the separation of the sheep and the goats, to the highly imaginative interpretations of the later Renaissance painters. In the latter, Christ is shown as the Presiding Judge. Frequently, the Virgin Mary is shown at His right, and St. John the Baptist at His left. In the upper part of the scene are the angelic hosts and the blessed company of saints and martyrs. Below, the graves yield up their dead at the sound of the trumpets borne by angels. Michael, the Archangel of the Last Judgment, balances the good and the evil in his scales, or sounds the trumpet of the Last Judgment. Often, other angels hover near Christ, bearing the instruments of His Passion. At His right hand, the elect are rising to their reward in Heaven; and at His left hand, the damned are being cast down into Hell.

Christ, with a radiance about Him, is usually seated upon a throne or rainbow. He shows His wounds, the mantle He wears leaving His right side uncovered. His appearance is expressive of His role as Judge. He may turn away from the damned; His right hand, with palm upward, extends

welcome to the elect; His left hand, with palm downward, rejects the damned. St. Peter, with his keys, often stands near by to admit the elect into Heaven. The scene of the Last Judgment may be shown in a single composition. Frequently, however, Heaven and Hell are shown as separate compositions.
Heaven: The three Renaissance concepts of Heaven: namely, the Realm beyond the Skies, the Garden of Paradise, and the Heavenly City, have the first two more frequently shown. Seated upon banks of clouds, the ranks of the elect are introduced to the everlasting happiness of eternal life in a richly flowered garden. Frequently the Garden of Paradise is shown beyond the gates of Heaven.
Hell: The imagination of the Renaissance painters gave many concepts to the representation of Hell. Sometimes it was indicated as a dragon's mouth into which demons and lost souls were entering. Again, the Devil and a few of his host sufficed to convey the idea. At other times the Infernal City was shown filled with fire and smoke. Most elaborate are the pictures which represent, on a terraced mountain, the seven successive circles of damnation.

SECTION IX

The Trinity, the Madonna, and Angels

In Renaissance painting, God may be represented in two principal ways. The Unity of the Godhead may be stressed or the Three Persons of the Trinity may be depicted. In the latter representations, the Father, the Son, and the Holy Ghost may appear together or separately, depending upon the subject portrayed. Generally, the activity of the Person of the Godhead is emphasized: God the Father presides over the creation of the world, the Son endures the Passion, and the Holy Ghost illumines the Church, the society of the redeemed.

God the Father. In obedience to the second commandment, pictorial representations of God the Father had been avoided by early painters. Gradually, however, the feeling of sacrilege involved in the portrayal of the Almighty was overcome. At first, only the hand of God emerging from a cloud as a sign of His power came to be portrayed. Later His head was shown, then His bust, and finally His whole figure. By the time of the Renaissance, the representations of God the Father were used freely. Previously, when the whole figure of God was shown it stood for the Trinity rather than for the

Father alone, but by the time of the Renaissance this distinction had been lost. The distinctive attributes of God the Father, by which He may be identified in Renaissance art in contrast to the other Persons of the Trinity, are His age and often the triangular halo. He may hold the globe or a book, though these attributes He shares with other personalities. He may be clad in papal dress and wear the papal tiara, although this attire is more frequent in Northern painting than in the Italian Renaissance.

God the Son. Representations of Christ as the Son of God appear not only in scenes of His earthly life but also in His continuing activity as the Son of God: seated at the right hand of the Father; the Judge of the living, and the dead. In these, Christ is portrayed in a manner appropriate to the scene. (See Jesus Christ, in Section VIII.)

In devotional pictures, Christ is usually depicted as younger than His Father. He may be represented in His maturity, bearded, bearing the wounds, and with bare feet; or He may appear as a child, either in company with His mother, or, more rarely, alone. The Christ Child always stands for the Incarnation, but He may carry the symbols of His Passion to emphasize the relationship between His Incarnation and His sacrifice on behalf of mankind. Instead of being shown in His human nature, Christ may also be represented as a lamb, with reference to the words of St. John the Baptist (John 1: 29), '. . . Behold the Lamb of God, which taketh away the sin of the world,' and also with reference to the vision in Revelation 5: 6, 'And I beheld, and, lo, in the midst of the throne and of the four beasts, and in the midst of the elders, stood a Lamb as it had been slain, having seven horns and seven eyes, which are the seven Spirits of God sent forth into all the earth.'

Less frequently Christ is represented as a lion. The fish, His very common symbol in Early Christian art, seems to have become obsolete by the Renaissance. Other representations widely portrayed are:

The Crucified Christ: Christ upon the Cross, usually with the crosses of the two thieves on either side, with the Virgin and St. John the Evangelist standing at the foot of His Cross.

The Descent from the Cross: Christ being tenderly taken down from the Cross. This scene is also known as 'The Deposition.'

The Entombment: The Christ is frequently portrayed, after His death, being placed in the tomb. He may be erect, or sitting upright, showing His wounds and supported by angels. With Him may be the Virgin Mary, St. John the Evangelist, and the other two Marys.

Pietà: The dead Christ is shown in the arms of the Virgin Mary.

The Man of Sorrows: The Christ, living but showing His five wounds, and often accompanied by the instruments of His Passion.

Salvator Mundi (*Saviour of the World*): Christ holding the globe, crowned with thorns and sometimes carrying the Cross.

Noli Me Tangere and the *Road to Emmaus*: Both of these are Resurrection appearances which may depict the Christ as a gardener or pilgrim.

The specific attributes of Christ customary in Renaissance art are the cruciform halo, the cross, the stigmata and the book. The book may have an inscription written upon it. Inscriptions most often used were 'Pax vobis' (Peace be unto you), 'Ego sum via, veritas, et vita' (I am the way, the truth, and the life), 'Ego sum lux mundi' (I am the light of the world), 'Ego sum resurrectio' (I am the resurrection), and 'Qui videt me videt et Patrem' (Whoever seeth me, seeth the Father). Various monograms are also used as symbols of Christ. Greek alphabetical letters, such as alpha and omega (the first and the last), or chi and rho, the first two letters of 'Christos' (Christ) in Greek, frequently appear in representations of Christ. (See Cross, in Section XIII; Monograms, in Section XI.)

God the Holy Ghost. The Holy Ghost is usually depicted as a white dove. When seen together with the other Persons of the Trinity, He may be depicted in human form, either identical with the other Persons or of a considerably younger age. On Pentecost, in accordance with the promise of Christ that He would send the Holy Ghost to dwell in His Church, the Apostles were gathered in one place, and 'suddenly there came a sound from heaven as of a rushing mighty wind, and it filled all the house where they were sitting. And there appeared unto them cloven tongues like as of fire, and it sat upon each of them. And they were all filled with the Holy Ghost . . .' (Acts 2: 2–4). In the paintings of Pentecost the Holy Ghost appears in the form of rays of light or flames.

The Trinity. There are various ways of depicting the Trinity. When the idea of the Oneness or the Unity of God is being stressed, one figure, or three identical figures, may be shown. Otherwise, the three Persons are distinguished by Their individual attributes. God the Father is represented as a white-bearded older man; the Son, younger, bears the Cross or is nailed to it; and the Holy Ghost is depicted in the form of a dove. More rarely, the Trinity is represented by three persons of different ages.

The Virgin Mary. With the exception of Christ, no other figure is so frequently portrayed in Renaissance art as the Virgin Mary. Basically, Mary is the personification of grace and purity. She is the merciful mother, gathering together in her nature all the sweetness of womanhood. In art, many different symbols and attributes are used to identify her and to emphasize her

outstanding characteristics. Most common among the devotional and idealized representations of Mary are:

The Madonna Adoring the Christ Child: Such pictures show Mary kneeling before the Infant Christ in worship and adoration. This concept is sometimes combined with representations of the Nativity.

The Mater Amabilis (Mother Worthy of Love): Mary holds the Divine Child. She is usually standing, but is often seated on a throne.

The Madonna of Humility: Such pictures show Mary seated on the ground with the Christ Child.

The Virgin in Glory, wherein Mary is usually shown standing in the sky, surrounded by a radiance and supported, or surrounded, by heads of cherubs.

The Queen of Heaven, wherein Mary is portrayed standing on the crescent moon, crowned as a queen. Frequently the crown bears the twelve stars of the apocalyptic vision (Revelation 12: 1).

The Majesty of the Madonna, which shows Mary as a celestial monarch enthroned amid a retinue of angels.

Madonna della Misericordia (Mother of Mercy), wherein Mary is shown standing and gathering under her mantle kneeling crowds of the faithful whom she is protecting. Sometimes, when such devotional pictures were commissioned by monastic orders or religious brotherhoods, the kneeling crowds wear the habit of the particular order or brotherhood for which the painting was done.

The Madonna del Soccorso (Mother of Succor), closely connected with the Mother of Mercy, is a particular form of devotion to the Virgin as the protector of children. The Virgin as protector is commonly shown carrying a club and chasing away an ugly devil which is trying to frighten a child. This type of image seems to be peculiar to the Renaissance and was used for the most part in central Italy.

The Mater Dolorosa (Mother of Sorrows) shows the Virgin sorrowing for the Passion of her Son, with hands clasped, tears running down her face, and sometimes wearing the crown of thorns over her veil.

The Virgin of the Immaculate Conception, wherein, during the Renaissance period, she is shown either in connection with her parents Joachim and Anna or with the Godhead (Father, Son, Holy Ghost). The attributes which most frequently identify the Virgin of the Immaculate Conception are:

1. the sun and moon (see Sun and Moon, in Section III)

2. the lily (see Lily, in Section II)

3. the rose without thorns (see Rose, in Section II)

4. the enclosed garden (see Garden, in Section III)

5. the sealed fountain (see Fountain, in Section III)
6. the cedar of Lebanon (see Cedar, in Section II)
7. the tree of Jesse (see Tree, in Section II)
8. the closed gate (see Gate, in Section XIV)
9. the spotless mirror (see Mirror, in Section XIV)
10. the tower of David (see Tower, in Section XIV)
11. the twelve stars (see Star, in Section III)

The Virgin of the Rosary was particularly favored by the Dominicans because, according to legend, the Virgin appeared to St. Dominic, founder of the order, and gave him a rosary. In paintings of this type, the central figure of the Virgin, holding a rosary, is often accompanied by her three types of mysteries: the joyful, the sorrowful, and the glorious. (See Rosary, in Section XIII.)

Votive images of the Virgin may be connected with a particular occasion, or with a specific church for which the Virgin is said to have performed some miracle or evidenced a special favor. Some of the best known among these are:

The Madonna del Carmine, which portrays the Virgin as the founder of the Carmelite Order.

The Madonna di Loreto, which alludes to the miraculous transportation of the house of Nazareth to Loreto in Italy after the Holy Land was conquered by the infidel Saracens. In paintings of this type, the Virgin holds in her hand a building, which often has the appearance of a church. This represents the Sanctuary of Loreto, built over the original small chapel to protect it.

The Santa Maria della Neve, which refers to the miraculous building of the Church of Santa Maria Maggiore in Rome. According to legend, the Virgin indicated the plan of the church by a miraculous snowfall in August, which marked the site for the church as well as its future contours.

The Santa Maria della Vittoria, which depicts the image of the Virgin invoked in battle. She is usually represented in the sky, with an army or fighting ships below. She may be represented enthroned with the victors in adoration.

The Madonna della Peste, a devotional image of the Virgin invoked against the plague. Here the Virgin is shown either hovering over a plague-stricken city or surrounded by the saints customarily invoked against the plague, such as St. Sebastian, St. Roch, and the physician saints, Cosmas and Damian. Local patron saints may also appear in the picture, such as St. Petronio for Bologna, or St. Rosalie for Palermo.

In addition to the attributes mentioned above, others frequently used to identify the Virgin are the star, the rose, the sealed book, and the girdle (see individual listings).

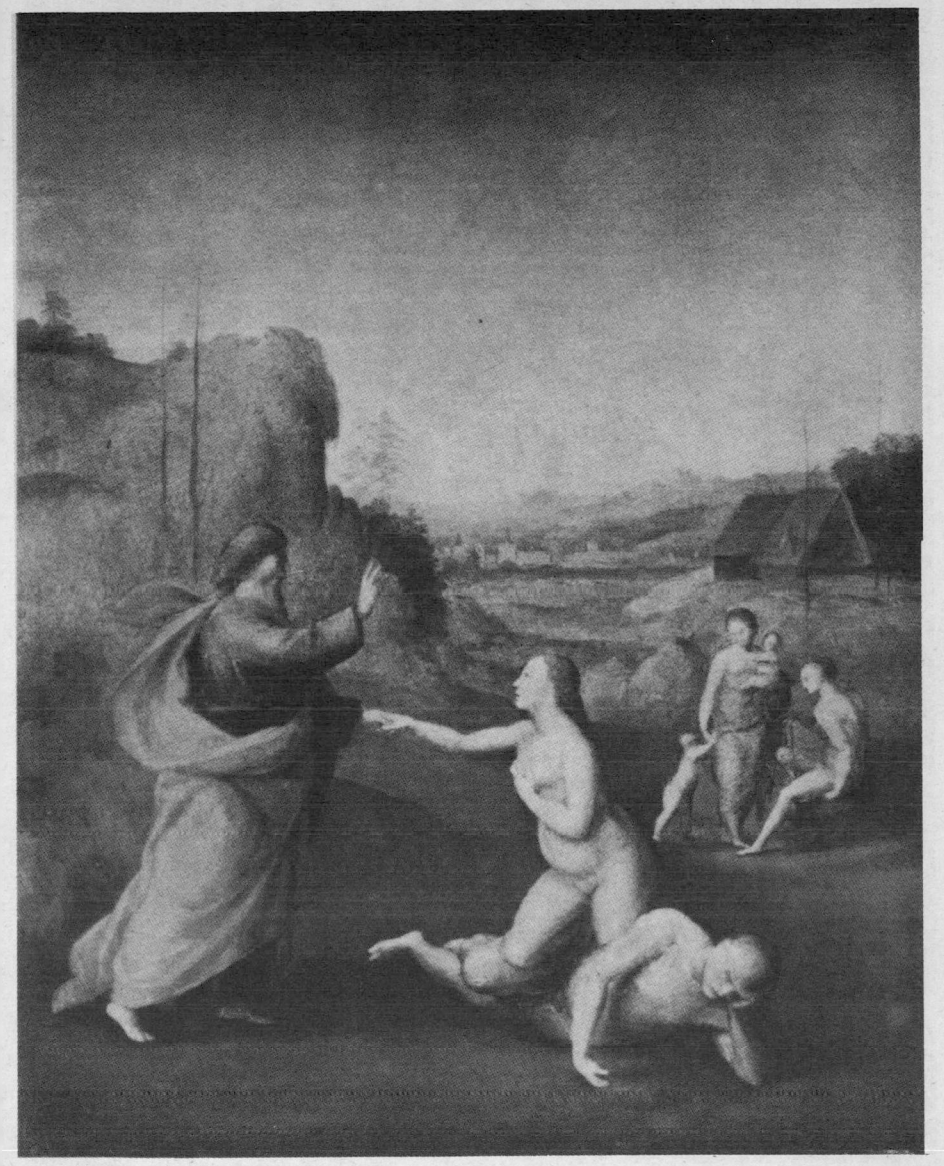

1. Fra Bartolommeo della Porta: *The Creation of Eve*. Seattle Art Museum, Seattle, Washington

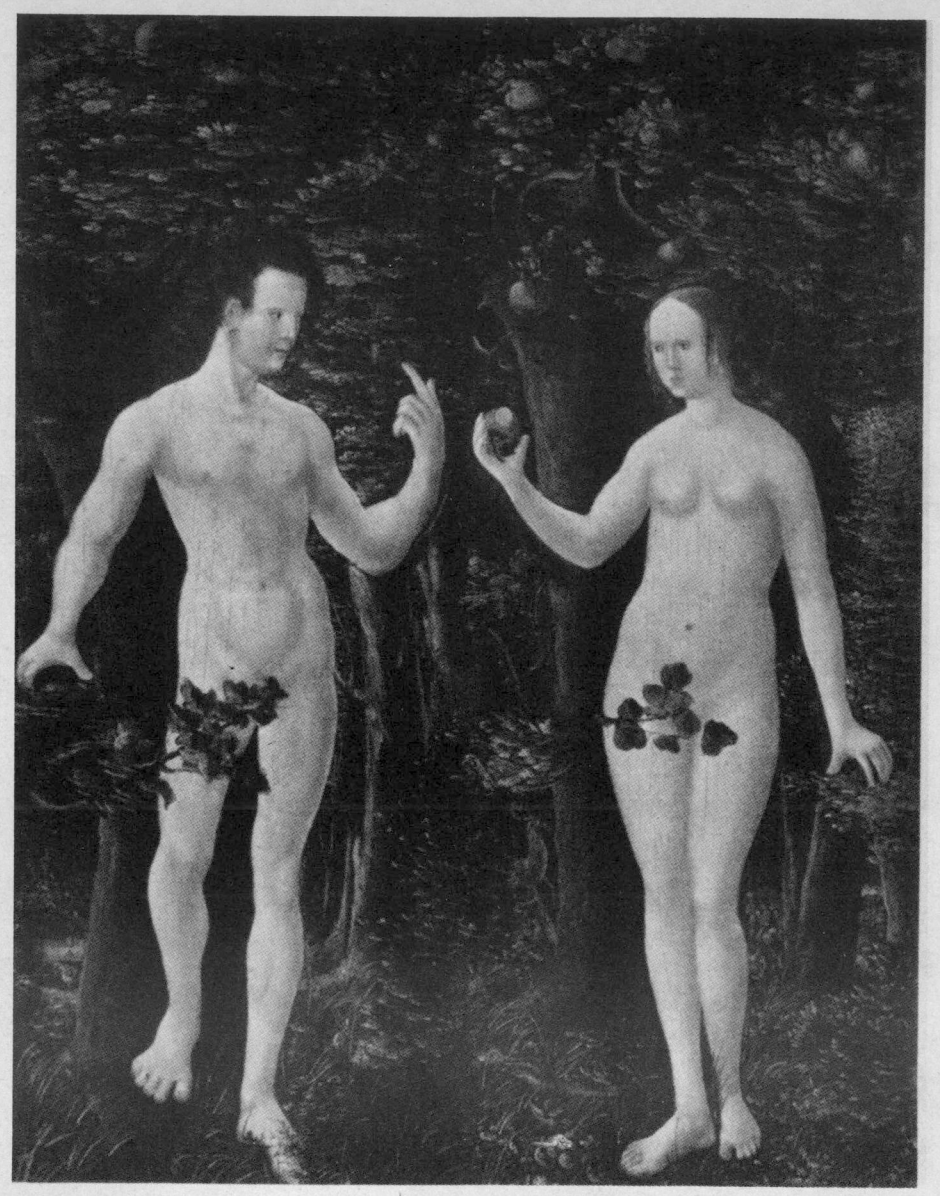

2. Circle of Albrecht Altdorfer: *Adam and Eve*. Centre panel of the triptych 'The Fall of Man'. National Gallery of Art, Washington

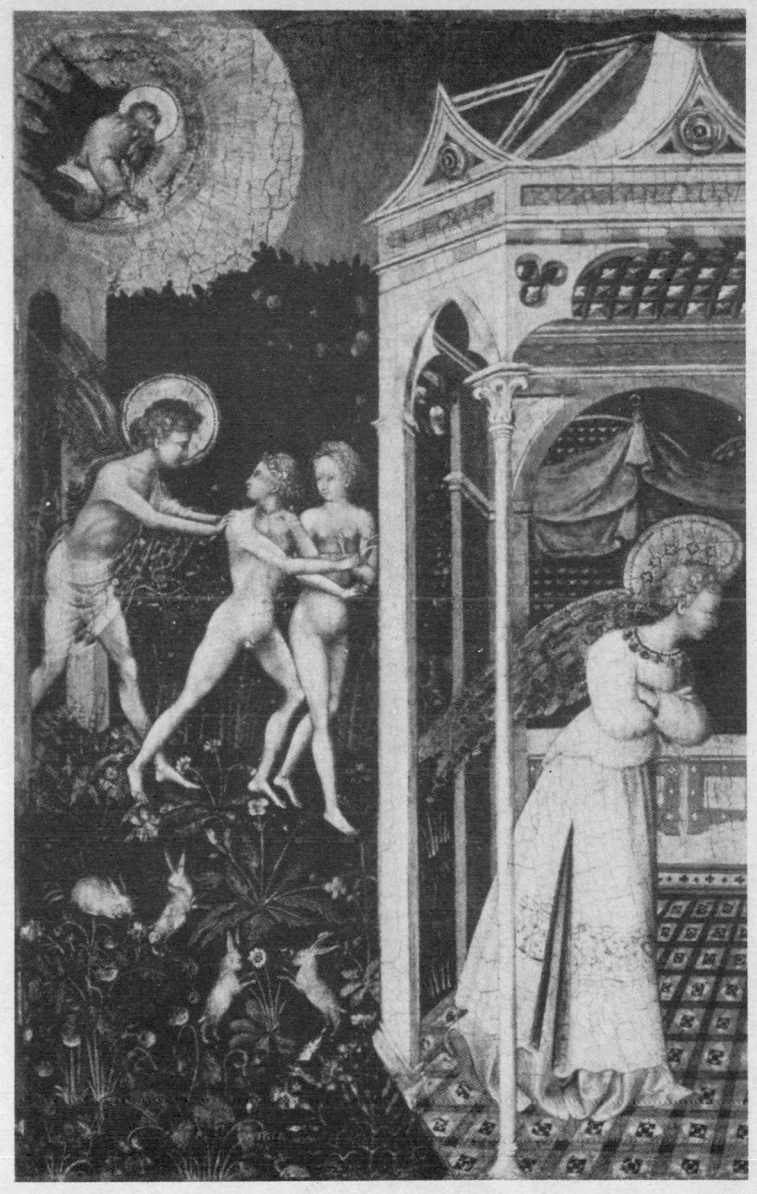

3. Giovanni di Paolo: *The Expulsion of Adam and Eve*. Detail from 'The Annunciation'.
National Gallery of Art, Washington

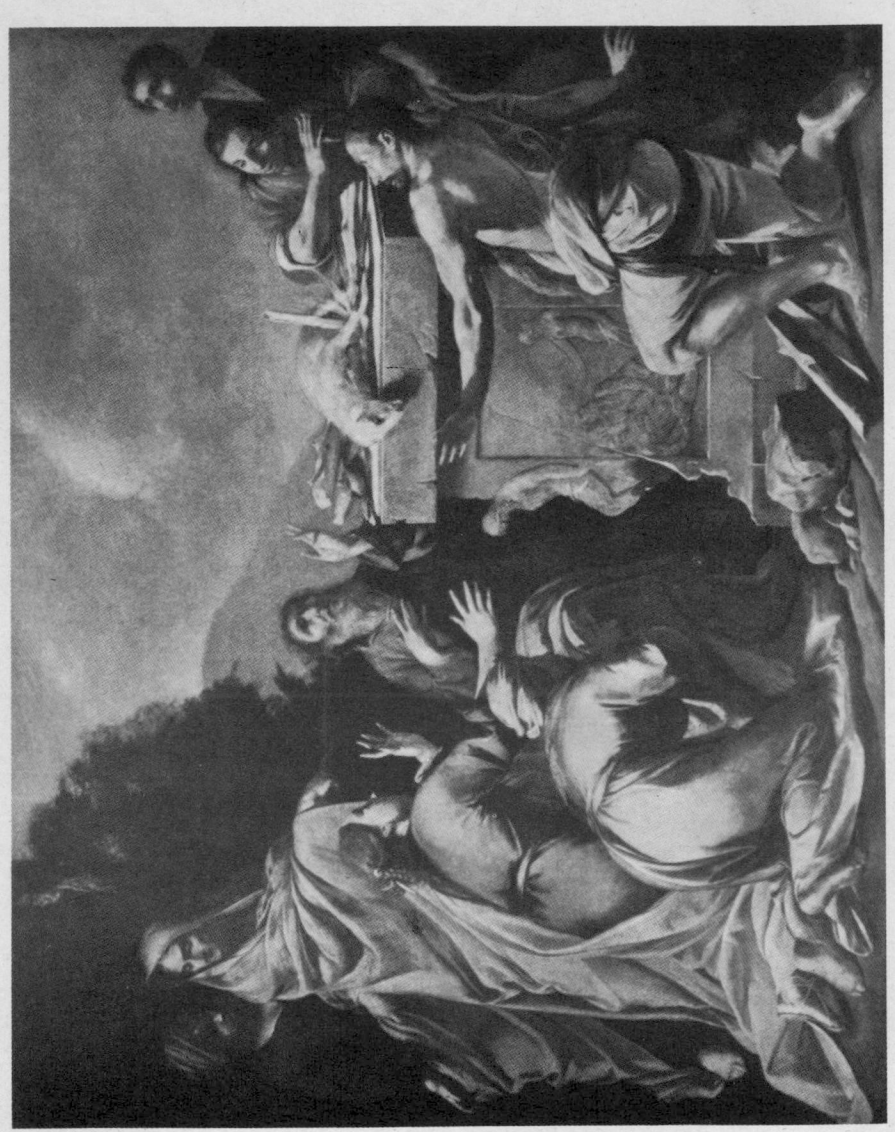

4. Bernardo Cavallino: *Noah's Sacrifice*. Museum of Fine Arts, Houston, Texas

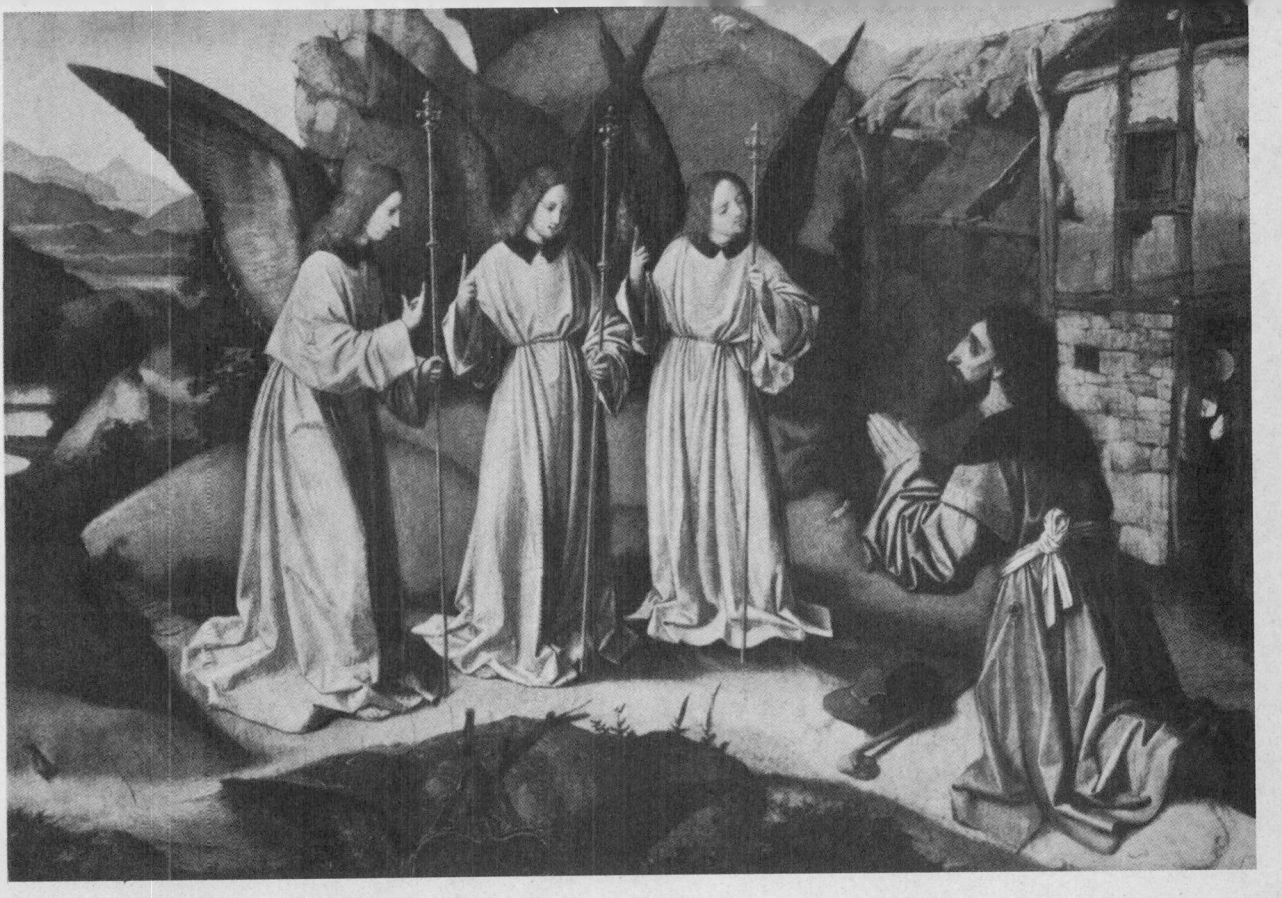

5. Close Pupil of Antonello da Messina: *Abraham visited by the Angels*. Denver Art Museum, Denver, Colorado

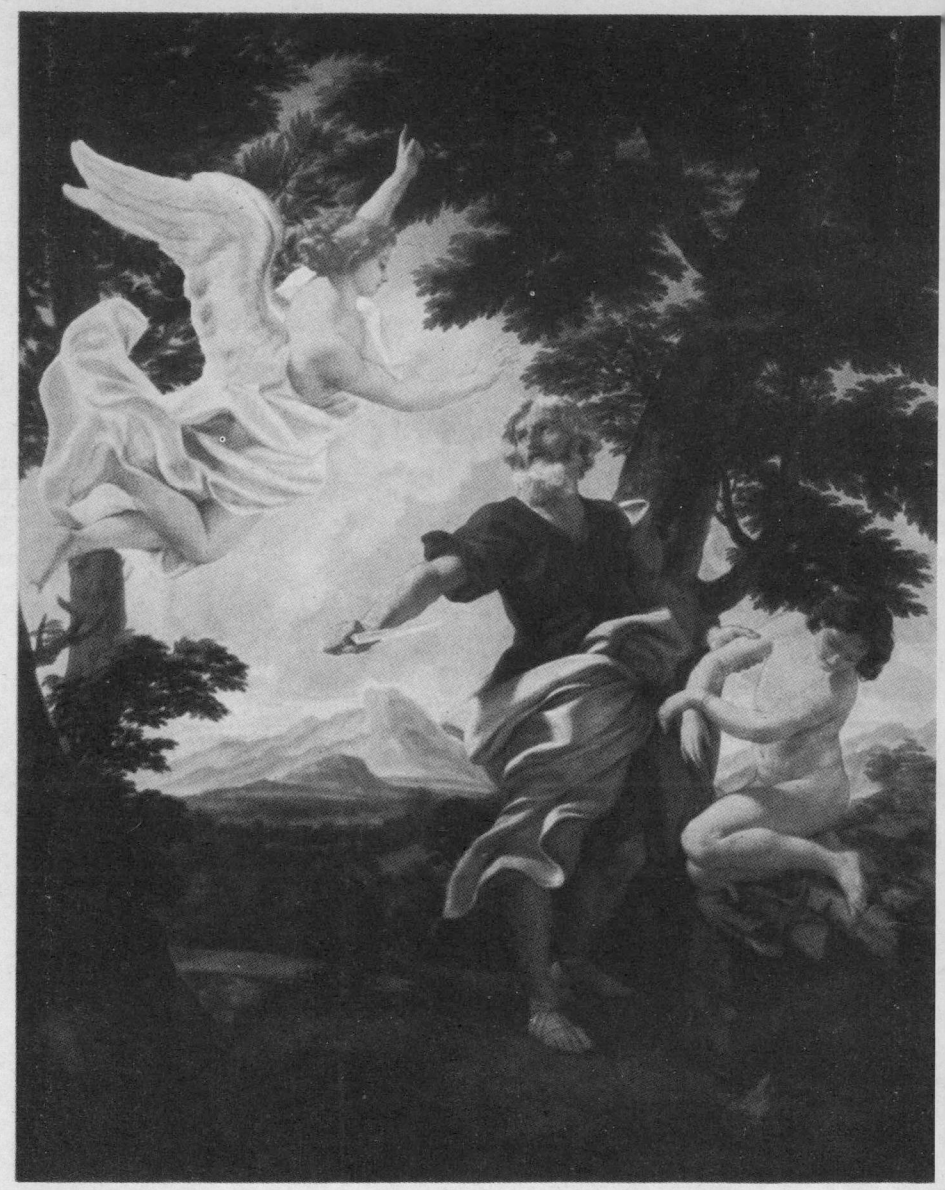

6. Giovanni Battista Gaulli, called Bacciccio: *The Sacrifice of Isaac.*
Atlanta Art Association Galleries, Atlanta, Georgia

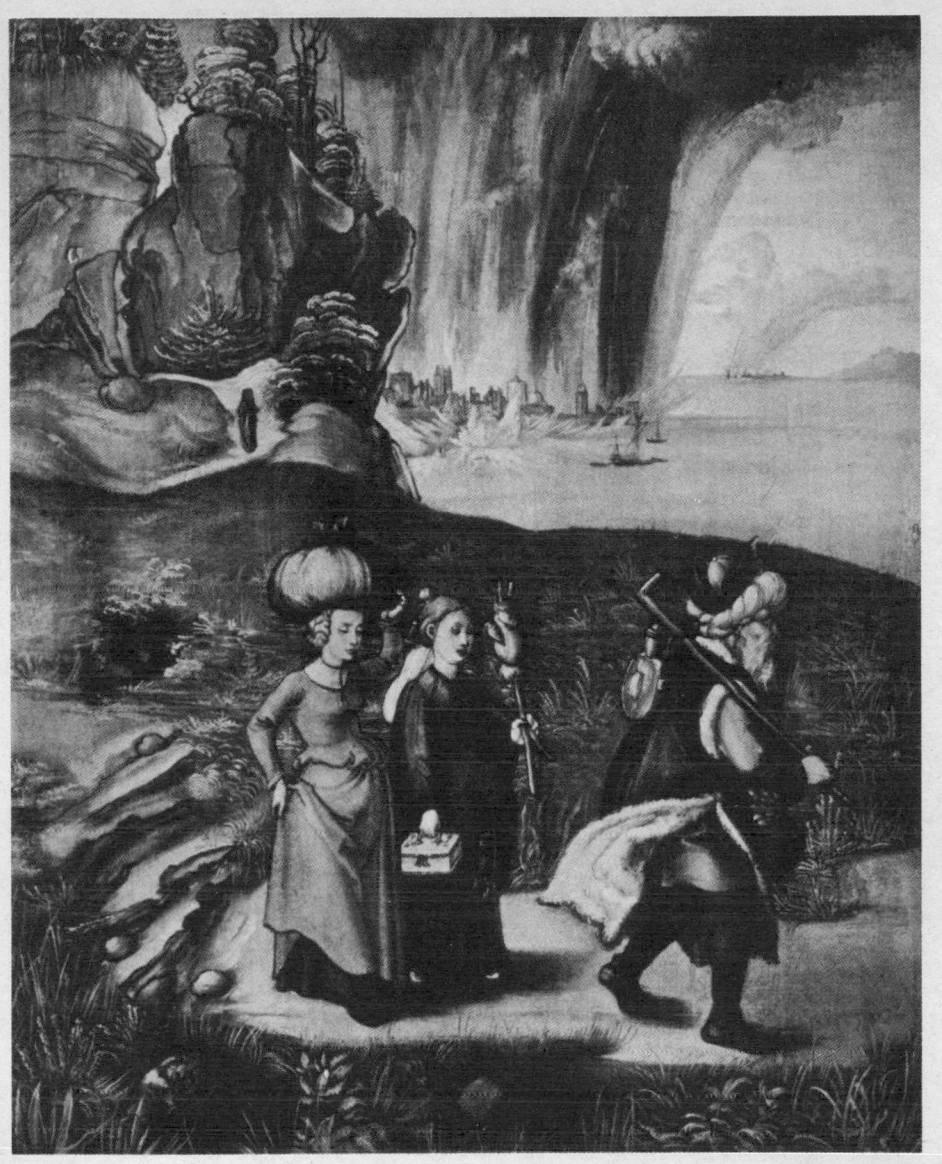

7. Albrecht Dürer: *Lot and his Daughters*. Reverse of 'Madonna and Child'.
National Gallery of Art, Washington

8. Paolo Veronese: *Rebecca at the Well*. National Gallery of Art, Washington

9. Giovanni Andrea de Ferrari: *Joseph's Brothers bring his Bloody Coat to Jacob*. El Paso Art Museum, El Paso, Texas

10. Master of the Apollo and Daphne Legend: *Scenes from the Life of Moses*. Berea College, Berea, Kentucky

11. Master of the Apollo and Daphne Legend: *The Submersion of Pharaoh's Army*. Bucknell University, Lewisburg, Pennsylvania

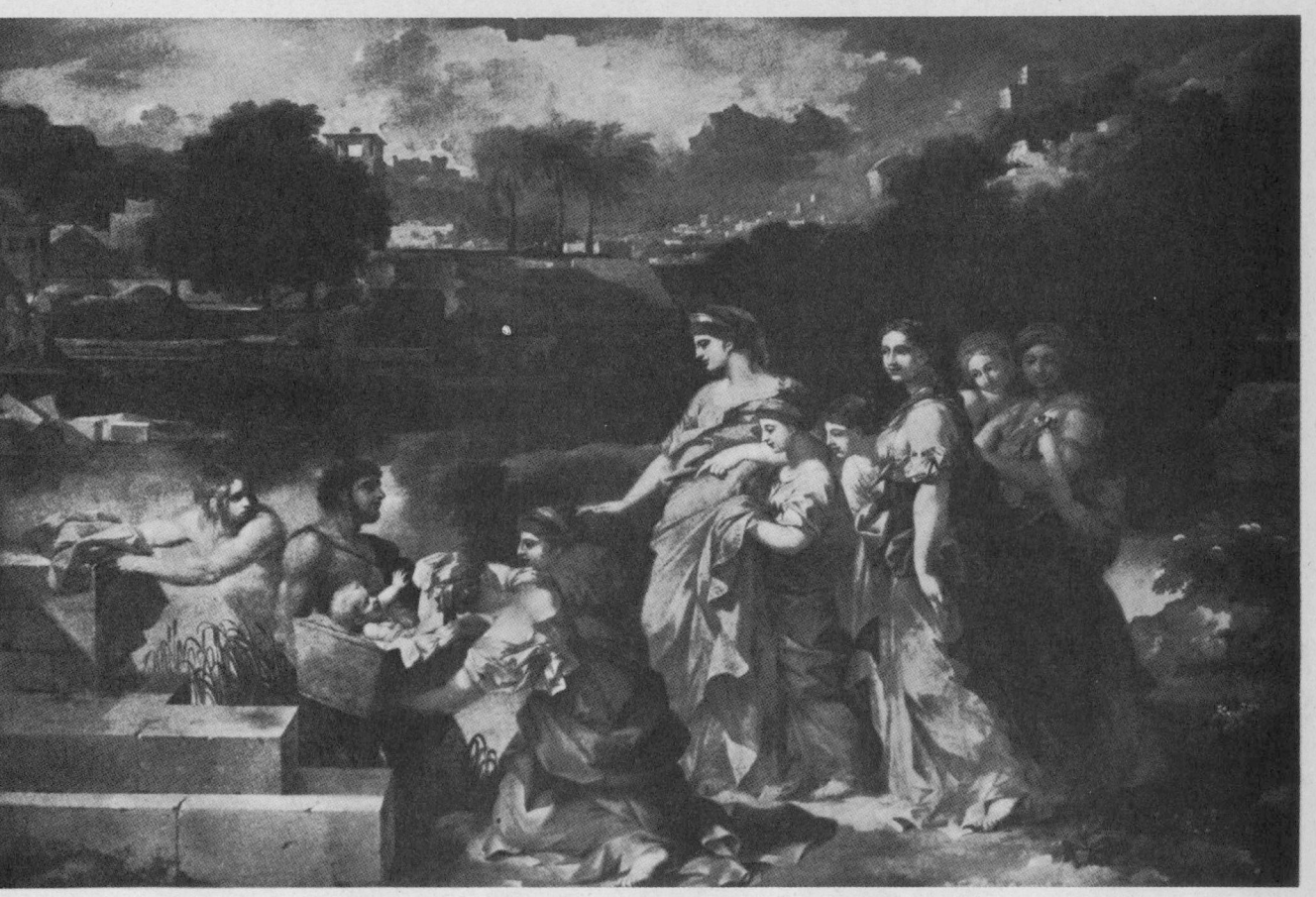

12. Sebastien Bourdon: *The Finding of Moses*. National Gallery of Art, Washington

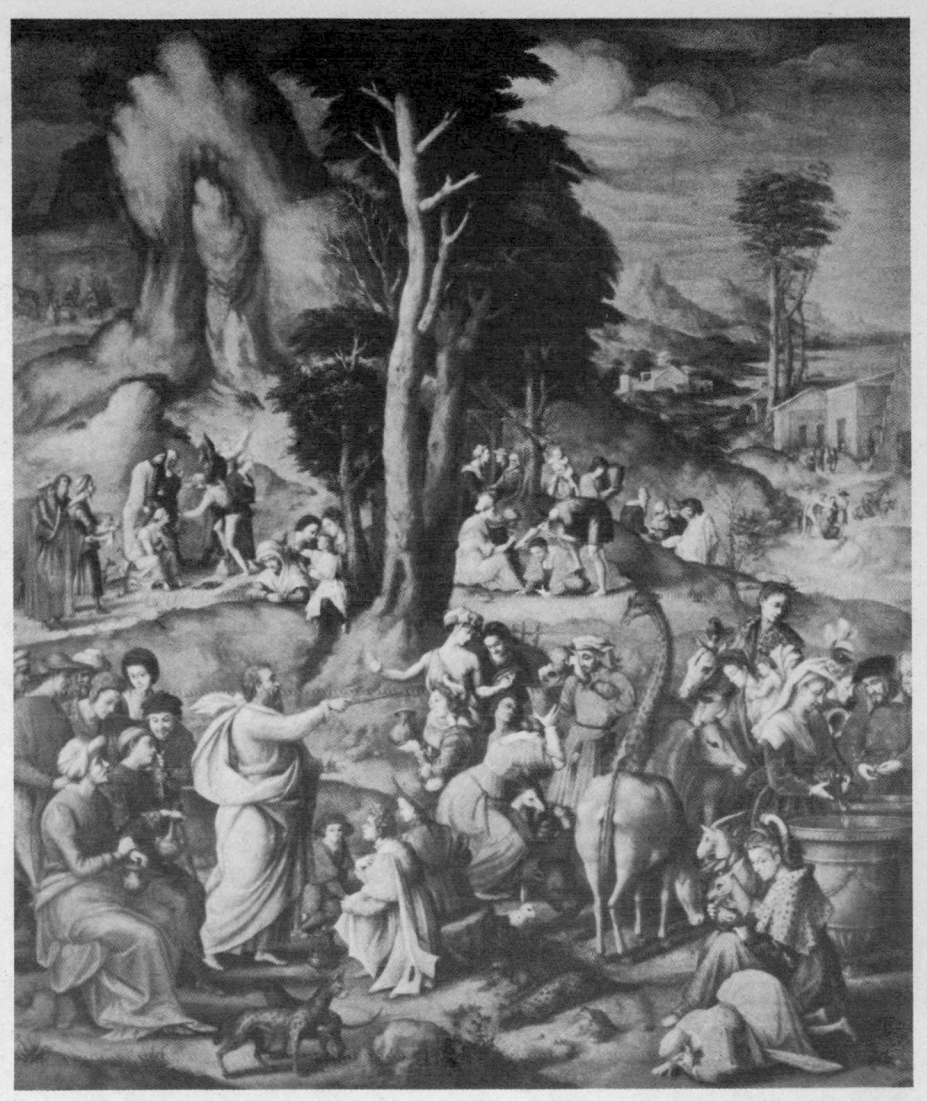

13. Francesco Ubertini, called Bacchiacca: *The Gathering of Manna*.
National Gallery of Art, Washington

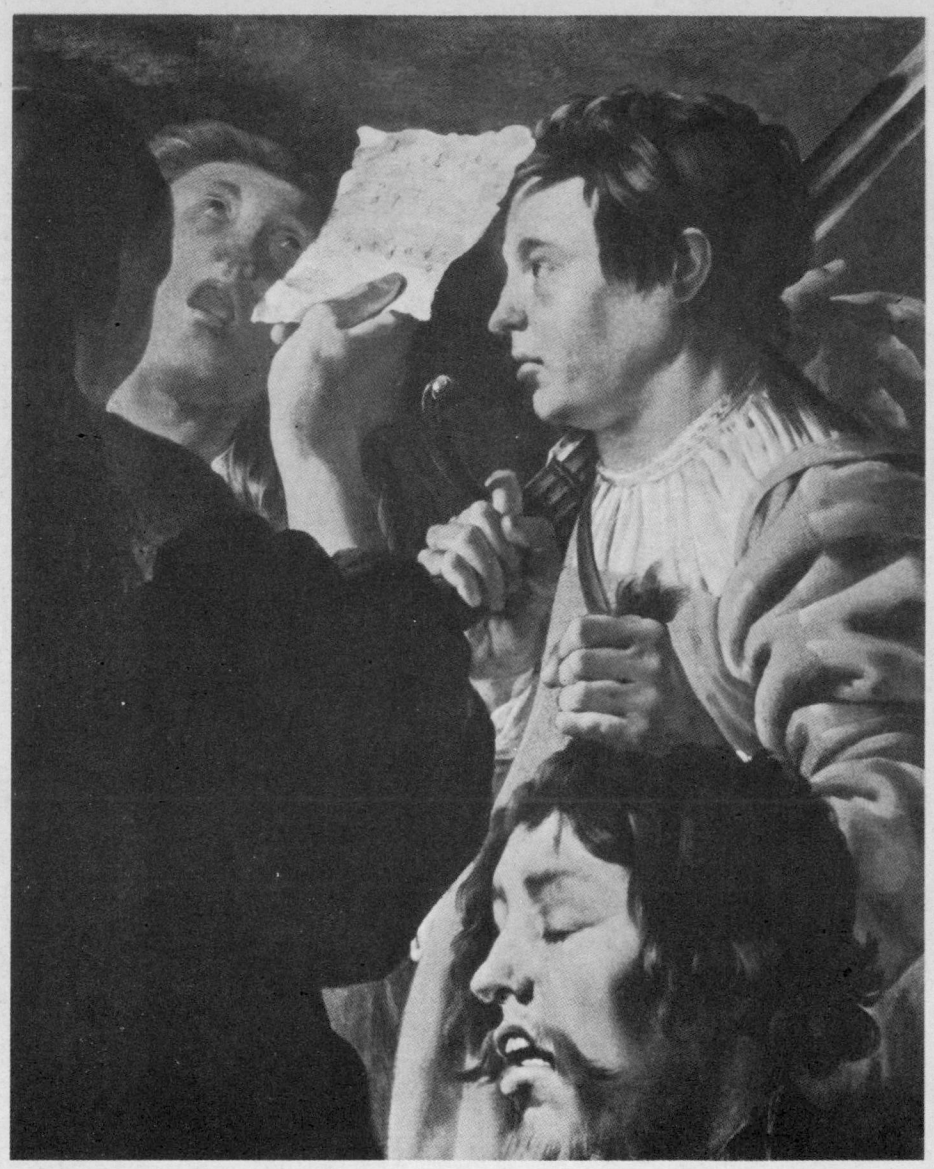

14. Hendrick Terbrugghen: *David and the Singers*. Detail. North Carolina Museum of Art, Raleigh, North Carolina

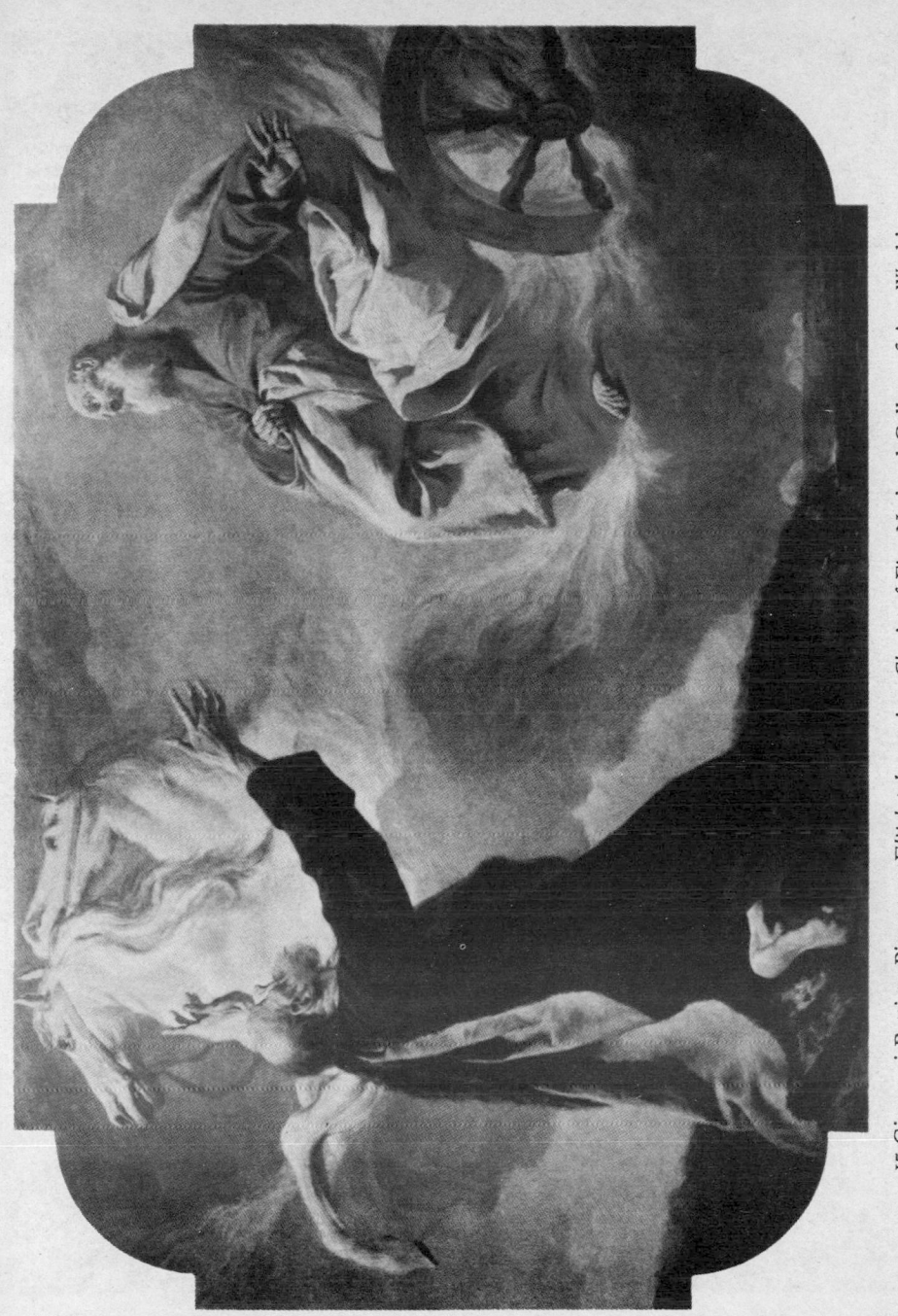

15. Giovanni Battista Piazzetta: *Elijah taken up in a Chariot of Fire*, National Gallery of Art, Washington

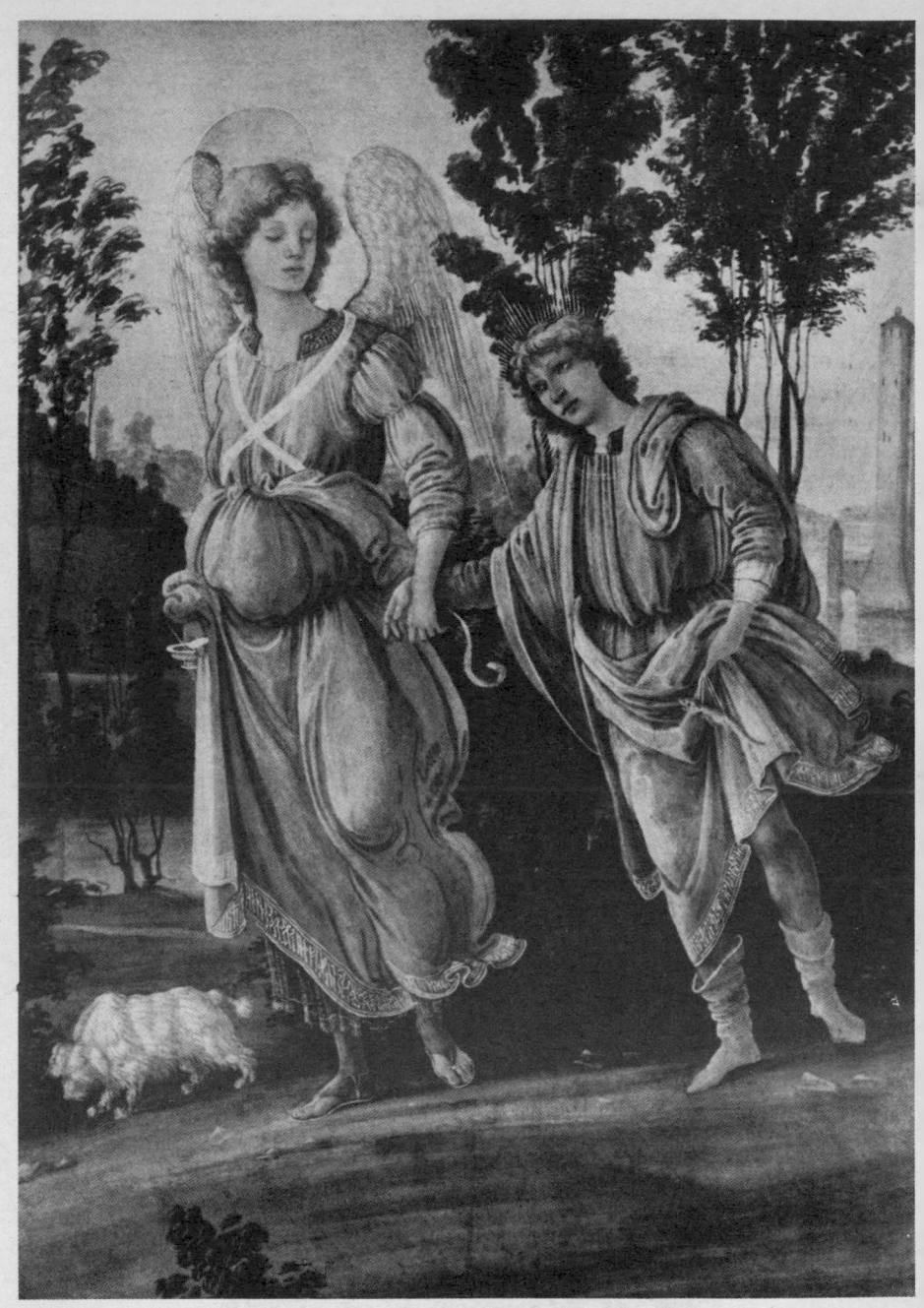

16. Filippino Lippi: *Tobias and the Angel*. National Gallery of Art, Washington

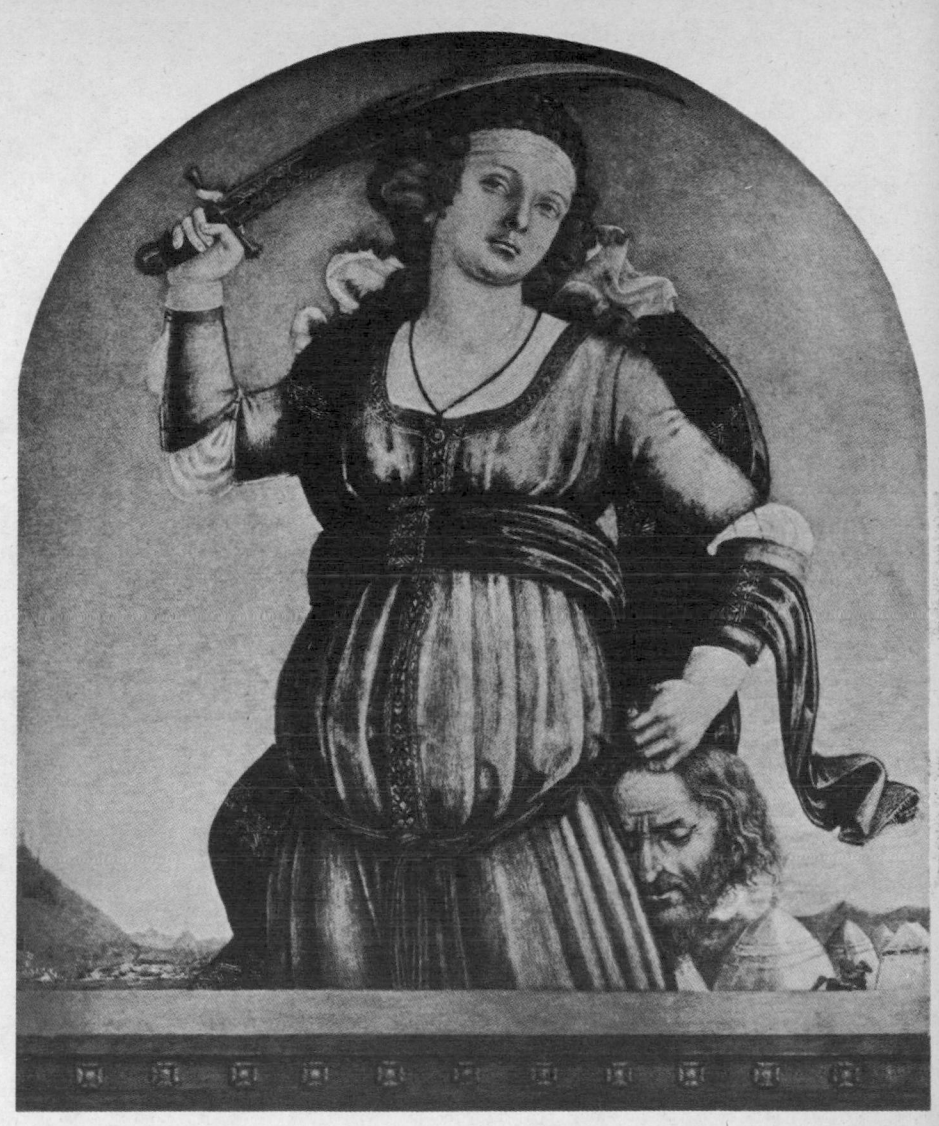

17· Matteo di Giovanni: *Judith with the Head of Holofernes*. University of Indiana, Bloomington, Indiana

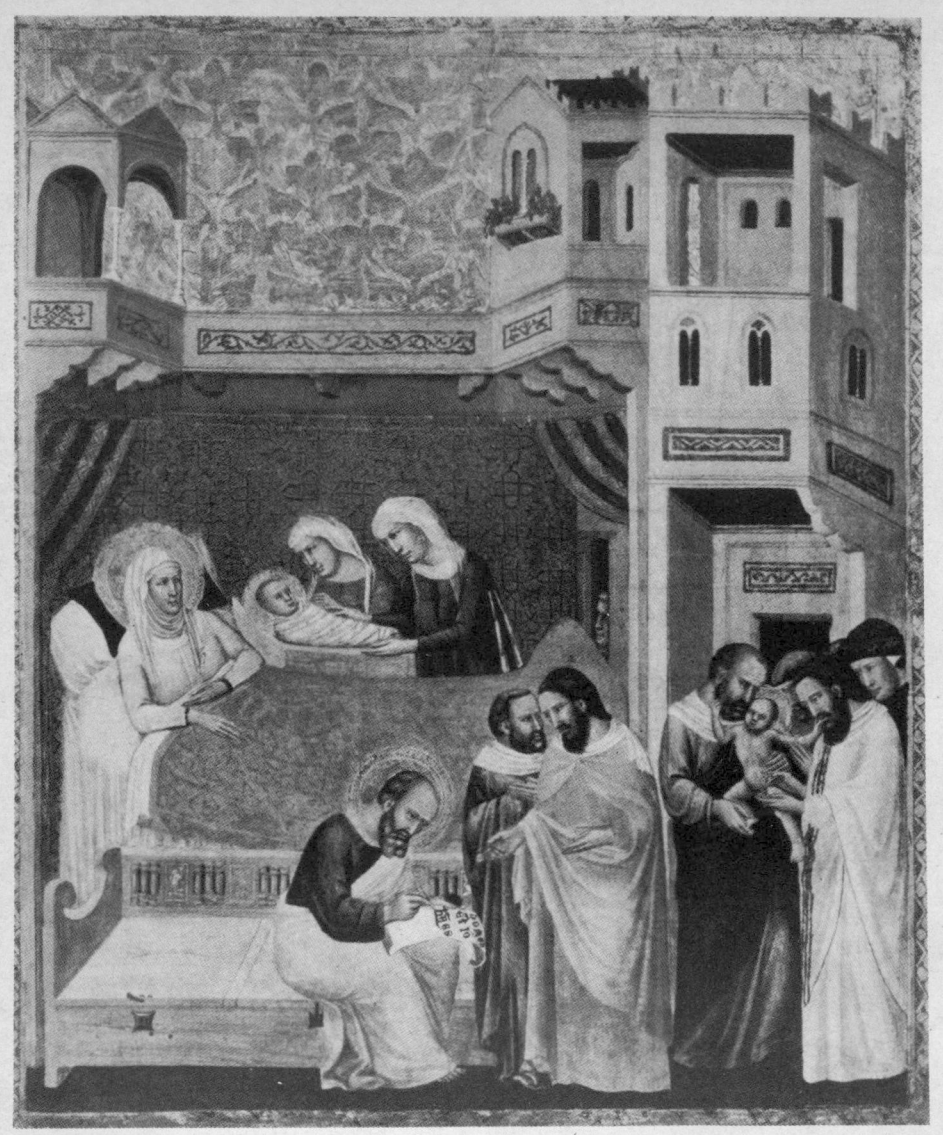

18. Master of the Life of St. John the Baptist: *Birth, Naming and Circumcision of St. John the Baptist.*
National Gallery of Art, Washington

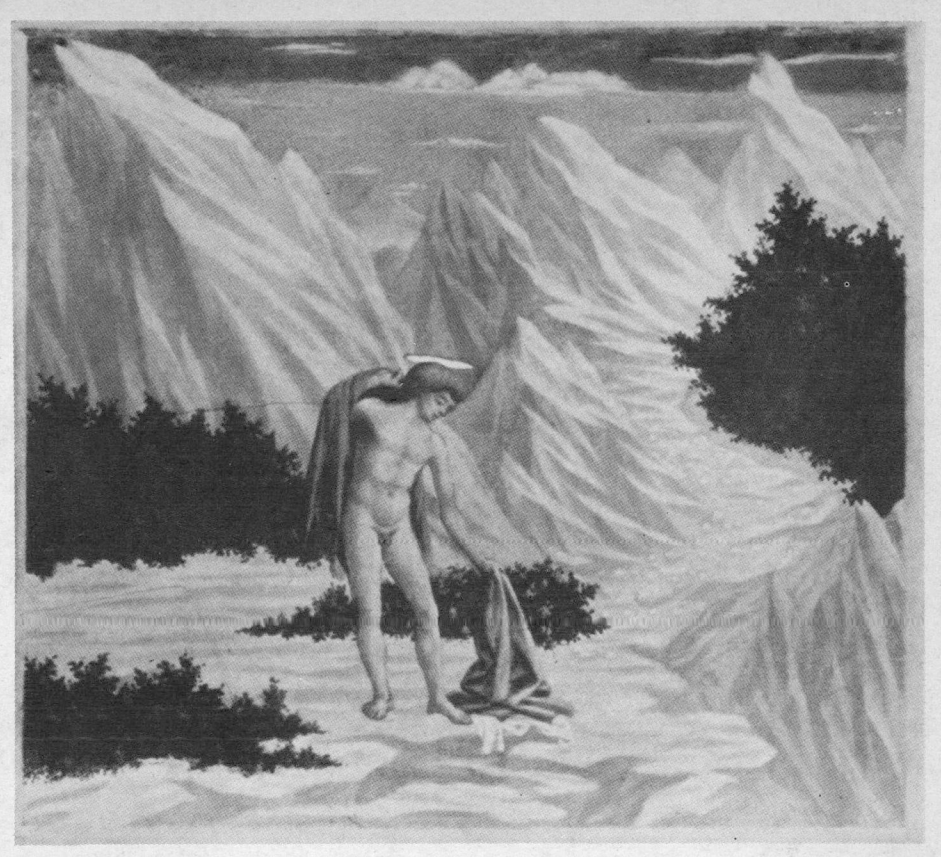

19. Domenico Veneziano: *St. John in the Desert*. National Gallery of Art, Washington

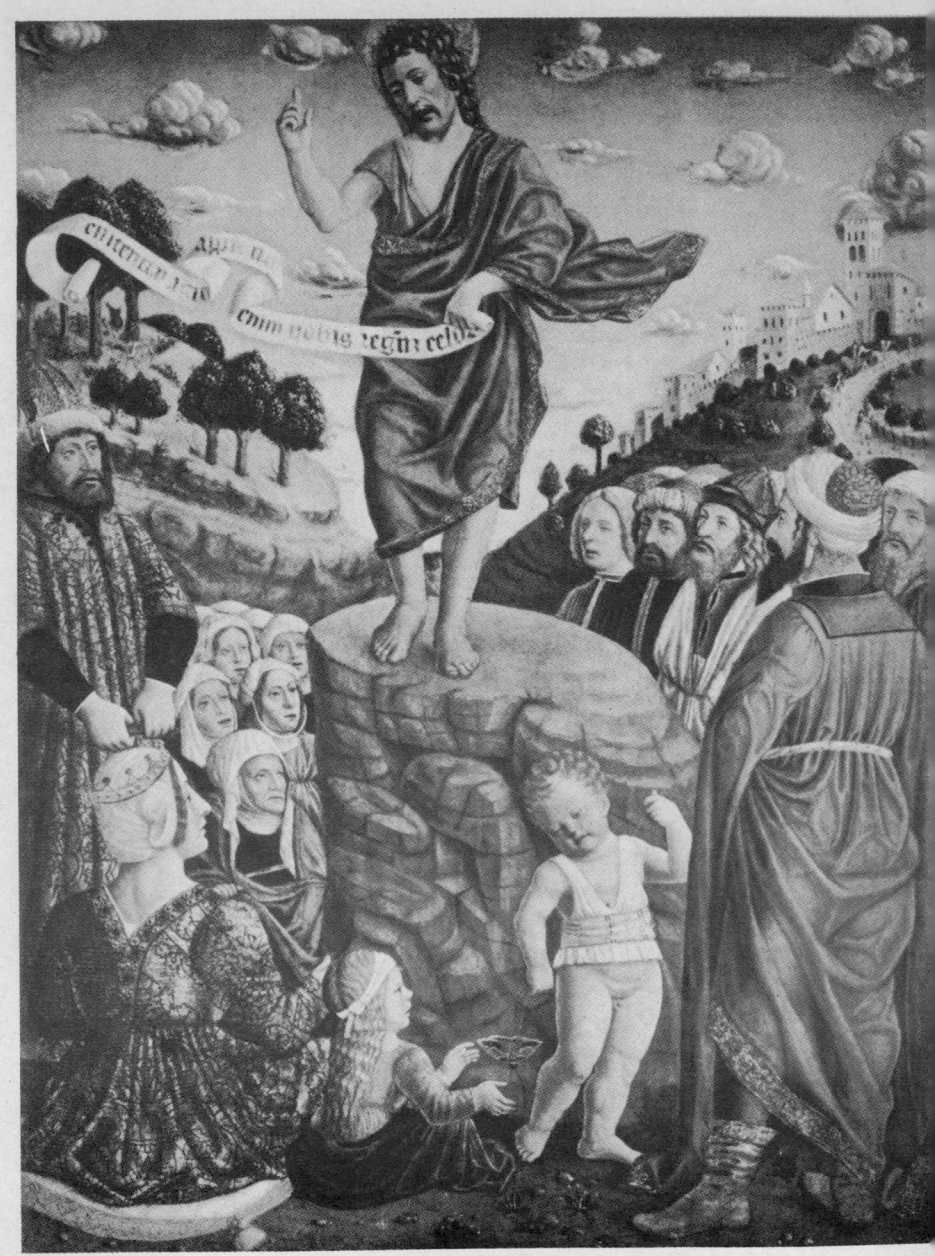

20. Circle of Nicolo da Varallo: *St. John Preaching*.
Columbia Museum of Art, Columbia, South Carolina

21. Benozzo Gozzoli: *The Beheading of St. John*.
Detail from 'Dance of Salome and Beheading of St. John the Baptist'.
National Gallery of Art, Washington (see Pl. VII.)

22. Benozzo Gozzoli: *Dance of Salome and Beheading of St. John the Baptist.*
National Gallery of Art, Washington

23. Andrea di Bartolo: *The Nativity of the Virgin*. National Gallery of Art, Washington

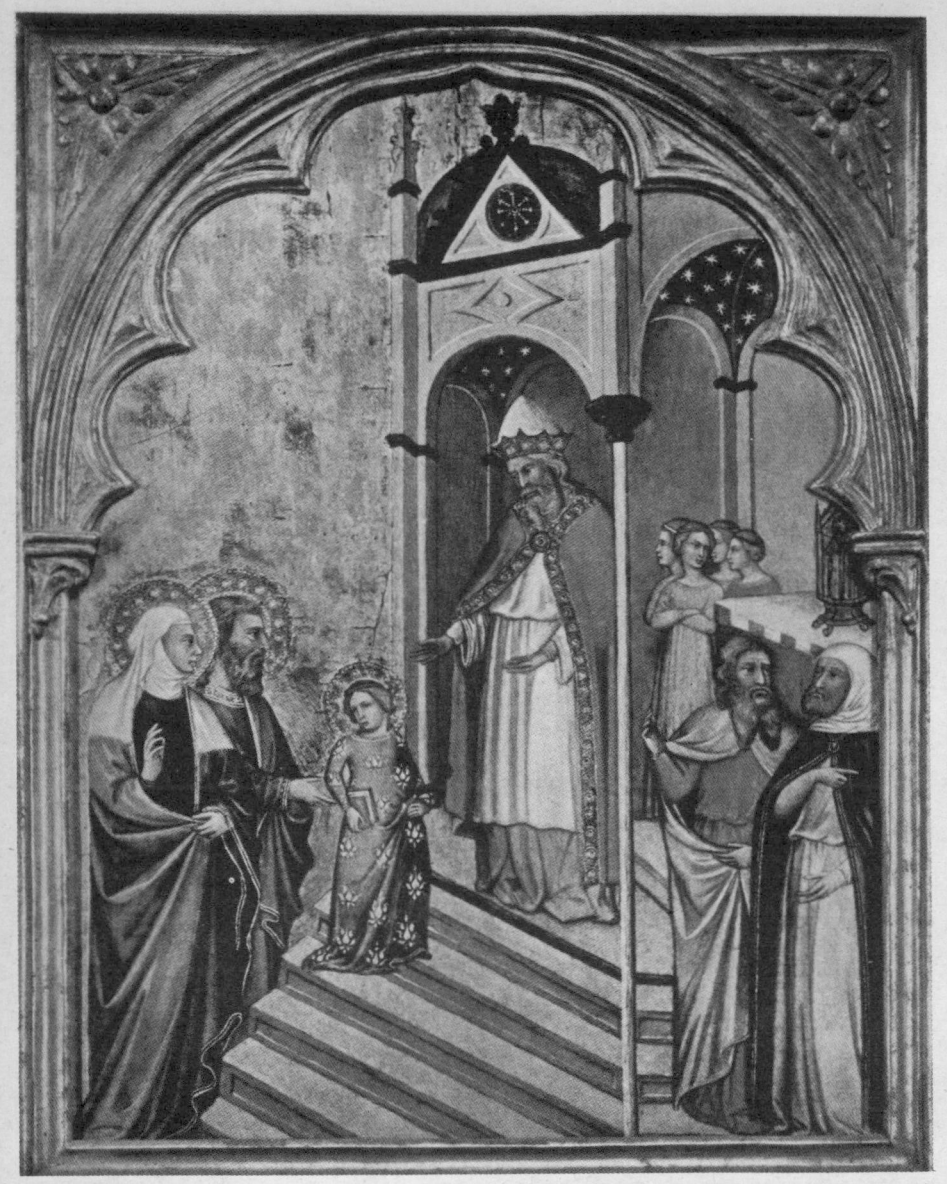

24·Andrea di Bartolo: *The Presentation in the Temple*. National Gallery of Art, Washington

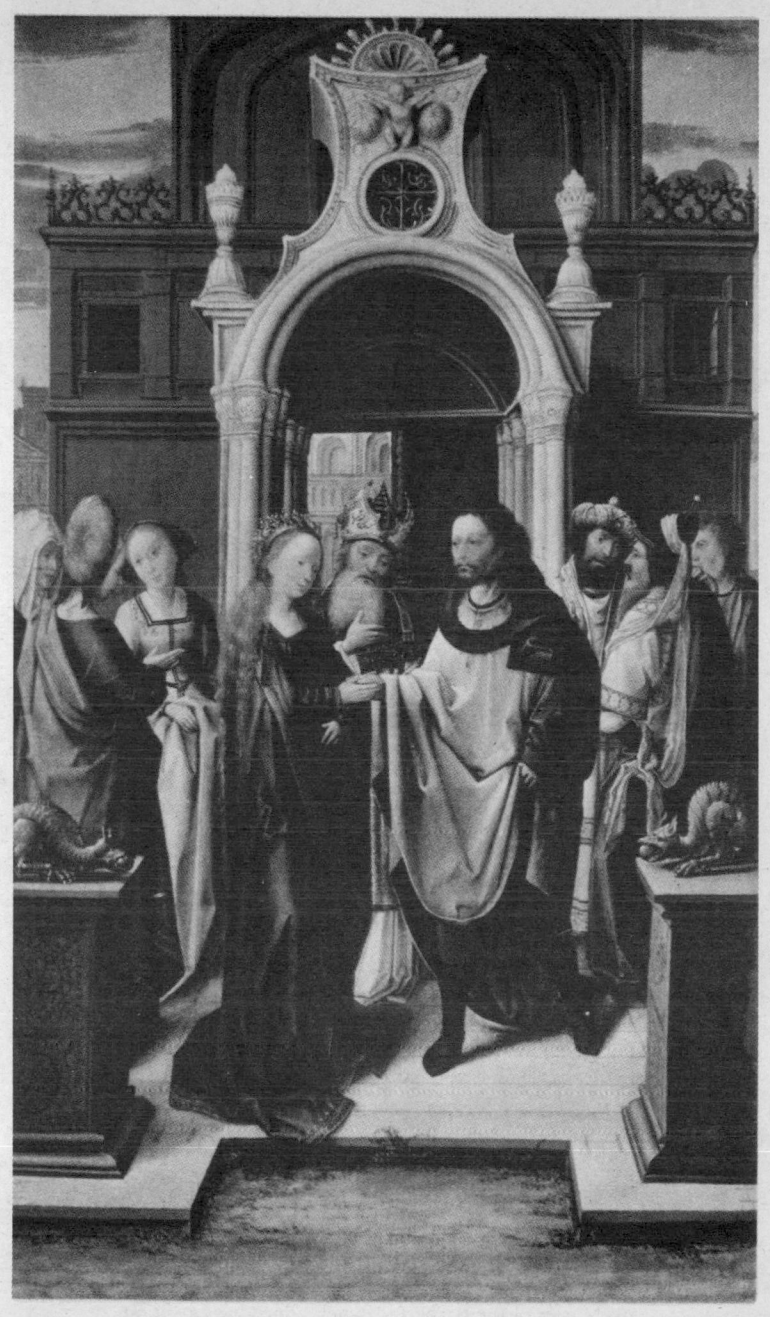

25. Bernart van Orley: *The Marriage of the Virgin*. National Gallery of Art, Washington

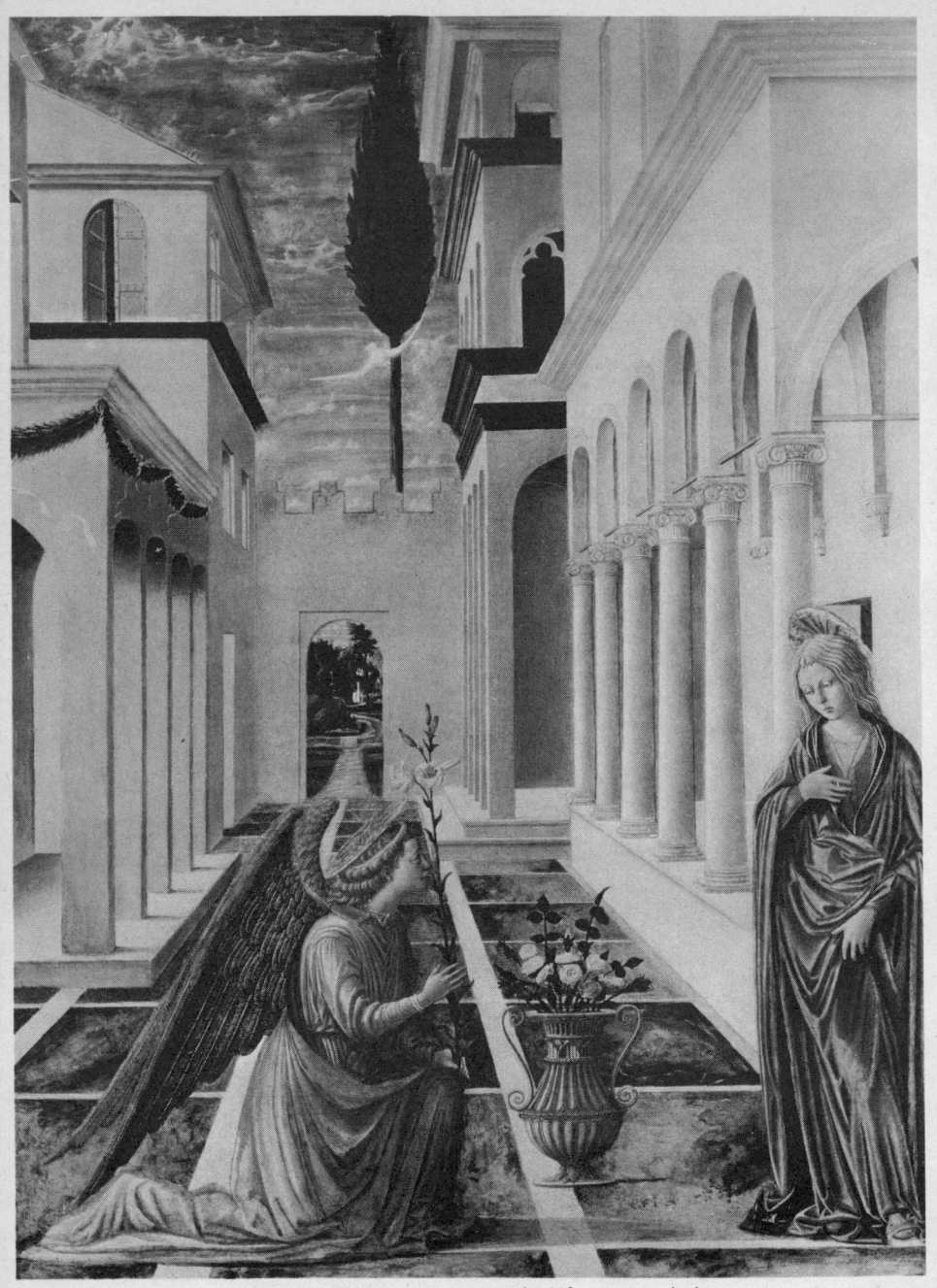

26. Master of the Barberini Panels: *The Annunciation*.
National Gallery of Art, Washington

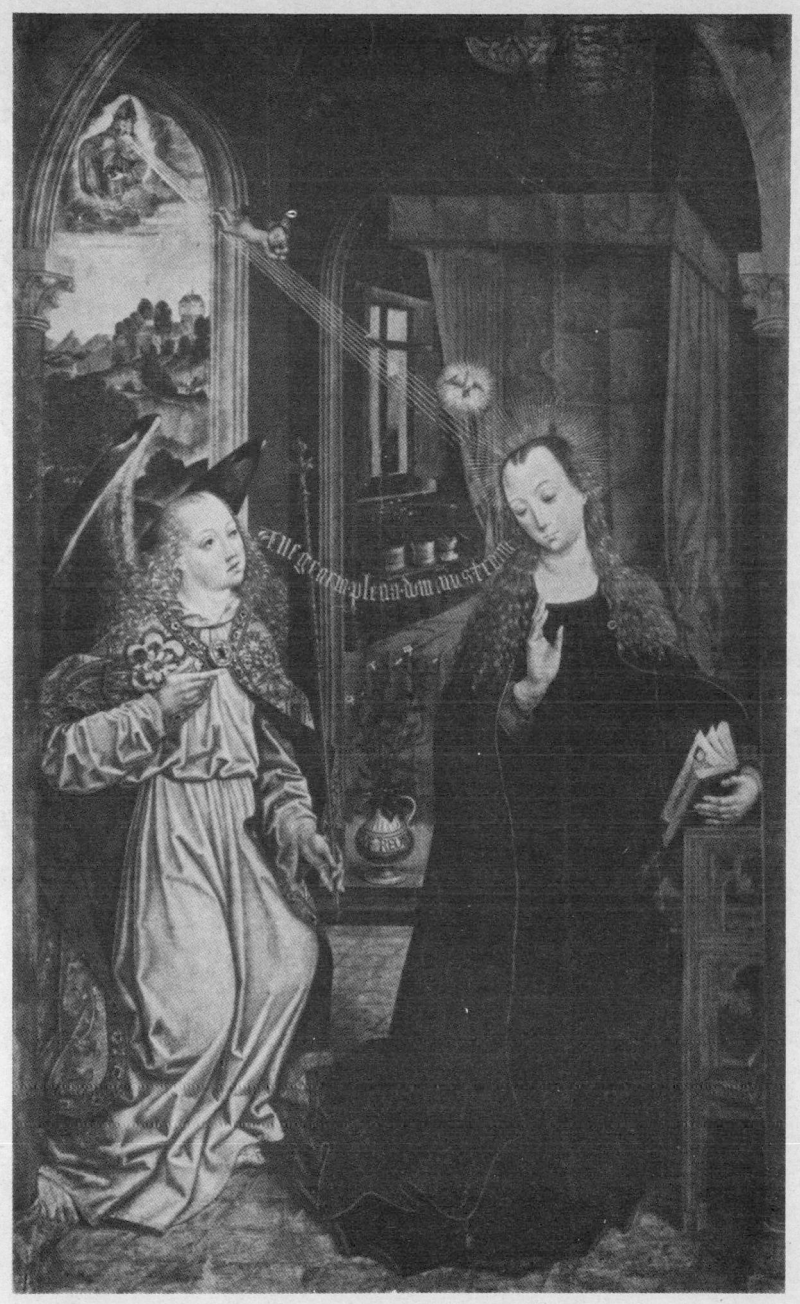

27. Master of the Retable of the Reyes Catolicos: *The Annunciation*.
M. H. de Young Memorial Museum, San Francisco, California

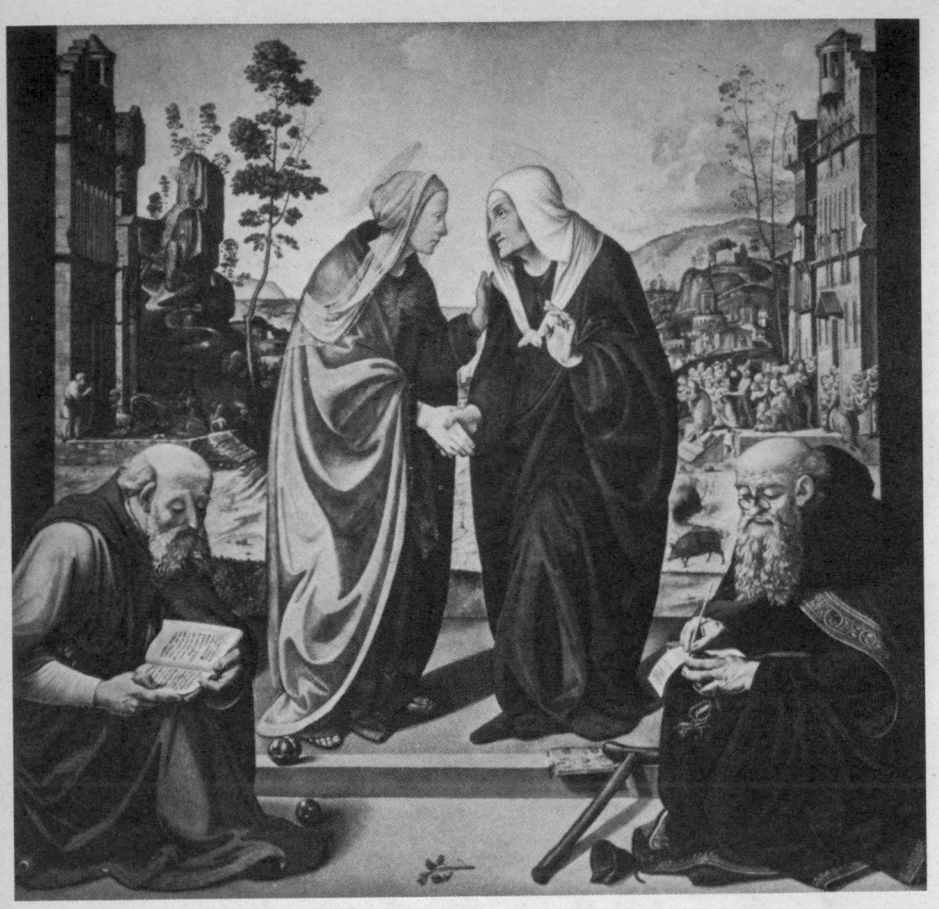

28. Piero di Cosimo: *The Visitation with two Saints ;*
in the background, right, *The Massacre of the Innocents*, left, *The Adoration of the Child*.
National Gallery of Art, Washington

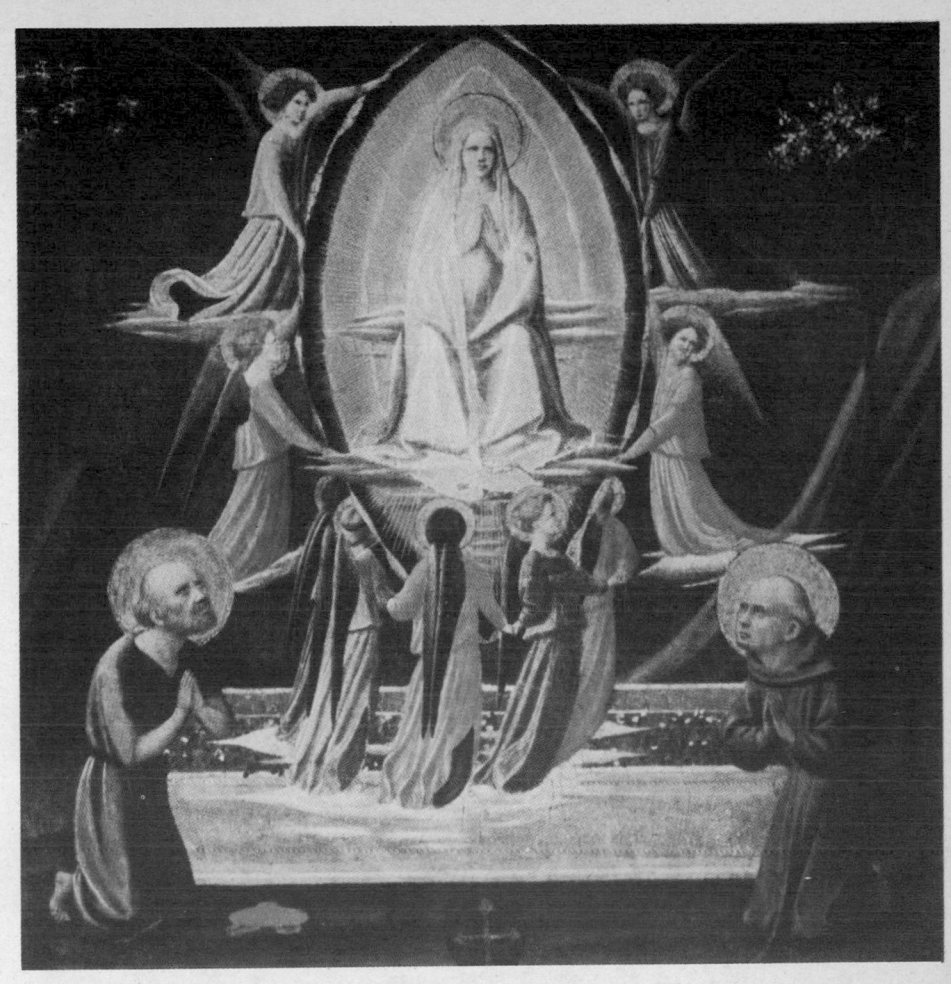

29. Andrea di Giusto: *The Assumption of the Virgin, with St. Jerome and St. Francis.*
The Philbrook Art Center, Tulsa, Oklahoma

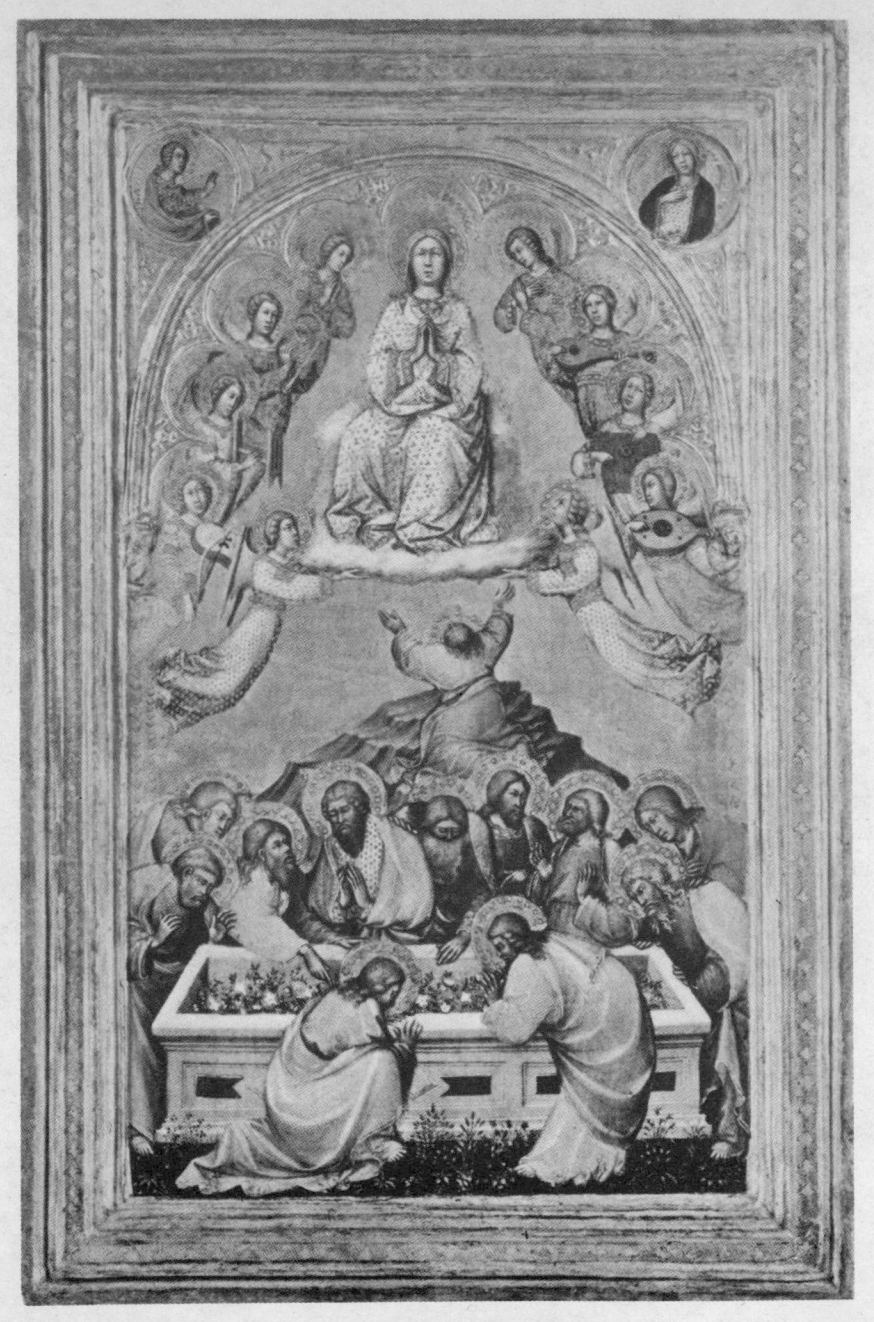

30. Paolo di Giovanni Fei: *The Assumption of the Virgin*. National Gallery of Art, Washington

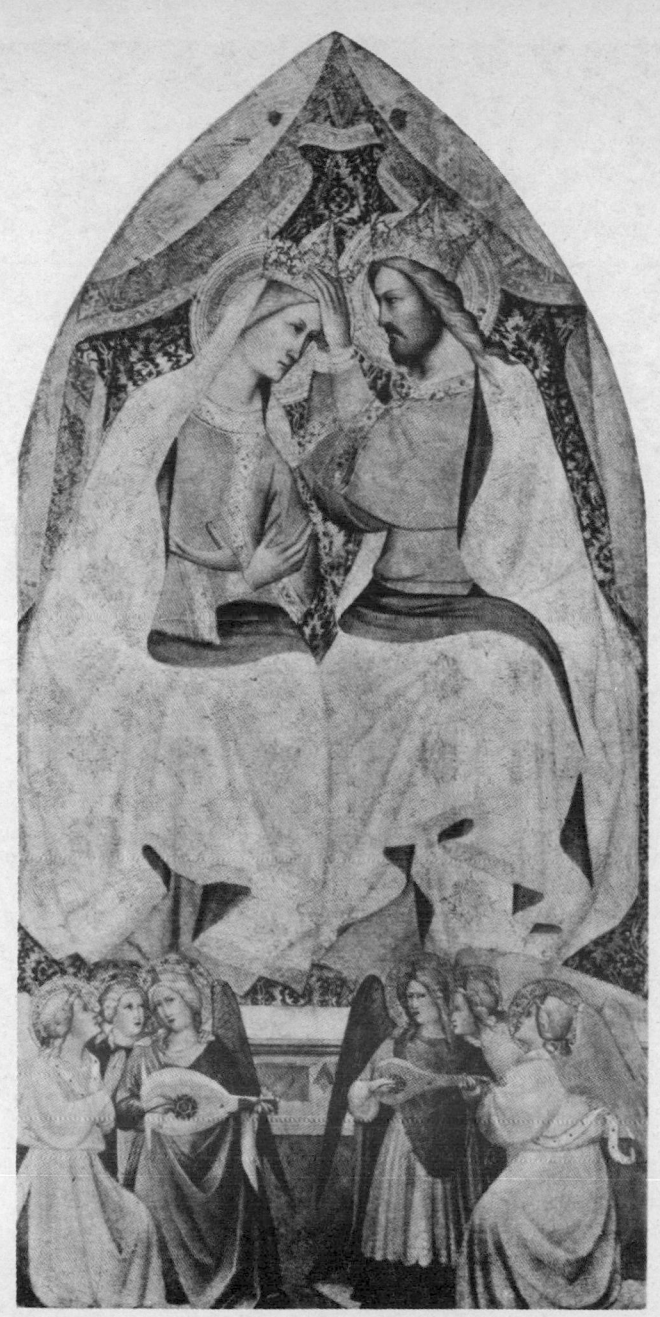

31. Agnolo Gaddi: *The Coronation of the Virgin.*
National Gallery of Art, Washington

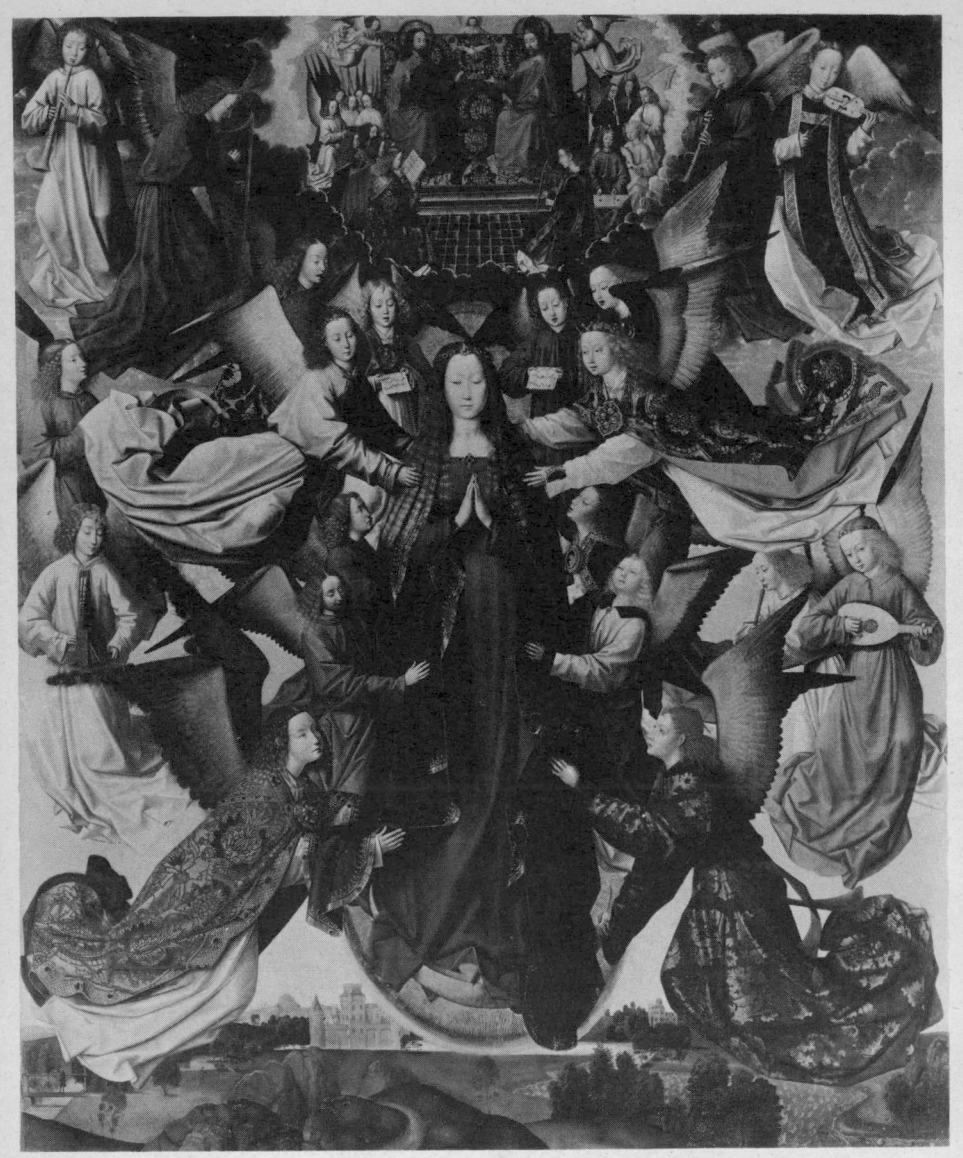

32. Master of the St. Lucy Legend and Assistant: *Mary, Queen of Heaven*.
National Gallery of Art, Washington

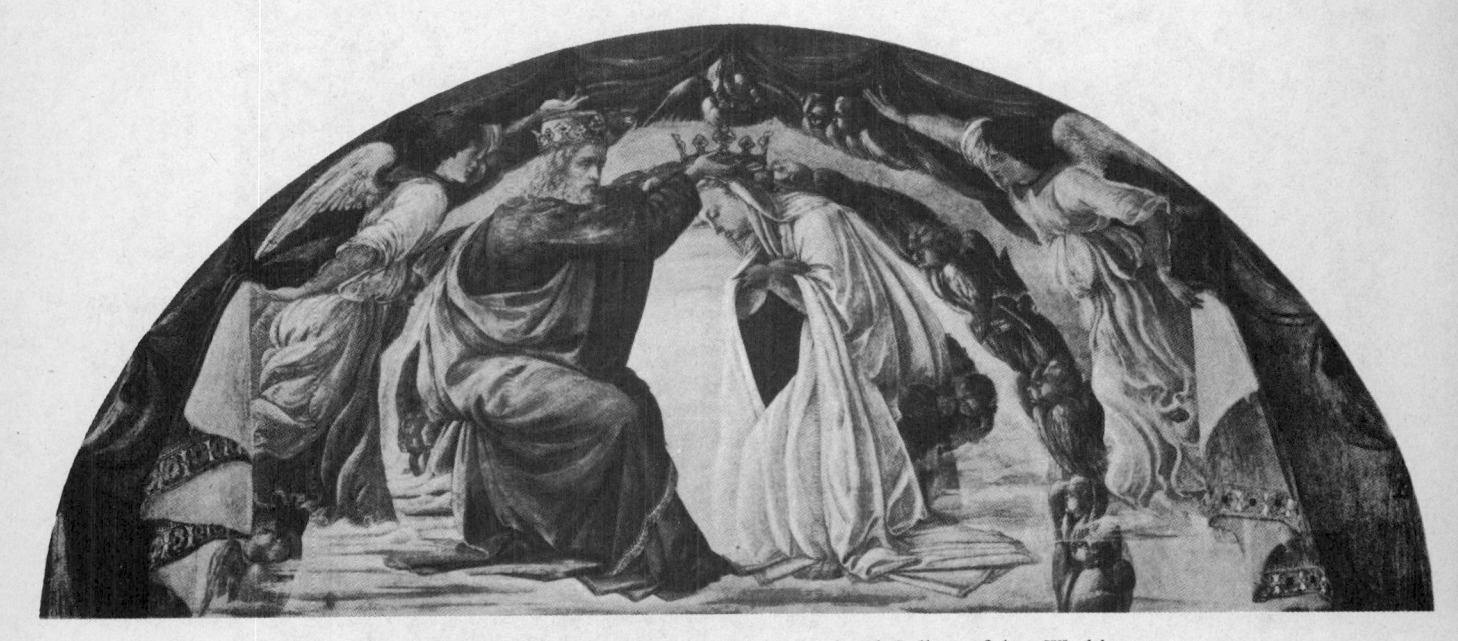

33. Filippino Lippi: *The Coronation of the Virgin*. National Gallery of Art, Washington

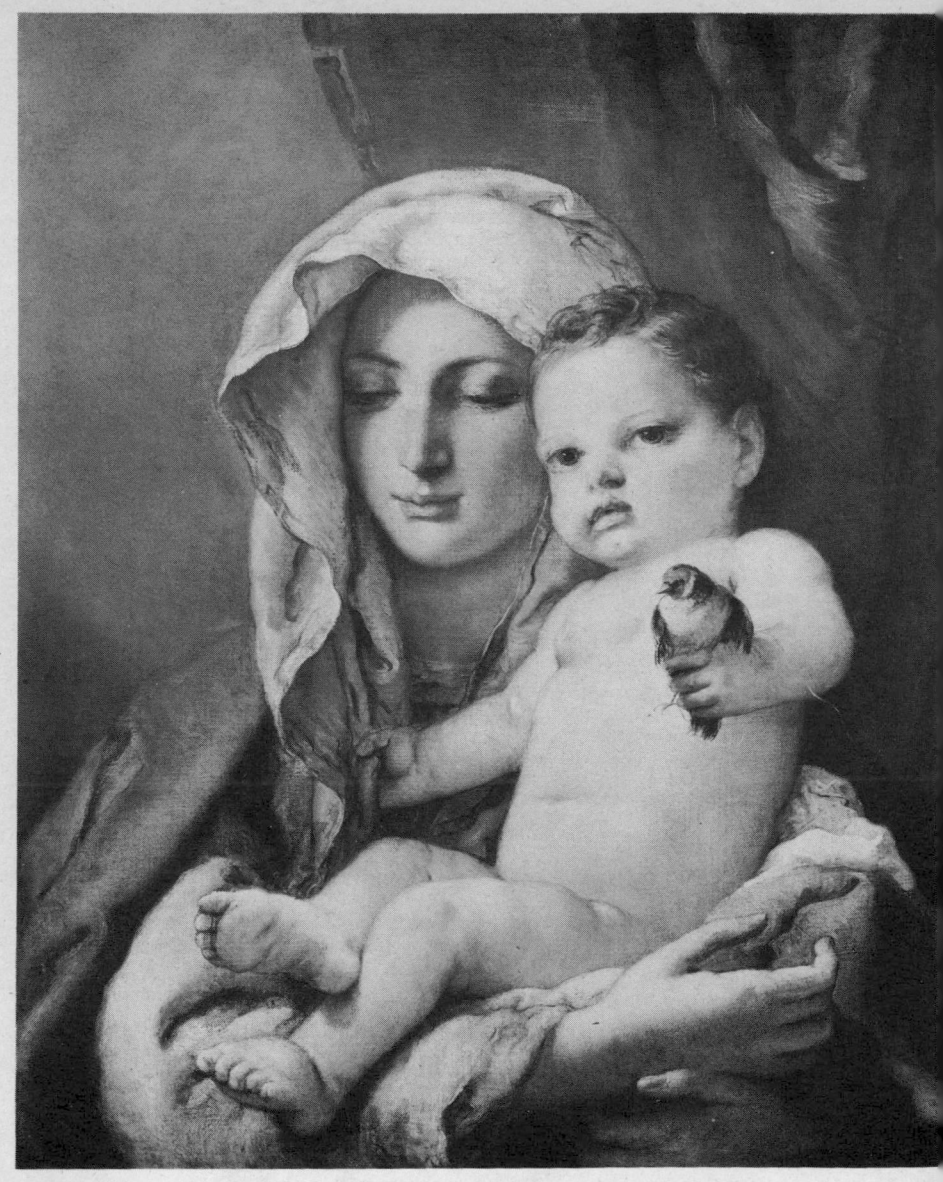

34. Giovanni Battista Tiepolo: *Madonna of the Goldfinch*.
National Gallery of Art, Washington

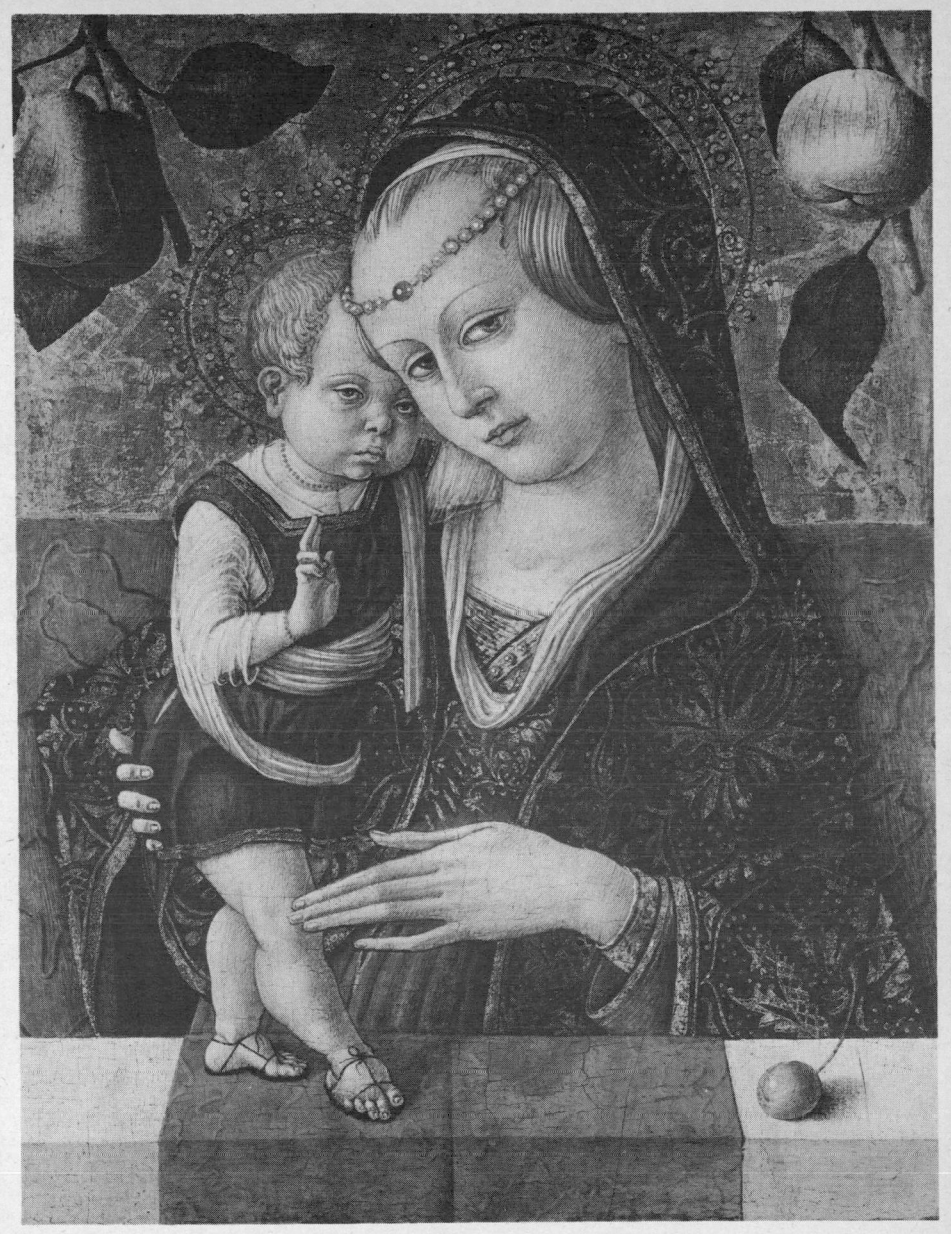

35. Carlo Crivelli: *Madonna and Child*. National Gallery of Art, Washington

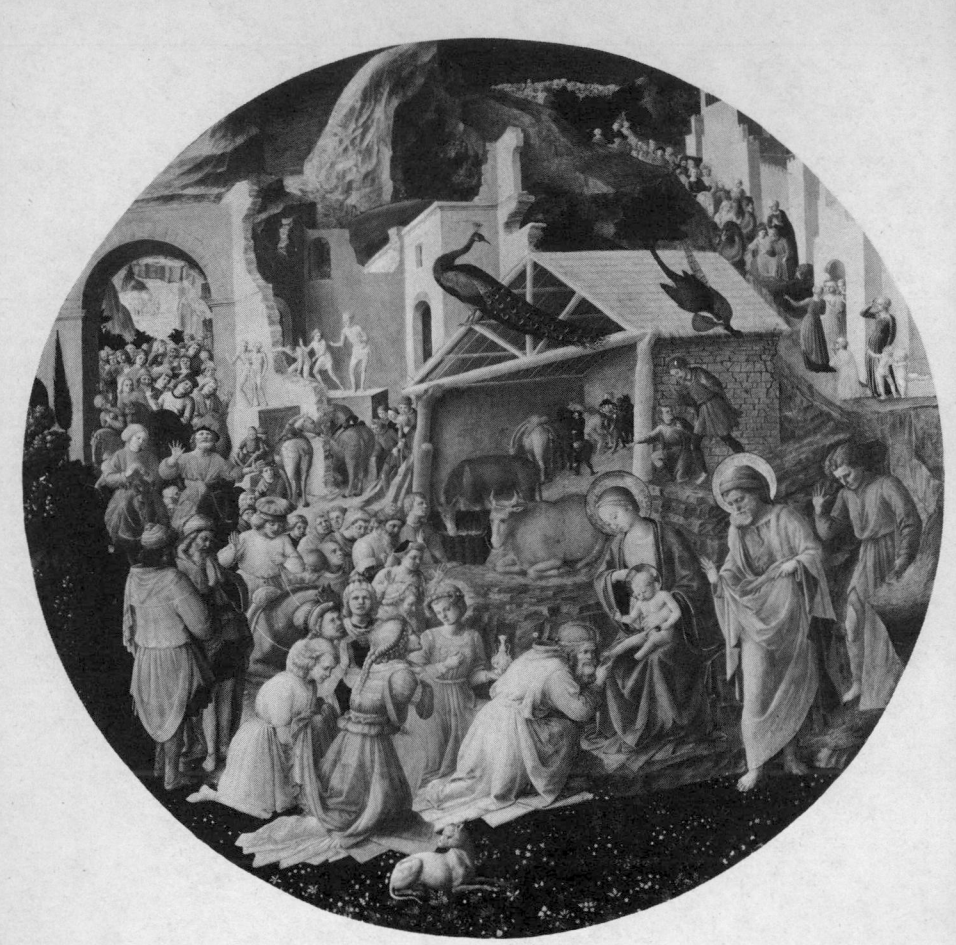

36. Fra Angelico and Fra Filippo Lippi: *The Adoration of the Magi*.
National Gallery of Art, Washington

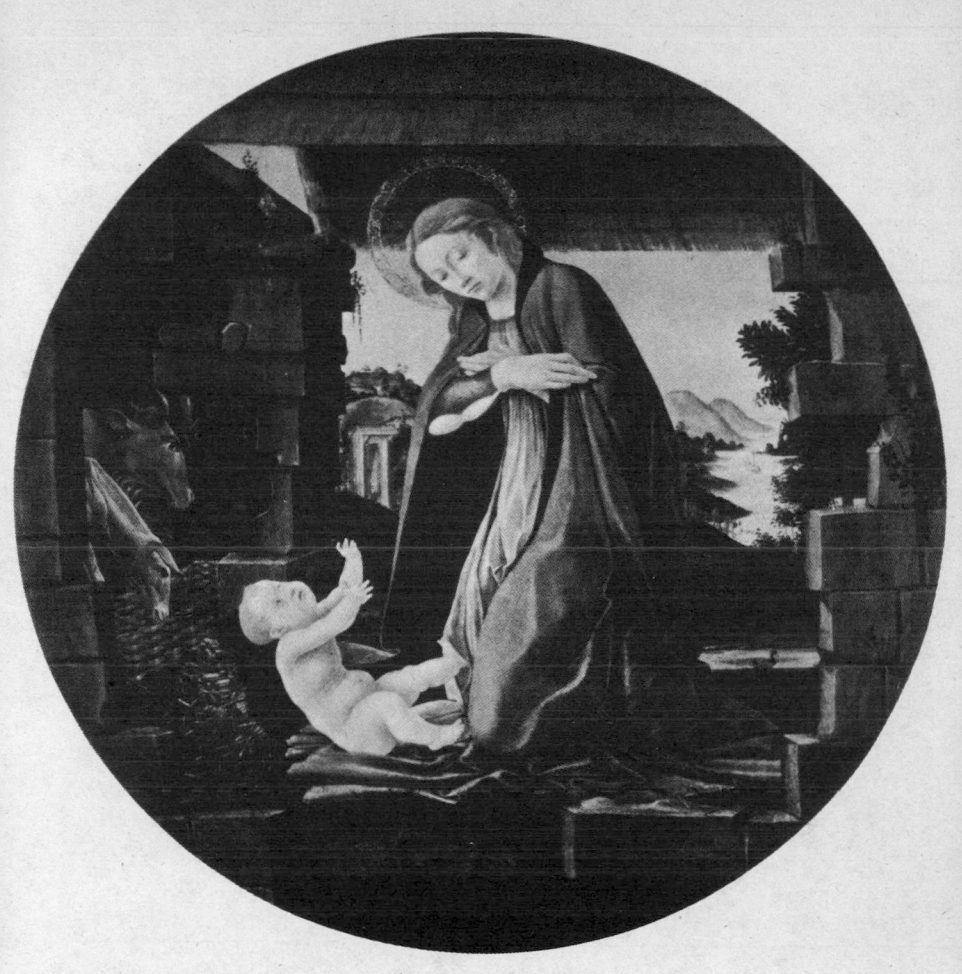

37·Sandro Botticelli: *The Virgin adoring her Child*. National Gallery of Art, Washington

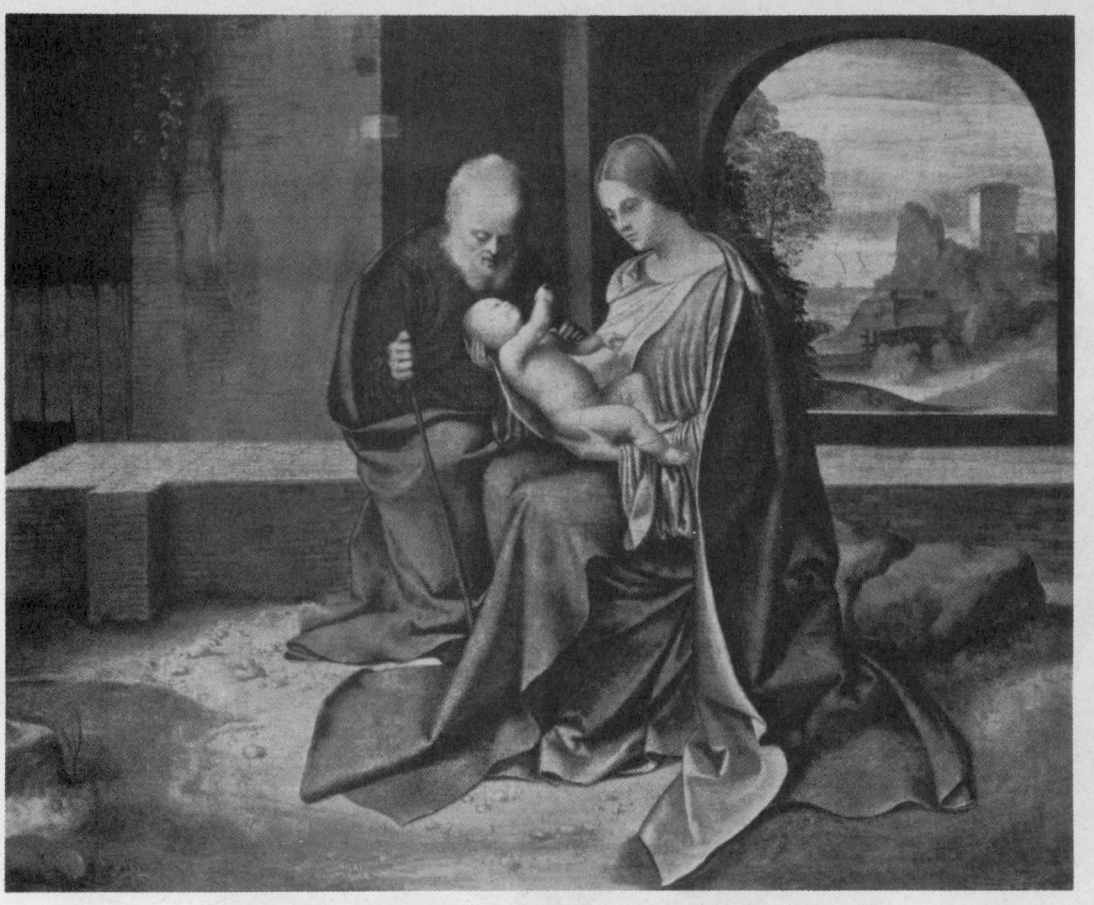

38. Giorgione: *The Holy Family*. National Gallery of Art, Washington

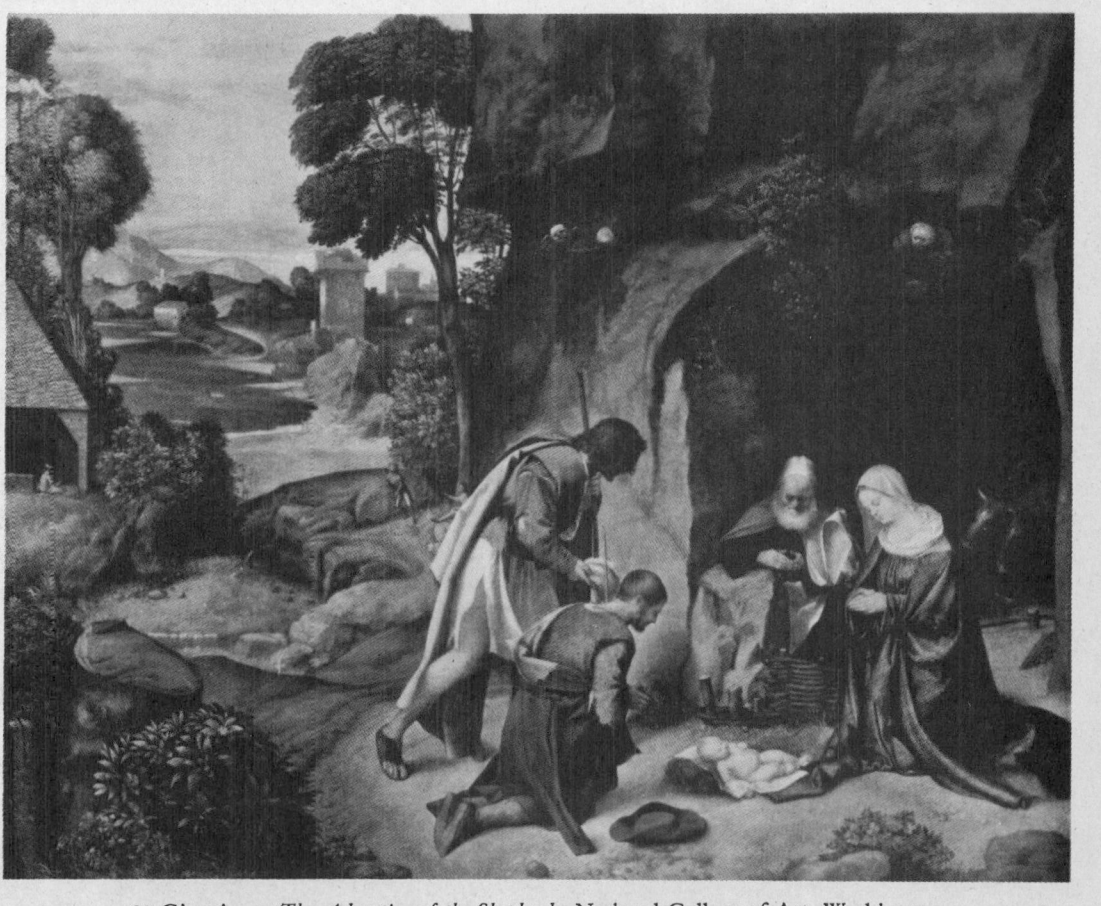

39·Giorgione: *The Adoration of the Shepherds*. National Gallery of Art, Washington

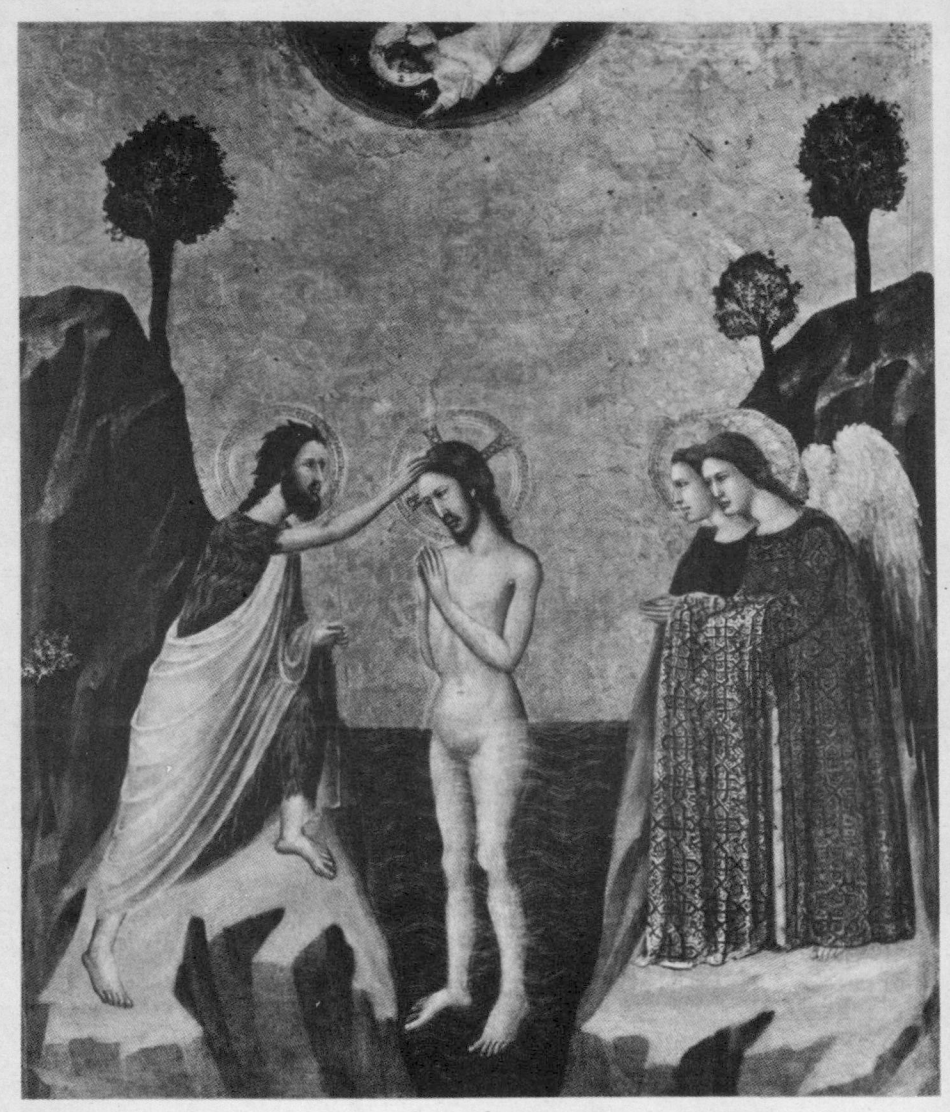

40. Master of the Life of St. John the Baptist: *The Baptism of Christ.*
National Gallery of Art, Washington

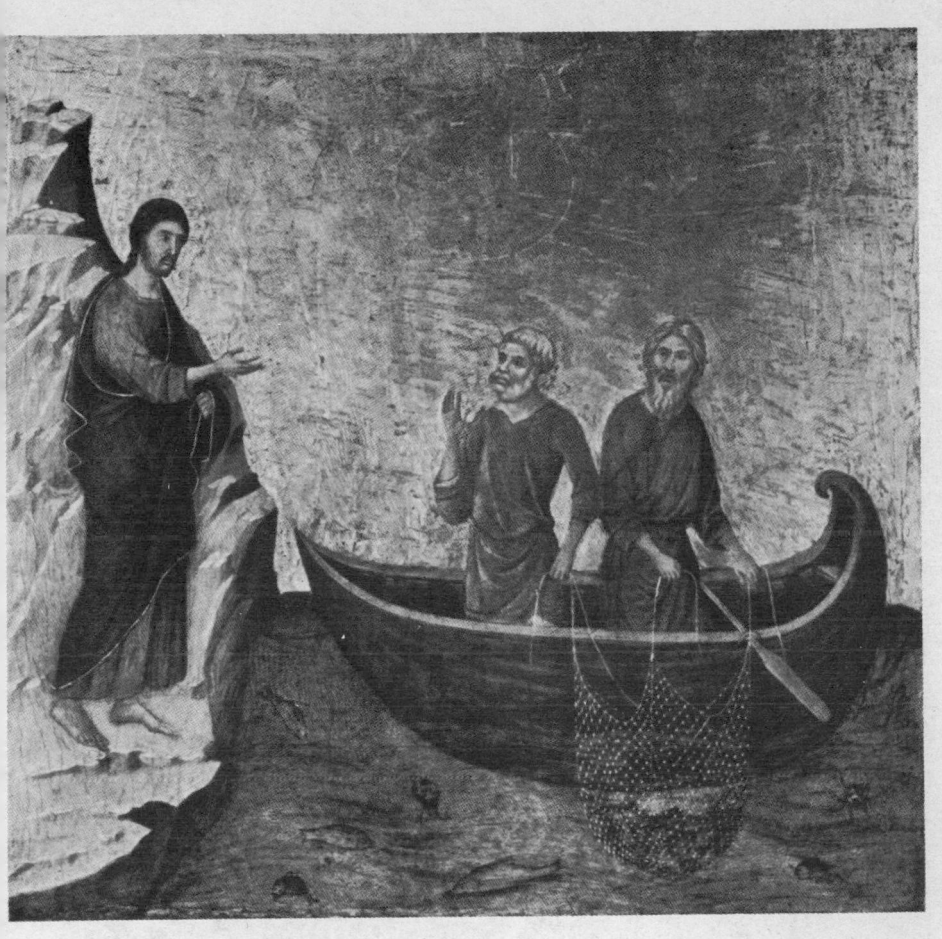

41. Duccio di Buoninsegna: *The Calling of the Apostles Peter and Andrew.*
National Gallery of Art, Washington

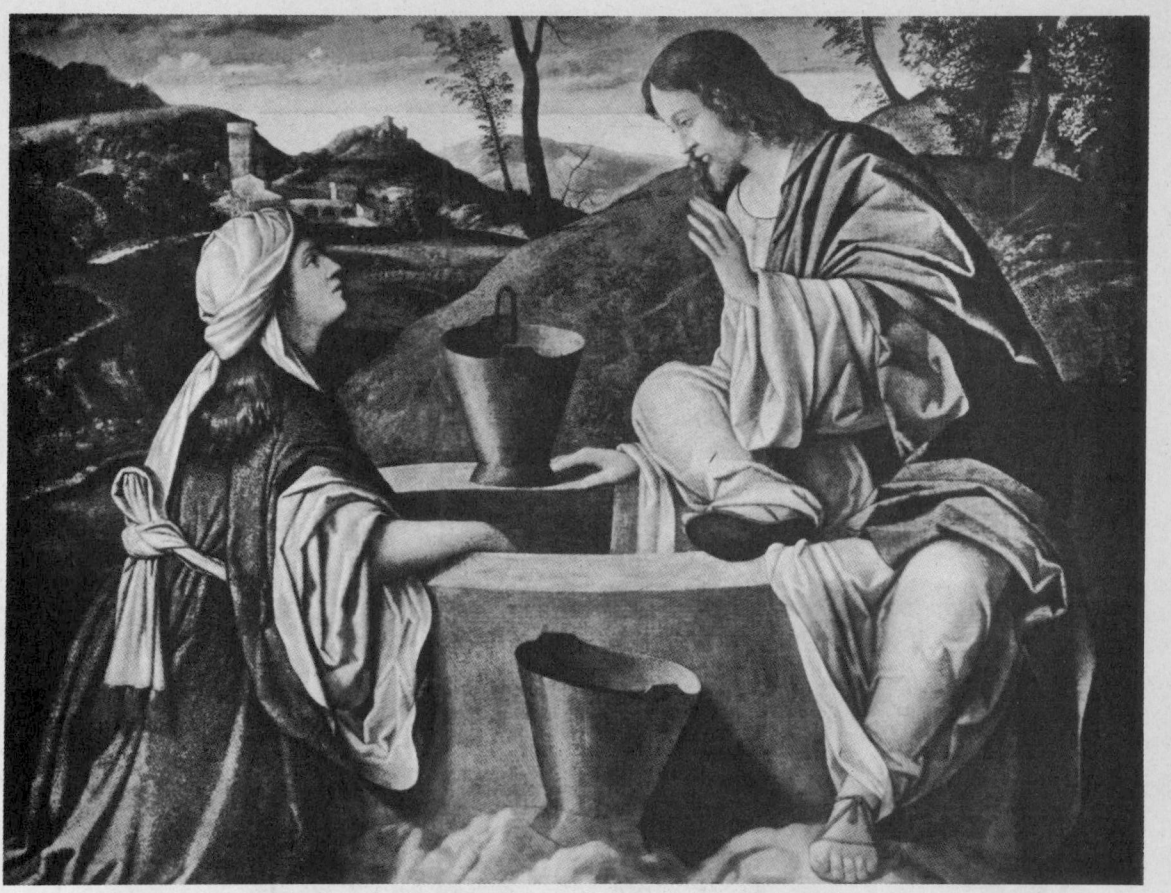

42. Attributed to Vincenzo Catena: *Christ and the Samaritan Woman*.
Columbia Museum of Art, Columbia, South Carolina

43. Jacopo Tintoretto: *Christ at the Sea of Galilee.* National Gallery of Art, Washington

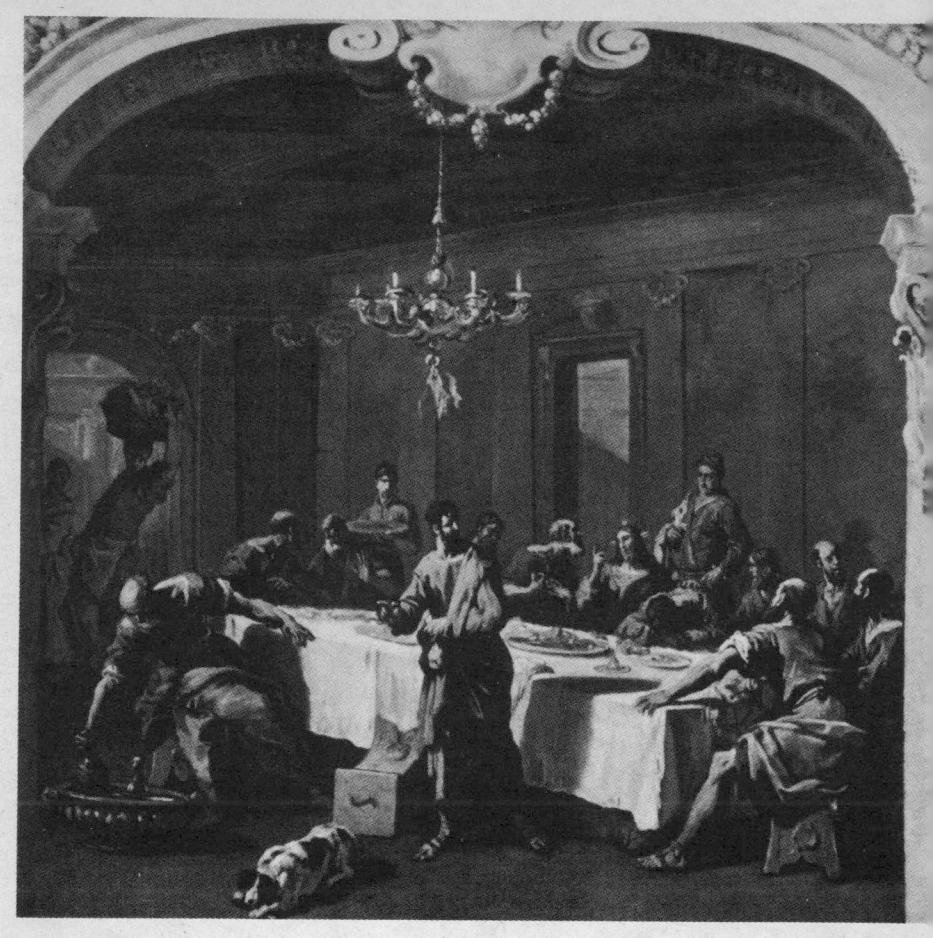

44. Sebastiano Ricci: *The Last Supper*. National Gallery of Art, Washington

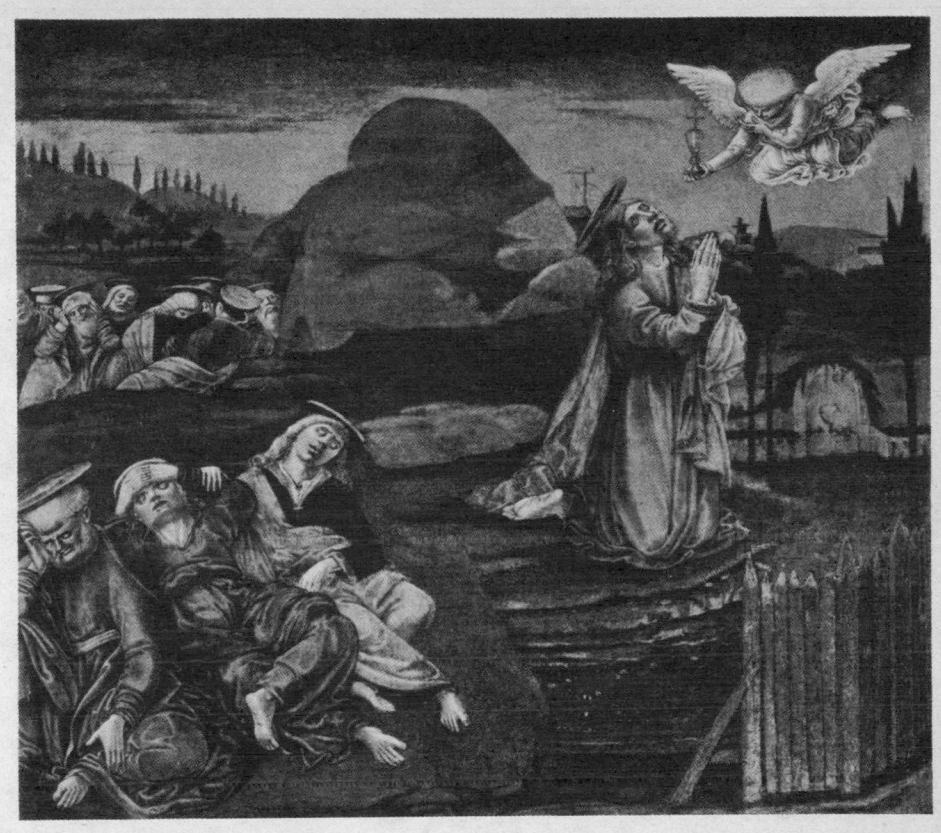

45. Benvenuto di Giovanni: *The Agony in the Garden*.
From the predella 'The Passion of Our Lord'. National Gallery of Art, Washington

46. Umbrian School, Early 16th Century: *The Flagellation of Christ.*
National Gallery of Art, Washington

47. Jacopo del Sellaio: *Christ with the Symbols of the Passion*.
Birmingham Museum of Art, Birmingham, Alabama

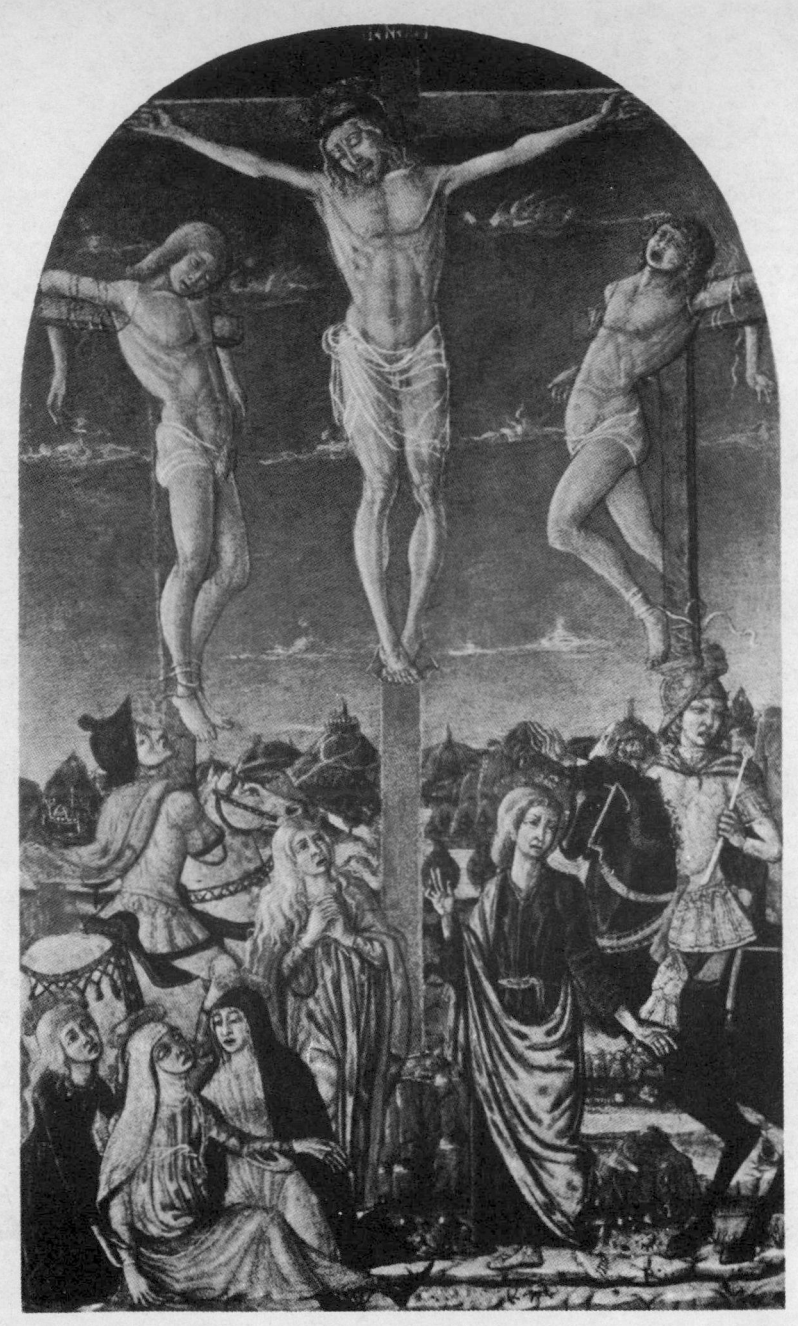

48. Guidoccio Cozzarelli: *The Crucifixion*. University of Arizona, Tucson, Arizona

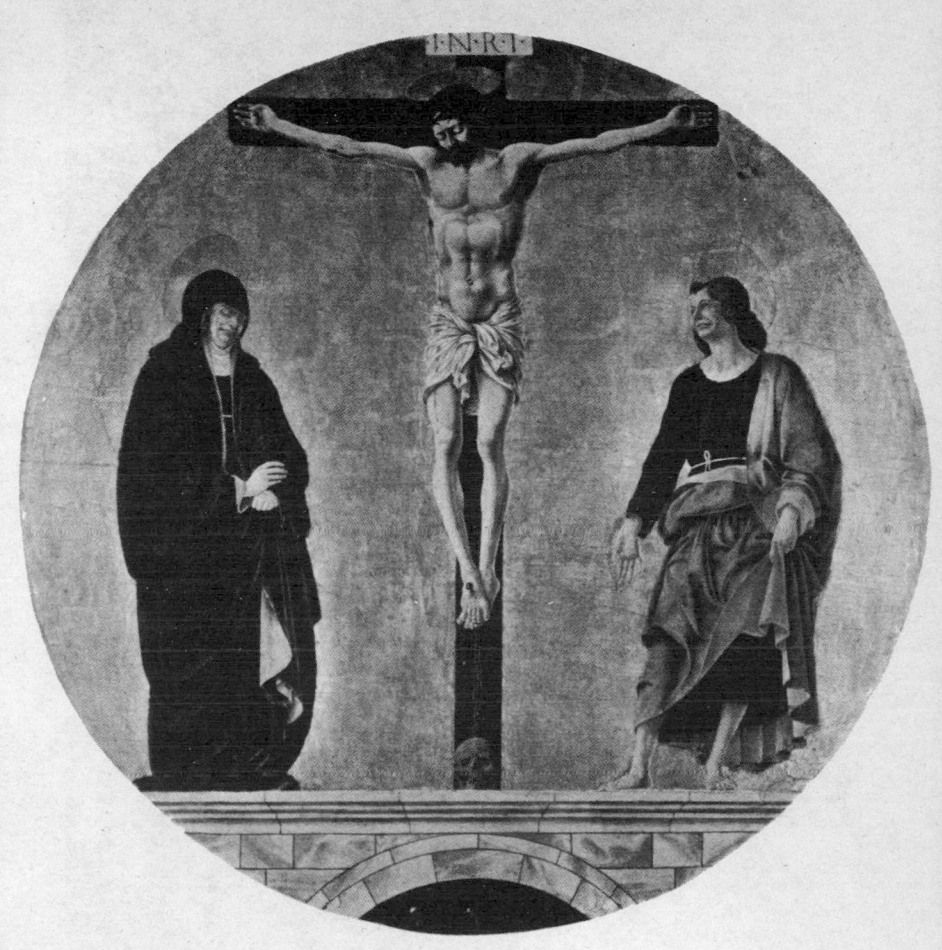

49. Francesco del Cossa: *The Crucifixion*. National Gallery of Art, Washington

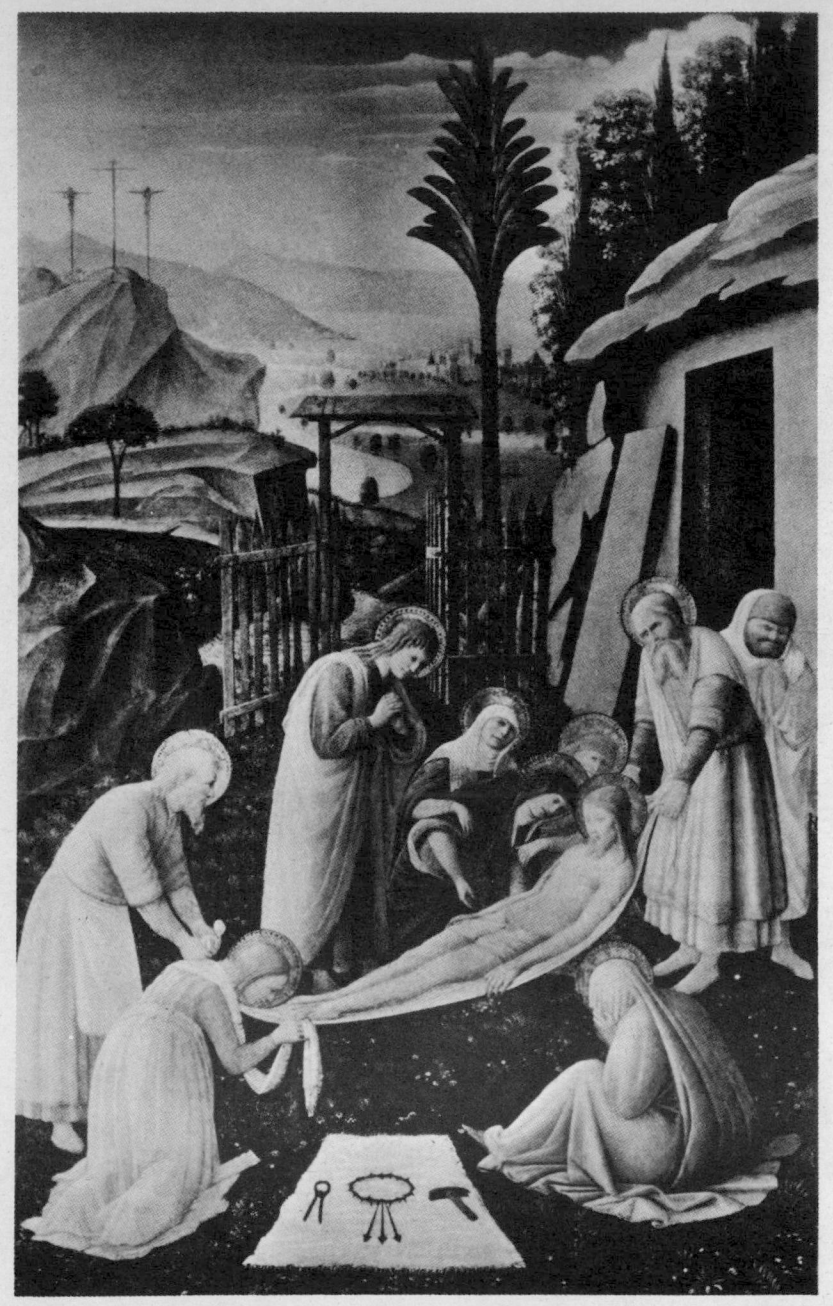

50. Attributed to Fra Angelico: *The Entombment*. National Gallery of Art, Washington

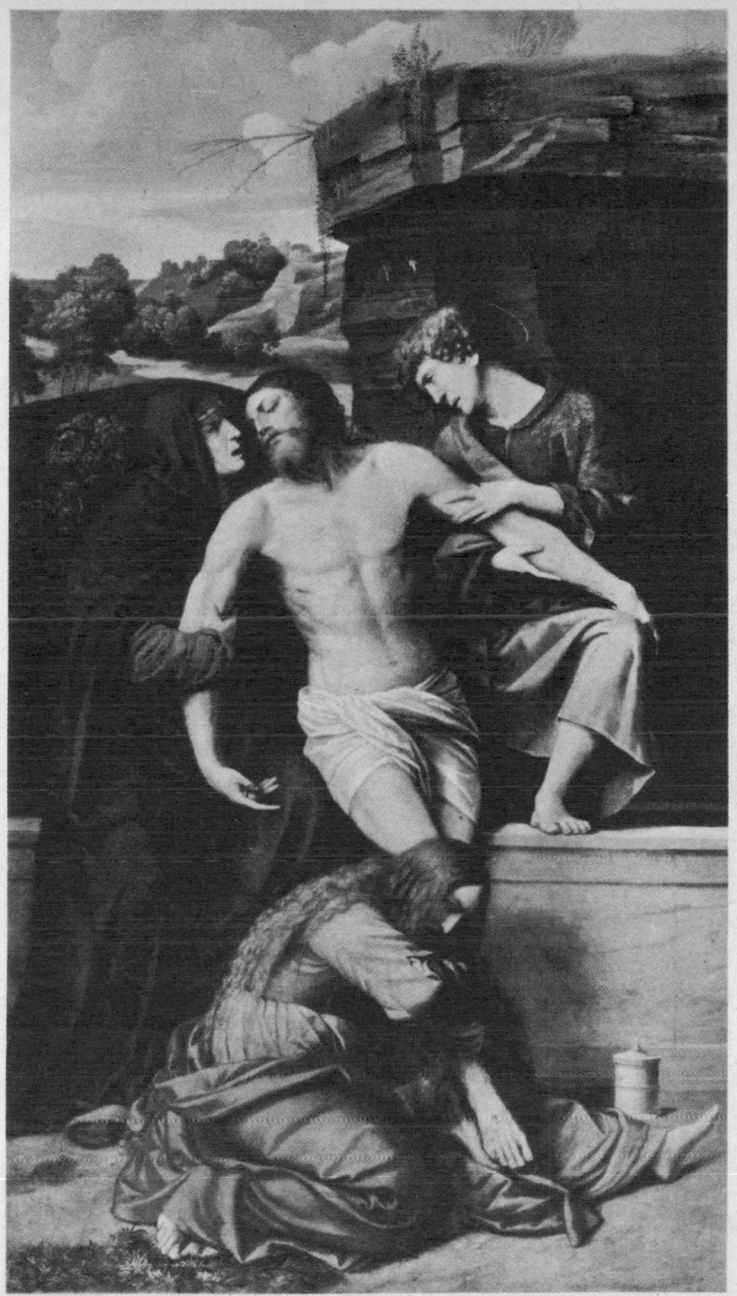

51. Moretto da Brescia: *Pietà*. National Gallery of Art, Washington

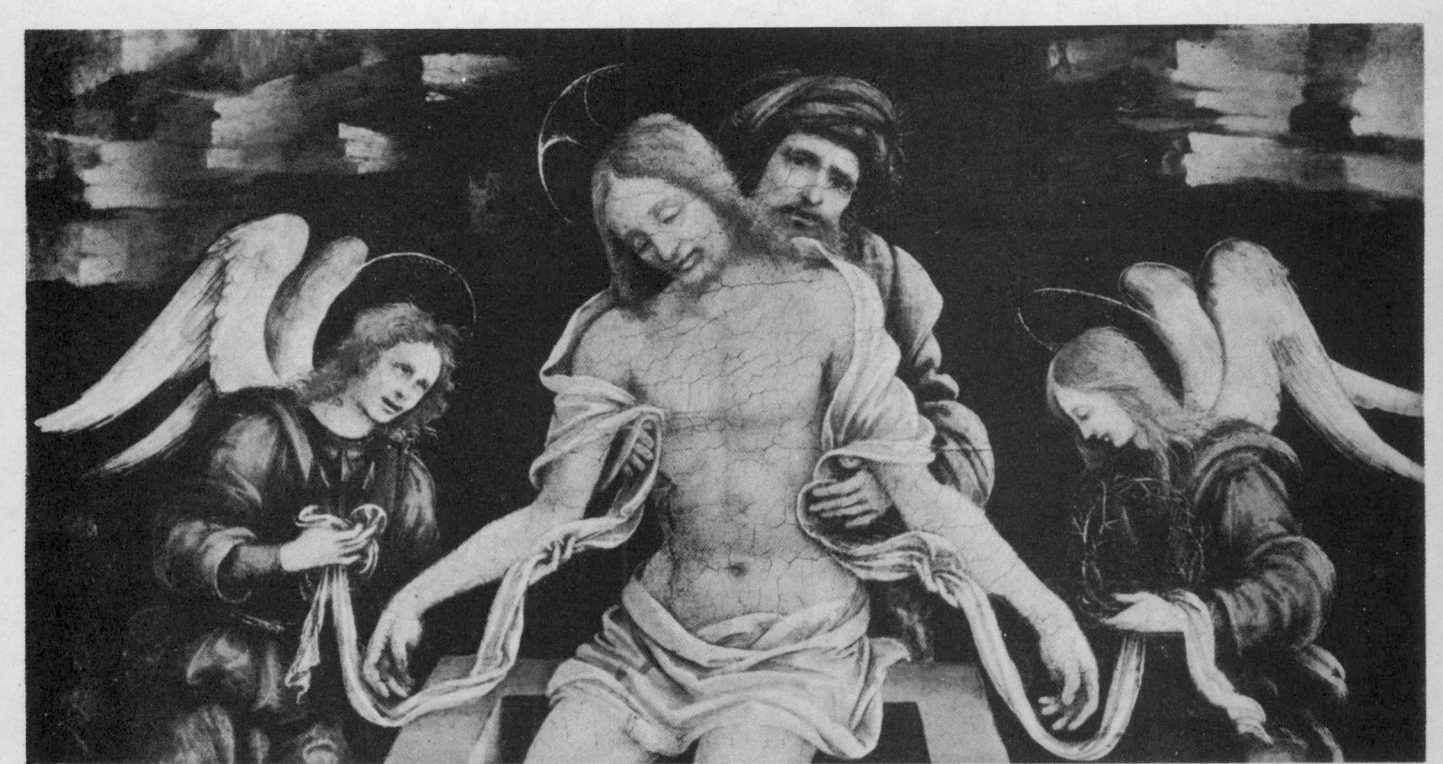

52. Filippino Lippi: *Pietà*. National Gallery of Art, Washington

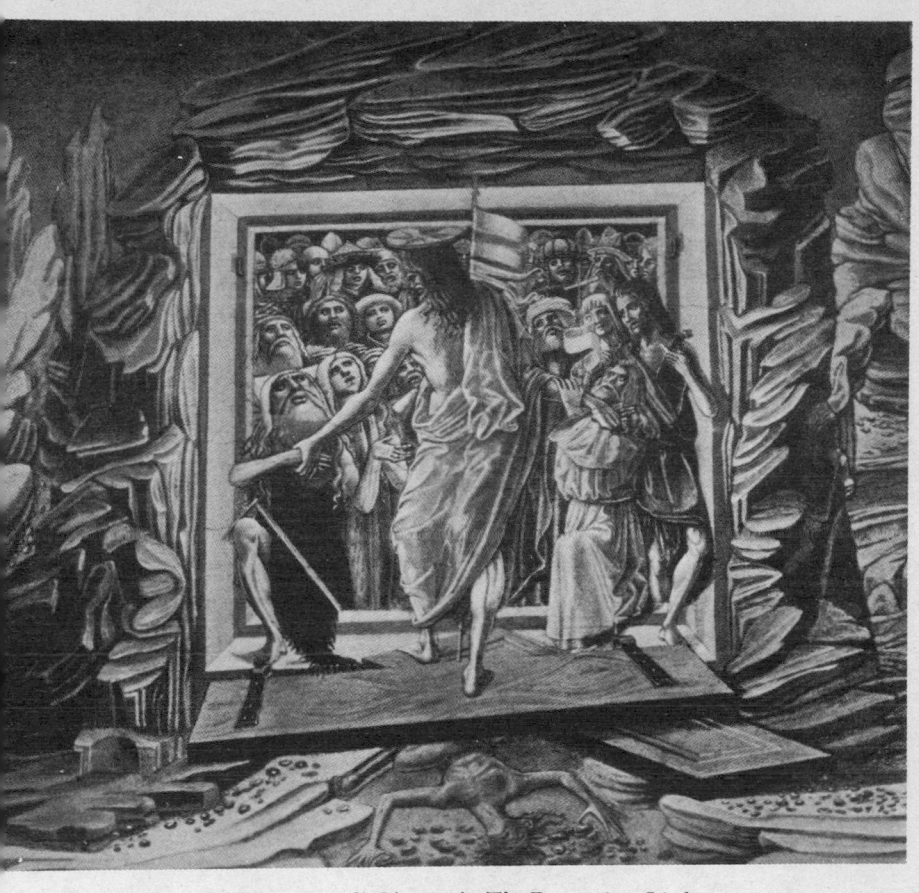

53. Benvenuto di Giovanni: *The Descent into Limbo*.
From the predella 'The Passion of Our Lord'. National Gallery of Art, Washington

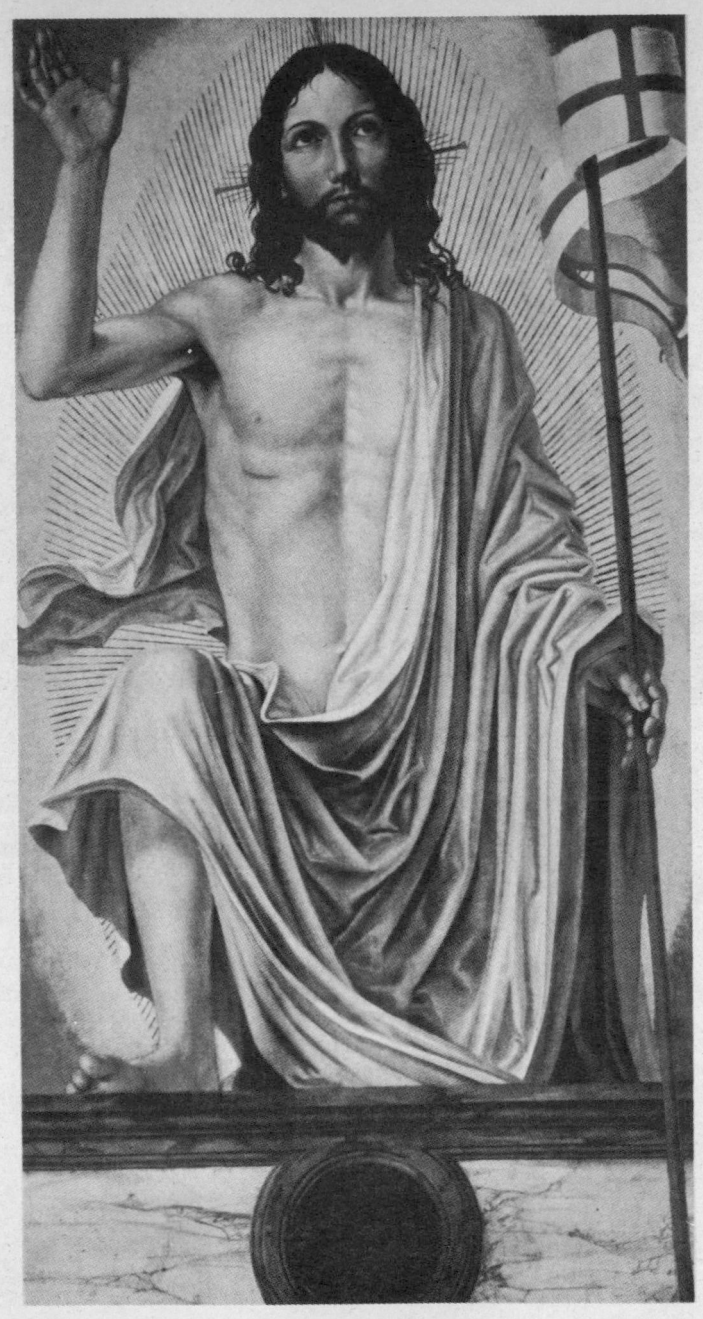

54. Ambrogio Borgognone: *The Resurrection*. National Gallery of Art, Washington

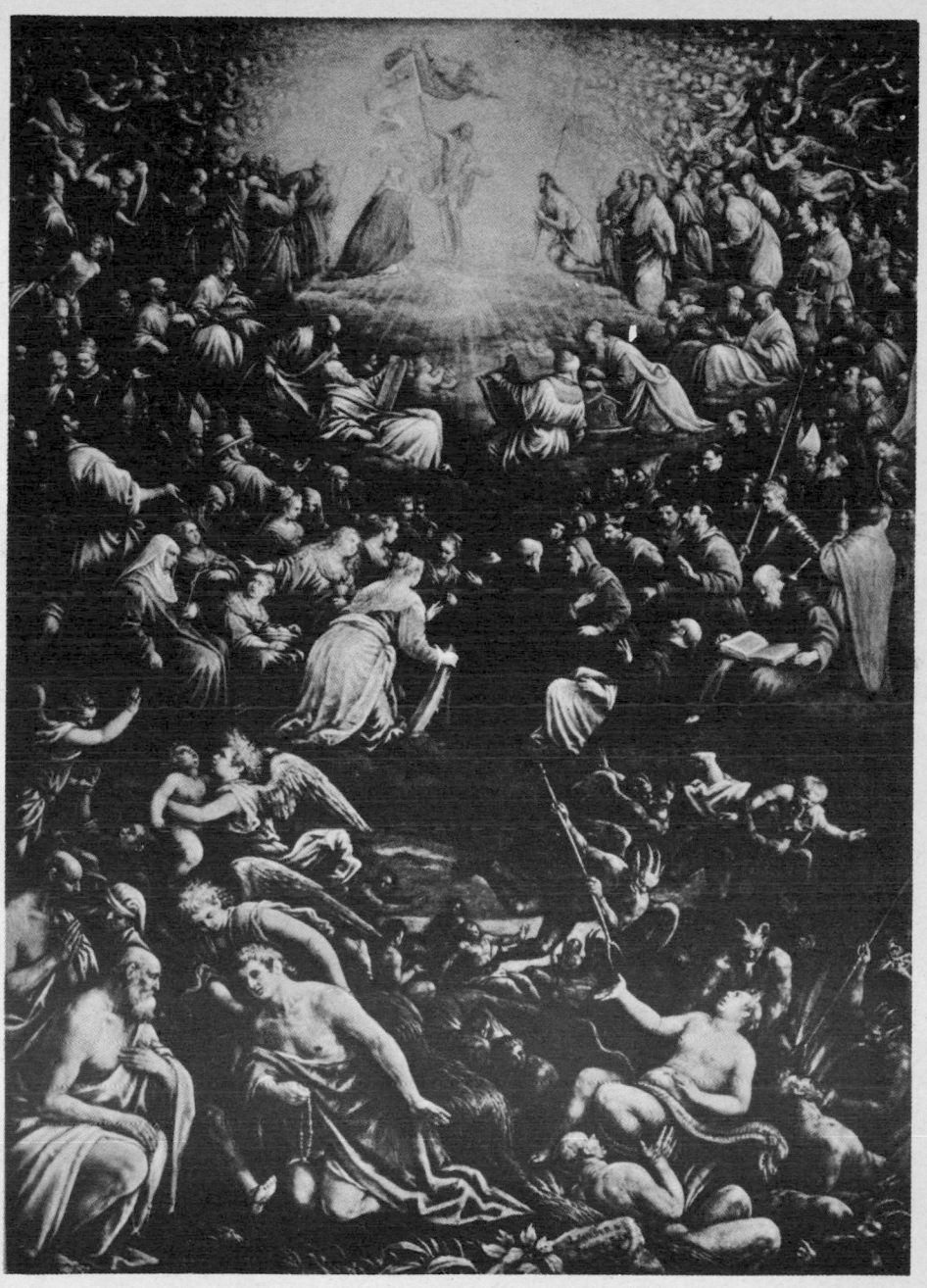

55. Leandro da Ponte da Bassano: *The Last Judgment*. Birmingham Museum of Art, Birmingham, Alabama

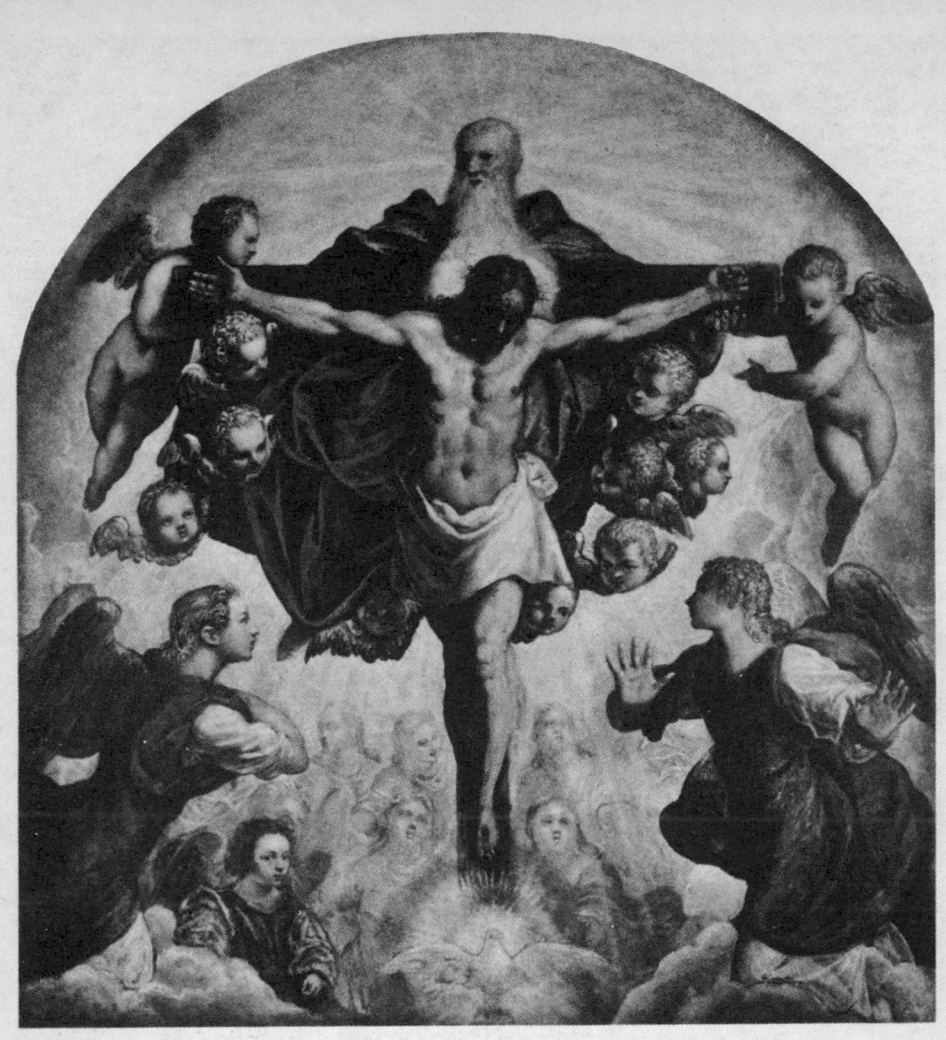

56. Jacopo Tintoretto: *The Trinity adored by the Heavenly Choir*. Columbia Museum of Art, Columbia, South Carolina

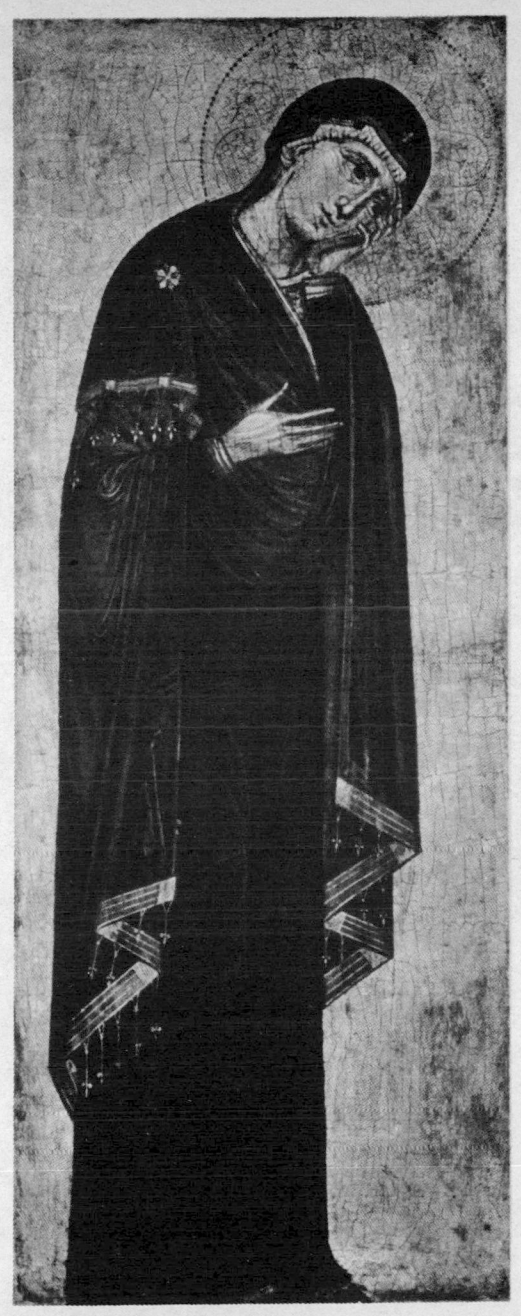

57. Master of the Franciscan Crucifix: *The Mourning Madonna*.
National Gallery of Art, Washington

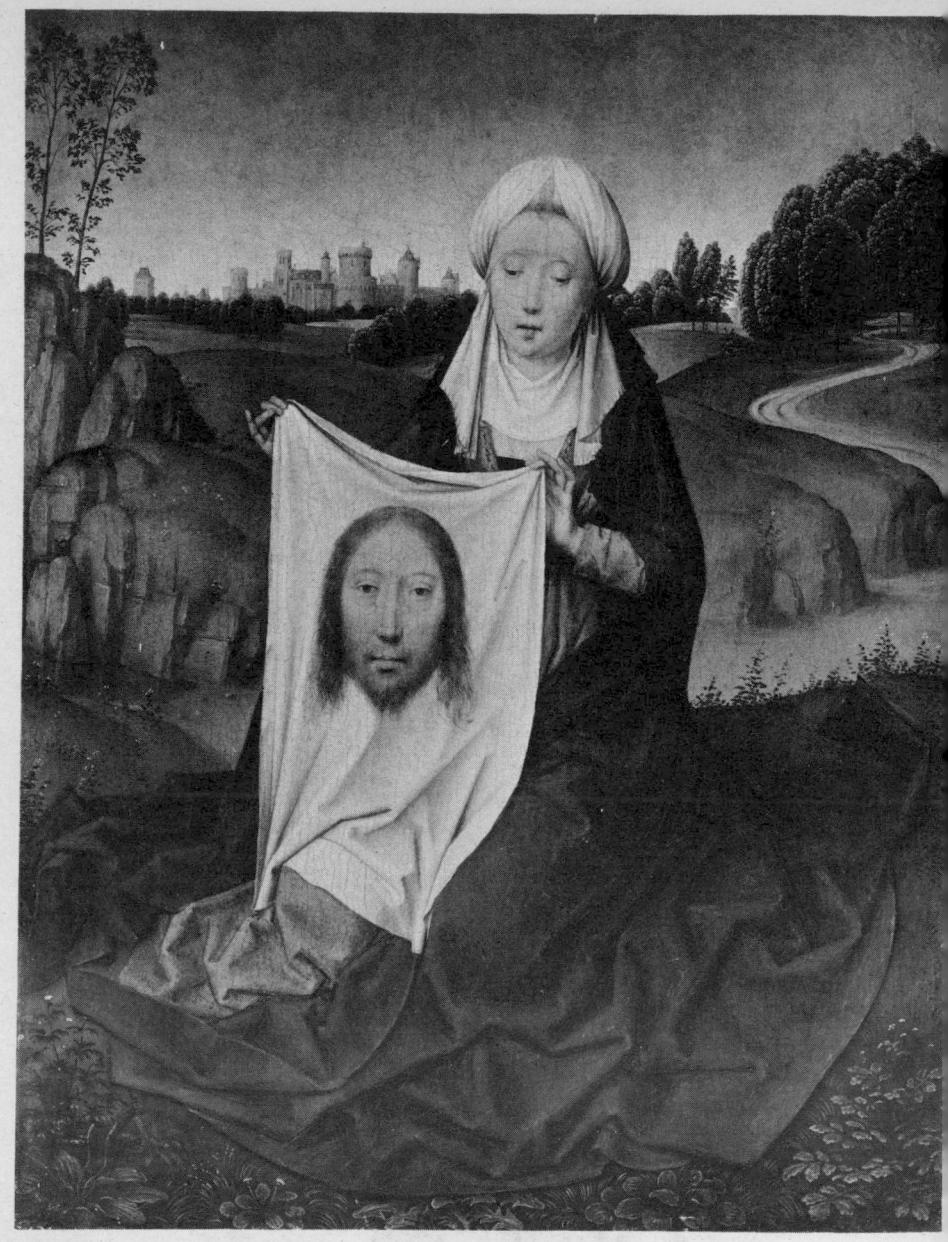

58. Hans Memling: *St. Veronica*. National Gallery of Art, Washington

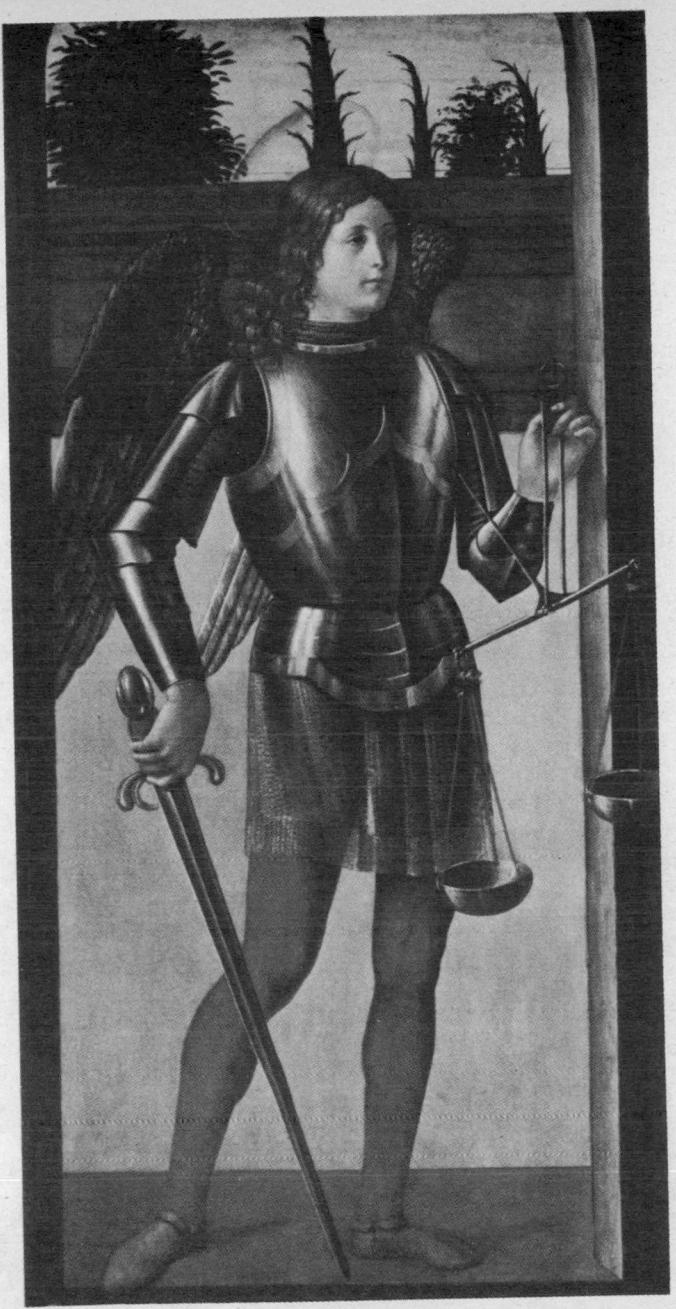

61. Follower of Domenico Ghirlandaio: *St. Michael*.
Portland Art Museum, Portland, Oregon

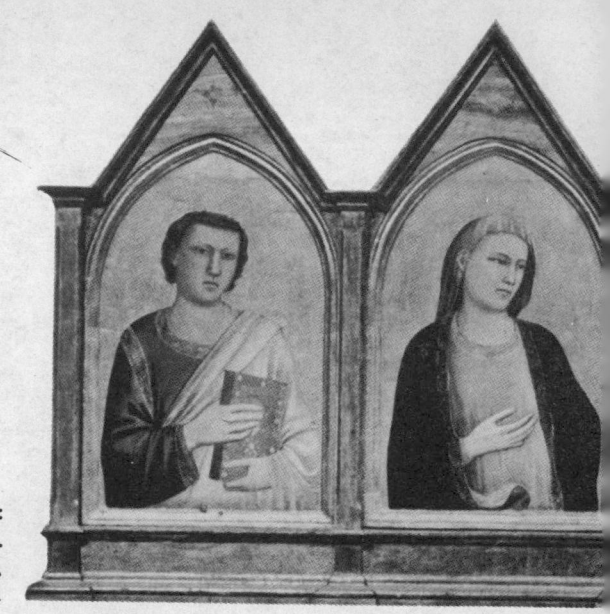

59. Giotto and Assistants:
The Peruzzi Altarpiece.
North Carolina Museum of Art,
Raleigh, North Carolina

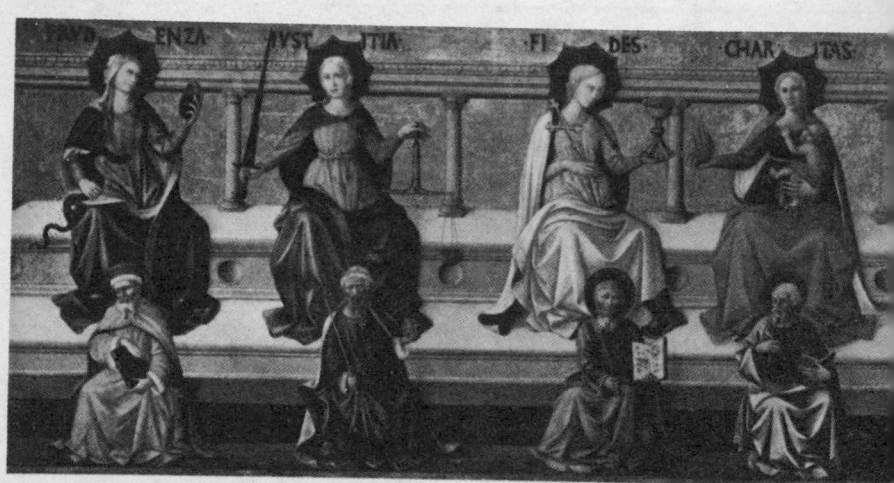

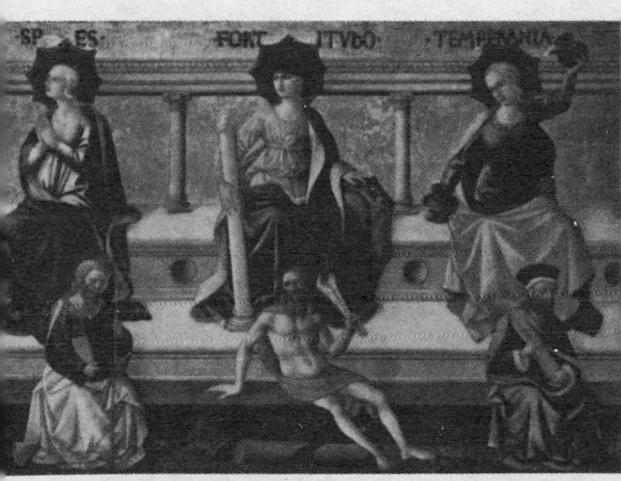

SP ES· FORT ITVDO · TEMPERANTIA·

60. Francesco Pesellino
and Studio:
The Seven Virtues.
Birmingham Museum of Art,
Birmingham, Alabama

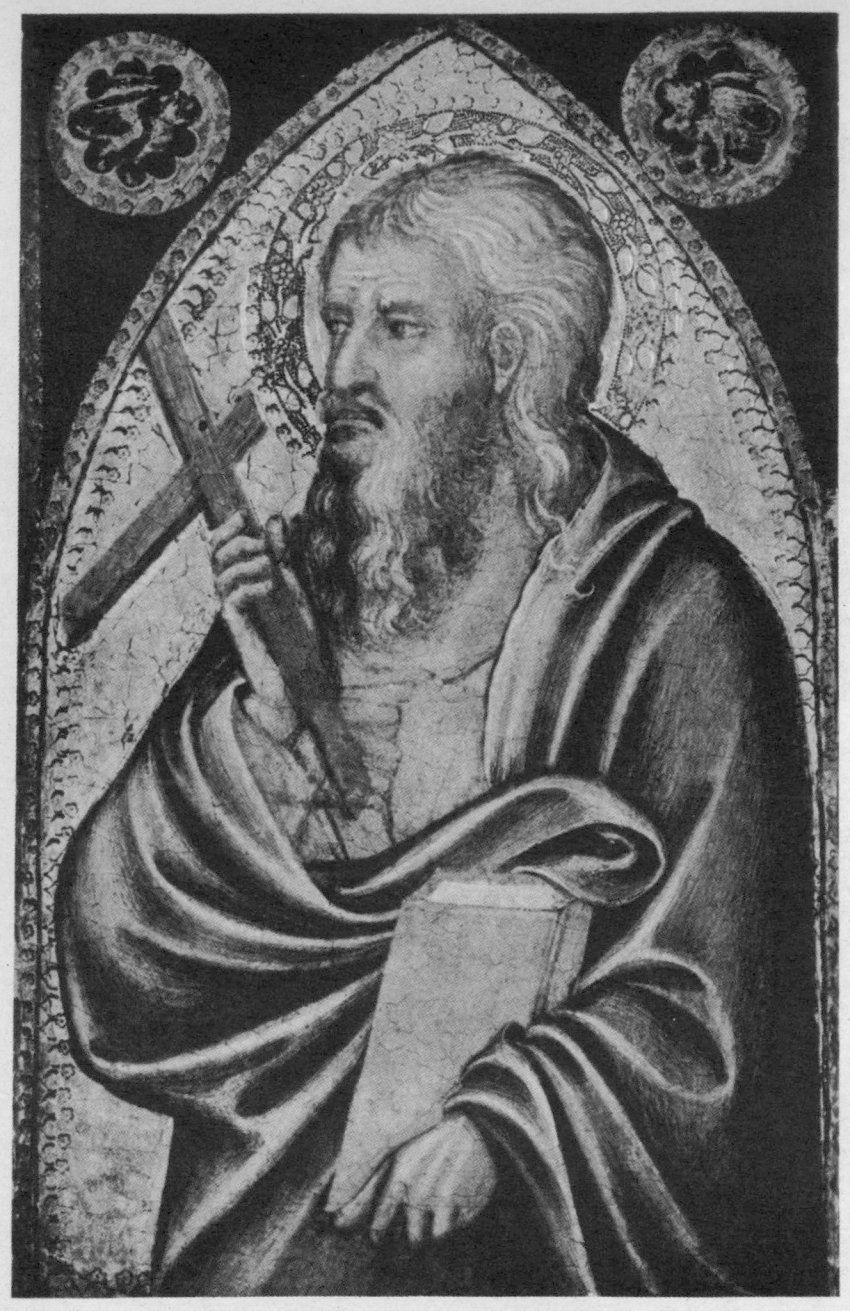

62. Follower of Pietro Lorenzetti: *St. Andrew the Apostle*.
Bridgeport Museum of Art, Science and Industry, Bridgeport, Connecticut

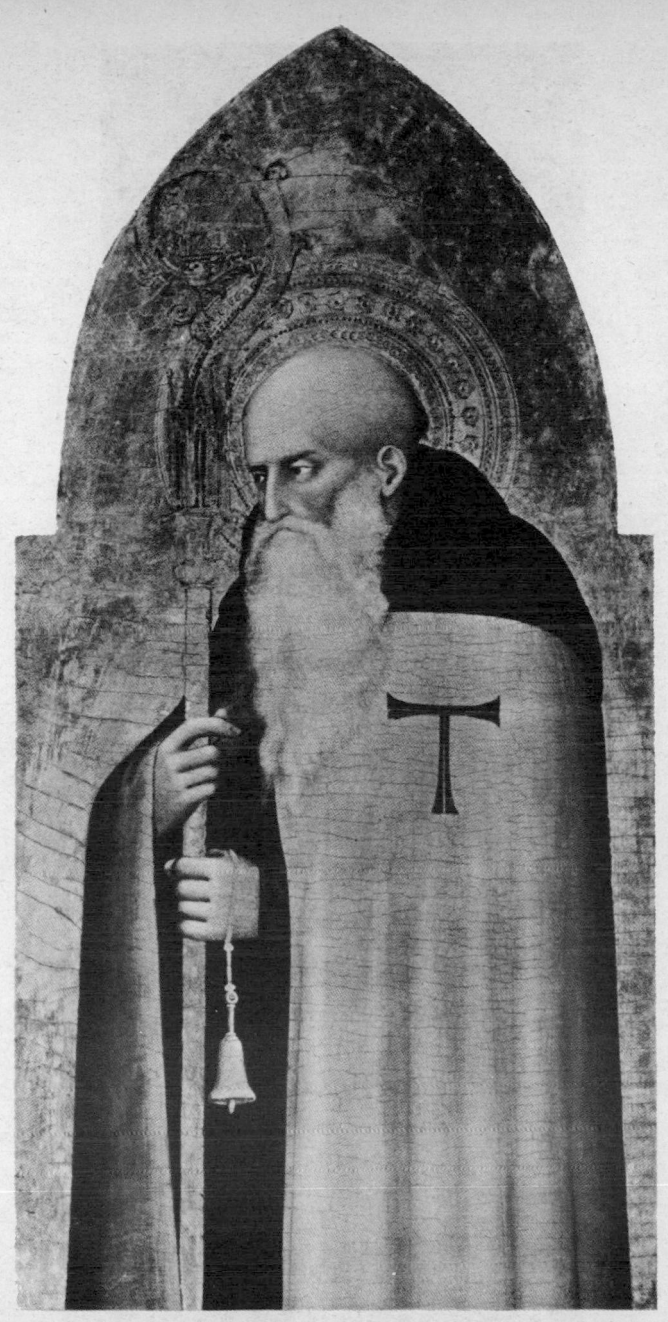

63. Giovanni da Milano: *St. Anthony Abbot*. Williams College,
Williamstown, Massachusetts

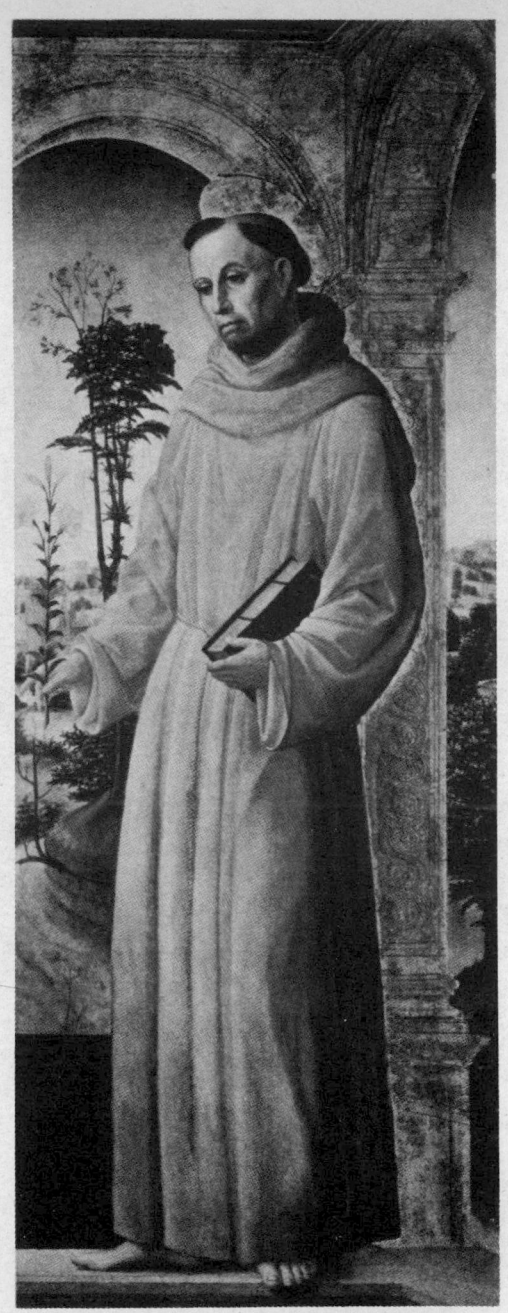

64. Vincenzo Foppa: *St. Anthony of Padua*.
National Gallery of Art, Washington

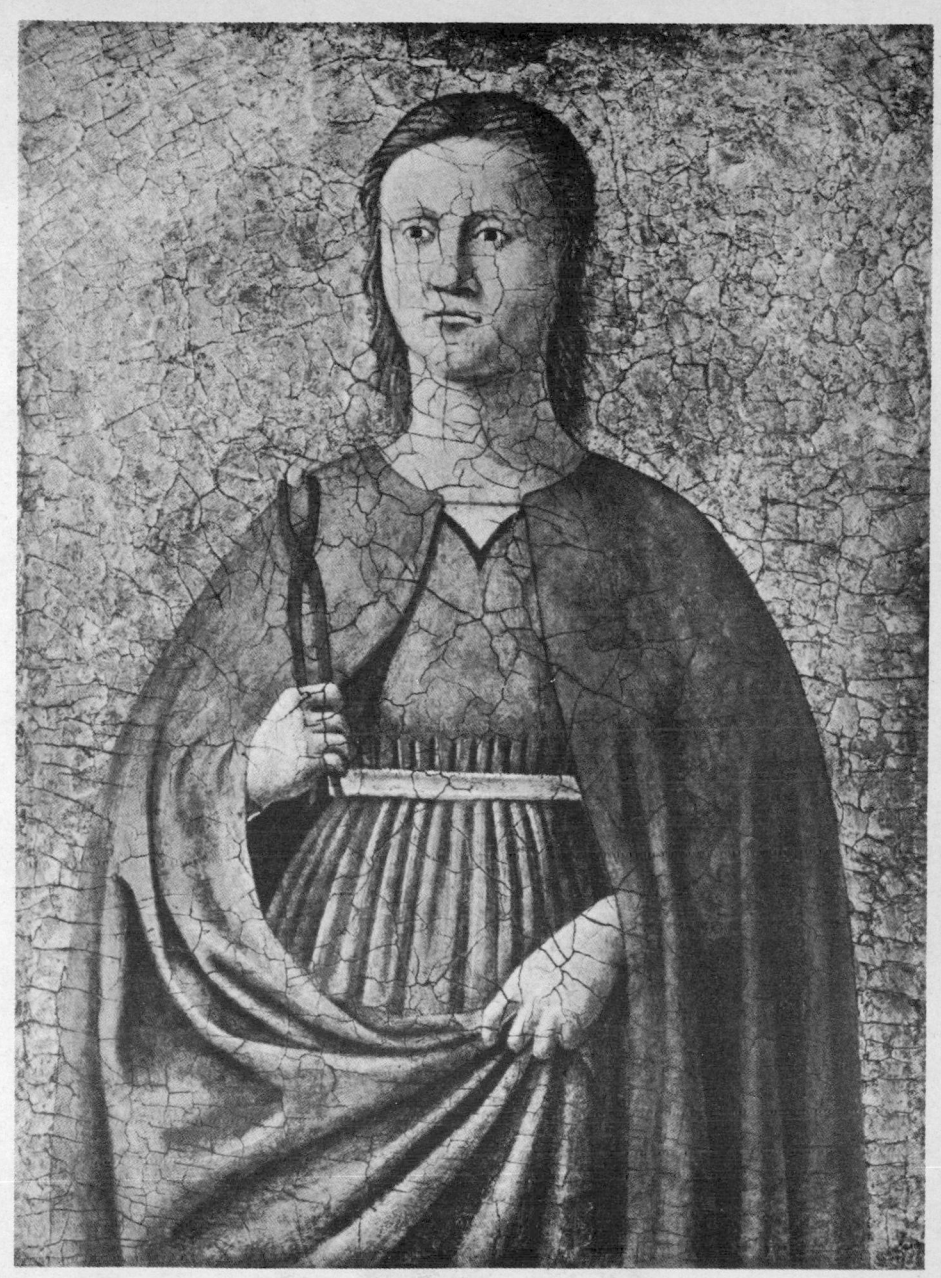

65. Assistant of Piero della Francesca: *St. Apollonia.*
National Gallery of Art, Washington

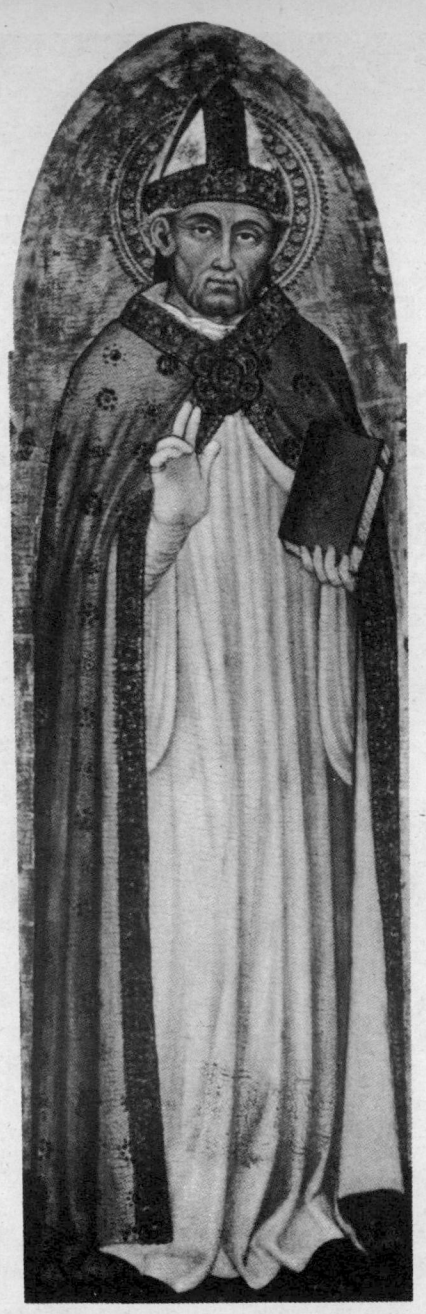

66. Taddeo di Bartolo: *A Bishop Saint blessing.*
Isaac Delgado Museum of Art, New Orleans, Louisiana

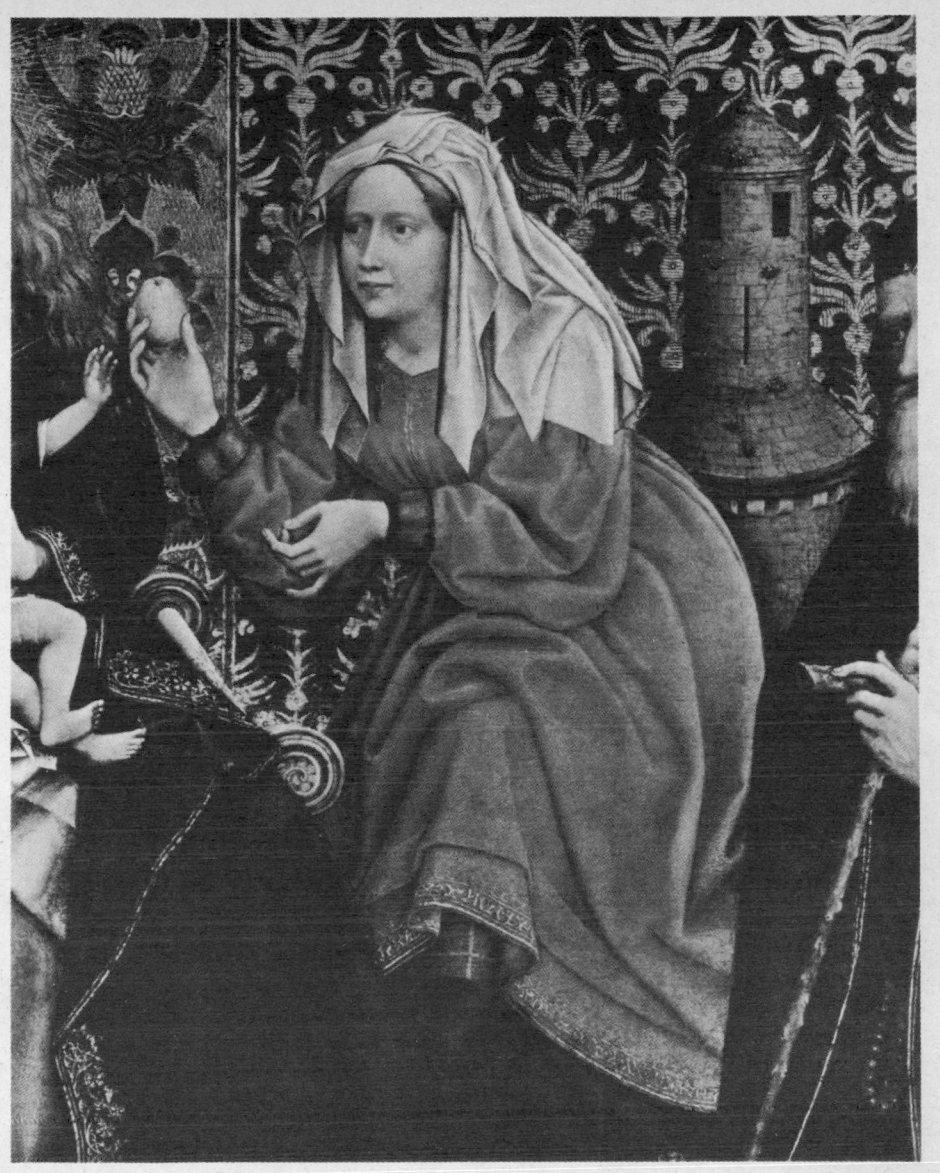

67. Master of Flémalle and Assistants: *St. Barbara*.
Detail from 'Madonna and Child in the Enclosed Garden' (see Pl. 111)
National Gallery of Art, Washington

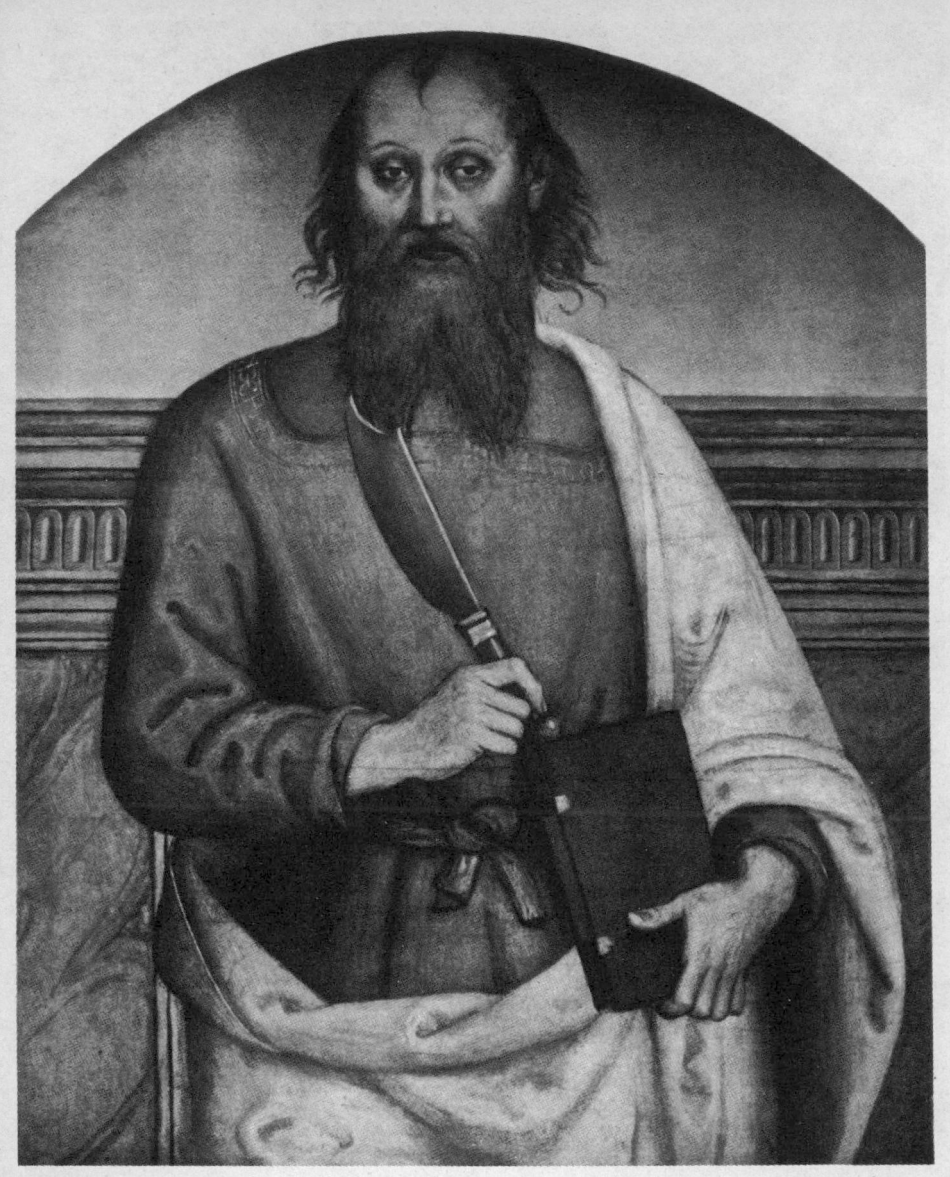

68. Pietro Perugino: *St. Bartholomew*. Birmingham Museum of Art, Birmingham, Alabama

69. Fra Filippo Lippi: *St. Benedict Orders St. Maurus to the Rescue of St. Placidus*. National Gallery of Art, Washington

70. Follower of Antoniazzo Romano: *St. Blaise.*
E. G. Crocker Art Gallery, Sacramento, California

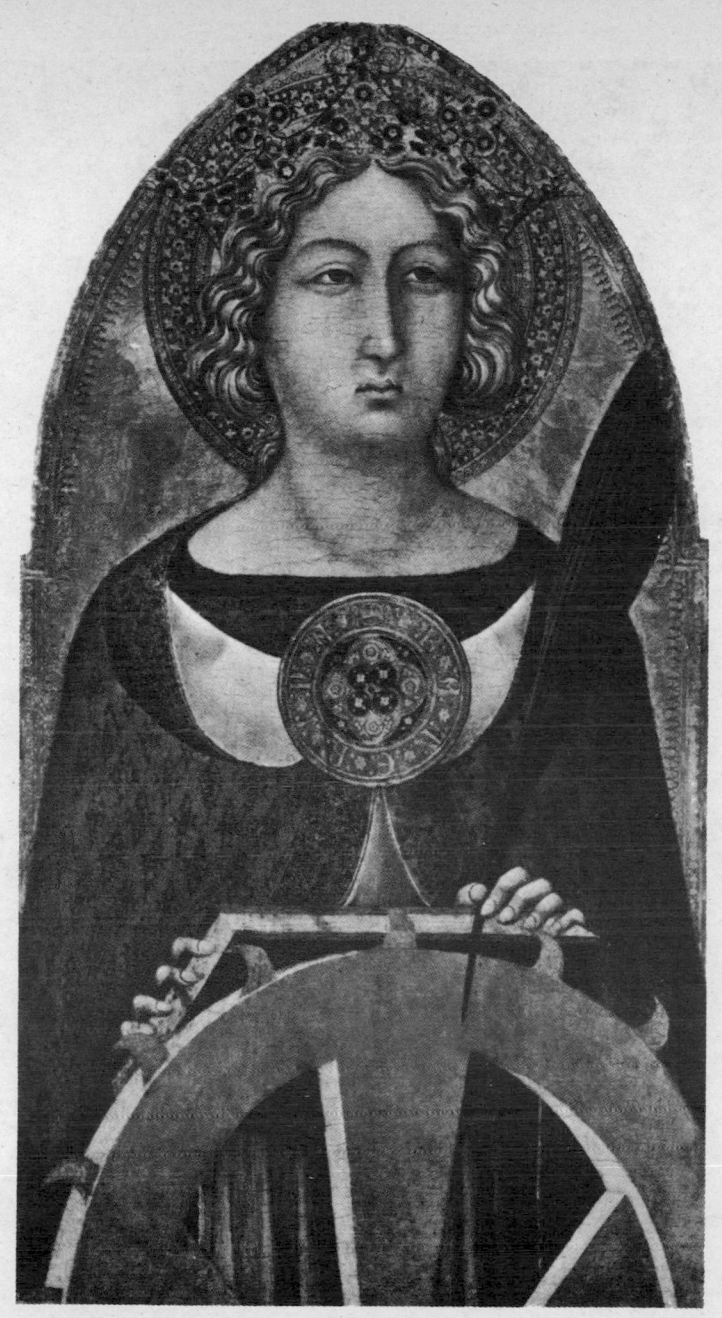

71. Master of the Ovile Madonna ('Ugolino Lorenzetti'): *St. Catherine of Alexandria*. National Gallery of Art, Washington

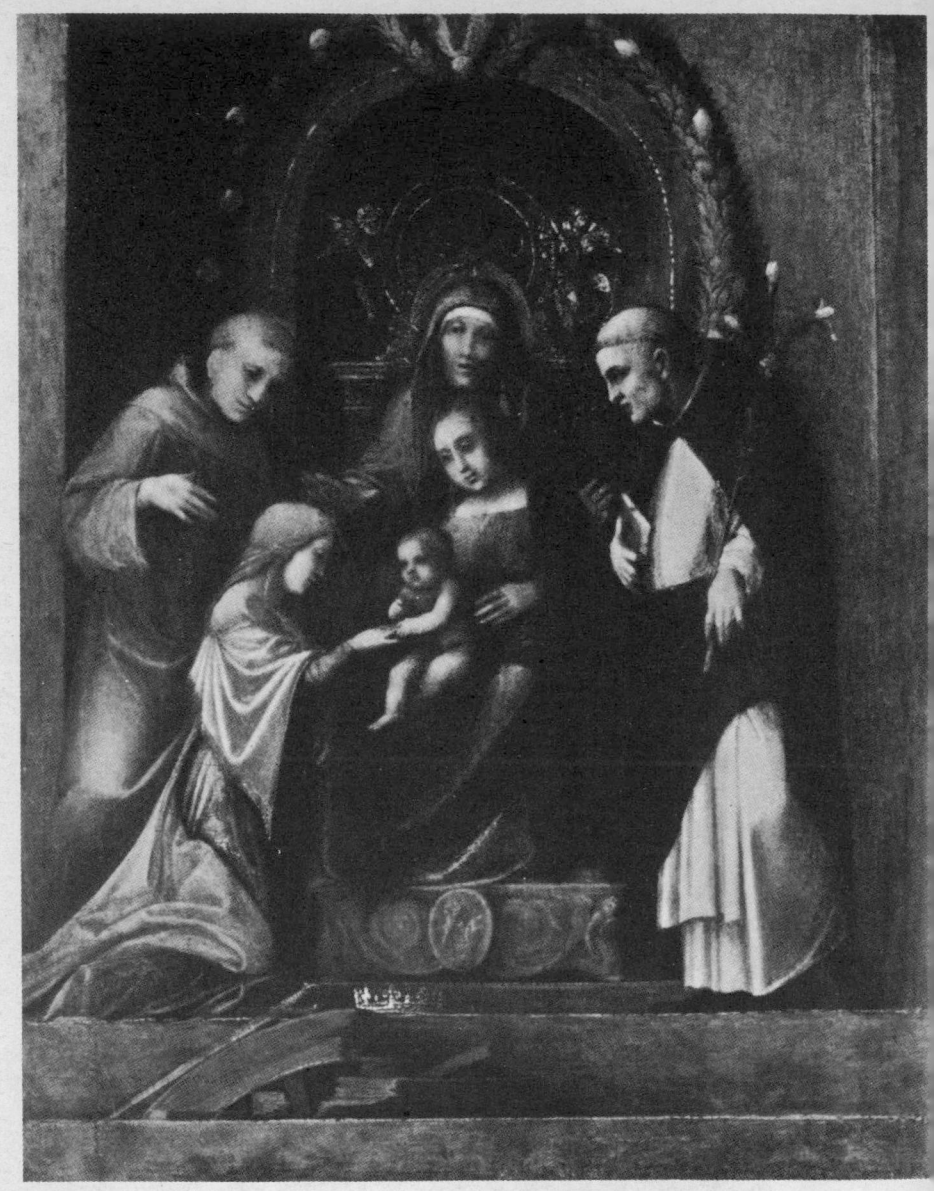

72. Antonio da Correggio: *The Mystic Marriage of St. Catherine*.
National Gallery of Art, Washington

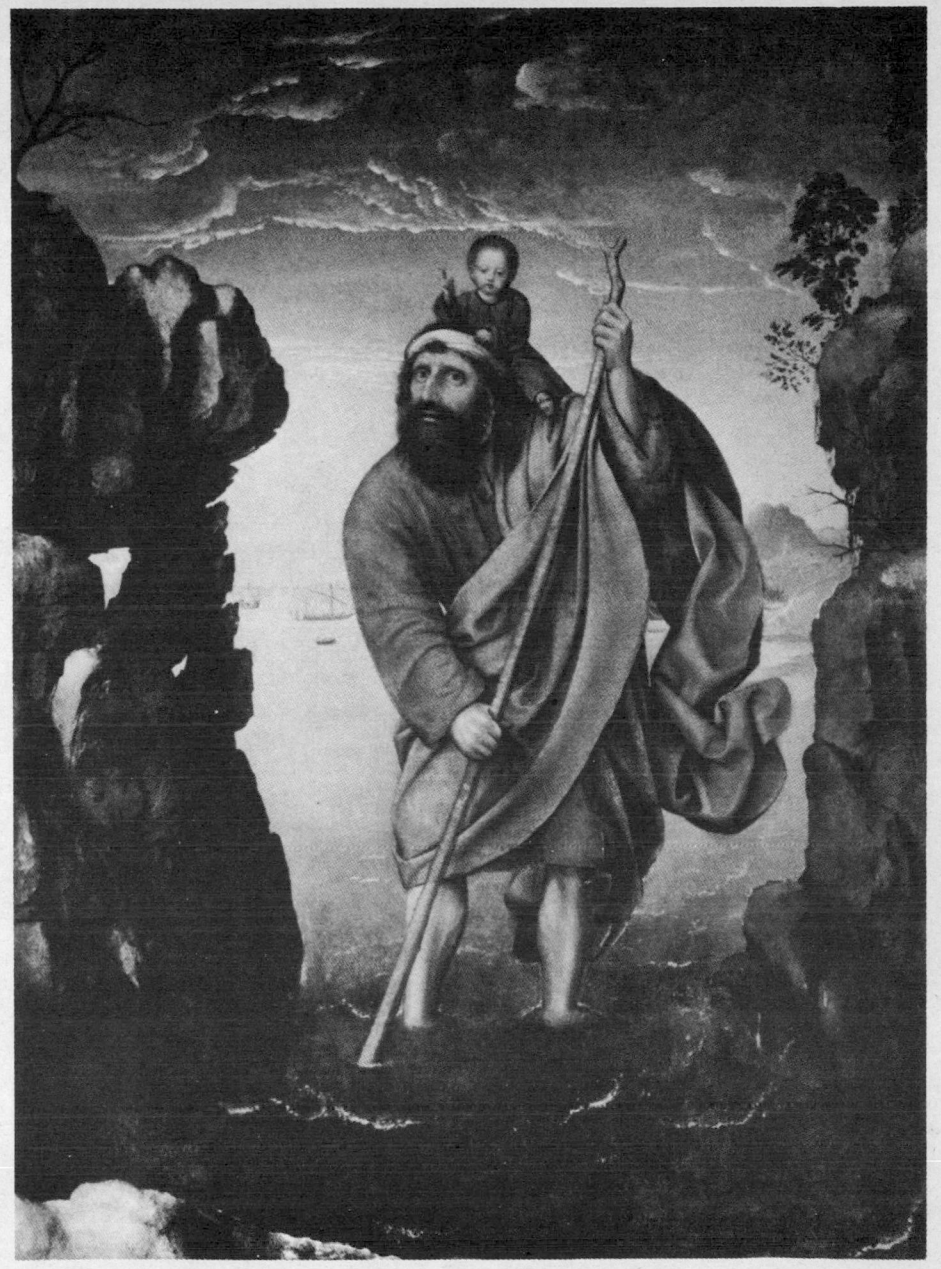

73. Quentin Massys: *St. Christopher*. Allentown Art Museum, Allentown, Pennsylvania

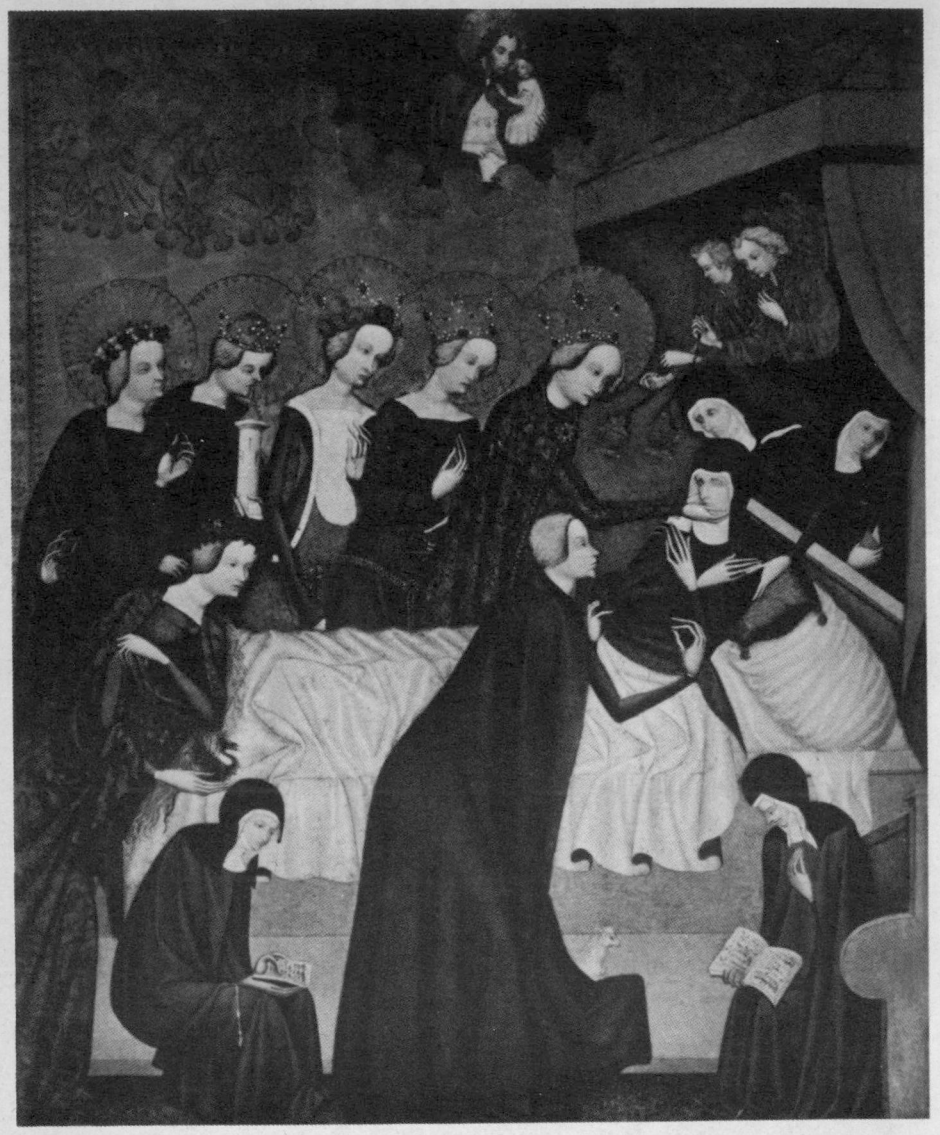

74. Master of Heiligenkreuz: *The Death of St. Clare.*
The Virgin is holding St. Clare's head. In front, with a lamb, is St. Agnes, or perhaps
Blessed Agnes, St. Clare's sister. Left, with dragon, St. Margaret. Back, left to right:
St. Dorothy with basket, St. Barbara with tower, and St. Catherine with wheel.
National Gallery of Art, Washington

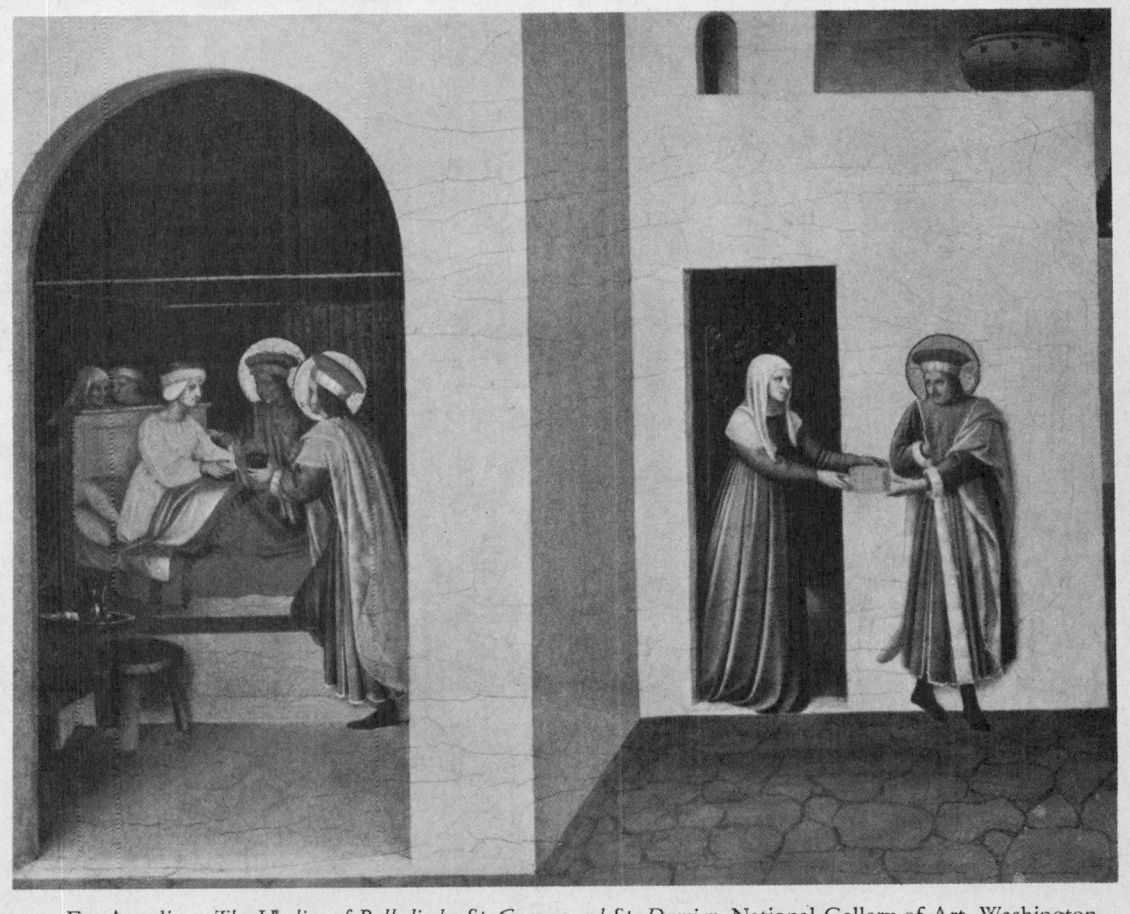

75. Fra Angelico: *The Healing of Palladia by St. Cosmas and St. Damian*. National Gallery of Art, Washington

76. Lippo Vanni: *St. Dominic*. University of Miami, Miami, Florida

77. Lippo Vanni: *St. Elizabeth of Hungary*. University of Miami,
Miami, Florida

78. Vittore Crivelli: *St. Francis*. El Paso Art Museum,
El Paso, Texas

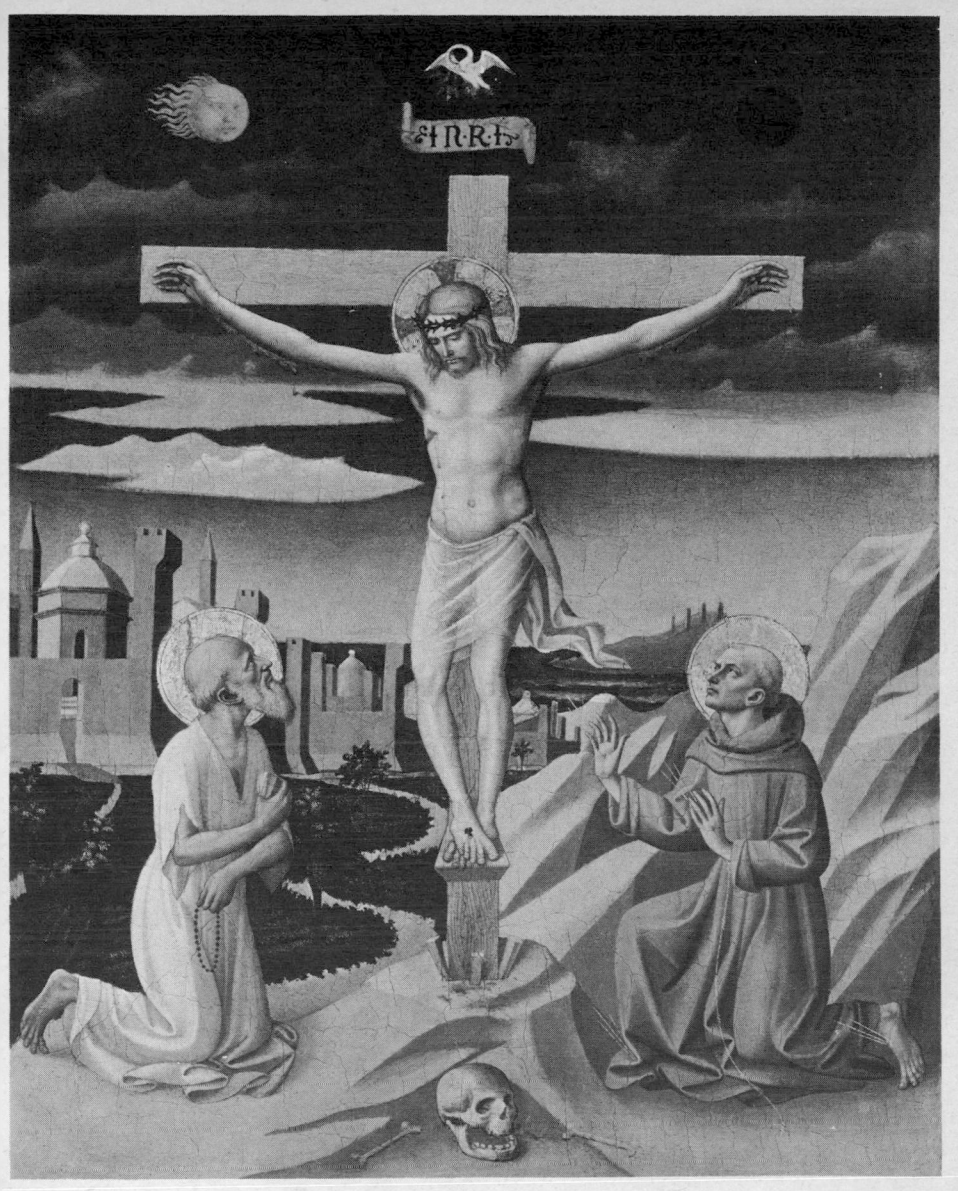

79. Francesco Pesellino: *The Crucifixion with St. Jerome and St. Francis.*
National Gallery of Art, Washington

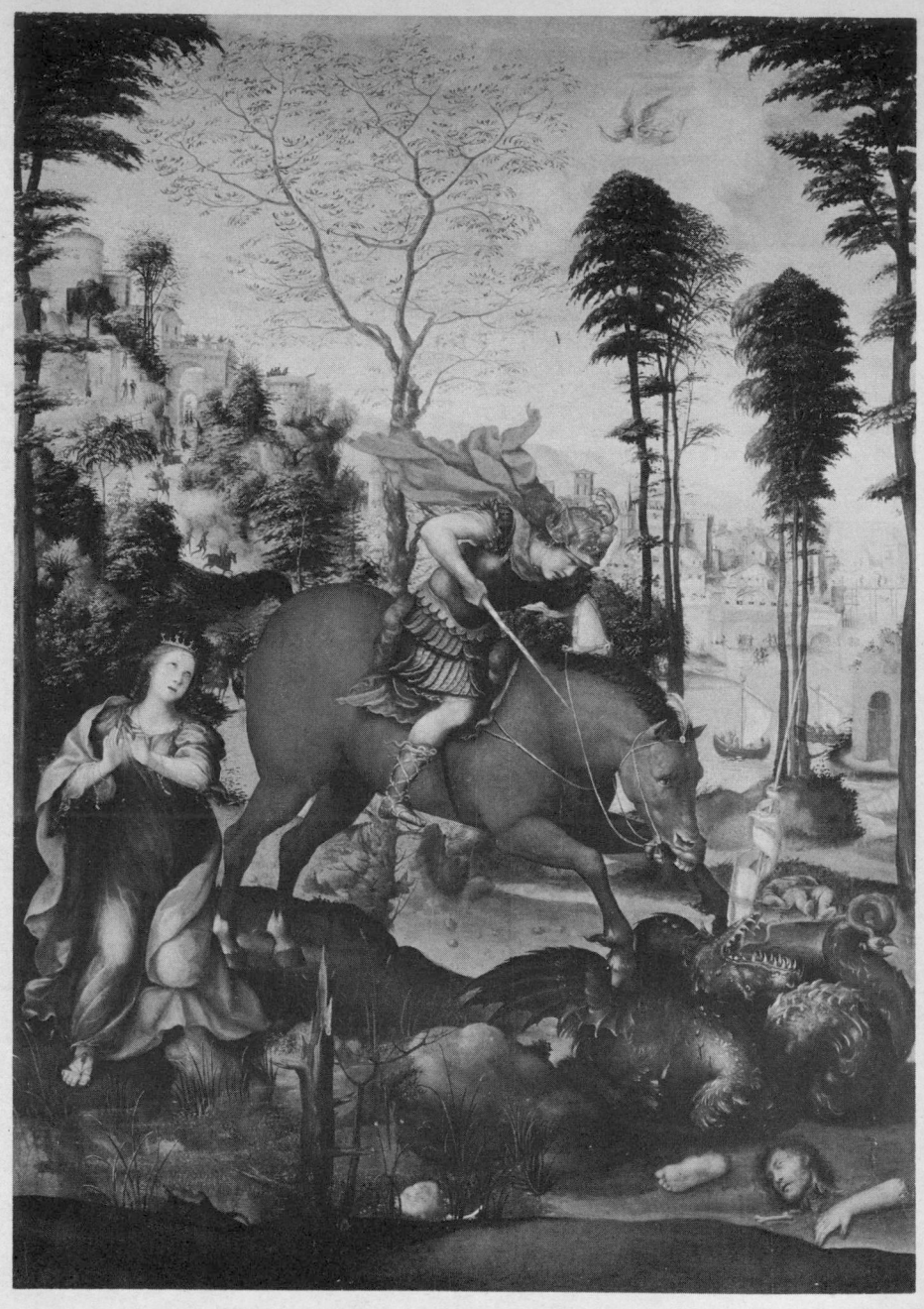

80. Giovanni Antonio Bazzi, called Sodoma: *St. George and the Dragon*.
National Gallery of Art, Washington

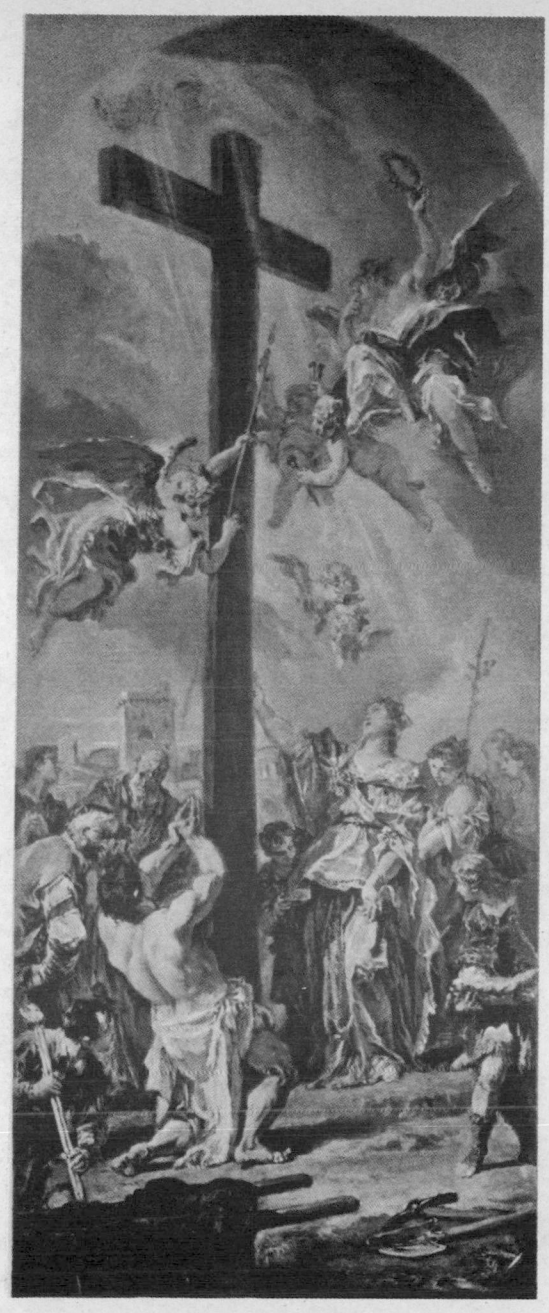

81. Sebastiano Ricci: *The Finding of the True Cross.*
National Gallery of Art, Washington

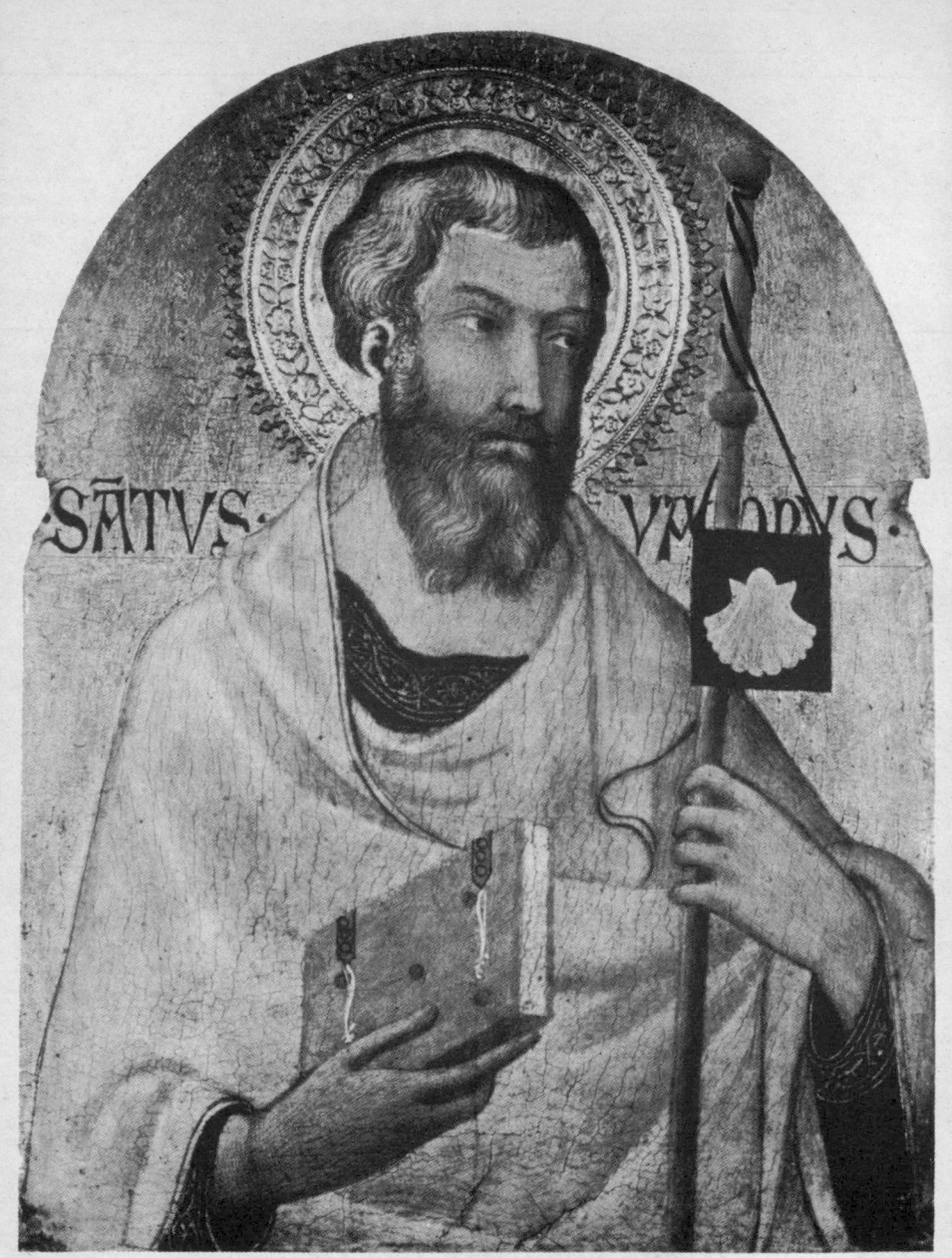

·SĀTVS· ·VM·OPVS·

82. Simone Martini and Assistants: *St. James the Great*. National Gallery of Art, Washington

83. Master of St. Francis, 13th Century: *St. James the Less.*
National Gallery of Art, Washington

84. Giovanni Battista Cima da Conegliano: *St. Jerome in the Wilderness.*
National Gallery of Art, Washington

85. Francisco Zurbaran: *St. Jerome, St. Paula and St. Eustochium.*
National Gallery of Art, Washington

86. Piero di Cosimo: *St. John the Evangelist*. Honolulu Academy of Arts, Honolulu, Hawaii

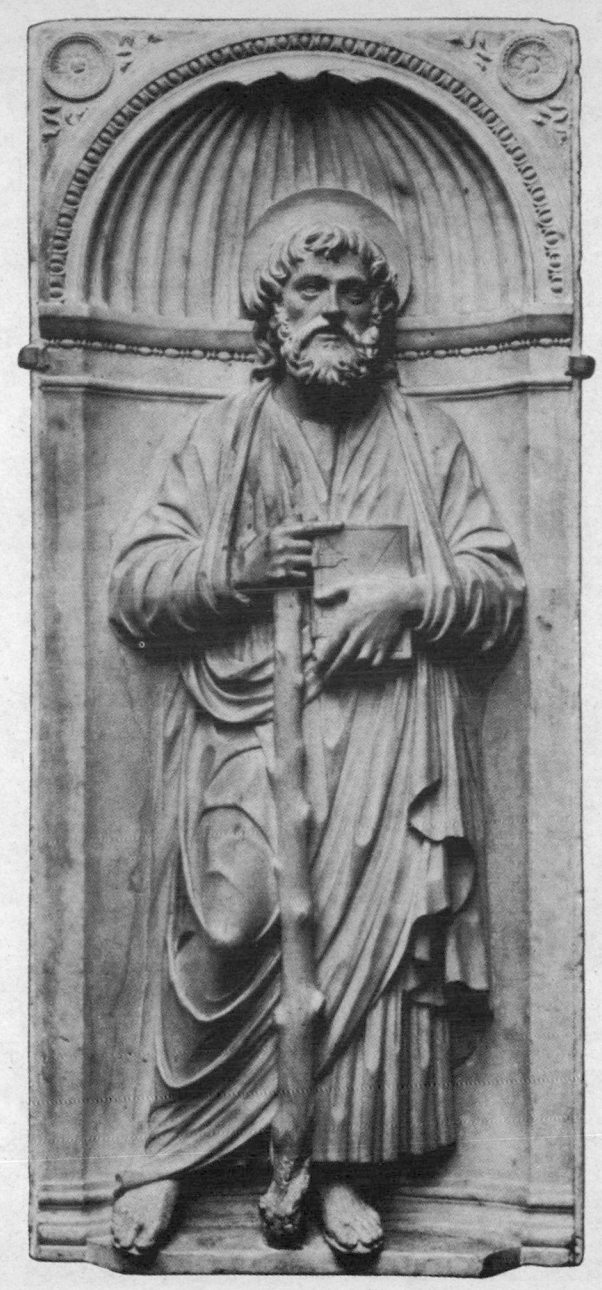

87. Andrea Bregno: *St. Jude*. Marble relief.
William Rockhill Nelson Gallery of Art, Kansas City, Missouri

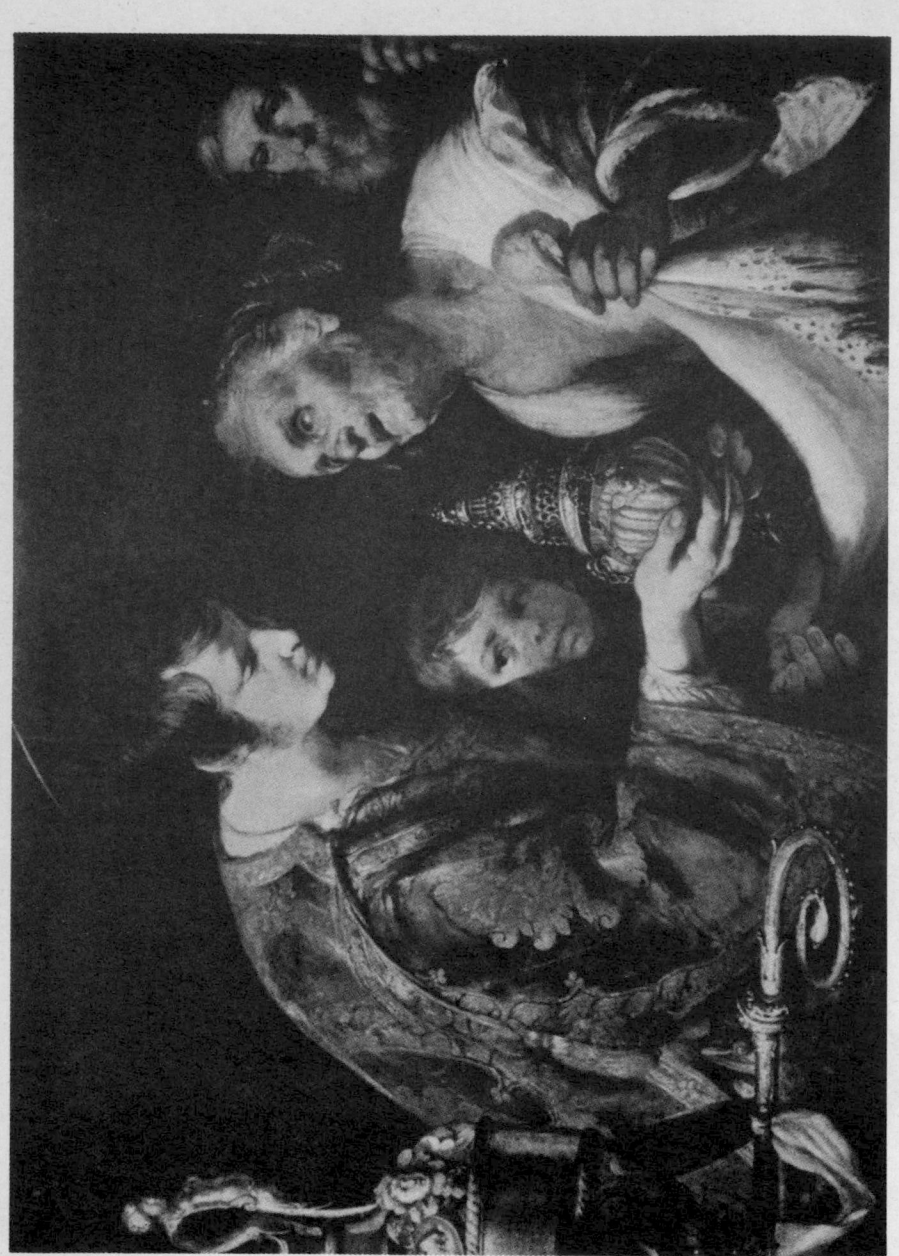

88. Bernardo Strozzi: *St. Lawrence giving the Treasures of the Church to the Poor.* Portland Art Museum, Portland, Oregon

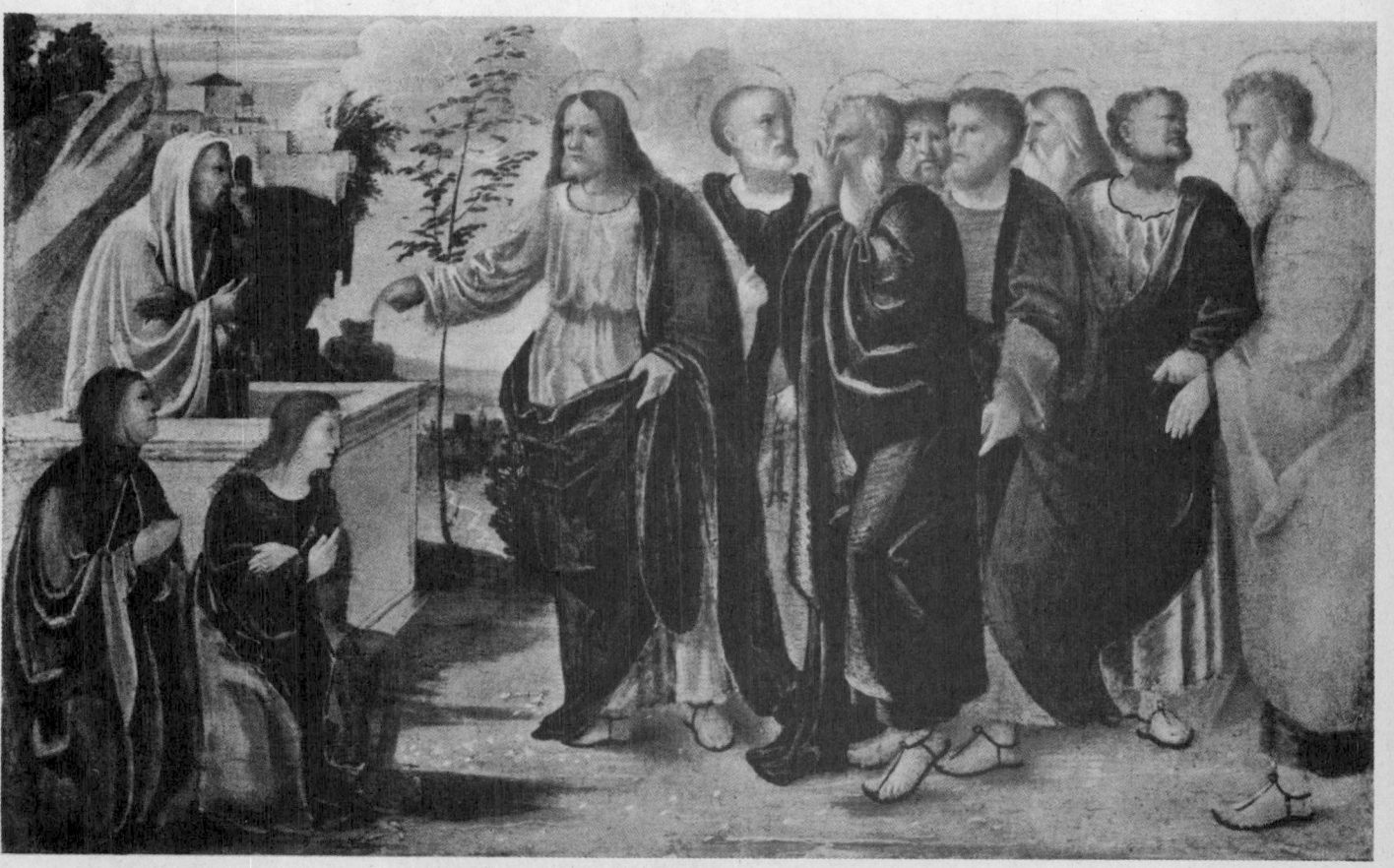

89. Bramantino: *The Raising of Lazarus.* Kress Collection, New York

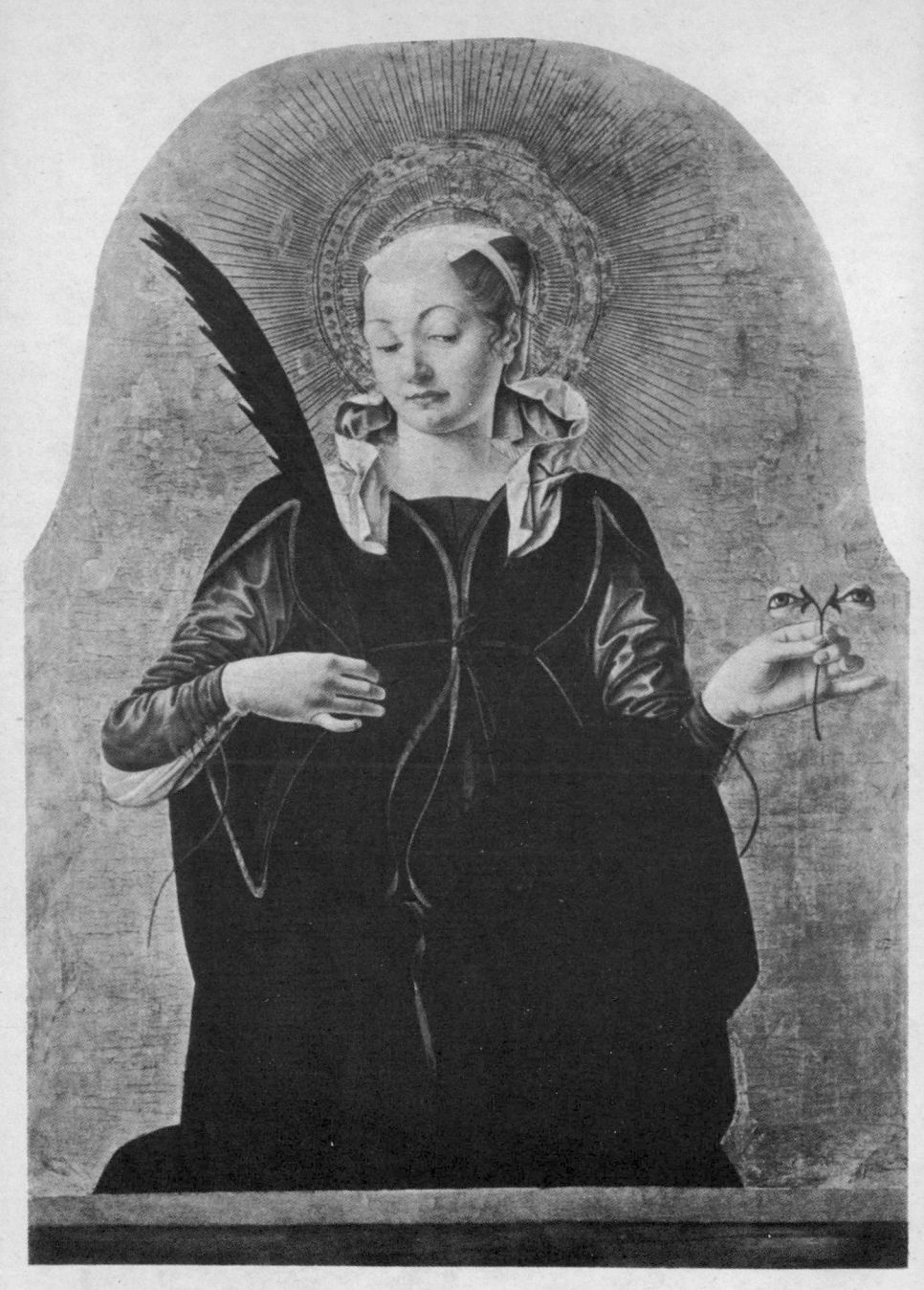

90. Francesco del Cossa: *St. Lucy*. National Gallery of Art, Washington

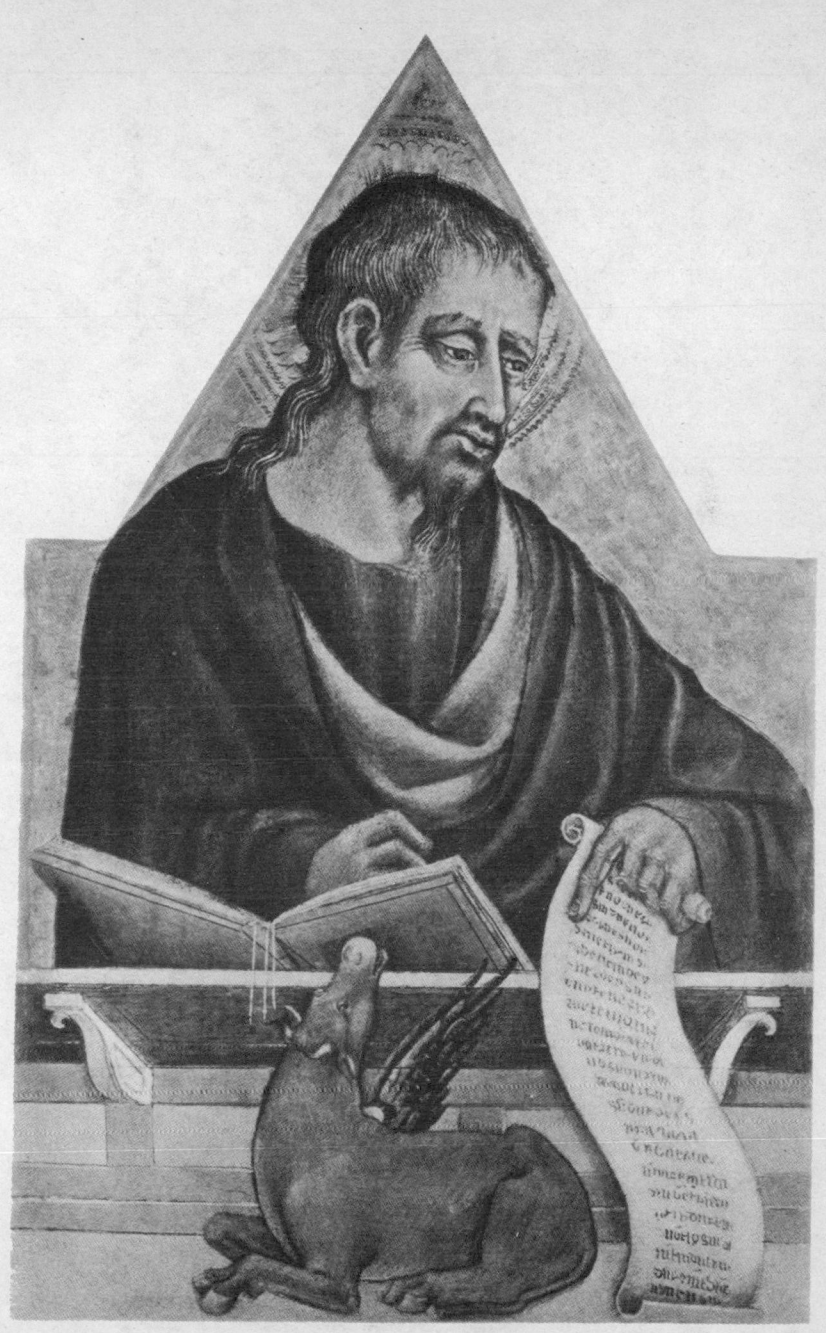

91. Giovanni di Paolo: *St. Luke the Evangelist*. Seattle Art Museum, Seattle, Washington

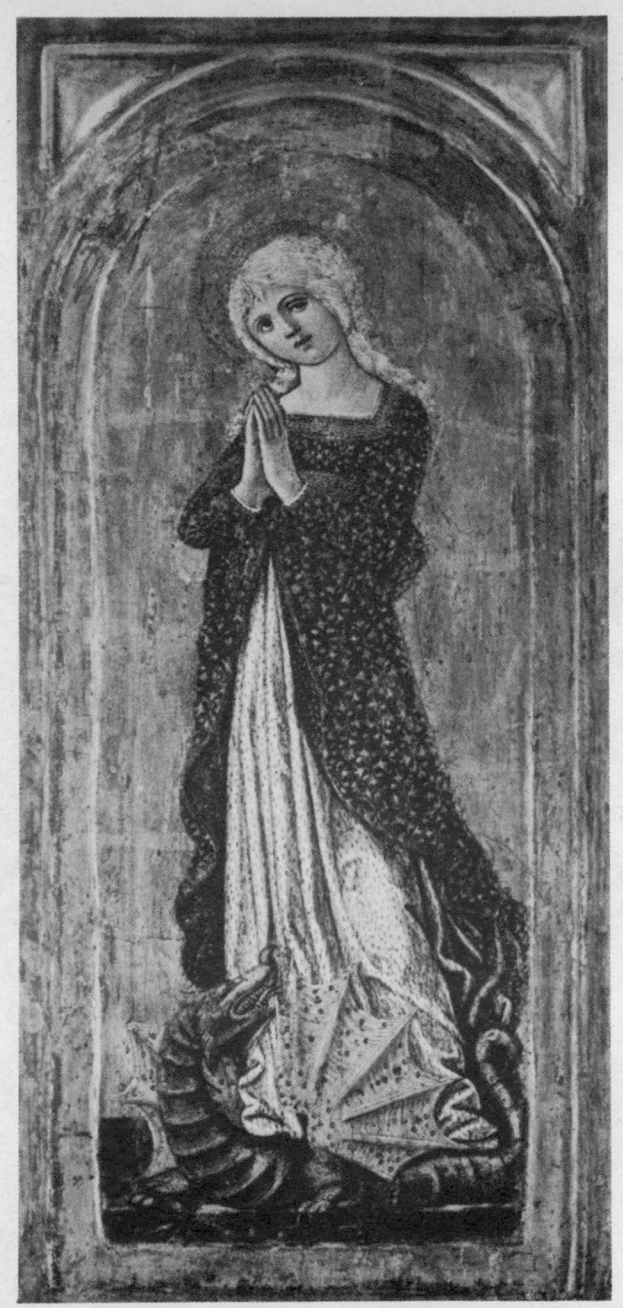

92. Girolamo di Benvenuto: *St. Margaret of Antioch*.
Isaac Delgado Museum of Art, New Orleans, Louisiana

93. Franco-Rhenish Master, about 1440: *The Mass of St. Martin of Tours.*
Allentown Art Museum, Allentown, Pennsylvania

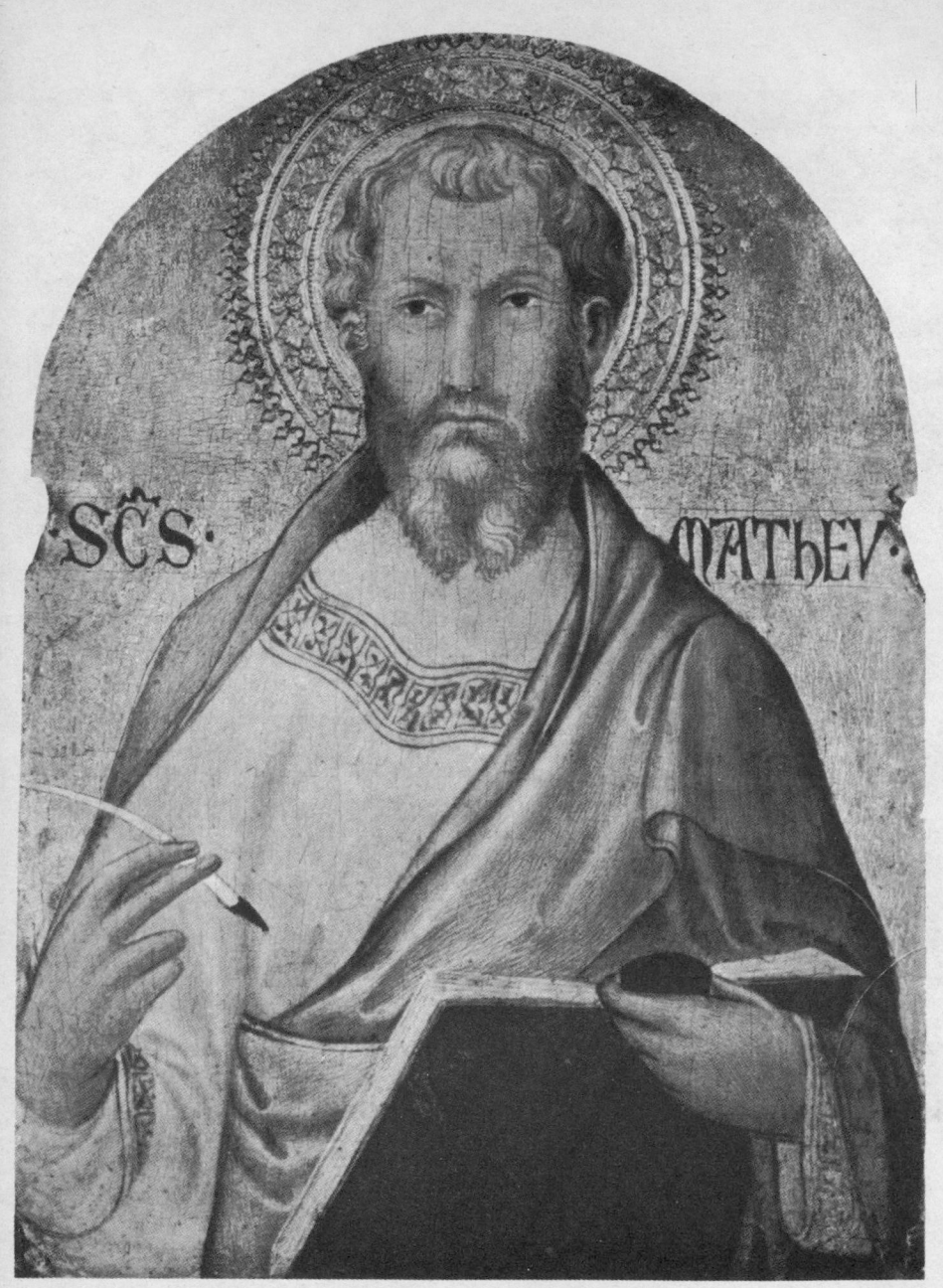

·SCS· MATHEV

94. Simone Martini and Assistants: *St. Matthew*. National Gallery of Art, Washington

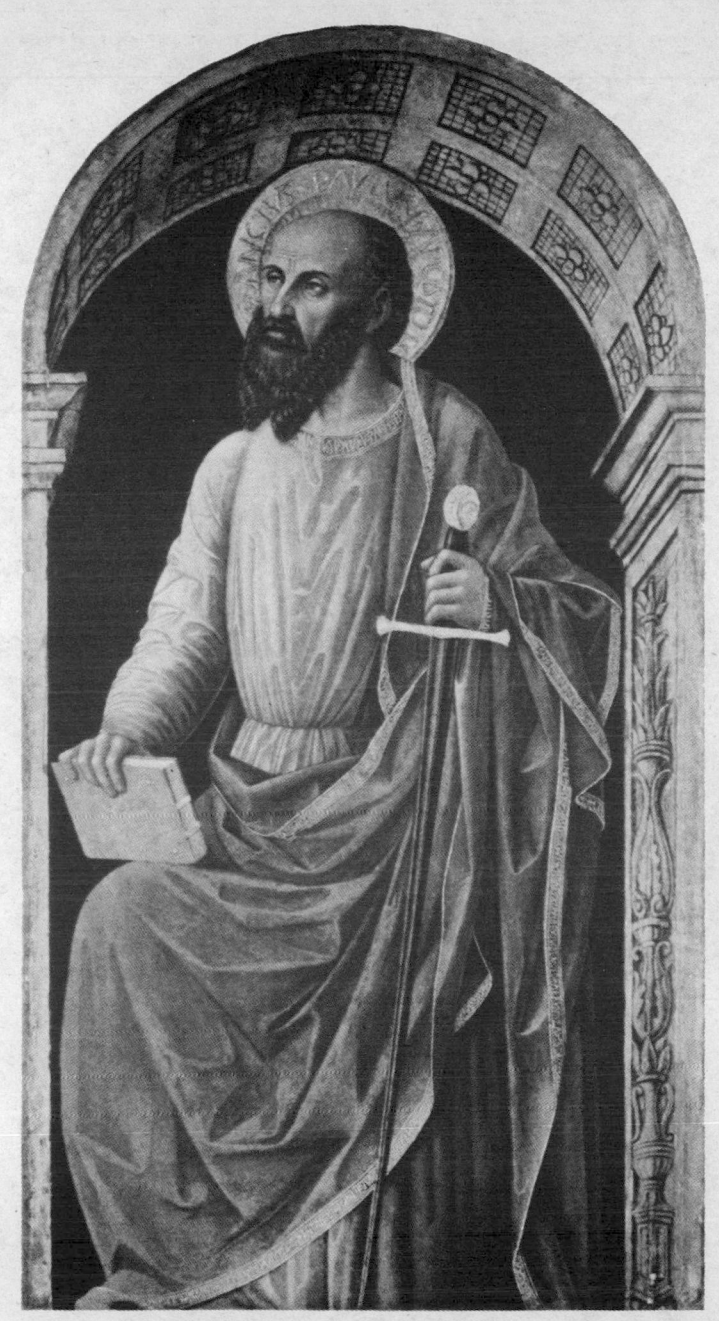

95. Vincenzo Foppa: *St. Paul the Apostle.*
Isaac Delgado Museum of Art, New Orleans, Louisiana

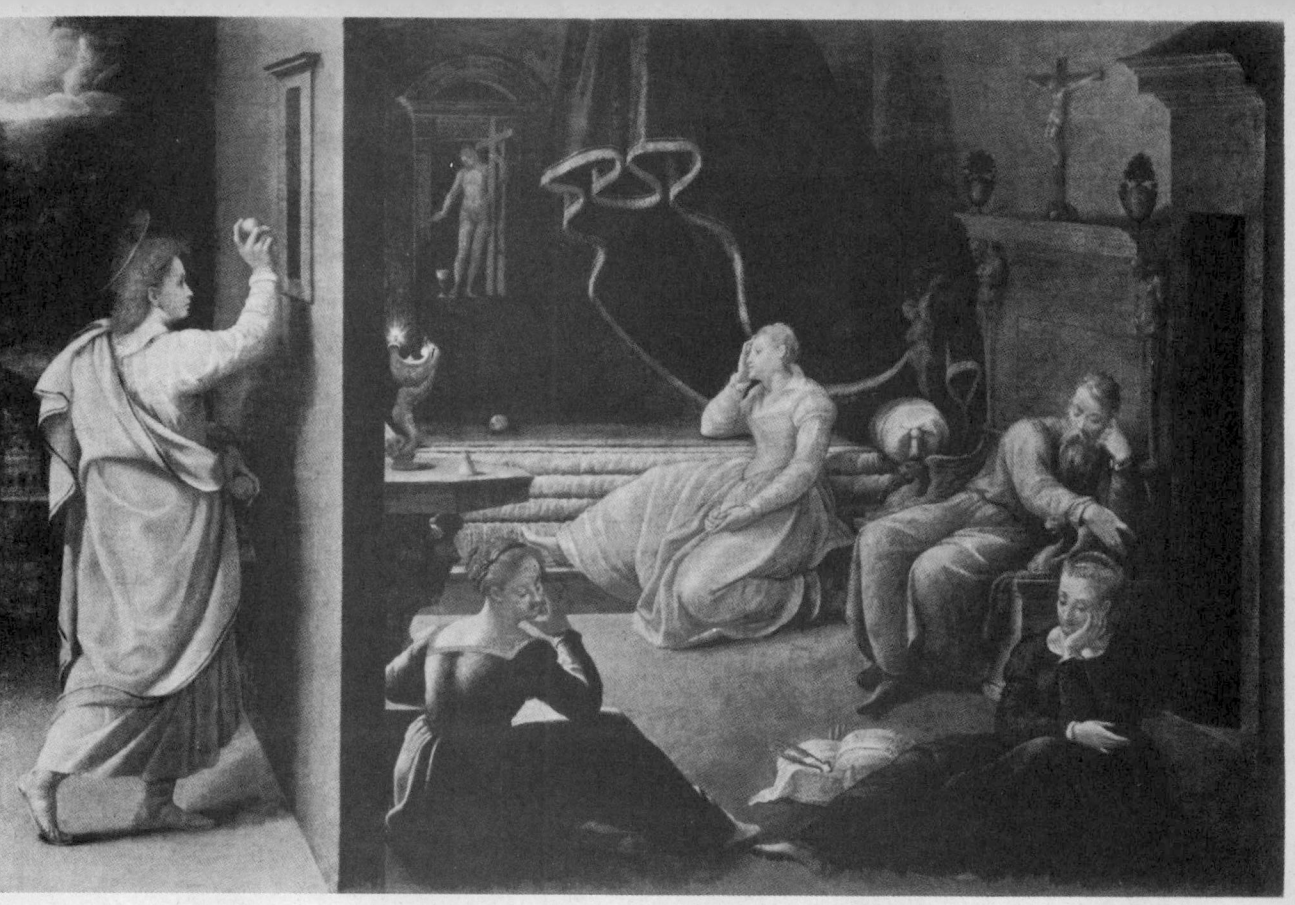

96. Pietro Candido: *A Scene from the Life of St. Nicholas*. Columbia Museum of Art, Columbia, South Carolina

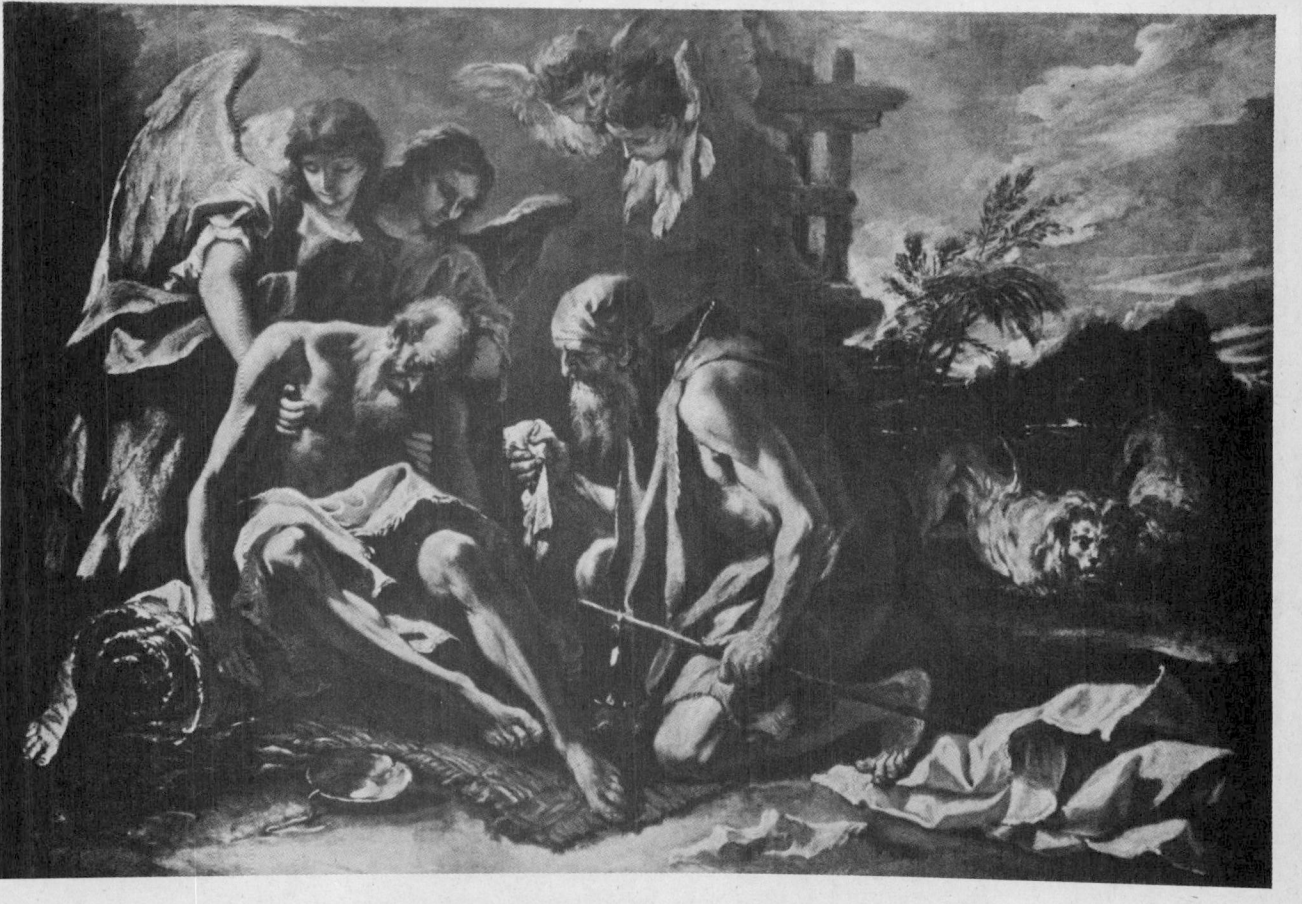

97. Sebastiano Ricci: *The Death of St. Paul the Hermit.* University of Kansas, Lawrence, Kansas

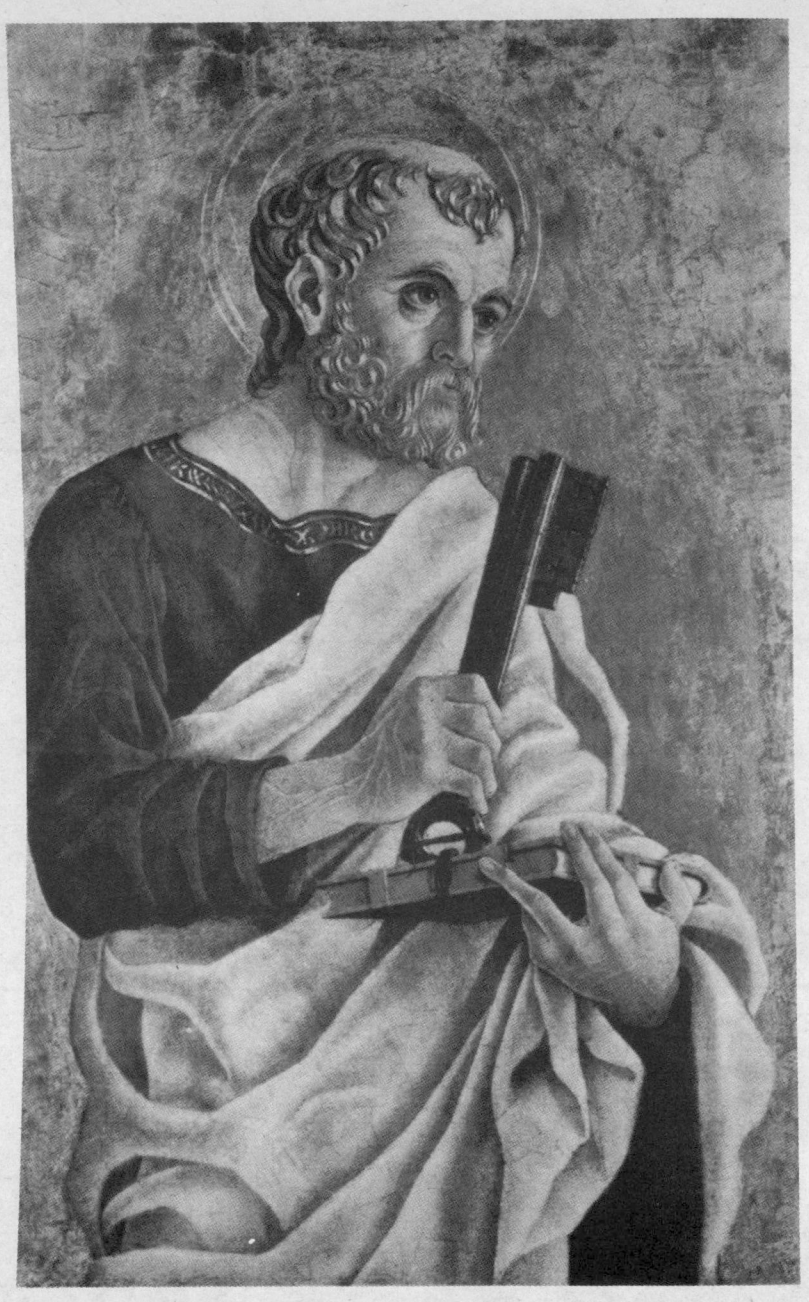

98. Marco Zoppo: *St. Peter*. National Gallery of Art, Washington

99. Andrea Bregno: *St. Philip*. Marble relief.
William Rockhill Nelson Gallery of Art, Kansas City, Missouri

100. Master of St. Gilles, late 15th Century: *The Conversion of an Arian by St. Remy.*
National Gallery of Art, Washington

101. Master of St. Gilles: *The Baptism of Clovis*.
National Gallery of Art, Washington

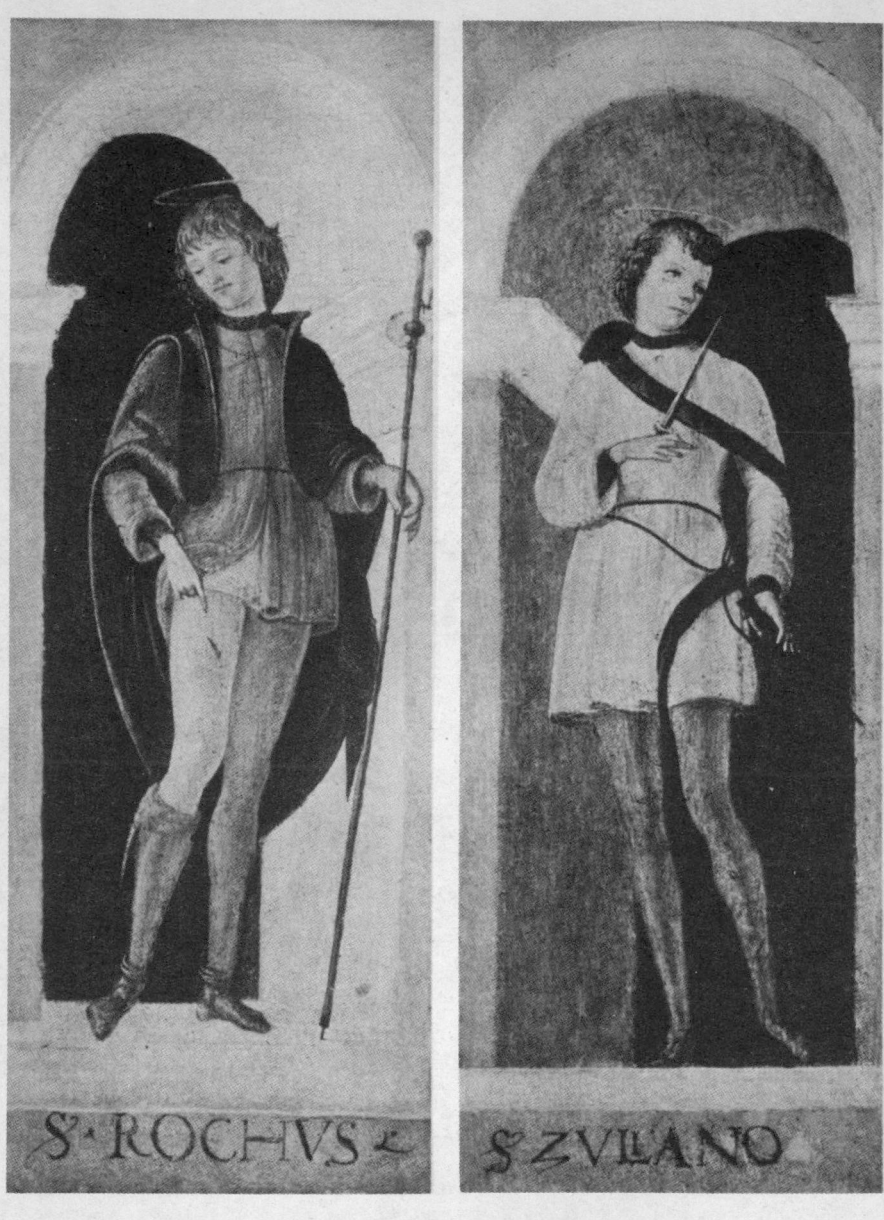

102. Attributed to Lorenzo Costa: *St. Roch* and *St. Julian*.
Atlanta Art Association Galleries, Atlanta, Georgia

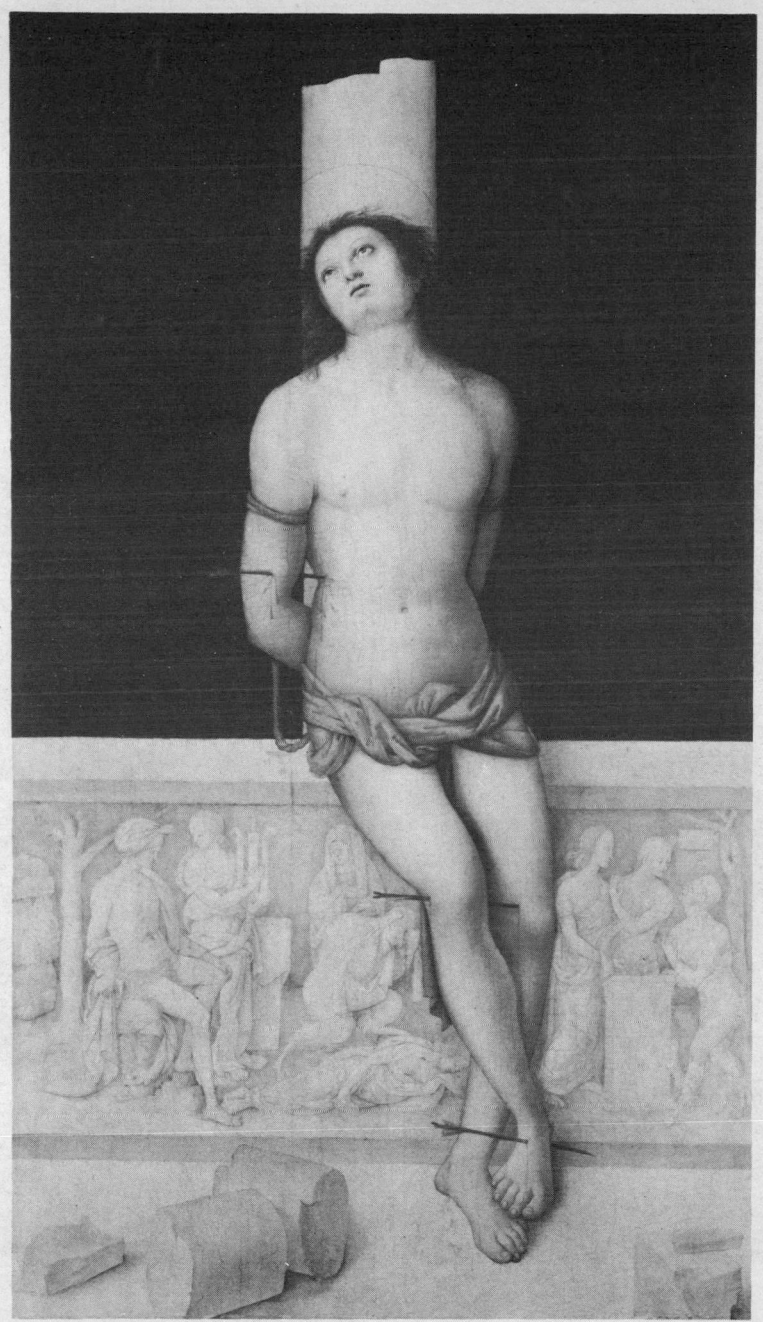

103. Amico Aspertini: *St. Sebastian*. National Gallery of Art, Washington

104. Vittore Carpaccio: *St. Stephen* and *St. Peter Martyr*.
Philbrook Art Center, Tulsa, Oklahoma

105. Master of Fucecchio: *Madonna and Child between St. Stephen and St. Lawrence.*
Bucknell University, Lewisburg, Pennsylvania

SANTVS SYMON

106. Simone Martini and Assistants: *St. Simon*. National Gallery of Art, Washington

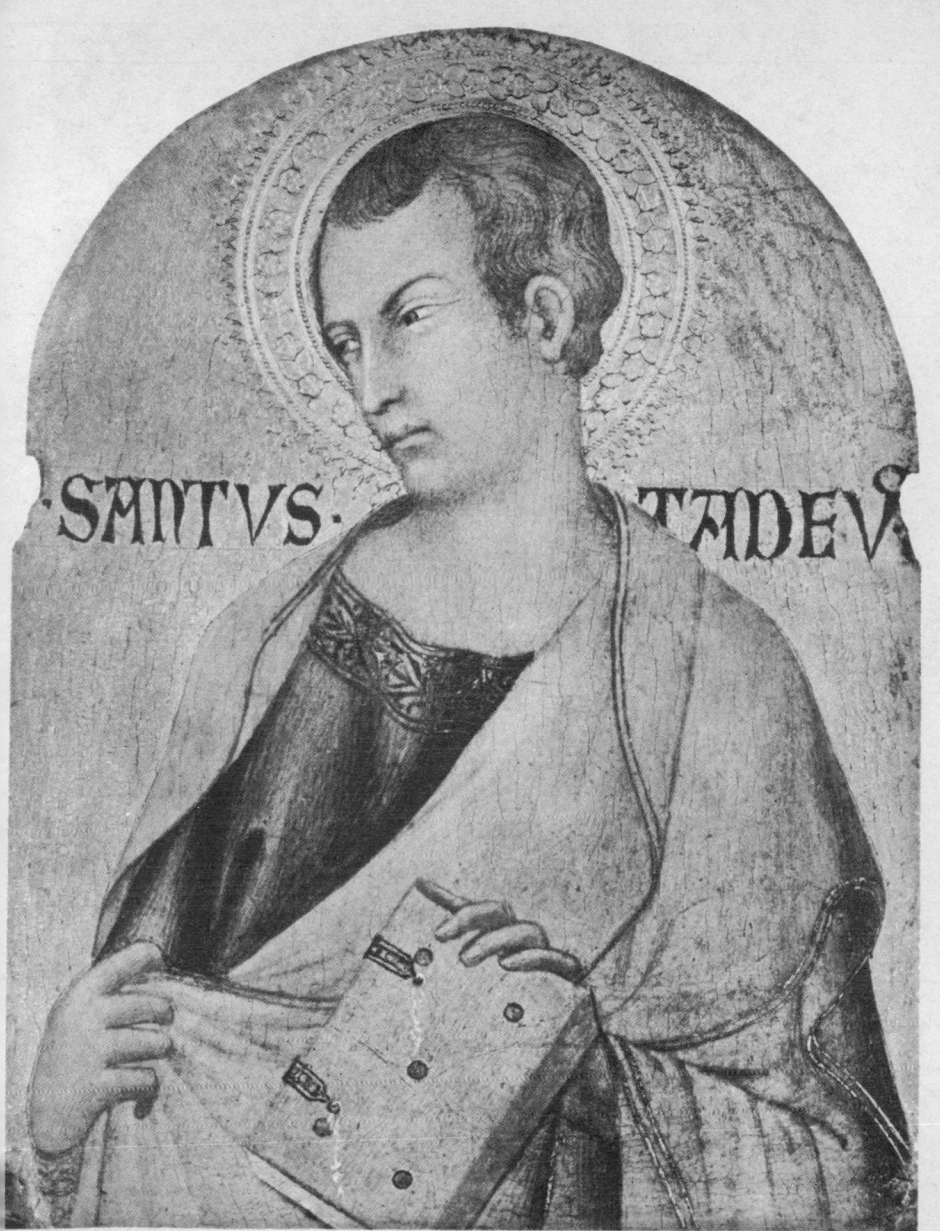

·SANTVS· TADEV

107. Simone Martini and Assistants: *St. Thaddens*. National Gallery of Art, Washington

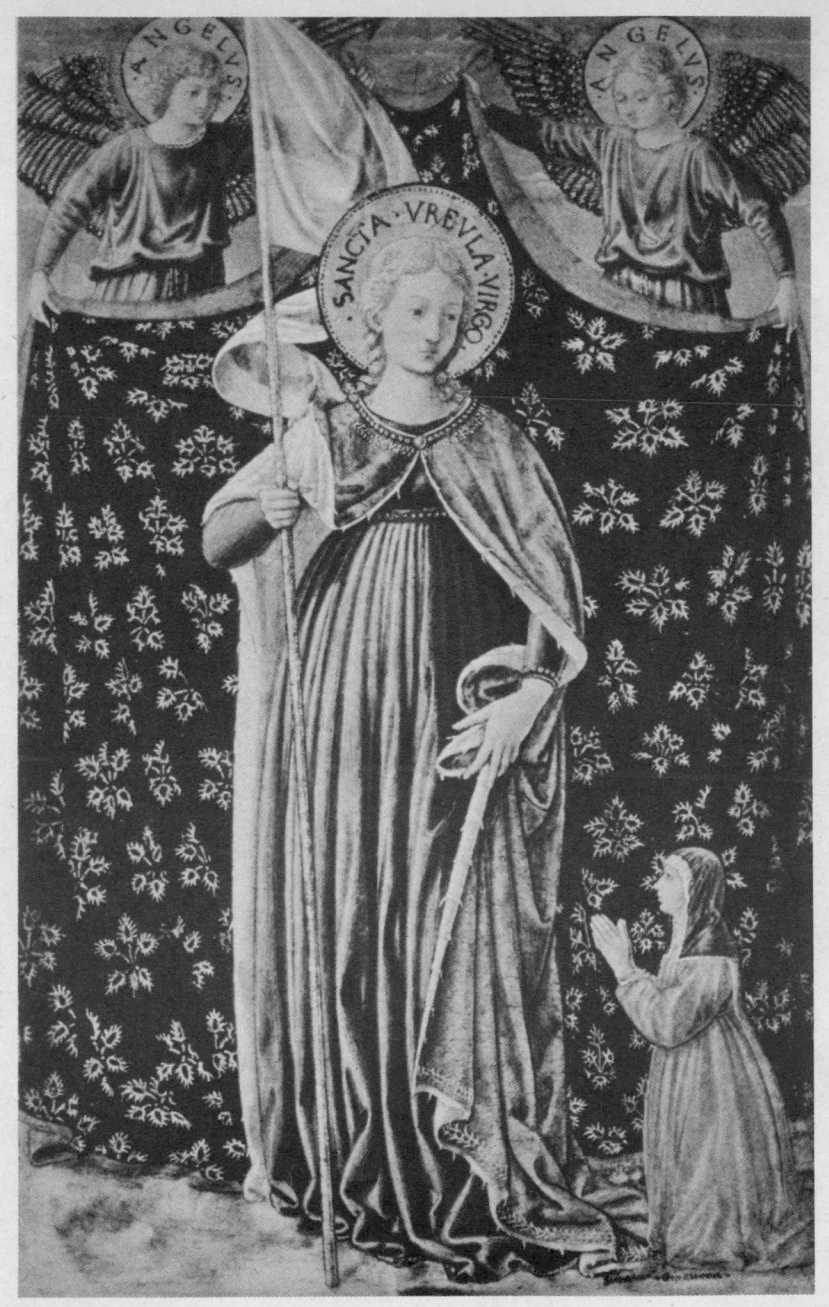

108. Benozzo Gozzoli: *St. Ursula with Angels and Donor*. National Gallery of Art, Washington

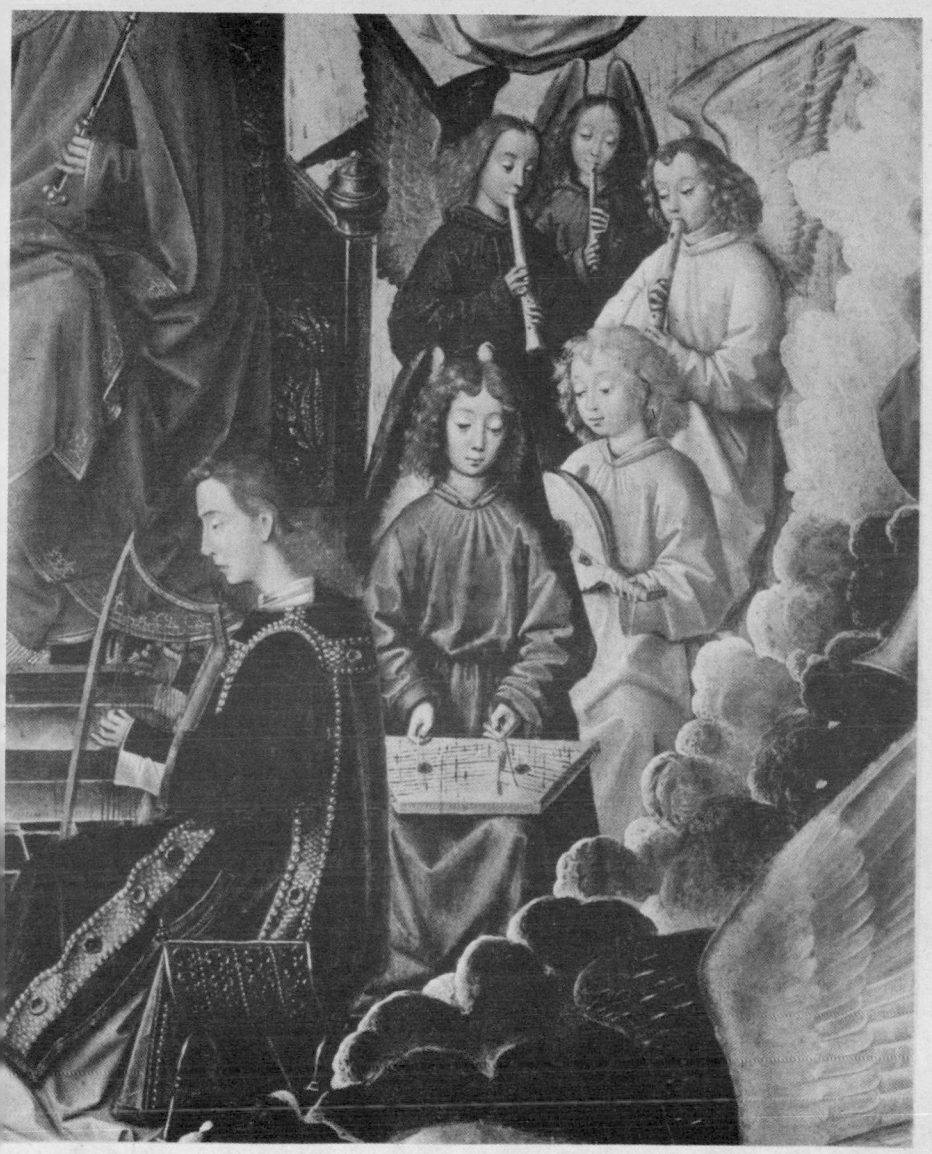

109. Master of the St. Lucy Legend and Assistant: *Angels with Musical Instruments.*
Detail from 'Mary, Queen of Heaven'. National Gallery of Art, Washington (see Pl. 32)

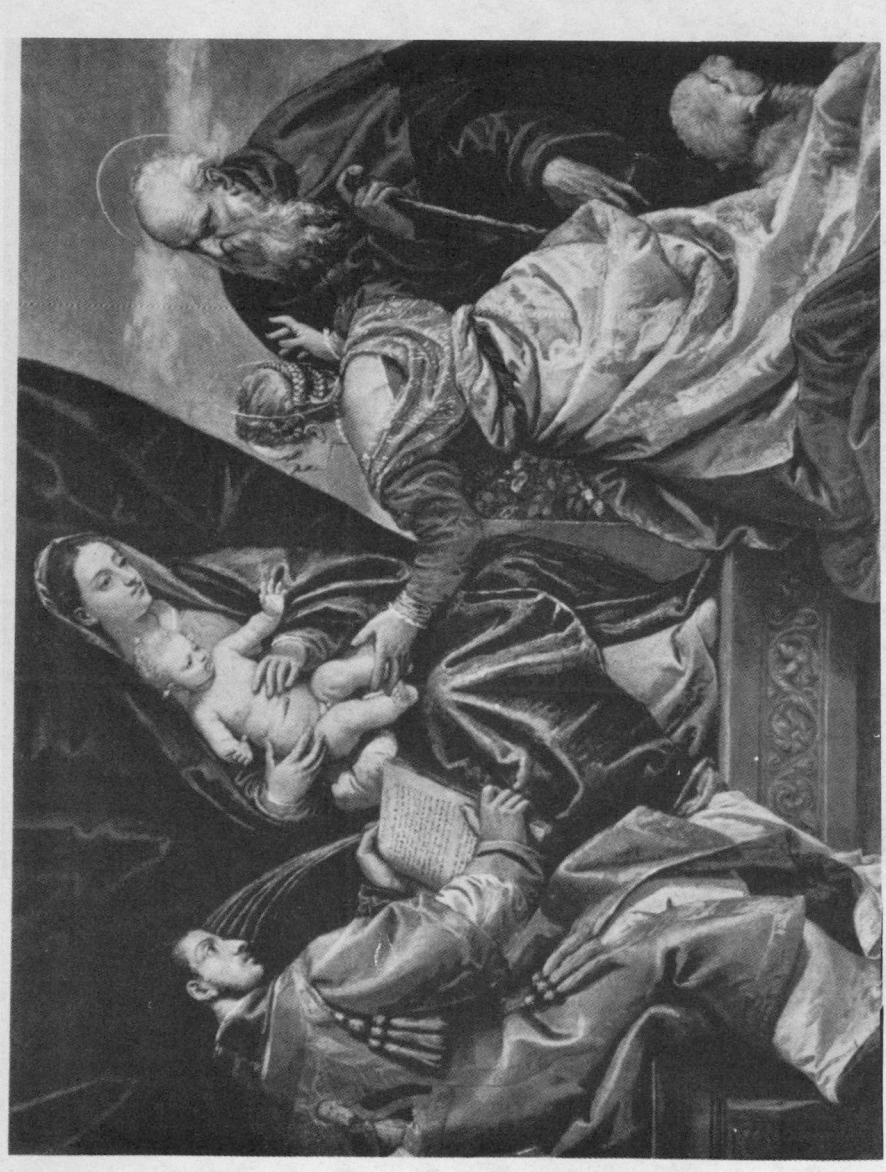

110. Paolo Veronese: *Sacra Conversazione*: Madonna and Child with Saints Lawrence, Agnes and Anthony Abbot. Isaac Delgado Museum of Art, New Orleans, Louisiana

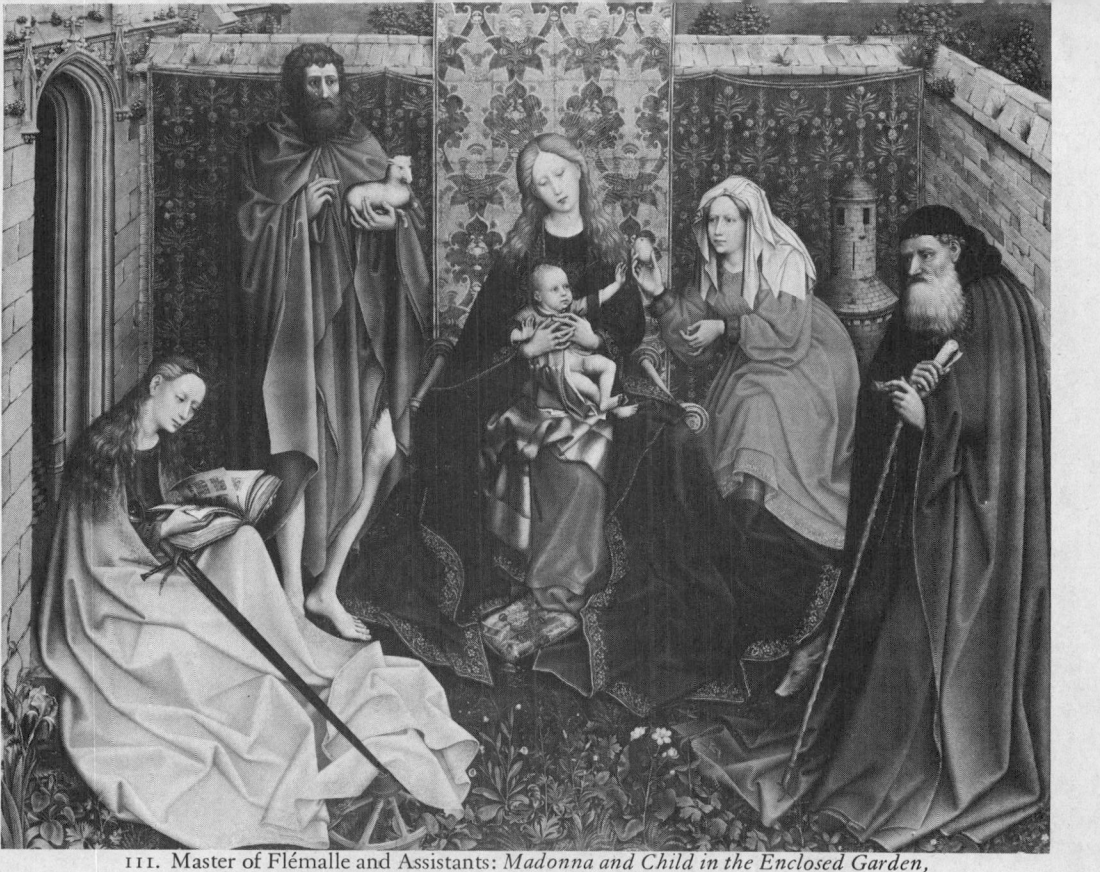

III. Master of Flémalle and Assistants: *Madonna and Child in the Enclosed Garden,
with Saints Catherine of Alexandria, John the Baptist, Barbara and Anthony Abbot.*
National Gallery of Art, Washington

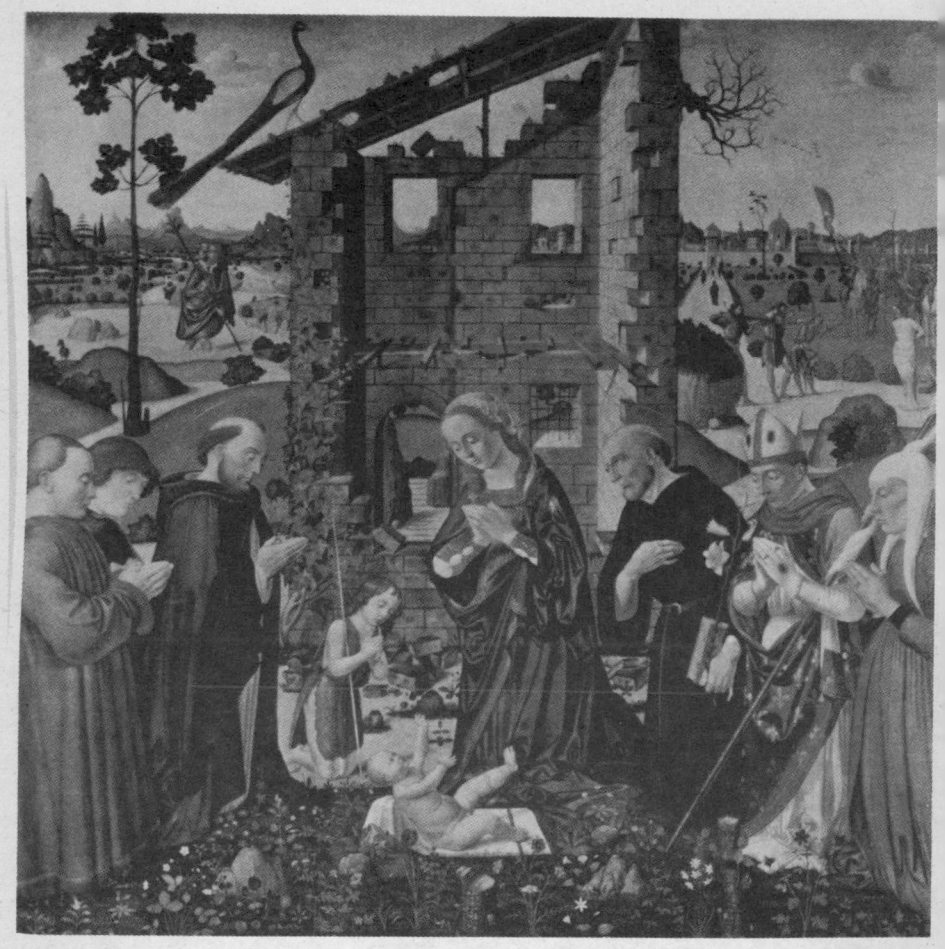

112. Biagio d'Antonio da Firenze: *Adoration of the Child with Saints and Donors*. Left to right: Donor and his son, St. Dominic, St. John the Baptist, St. Nicholas of Tolentino, St. Louis of Toulouse, the donor's wife. In the background, left, St. Christopher, right, St. Sebastian. Philbrook Art Center, Tulsa, Oklahoma

Angels and Archangels. The word 'angel' means a messenger, a 'bringer of tidings.' Mention of the angels and of their office as 'messengers and ministers from God' is so frequent in the Scriptures that belief in their existence is embedded in the Christian tradition. In this tradition the angelic host is divided into three tiers, or hierarchies, and each of these is in turn divided into three choirs. The most commonly accepted division and order of the angelic host is that established by Pseudo-Dionysius the Areopagite, as follows:

First Hierarchy: Seraphim, Cherubim, Thrones.

Second Hierarchy: Dominations, Virtues, Powers.

Third Hierarchy: Princedoms, Archangels, Angels.

In the *First Hierarchy* the Seraphim are absorbed in perpetual love and adoration immediately around the throne of God. Seraphim, as representatives of Divine Love, are usually painted in red color and sometimes hold burning candles. The Cherubim know God and worship Him. Cherubim, representing Divine Wisdom, are portrayed in golden yellow or in blue. They are sometimes shown holding books. The Thrones sustain His Seat. Thrones represent Divine Justice. Frequently they wear the robes of judges and carry the staff of authority in their hands. They are believed to receive their glory directly from God and to bestow it upon the Second Hierarchy. The *Second Hierarchy*, composed of the Dominations, Virtues, and Powers, is made up of the regents and the governors of the stars and the elements. They, in turn, illuminate the Third Hierarchy with the glory which they have received. Dominations are crowned, carry sceptres, and sometimes orbs, as emblems of authority. They represent the Power of God. Virtues carry white lilies, or sometimes red roses as symbols of Christ's Passion. Powers are often dressed in full armor as victorious warriors against the hordes of evil devils. It is through the *Third Hierarchy*, the Princedoms, Archangels, and Angels, that the heavenly contact is maintained with the created universe and with man, for these are the executors of the Will of God. In relation to man the Princedoms are the dispensers of the fate of nations; the Archangels are the warriors of heaven; the Angels are the guardians of the innocent and the just. Both Archangels and Angels are the messengers of God to man. In addition to the functions already listed, the angelic hosts act as the choristers of heaven.

Archangels. In spite of the fact that angels are almost universally represented in Renaissance art, only the archangels have assumed an individual form with definite character and attributes. Revelation 8: 2 mentions 'the seven angels which stood before God,' but they are not acknowledged by name in the Church. Seven great angels are occasionally introduced as being in atten-

dance at the Crucifixion, in scenes of the Last Judgment, and in the Pietà. More often, they are used as decorative figures.

The four archangels mentioned in the Scriptures are Michael, Gabriel, Raphael, and Uriel. According to the Hebrew tradition, these four archangels sustain the throne of God. Of these four, only the first three are given distinct personalities and have been accorded the title of saint. As heavenly messengers, guides, and protectors of the church militant on earth, their gracious beauty, divine prowess, and lofty relations with mortal man have made them most prominent in Christian art.

St. Michael. The name of the Archangel Michael means 'like unto God.' Christian tradition describes him as the Captain-General of the hosts of heaven, the Protector of the Jewish nation who became, after the Christian revelation, the Protector of the Church Militant in Christendom. God has bestowed upon Michael many and great privileges. It is he who will sound the last trumpet at the general resurrection; 'In a moment, in the twinkling of an eye, at the last trump: for the trumpet shall sound and the dead shall be raised incorruptible, and we shall be changed' (I Corinthians 15: 52). It is his office to receive the immortal spirits when they are released from death and to weigh them in a balance; 'Thou art weighed in the balances, and art found wanting' (Daniel 5: 27). His office of Protector of the Hebrew nation led him to become the guardian of the redeemed in Christendom against his old adversary, the Prince of Hell.

The representations of St. Michael the Archangel in the Renaissance era were many. He is invariably depicted as young and beautiful, and most often clothed in a dazzling coat of mail with sword, spear, and shield. Resplendent wings rise from his shoulders. He sometimes wears a jeweled crown. Most frequently he is doing battle with Satan, who is represented as a serpent, dragon, or demon. This refers to the dramatic description in Revelation 12 7–9, 'And there was war in heaven: Michael and his angels fought against the dragon; and the dragon fought and his angels, and prevailed not; neither was their place found any more in heaven. And the great dragon was cast out, that old serpent, called the Devil, and Satan, which deceiveth the whole world: he was cast out into the earth, and his angels were cast out with him.' When Michael is represented carrying scales, or balances, in his hand he is acting in his office as the weigher of souls.

St. Michael frequently appears in Old Testament paintings, such as the Sacrifice of Isaac, Moses and the Burning Bush, with Joshua at Jericho, and at the Rebuking of David. He plays an important part in the legends of the Virgin, and it was Michael who was sent to announce to the Virgin her approaching death.

St. Gabriel. The Archangel Gabriel, together with Michael and Raphael, is given the title saint in the Christian Church. His name means 'God is my strength.' He is the guardian of the celestial treasury, the Angel of Redemption, and the Chief Messenger of God. It is in this latter office that he figures so prominently in the Christian tradition.

It is Gabriel who is sent to Daniel to announce the return of the Jews from their captivity. He foretells the birth of Samson in the likeness of a 'man of God with the countenance of an angel' (Judges 13). It is Gabriel who appears to Zacharias in the temple and tells him that his wife Elisabeth shall bear a son who shall be called John. He is the Angel of the Annunciation; 'And in the sixth month the angel Gabriel was sent from God unto a city of Galilee, named Nazareth, to a virgin espoused to a man whose name was Joseph, of the house of David; and the virgin's name was Mary. And the angel came in unto her, and said, Hail, thou that art highly favoured, the Lord is with thee: blessed art thou among women' (Luke 1: 26-28). As the Angel of the Annunciation, Gabriel usually bears in his hand a lily or a sceptre; in the other he carries a scroll upon which is inscribed *Ave Maria, Gratia Plena* (Hail Mary, full of grace).

In the earlier paintings of the Annunciation, Gabriel is usually shown as a majestic figure and richly robed. He wears a crown and bears a sceptre to indicate sovereignty. His wings are large and many-colored. His right hand is extended in salutation and benediction. He is the principal figure, while the Virgin is represented as receiving the angel with the utmost submission and in deep humility. It is to be noted in representations of this scene after the fourteenth century that a change in the importance of the Virgin and Gabriel takes place. The Virgin becomes the more prominent person and the superior being. She is portrayed as the Queen of the Angels. Gabriel no longer carries the sceptre, but he bears a lily as the symbol of the purity of the Virgin. He is usually shown kneeling with his hands folded on his breast.

St. Raphael. The Archangel Raphael, whose name means 'the Medicine of God,' is chief of the guardian angels and the guardian angel of all humanity. He is represented as the benign friend of those he serves. He is usually shown as the protector of Tobias on his journey to Gabael in Media. (See Tobias, The Old Testament, in Section V.) It is from this ancient Hebrew romance that the attributes of Raphael are gathered and portrayed. Raphael is the protector of the young and the innocent. Especially does he watch over and protect the pilgrim and the wayfarer.

He is usually pictured as a kind, mild, and loving person. His dress is that of a pilgrim or traveler: he wears sandals, and his hair is bound with a diadem. He carries a staff in his hand, and there is sometimes a gourd of water or a

wallet slung to his belt. When he is portrayed as a guardian spirit, however, he is richly dressed and a casket or wallet held by a golden belt is slung over his shoulder. He bears a sword in one hand, and the other is raised in the attitude of a warning gesture, as though to say, 'Take heed.'

Christian tradition relates that it was Raphael, in his office of guardian angel, who appeared to the shepherds on Christmas night with the message: 'Fear not: for behold, I bring you good tidings of great joy, which shall be to all people. For unto you is born this day in the city of David a Saviour, which is Christ the Lord' (Luke 2: 10–11).

Uriel. Uriel is portrayed much less frequently than are Gabriel and Michael. The name Uriel signifies 'the Light of God' and, in Milton's 'Paradise Lost,' the archangel is represented as the regent of the sun. Early legend states that it was Uriel who, as ambassador of Christ, appeared to the disciples at Emmaus. (See Jesus Christ, in Section VIII.)

In art, Uriel is usually represented carrying a scroll and a book indicating his role as interpreter of judgments and prophecies.

Prophets. At the time of the Renaissance the general belief was that the Old Testament was to be understood as a record of God's preparing men, in their lives and thinking, for the coming of Christ. The events of the Old Testament were seen as anticipating that which had now come to pass in the Christian era. As the great patriarchs, kings, and leaders of the Old Testament were seen in their similarities to Christ, so the Prophets were honored because they had predicted His coming.

In art, the Prophets were the embodiment of a symbol rather than portraits of actual human beings. For this reason no special attempt was made at characterization. The Prophets are usually a counterpart of the four Evangelists and the twelve Apostles, so that their number may be as many as sixteen, but their selection varies a great deal, and often patriarchs and kings were included with them without discrimination. The Prophets most frequently represented are Isaiah, Jeremiah, Daniel, Ezekiel, and Jonah. Only Jonah has an attribute which is distinctive: the whale. The other Prophets are usually recognized by a book or scroll upon which their prophecy is written. Besides the Jonah story, there are other illustrations from the books of the Prophets in Italian Renaissance art, notably the Vision of Ezekiel based on Ezekiel I. The best-known examples, of course, are those of Michelangelo on the ceiling of the Sistine Chapel.

Sibyls. The Sibyls are the counterpart of the Prophets. As the Prophets connect the Jewish world with Christianity, so the Sibyls connect the Greek and

Roman world with the Christian era. The Sibyls had considerable prominence in antiquity. Varro, who lived the first century before Christ, says they were ten in number. To these were later added two more. The attributes of the Sibyls vary, just as there is no agreement concerning their prophecies. Those most commonly represented in the Middle Ages were the Erythrean, who is supposed to have foretold the Annunciation, and the Tiburtine. The Latin adjectives indicating the geographical associations of the various Sibyls are as follows: Persica, Libyca, Erythrea, Delphica, Samia, Cumena, Cimmeria, Hellespontina, Phrygia, Tiburtina, Agrippa, or Hebraica, and Europa. These are often inscribed beside the representations of the Sibyls in Renaissance art. Portrayals of the Sibyls are frequent in the Renaissance, either isolated or as a group.

Virtues and Vices, and Liberal Arts. Among the abstract personalities that are frequently represented in Renaissance art are those of the Seven Virtues, the Seven Vices, and the Liberal Arts. The Seven Virtues, all female, are usually as follows:

Faith is represented as a woman with a chalice or a cross, or both. At her feet is St. Peter.

Hope is a winged woman who raises her hands toward heaven. Her standard attribute is the anchor. St. James the Great is at her feet.

Charity usually has children around her and is nursing one of them. Sometimes she holds flames or a heart. St. John the Evangelist is seated at her feet.

Temperance holds a sword or two vases. At her feet is Scipio Africanus.

Prudence may have two heads, and she holds a mirror and a serpent. At her feet is Solon.

Fortitude may have a sword, a club, a shield, a globe, and a lionskin, or a column, in allusion to Samson's destruction of the Philistine temple. At her feet is Samson.

Justice holds scales and a sword. The Emperor Trajan is at her feet.

The first three of these are called the Theological Virtues, while the last four are known as the Cardinal Virtues.

To the Seven Virtues are opposed the Seven Vices, as follows: pride, covetousness, lust, anger, gluttony, envy, and sloth. Their attributes are not clearly defined.

In Renaissance painting, the Seven Virtues are sometimes accompanied by the seven Liberal Arts: grammar, logic, rhetoric, arithmetic, music, geometry, and astronomy. Their attributes are not clearly defined.

SECTION X

The Saints

St. Agatha of Sicily (third century) was a beautiful Christian girl who consecrated her body and soul to the Saviour. Quintianus, at that time the governor of Sicily, heard of Agatha's beauty and had her brought to his palace. In spite of every offer, however, Agatha refused to deny Christ, declaring that she belonged to her Heavenly Bridegroom. Enraged by her refusal to give herself to him, Quintianus resolved to punish her by subjecting her to the most cruel tortures. He had Agatha's breasts torn with shears and ordered that she was to be thrown into a great fire. Divine help saved her. Her wounded breasts were healed during the night by St. Peter and an accompanying angel, while an earthquake saved her from the fire. At last, the weary saint prayed that she might be released from her pain by death, and her prayer was granted.

About a year after her death, the city of Catania was threatened with destruction by a stream of molten lava which poured down from Mt. Etna. The people of the city rushed to the tomb of St. Agatha and, taking her silken veil, carried it upon a lance to meet the advancing river of fire. When the stream of lava met the sacred relic it turned aside, and the town was saved. Many were converted to Christianity by this miracle.

St. Agatha is usually painted carrying in one hand a palm branch as a symbol of victory and in the other a dish or salver bearing two female breasts, in allusion to her martyrdom. The shears, or pincers, instruments of her martyrdom, are sometimes shown in her hand or beside her. She is generally wearing a long veil, with reference to the miracle that saved Catania from the eruption of Mt. Etna.

St. Agnes (Inez) (third century), the child saint of Salerno and Rome, was only thirteen when she consecrated her life to Christianity. She declared herself the Bride of Christ and refused to marry the son of the prefect of Rome, who greatly loved her. The boy's father tried to shake her resolve, first by persuasion and then by shame. He caused her to be brought to a house of ill repute, where she was stripped of her garments. But as she prayed that her body, consecrated to Christ, might be kept pure for His sake, her hair grew to great length and covered her, and a bright and shining robe was sent to her from Heaven. Thereupon the prefect said that she was to be burned, but she stood unharmed in the midst of the flames. Finally, one of the soldiers standing by was told to strike off her head with his sword. After her burial

many Christians came to worship at her grave, and on one occasion she is said to have appeared before them radiant with heavenly glory and with a lamb, symbol of purity, at her side.

In art, St. Agnes is recognizable by her attribute, the lamb. She may have a sword or flames at her feet in token of her martyrdom. She is sometimes shown covered by her long hair or by a long robe.

St. Ambrose (fourth century) is one of the four Latin Fathers of the Church. The son of a Roman prefect, he was born in Treves, in Gaul, and educated at Rome. He himself became a prefect of two Roman provinces and, in this capacity, went to Milan to restore peace in a dispute with the Arians which arose during the election of a new bishop. Legend states that he was addressing the people in Milan one day when a child's voice was heard to declare, 'Ambrose shall be Bishop.' This was taken as a sign from Heaven, and Ambrose was forthwith elected to the post, although he was not at that time even baptized. He devoted himself, however, to his new duties and proved to be a great statesman, theologian, and religious poet. He was responsible for raising the Church services to a new dignity and impressiveness, and he originated the Ambrosian chant, a mode of intoning the liturgy.

St. Ambrose is painted in the dress of a bishop with mitre and crosier and holding a book. Sometimes he carries a scourge, which refers to his part in driving the Arians out of Italy. He is also shown with a beehive, a reference to the legend that, when he was an infant, a swarm of bees alighted on his mouth, thus foretelling his future eloquence.

St. Andrew the Apostle, brother of Simon Peter, the fisherman of Bethsaida in Galilee, was one of the first disciples of Christ. According to tradition, when the Apostles were each allotted a part of the world to evangelize, Andrew was given the country to the north as far as southern Russia. His preaching converted so many people to the Christian faith that the Roman governor of Patrae in Greece feared a popular uprising. He had Andrew arrested and, after subjecting him to all kinds of tortures, had him bound to a cross in order to prolong his sufferings. The cross to which he was tied is believed to have been in the shape of an X, although very early representations of the saint show him tied to the straight cross or to one of the shape of a Y.

The attribute of St. Andrew is the X cross, instrument of his martyrdom. He is the patron saint of Scotland.

St. Anna, according to tradition, mother of the Virgin Mary, appears in many Renaissance works of art. She is shown in scenes of the life of the

Virgin, such as the Meeting at the Golden Gate, teaching her child to read, or in the Presentation of the Virgin in the Temple. She also appears in pictures of the Holy Family with the Christ Child. (See The Virgin Mary, in Section VII.)

Her chief emblems are the green mantle and red dress, symbols of immortality and divine love. She may also be depicted holding a book.

St. Ansanus (third century), born of a noble Roman family, was secretly baptized by his nurse Maxima, when he was a child, and brought up as a Christian. At nineteen, in spite of the persecution of the Christians under the Emperor Diocletian, Ansanus openly declared his faith, and he and Maxima were subjected to the scourge. Maxima died, but Ansanus recovered and was taken as a prisoner to the city of Siena. There he preached the gospel and made many converts. Because of this, he was beheaded by order of the Emperor.

Ansanus was known as the Apostle of Siena and was adopted as a patron saint of that city. His customary attributes are a banner with the Cross and the fountain or baptismal cup.

St. Anthony the Great, or **Anthony Abbot** (fourth century), is one of the figures most frequently portrayed in Renaissance paintings. He was born in Upper Egypt of noble and wealthy Christian parents. After their death, when Anthony was eighteen, his spirit was suddenly awaked. He distributed his worldly goods among the poor and, staff in hand, joined a band of hermits in the desert. His whole future life was devoted to self-denial and spiritual growth. For twenty years he lived alone in a ruin near the Nile, where he strove to overcome all weakness of the flesh and to live for God alone. His struggles with temptations, which he called his 'demons,' have been the subject of many works of art. When he reappeared from his solitude, he had acquired such spiritual strength that many came to live near him in order to be under his guidance. At the age of ninety, he believed that no man had lived so long as he in solitude and self-denial. But he heard a voice saying, 'There is one holier than thou, for Paul the Hermit has served God in solitude and penance for ninety years.' Anthony, therefore, went in search of the Hermit Paul.

On his way he met many wonders and temptations. A centaur and a satyr pointed out the way to him, while an ingot of gold was placed on his path by the Devil to stop him. But the saint dispelled all temptations with the sign of the Cross, and finally reached the cave where Paul was living. When they met, Paul told how each day for sixty years a raven had brought him half a loaf of bread. The two old men started to live together in the desert, and the

raven thereafter brought, every day, a whole loaf of bread. After Paul's death, Anthony returned to his own dwelling, where he remained for fourteen years, until his own death at the age of one hundred and five.

St. Anthony is regarded as the father of monasticism. He is, therefore, usually represented in the hood and robe of a monk. On his left shoulder is a blue T, originally a theta, the first letter of the word 'Theos,' which means 'God' in Greek. He bears a crutch, significant of his great age, and carries a bell, either in his hand or suspended from his crutch. The significance of this attribute is explained in different ways. The most common belief is that it symbolizes the ability of the saint to exorcize demons and evil spirits. A hog, representative of the demon of sensuality and gluttony, often accompanies St. Anthony as an indication of the saint's triumph over sin.

As a reminder that a vision of the flames of hell killed in St. Anthony the desires of the flesh, the saint is sometimes represented with flames under his feet.

St. Anthony of Padua (thirteenth century) was born in Lisbon and brought up in the cathedral school of that city. He first joined the Order of St. Augustine but, having heard much of the holiness of St. Francis, he sought out the founder of the Franciscans in Assisi. St. Francis at first thought Anthony was a simple, well-meaning youth, but after Anthony had had an opportunity to preach, St. Francis appreciated the young man's oratorical ability and entrusted to him much of the educational work of the Order. Anthony soon became the favorite disciple and close friend of Francis. He developed a wonderful gift of preaching and was greatly beloved by the people. He taught divinity at Bologna, Montpellier, Toulouse, and at Padua, where he died at the early age of thirty-six.

Several legends are told about this saint. Among them is the story of the heretic of Toulouse who refused to believe in the presence of Christ in the Eucharist unless his ass left its stable and knelt before the Sacrament. A few days later, when St. Anthony was leaving the church to carry the Eucharist to a dying man, the ass met him at the steps and knelt before the Sacrament. Because of this legend, St. Anthony is frequently portrayed with a kneeling ass. He is generally painted in the robe of the Franciscan Order. In his hands are often seen his other attributes in art: the lily, the flowered Cross, the fish, a book, and fire. Especially after the Renaissance he came to be represented carrying the Christ Child. He is the patron saint of Padua.

St. Apollonia (third century). It is said in Alexandria there was a magician who was held in great esteem by the pagan population. He ordered a general persecution of the Christians because they despised and destroyed the gods he

worshiped. Many Christians left the city to avoid death, but Apollonia, a deaconess of the Church, remained in the city to comfort the few who were left there. She awaited her martyrdom with joy, preaching the Christian faith and making many converts. For this she was arrested by the authorities and ordered to sacrifice to the gods of the city. The saint, however, made the sign of the Cross before the idols she was ordered to worship, and the statues broke into a thousand fragments. As punishment she was bound to a column and her teeth were pulled out by pincers. She was then taken outside the city, where a great fire had been prepared for her death. But Apollonia, far from being afraid, cast herself into the fire and offered her body to Christ. Her attributes are the palm of martyrdom and a pair of pincers holding a tooth. She is the patron saint of dentists.

St. Augustine (fifth century), one of the four Latin Fathers of the Church, was born in Numidia and educated in Carthage. He then went to Rome, where he studied law and became noteworthy for his learning. His mother, Monica, was a Christian and sought to have him follow the doctrine of the Church. Augustine, however, having previously embraced the Manichean teaching, refused her plea, although he became increasingly aware of a great moral struggle within himself. His argument for rejecting the Christian faith was that it was too simple, and valuable only for simple minds. It was not until he came to Milan, as professor of rhetoric, that he was attracted to Christianity. It was the influence of St. Ambrose, then Bishop of Milan, that finally led him to accept the Christian faith. He made a public confession and received baptism. It was on this occasion that the *Te Deum* was sung for the first time.

Augustine later became Bishop of Hippo, in Africa, where he remained for the rest of his life, and where he died of fever at the age of seventy-six during the siege of the city by the Vandals. He had a tremendous influence on the Christian religion, both through his writings and his spiritual example. In his famous literary work, his *Confessions*, he told the story of his spiritual life. St. Augustine is generally painted in the habit of a bishop bearing a book and pen, in reference to his writings. His special attribute, however, is a flaming heart, sometimes pierced by an arrow, suggestive of his flaming piety and love of God.

One episode of his life has been frequently represented. The story is that, while walking along the seashore, St. Augustine came upon a small boy who was apparently trying to empty the entire ocean into a hole in the sand. The saint remarked to the youngster that he was seemingly attempting the impossible. To this the boy replied, 'No more so than for thee to explain the mysteries on which thou art meditating.'

St. Barbara (third century) was born either at Heliopolis in Egypt or at Nicomedia in Asia Minor. She was brought up by her father, a rich heathen, who loved her very much and was fearful some man would marry her and take her away. According to the legend, he therefore built for her a high tower, richly furnished, where she was jealously guarded from the world. Hearing of Christianity, she became interested and arranged to receive a Christian disciple disguised as a physician. She was converted and baptized. One day, during her father's absence, realizing that her tower had but two windows, she commanded the workmen to make a third. On her father's return, she confessed her new faith to him and explained that the soul received its light through three windows: the Father, Son, and Holy Ghost. Enraged at her conversion to Christianity, the girl's father gave her up to the authorities, who ordered her to be tortured. Finally, at his own request, her father was permitted to strike off her head. As he returned home after committing this awful deed, the father was killed by a bolt of lightning, which struck him down in the midst of a great crash of thunder. Because of this thunderous punishment, St. Barbara has become the patron saint of artillery and hence of soldiers, gunsmiths, and fire fighters. She is invoked against accidents and sudden death.

Her invariable attribute is the tower, generally with three windows. She also sometimes carries the sacramental cup and wafer, and is the only female saint who bears this attribute. She does so in reference to her last wish. At the moment of her death, the saint requested the grace of the Sacrament for all who would honor her martyrdom. A peacock's feather, which is also her attribute, refers to Heliopolis, the city of her birth. This city was said to be the place in which the fabulous phoenix rejuvenated itself. Since the phoenix was unknown in the West, a peacock was substituted as emblem of the city.

St. Bartholomew, Apostle, is one of Christ's disciples about whom little is known. The tradition is that he traveled east as far as India. While preaching in Armenia, on his return journey, he was seized by the heathens, flayed alive, and then crucified. Thus, his invariable attribute is a large knife of peculiar shape, the instrument of his martyrdom. He is occasionally portrayed bearing a human skin over one arm, which indicates his flaying.

St. Benedict (sixth century), founder of the Benedictine Order, was born near Spoleto at Norcia, in what is now Umbria. At an early age, he became a hermit and attracted many disciples because of the holiness of his life. In order to provide a rule of life for his followers, he established them in twelve monasteries, with a Superior in charge of each. At Monte Cassino he established the great monastery, and there he wrote the basic rules that have

served as a guide for most of Western monasticism. His sister, Scholastica, became the head of the first community of Benedictine nuns.

St. Benedict is usually shown with a flowing beard, often white, and dressed in the habit of a Benedictine abbot, wearing either the black robe of the original habit of the Order or the white robe of the Reformed Order. Several attributes are given to him, each referring to some well-known episode in his life. A dove represents the soul of his sister Scholastica, which he saw ascending to Heaven at her death. A crystal glass with a serpent or a broken glass with wine running from it recalls the poisoned wine that was once offered to him in an attempt upon his life. A raven recalls the bird that he fed when, as a hermit, he was living in a cave. The index finger sometimes shown across his lips is an allusion to the rule of silence which he gave to his Order. A broken vessel is given to him in reference to the legend of the miracle he once performed in joining together the fragments of a pot broken by his nurse. A luminous ladder refers to the ladder on which he is said to have ascended to Heaven. He is also sometimes represented as a naked youth rolling in a thorny bush to punish his flesh for the sin of lust. A blackbird, referring to his temptation by the Devil, is shown frequently. He is often painted in company with two youths, Maurus and Placidus, who were his close friends and are among the important saints honored by the Benedictine Order.

A famous legend tells how on one occasion Placidus left the monastery in which they were living to fetch a pail of water from a near-by lake. In so doing, he slipped and fell into the water and was in danger of drowning. Aware of the situation, Benedict called to Maurus to go to the assistance of their brother monk. Maurus ran toward Placidus and, seizing him by the hair, dragged him to safety. Only after he had returned to the shore of the lake did Maurus realize that he had actually walked upon the water.

St. Bernard (twelfth century), abbot of Clairvaux in France, was a descendant of one of the greatest families of Burgundy. He studied at the University of Paris and, at the age of twenty-three, entered the parent monastery of the Cistercian Order at Cîteaux. His qualities of leadership were such that only two years after he had entered the monastery of Cîteaux he was sent with twelve disciples to found a new monastery. The place chosen was Clairvaux. Here Bernard became the great spiritual leader of all Europe. Even the kings of England and France gave heed to his advice and moral persuasion. He was largely instrumental in influencing Louis VI of France to undertake the Second Crusade.

Bernard is usually represented in the white habit of the Cistercian Order with a book or pen in his hand, indicative of his position as head of his Order and

of his quality of Doctor of the Church. He is sometimes shown with a demon in chains to represent his defeat of heresy; with three mitres at his feet in reference to the three bishoprics that he refused; or with a beehive in token of his eloquence. The Cross and the instruments of the Passion refer to his main mystic writing, the *Meditations*.

St. Bernardino of Siena (fifteenth century) was born of a patrician family of that city. As a youth, he built himself a small chapel outside the city where he devoted himself to a life of severe asceticism. He later studied law at Siena, where, in 1400, a terrible outbreak of the plague took place. For months Bernardino worked to help the stricken people. He then determined to join the Order of St. Francis and to give away all his possessions. After he had been ordained a priest, he journeyed throughout Italy and became tremendously influential in both religious and public affairs. He was offered three bishoprics, which he refused in order to continue as a missionary. At one time, he was accused of heresy by Pope Martin V because of the tablet, inscribed with IHS, the Greek letters symbolizing the name of Jesus, which he used in preaching. At his trial in Rome, he was triumphantly acquitted, and he became known as the founder of the 'cult of the devotion to the name of Jesus,' which led to the public display of the Holy Name.

Bernardino is generally represented in the Franciscan habit bearing a tablet or sun inscribed with IHS, or a heart. In some paintings mitres, which are symbolic of the three bishoprics he refused, are depicted.

St. Blaise (third century), Bishop of Sebaste in Armenia, was a physician by profession. Moved by divine inspiration, he retired to a cave in the mountains where he lived in contemplation, surrounded by wild animals. Instead of attacking him, however, the savage beasts welcomed him and fawned upon him, and came to him when they were sick or wounded. Here, one day, he was discovered by some of the emperor's huntsmen, who believed him to be a magician and took him prisoner. Brought before Licinius, he was sentenced to be tortured by having his flesh torn with iron combs and afterward to be thrown into a lake. The story continues that through divine help the saint's wounds were healed, and he walked upon the water, preaching to the multitudes. Thereafter he was beheaded.

In Renaissance painting, the saint is represented as an old man with a white beard, attired as a bishop. He holds an iron comb in allusion to his martyrdom, and a lighted candle in memory of his dying wish for the healing of the sick. He is a patron saint of wild animals. St. Blaise is invoked against sore throats because of the legend that he once saved a child from choking after it had swallowed a fish bone.

St. Bonaventura (thirteenth century). According to legend, the name of this saint may be traced to his infancy when, seriously ill, he was taken by his mother and laid at the feet of St. Francis, who was asked to intervene to save the child's life. The child recovered and St. Francis exclaimed, 'O buona ventura!' (Oh good fortune). The mother then dedicated her child to God under that name.

Born at Bagnorea in Tuscany in 1221, Bonaventura joined the Franciscan Order in 1251 and eventually became its Minister General. He was a profound student, theologian, and mystic, and is recognized as the great scholar of the Franciscans, being called the Seraphic Doctor. Among his well-known writings, of particular interest is his life of St. Francis. He died in Lyons in 1274 while acting as secretary to Pope Gregory X.

According to legend, when the ambassadors of the Pope came to Bonaventura to make him a cardinal, they found him washing his dinner plate. He asked the emissaries to hang his cardinal's hat on the limb of a tree until he was ready to receive it. Therefore, Bonaventura is frequently painted with the cardinal's hat hanging beside him or at his feet. Bonaventura was too humble in spirit to go to the altar to receive the Holy Sacrament, whereupon an angel brought it to him. An angel bearing the sacramental wafer is sometimes shown in paintings of the saint. Other attributes of the saint are the Cross and the chalice. He is usually portrayed in the habit of the Franciscans, sometimes as a cardinal, sometimes as a friar, but always clean-shaven.

St. Catherine of Alexandria (third century) was born at Alexandria in Egypt, of a noble and illustrious family, some say of royal blood. The rich legend of this widely loved saint relates that before she was baptized she had a remarkable dream. In it she saw the Virgin Mary holding the Christ Child in her arms. The Virgin asked Jesus to take Catherine as a servant. But the Child averted His head and said that she was not beautiful enough. When she awoke, Catherine, who was famous for her beauty and her learning, began to wonder how to please the Divine Child, and found no peace until she was baptized. After her baptism, Christ appeared to her again in a dream and took her as His celestial spouse. He put a ring on her finger, which the saint found upon awakening and which she kept for the rest of her life.

At this time Maximin II, who shared the imperial crown with Constantine the Great and Licinius, selected Alexandria as the capital of his part of the Empire. He had pledged himself to the persecution of all Christians and ordered the massacre of all who refused to sacrifice to the gods. Catherine, dedicated to preaching the Christian faith, determined to see the emperor and open his eyes to his cruelty. She delivered such a learned speech that the emperor was taken aback, and decided to gather the most famous philosophers

of his realm to refute her teaching. Catherine accepted the challenge and, by her eloquence and intelligence, converted the philosophers to her faith. Enraged, the emperor had the wise men beheaded, and imprisoned Catherine in a dungeon, where he sought to starve her into submission. Angels, however, brought her food, and Catherine succeeded in converting the wife of the emperor and all her retinue. In blind fury, the monarch passed the death sentence on all Christians except Catherine. Overcome by her serene beauty, he offered to make Catherine his wife and empress of the world, but she indignantly refused him. In a final burst of disappointed rage, Maximum then ordered her to be bound between four wheels, rimmed with spikes, and torn to death. As the sentence was being carried out, a great burst of flame from Heaven destroyed the wheels. She was then beheaded.

As the spouse of Christ, and the patron saint of girls, St. Catherine was one of the favorite themes in Renaissance painting. The Marriage of St. Catherine to Christ was widely portrayed. St. Catherine's special and peculiar attribute is the spiked wheel. She is usually shown wearing a crown to signify royalty, bearing a palm in token of victory, and carrying a sword, the instrument of her martyrdom. Sometimes she holds a book, in reference to her great learning.

St. Catherine of Siena (fourteenth century), as a young girl, dedicated herself to a religious life and prayed that like Catherine of Alexandria she might have Christ as her Heavenly Bridegroom. Her devotion was at first opposed by her family, until one day her father found her kneeling in prayer with a white dove perched upon her head. Thereafter, he allowed her to join the convent of St. Dominic. There she remained for three years in solitude and prayer, and her soul became 'enamoured of God's truth.' It was following this period of religious seclusion that her Mystic Marriage to Christ is reputed to have taken place. She left the convent and devoted her life to the care of the poor and the sick. Her fame became such that, when the people of Florence were excommunicated by Pope Gregory XI, they requested Catherine to intercede for them. She went to Avignon, where the Pope was in residence, and so impressed him with her intelligence and tact that he permitted her to arrange the terms upon which the Florentines might be reinstated into the Church. She told Gregory that one of the chief causes for the disobedience of the Florentines was the Pope's continued residence in Avignon instead of Rome. As the result of her persuasions, Gregory returned to Italy. Throughout her life, she was a personage of great influence, constantly working for the strengthening and the purification of the Papacy. Many legends are told about St. Catherine. Among these is a religious experience that occurred at Pisa. One morning during her prayers she was

carried away by her love of the Lord. When she regained consciousness she found, imprinted on her hands and feet and side, the stigmata; that is, the marks of the wounds suffered by Christ upon the Cross.

St. Catherine of Siena is represented in the habit of the Dominican Order, of which she is considered to be the greatest female saint, and is shown bearing the stigmata which she is said to have received at Pisa. She frequently holds a cross surmounted by a lily, or a heart. She often carries a rosary and wears a crown of thorns. Her Mystic Marriage remained a popular subject, particularly as an incident in paintings of the Madonna and Child.

St. Cecilia (third century). The popular legend says that Cecilia was the daughter of a Roman patrician who brought her up as a Christian. She was engaged to a nobleman named Valerian, but after her marriage she told him that she had taken a vow of chastity, which she begged him to respect. Valerian agreed on condition that he might see the angel who, she said, was watching over her. Cecilia sent her husband to St. Urban, who was working with the Christians in the catacombs, and there Valerian was himself converted. On his return to Cecilia he found, standing in her presence, an angel bearing two crowns of flowers. The crown of lilies he placed upon the head of Cecilia, and the crown of roses upon the head of Valerian. Through the ministrations of the angel, Valerian's brother, Tiburtius, was also converted to Christianity, and the two brothers undertook to preach the gospel of Christ. Hearing of this, the governor of Rome ordered them to desist and, when they refused, he had them executed. Cecilia was at first spared, for the governor wished to gain possession of her wealth. He ordered her to sacrifice to the gods. When she refused, he attempted to kill her by suffocation. She was miraculously unharmed, so the governor sent for an executioner to have her beheaded. The executioner made three attempts to slay her with his sword, but succeeded only in wounding her three times in the neck. Cecilia remained alive for three days, in which time she distributed her wealth to the poor.

During her lifetime Cecilia was reputed to be so close to Heaven that she could hear the singing of the angels; it was also said that she could play any musical instrument. These gifts, however, did not suffice to give expression to the flood of heavenly melody that fired her soul. She therefore invented the organ, which she consecrated to the service of God. She is, for this reason, the patron saint of music and musicians.

In painting, she is usually portrayed listening to music, singing, or playing some musical instrument. Her particular attribute is the organ. She is sometimes shown with three wounds in her neck. There is often a crown of white and red roses on her head, or somewhere near by.

St. Christopher (third century) is a martyr whose story is probably woven about the Greek word, Christopher, meaning the Christ-Bearer. Christopher was reputed to be a man of huge stature and great strength, who resided in the land of Canaan. He wished to find the most powerful sovereign in the world, whom he could serve and obey. He first attached himself to a great king, but when one day a minstrel sang of Satan, the king crossed himself in fear. Christopher then realized that the Devil was even more powerful than the king. So he set out to find Satan, and came across him on a desert plain. They traveled together until they came to a crossroad where a cross stood. Satan was afraid to pass it, and Christopher again realizing that he was not serving the most powerful monarch of all, left Satan to find Christ.

In his wanderings, Christopher came upon a holy hermit who sought to instruct him in Christianity, but Christopher refused to fast, lest he lose his strength, nor would he pray. The hermit at last sent him to a river much swollen by rain, and there Christopher, aided by a palm tree which he had uprooted to use as a staff, helped many people to cross the flooded stream. One night, as Christopher slept, a small child called to him and asked to be carried over the river. Christopher lifted the child on his shoulders and, taking the staff, entered the water. As he strode forward, the river became more and more turbulent and the child upon his shoulders seemed to become heavier and heavier. It was only with the greatest difficulty that Christopher succeeded in reaching the far bank. As he set his passenger down, he breathed deeply and said, 'Who art thou, child, that hath placed me in such extreme peril? Had I borne the whole world upon my shoulders, the burden had not been heavier!' The child replied, 'Christopher, do not be surprised, for thou hast not only borne all the world upon thee, but thou hast borne Him that created the world. I am Jesus Christ, the King.' Christ then told Christopher that if he planted his staff in the earth, in the morning it would bear flowers and fruit. Christopher did this and the miracle was performed. In this way he was converted to Christianity.

Later, at Samos, he was taken before the king, who asked to know who he was. 'Formerly I was called Offero, the bearer,' he replied, 'but now I am called Christopher, for I have borne Christ.' The king tried to break down his faith but Christopher stood firm; whereupon the king had him tortured and finally beheaded. As Christopher was being led to his death, he prayed that all who saw him and trusted in God might be saved from fire, storm, and earthquake. For this reason, many statues were erected to him so that all might see him and be protected.

Christopher is generally painted wading through the water with the Infant Christ on his shoulders. In his hand he invariably grasps his palm-tree staff. He is the patron saint of travelers.

St. Clare of Assisi (thirteenth century) early dedicated herself to a religious life, becoming a disciple of St. Francis of Assisi. In the year 1212, she went secretly to the mother church of the Franciscan Order, where she was received into the Order of St. Francis. Later she was permitted to establish an order of her own, which was known as the Order of the Poor Clares. Its principal work was the care and education of poor girls. There is a legend that once, when her convent was besieged by Saracens, she arose from her bed and placed the pyx containing the Host on the threshold. She then knelt and began to pray and sing. Seeing the Host, the infidels threw down their arms and fled.

Based upon this legend, St. Clare's attribute in art is the pyx containing the Host. She is usually shown wearing a gray tunic with a black veil and the cord of St. Francis. Other emblems frequently shown with her are the lily of purity, the palm of victory, and the True Cross.

St. Clement of Rome (second century), an Apostolic Father, was one of the earliest bishops of Rome. He was a disciple of St. Peter and St. Paul—which leads some historians to maintain that he was the immediate successor of St. Peter. He was one of the most celebrated early Christian writers and many legends are recounted of him. During the reign of the Roman Emperor Trajan, Clement is said to have been banished to the marble quarries of the Crimea because of his refusal to deny Christianity. Many of his converts followed him, and their sufferings were intense due to the lack of fresh water. As Clement prayed for help, a lamb appeared and led them to a certain spot. Clement struck the ground with a pick axe, and immediately a stream of water gushed forth. Enraged at this miracle, his persecutors tied an anchor about his neck and hurled him into the sea. Upon the prayers of his followers, however, the waters drew back, revealing a small temple where the body of the saint was found.

Because of these legends, Clement is usually portrayed with an anchor around his neck or beside him. Often he is shown with the lamb that guided him to the water, or the fountain that gushed forth from the earth. He is generally painted in papal robes.

SS. Cosmas and Damian (third century), according to legend, were twin brothers of Arabian birth who were brought up in the Christian faith. They devoted their lives to medicine and surgery, of which they are patron saints, in order to help the sick and wounded. They are reputed to have performed various miracles of healing. On one occasion, they treated a man with a diseased leg by cutting off his leg and replacing it with the leg of a Negro who had just died. When the patient awoke from a deep sleep into which he

had fallen, he found he had a white leg and a brown one. This dramatic operation was depicted by Fra Angelico, among other Renaissance artists. During the persecution of Christians under the Emperor Diocletian, Cosmas and Damian were seized and condemned to death. They were first cast into the sea, but were rescued by an angel. They were then thrown into a great fire, but the flames would not touch them. Thereupon, they were bound to a cross and stoned, but the stones rebounded without hurting them and killed those who had hurled them. Finally, the two brothers were beheaded.

They are always represented together, generally attired in the physicians' habit of a long red gown and cap. They hold in one hand a box of ointment and in the other a surgical instrument, or a mortar and pestle. They were adopted as patron saints by the famous Medici family of Italy.

St. Dominic (thirteenth century), founder of the Dominican Order, was born at Calahorra, in Spain. He belonged to the noble family of Guzman, and was educated at the University of Palencia. At an early age he entered the service of the Church, and in 1215 he went to Rome to obtain papal sanction for his Order of Preachers. This was granted, and in the next few years his black-and-white-robed friars penetrated into every corner of Europe. In 1220, the Order adopted a vow of poverty and became a mendicant brotherhood. Dominic himself traveled constantly and preached wherever he went. He died at Bologna in 1221.

He is generally represented in the habit of his Order. His special attribute is the rosary, for it was he who instituted the devotion of the rosary. He is sometimes shown with a dog bearing a flaming torch in its mouth. Before his birth, his mother is said to have had a dream that revealed she had given birth to a dog carrying a lighted torch. This dream came to symbolize the activities of St. Dominic and his Order in spreading the Gospel. A star on his forehead, or on his halo, is in remembrance of the star said to have appeared on his forehead when he was baptized. A loaf of bread refers to an episode that occured one day during his life. When told that there was nothing to eat in the monastery, he ordered the bell to be rung for the meal and instructed the brothers to sit at table. When all the monks were seated and reciting their prayers, two angels appeared and gave each a loaf of bread. The lily, also an attribute of the saint, is indicative of purity.

St. Donatus of Arezzo (fourth century) was of noble birth and was brought up in the Christian faith, together with his foster-brother Julian, who later became emperor. Julian, however, denied his faith and persecuted the Christians, including Donatus and his mother and father, who fled to Arezzo. There Donatus was credited with miraculous powers and was eventually

chosen Bishop of Arezzo. A number of different legends are told about him and the miracles he performed. A certain tax collector of the city, while absent on a journey, entrusted his tax collections to his wife. To insure its safety, the wife buried the money, but unfortunately she died before her husband's return, so that the place of concealment was not known. The tax collector, accused of having stolen the money, appealed to Donatus, who went to the wife's tomb and asked her to reveal the hiding place. A voice from the tomb answered, and the money was recovered. On another occasion, while Donatus was celebrating mass, local ruffians came into the church and broke the communion cup. Donatus put the pieces together so not a drop of the communion wine was spilt. The ruffians were thereupon converted to Christianity.

Donatus is generally painted in his bishop's robes. His customary attribute is the broken communion cup. The incident of the tax collector and his wife also is represented in art.

St. Dorothea of Cappadocia (third century) was a Christian girl famous for her beauty and piety. The renown of her saintly life reached Sapricius, governor of the province, and he ordered two sisters who had renounced Christianity to take charge of her and persuade her to abandon her religion. But Dorothea stood fast, and at last induced the sisters to return to the Church. Sapricius then ordered the two sisters to be burned, and forced Dorothea to witness the execution. The saint encouraged the martyrs in their suffering, and then she was condemned to torture and execution. Legend relates that as she was being led to the place of execution a young lawyer named Theophilus jeered at her and asked her to send him some flowers and fruit from the heavenly garden where she was going. When at the place of execution an angel, in the guise of a small boy, appeared bearing three roses and three apples wrapped in white linen, she commanded him to give these to Theophilus. It was February, and all the trees were covered with frost. Theophilus, surrounded by friends, was scoffing when he saw the boy with the fruit and flowers. At the sight of this miracle, the young man was converted to the Christian faith and subsequently suffered martyrdom.

The usual attributes of St. Dorothea in painting are roses in the hand or on the head, or a basket with three roses and three apples held by an attendant angel. She is sometimes shown offering a basket of fruit and flowers to the Virgin or the Infant Christ. She is also sometimes shown tied to a stake, a burning torch being held at her side.

St. Elisabeth, mother of John the Baptist, is frequently represented in paintings of the Visitation and of the Birth of John the Baptist, and as an

elderly woman. She has no special attributes. (See The Virgin Mary in Section VII; St. John the Baptist in Section VI.)

St. Elisabeth of Hungary (thirteenth century), daughter of Andreas II, King of Hungary, was born at Pressburg. As an infant, she was betrothed to Ludwig, son of the Landgrave of Thuringia and Hesse, and was taken to live with the family of her future husband. There she was badly treated by the ladies of the court, who were jealous of her beauty. In her loneliness she instinctively turned to religion, devoting her time and substance to the poor. Shortly after her marriage, her husband fell ill while on a Crusade and died. Elisabeth was turned out of her castle by her brother-in-law, who wished to assure his own son of the succession, and placed under the direction of an ascetic priest. Her children were taken from her and, at the age of twenty-four, she died as a result of her fasts and of her labors on behalf of the poor.
Her life of self-sacrifice filled the world with admiration and many legends are told about her. It is said that on one occasion, in the middle of winter, she left her castle with her apron filled with food for the poor. On her way she chanced to meet her husband, who asked what she was carrying. When he opened her apron, he found it filled with roses, and when he bent to kiss her, he saw that her face was transfigured with the radiance of Heaven. Another legend tells how she met a leper whom she took home and put to bed in her own bed. When her husband came home, his mother accused Elisabeth of sharing her bed with a vile stranger, but God opened Ludwig's eyes and, instead of the leper, upon the bed he saw the figure of the crucified Christ.
St. Elisabeth was received into the Franciscan Order in 1228, and is considered one of the great saints of that Order. She is frequently painted as a Franciscan nun. He usual attribute is an apron full of roses, but she is sometimes shown with three crowns, indicative of her royal birth, her marriage estate, and her glorification in Heaven.

St. Euphemia (third century) was a famous saint of the Greek Church. According to legend, she was persecuted for her faith, but fire failed to burn her and lions refused to devour her. She was finally beheaded.
She is represented with a lion or a bear, the palm of victory, and a sword, which was the instrument of her martyrdom.

St. Eustace (second century), who was originally known as Placidus, was a captain of the guards of the Emperor Trajan. The legend about him states that one day, while hunting, he saw before him a white stag. Between its horns appeared a bright light which formed a cross. On the cross was the

figure of Christ. Placidus fell on his knees at the apparition, and the figure on the cross spoke, saying, 'Placidus, I am Christ whom thou hast hitherto served without knowing me. Dost thou not believe?' Placidus answered, 'Lord, I believe.' The vision then told him that he would suffer many tribulations, but that the Lord would not forsake him. As a result Placidus, his wife, and two sons were baptized, Placidus taking the name of Eustace.

As Christ had foretold, Eustace experienced much suffering, for his wife was carried away by pirates, and his sons by wild beasts. Eustace fled to the desert to pray, and after fifteen years his family was miraculously reunited. When the family refused to give thanks to the Roman gods, they were condemned to death by the emperor. All four were shut up in a huge brass bull, under which a great fire was kindled, and thus they died.

Eustace is usually represented as a soldier or knight on horseback. His most usual attribute is the stag with the crucifix between its horns. He is frequently accompanied by hounds, and is sometimes shown with a brazen bull, the instrument of his martyrdom. He is the patron saint of huntsmen.

St. Fina (thirteenth century), of the town of San Gimignano in Tuscany, became ill when she was a small child of ten and experienced five years of great suffering. She worked as long as she could, making garments for the poor, but finally was made helpless by paralysis. She then took a hard wooden board as her resting place, for she wished to make her sufferings as great as possible in order to be nearer to Christ. Her sufferings were increased because, as she lay alone on her board, rats came to attack her, and she was powerless to drive them off. For that reason, her most common attribute in art is a rat. It is said that after her death, when her body was lifted from the board, the wood was found covered with white violets of great sweetness. These flowers are therefore also one of her emblems in art.

St. Florian (third century) of Noricum (now Austria) became a soldier in the Roman army during the reign of the Emperor Galerius. He was converted to Christianity, and suffered martyrdom by being thrown into a river with a stone tied to his neck. He is credited with having performed a number of miracles, including extinguishing the flames of a burning city by throwing a single bucket of water on the conflagration. As a result, St. Florian is invoked for protection against fire.

In art, he is generally shown pouring water on a burning house or city, or with a millstone, the symbol of his martyrdom.

St. Francis of Assisi (thirteenth century) was born Giovanni Bernardone in Assisi, in 1182. The story is that he acquired the name Francesco (meaning

'the Frenchman') because he had learned French in his youth and loved to sing the Provençal ballads which were so popular at that time.

His particularly vivid personality is known to us through the excellence of his biographer, St. Bonaventura. This biography, begun in 1260, was the source for the famous series of Franciscan frescoes in the Upper Church of Assisi, which were executed at the end of the thirteenth century by Giotto.

Francis was a chivalrous warrior and a gay young man. But, according to legend, his spiritual quality was apparent even before he dedicated himself to God, for a certain man of Assisi, obviously inspired, would spread his cloak before Francis whenever they met, in recognition of the greatness that was to come.

His actual decision to consecrate himself to God came when Francis was twenty-four. One day on his way to the city he met a poor soldier to whom, out of compassion, he gave his rich clothes. That night St. Francis had a vision. Christ appeared to him and, pointing out a beautiful building filled with arms and banners, declared that these were to belong to St. Francis and his soldiers. Francis at first interpreted this to mean that he should continue his life as a soldier. But the voice of the Lord was to change his plans. For when he was passing near the neglected church of St. Damian at Assisi, he went in to pray before the crucifix for guidance, and a voice from the crucifix cried, 'Francis, go repair my house that thou seest is all in ruins.' Full of this mission, the impulsive youth secretly sold some silks from his father's warehouse to finance the project, whereupon his father had him brought to justice. At the bishop's court, Francis stripped himself of his fine clothes and money and flung them at his angry parent, renouncing forever his life of wealth. The bishop then wrapped him in a cloak.

Gathering the stone blocks himself and begging other necessary materials, St. Francis set himself to repairing the church of St. Damian. He went on to repair the abandoned Benedictine Chapel of the Portiuncula, known as St. Mary of the Angels. This became the mother house of the Franciscan Order, just as the church of St. Damian became the mother house for St. Clare and the Franciscan nuns, called the Poor Clares.

The words of St. Luke 9: 3, 'And he said unto them, Take nothing for your journey, neither staves, nor scrip, neither bread, neither money; neither have two coats apiece,' inspired St. Francis to formulate the simple rules of his Order. They were chastity, humility, obedience, and absolute poverty: his Lady Poverty, as St. Francis was wont to say.

St. Francis went to Rome to obtain approval of his Order, and at first he met with opposition from Pope Innocent III, whose cardinals considered the rules of the Order too severe for human strength. The Pope is said to have had a vision, in which he beheld St. Francis supporting a toppling Lateran Church

upon his shoulders. Soon thereafter, approval of the Franciscan Order, with permission to preach, was granted.

St. Francis called the members of his Order 'Frati Minori', meaning the lesser brothers. Their humility gained them an immediate popularity. They were soon to be seen everywhere, and their preaching and dedicated living inspired great religious fervor among the people. Unable to appear in person before all his flock, St. Francis would on occasion reveal himself to them in spirit. Thus he is said to have appeared, with his arms outstretched in the form of a cross, at a provincial chapter of the Order in Arles, during a sermon by St. Anthony of Padua. On another occasion, he appeared to his brethren in Assisi in the form of a dazzling light, suspended over a chariot of fire which was seen to pass three times through the house.

A companion told of a vision in which he saw many thrones in Heaven, one of which was much more beautiful than the rest. Then he heard a voice which declared that this throne, that was once the seat of a fallen angel, was now reserved for St. Francis: 'that the humble shall be exalted to that excellent glory from which the proud shall be cast down,' in the words of St. Bonaventura.

St. Francis traveled to Spain and North Africa, and finally to Syria, where the Crusaders were battling the Saracens. Unharmed, he was successful in penetrating the very palace of the Sultan. There St. Francis offered to test the strength of the Christian religion against that of Islam by walking through fire. The Sultan's priests refused the contest, and the Sultan himself, although he greatly admired the saint, declined conversion for fear his own people might rebel.

St. Francis always began his sermons with these words, 'God give you peace.' His fame became so great that he was asked to preach before Pope Honorius III. In the Pope's presence, Francis forgot the words of his sermon, whereupon he was inspired by the Holy Ghost.

The sweetness of the Franciscan spirit is best exemplified not so much by the cures and other miracles that St. Francis is credited with having accomplished, such as causing the devils at Arezzo to be expelled; the miracle of the Christmas Mass at Greccio, when the Christ Child appeared in his arms; the prayer for water, answered by a spring; the death of the knight of Celano, according to his prediction; but by the numerous accounts of his love for, and power over, wild beasts and lesser creatures, culminating in his beautiful sermon to the birds.

The climax of the legend of St. Francis is reached in the forty days of fasting and prayer which he undertook in his mountain retreat. During this withdrawal from the world a seraph appeared and filled the sky with its wings. Central in this vision was the figure of the crucified Christ, from whom St.

Francis received the marks of the stigmata. He bore these to the end of his life, indicating his spiritual identity with the Master, whom he followed in all humility. The simple, gentle, and indeed joyous humanity of St. Francis' life served to emphasize to the world the true humanity of the Saviour, which was in danger of being forgotten.

Two years after he received the stigmata, suffering from blindness and other ailments, St. Francis asked to be carried to the church of St. Mary of the Portiuncula. There, on October 4, 1226, he died. It is said that a friar beheld the soul of the saint being borne to Heaven on a white cloud; while a certain doubter, named Jerome, is said to have been converted to Christianity by touching the holy marks on the body of the saint. St. Francis was canonized by Pope Gregory IX in 1228.

St. Francis is generally shown in the dark brown habit of his Order. In addition to the stigmata, his principal attributes are the skull, the lily, the crucifix, the wolf, and the lamb. The symbolic scenes of the saint's marriage to poverty, and his receiving the Infant Christ from the hands of Mary, are important features of his pictorial cycle.

St. Geminianus (fifth century), a friend of St. Ambrose of Milan, was famous for his powers of healing. On one occasion, he was summoned by the Byzantine Emperor to Constantinople to cast out a demon that was troubling the emperor's daughter. It is also recounted that, when Attila and his Huns were attacking the town of Modena, St. Geminianus appeared in a vision to Attila and drove the savage hordes away. After his death, the saint is said to have saved the town of Modena from destruction by floods.

St. Geminianus is occasionally shown with the demon from which he freed the emperor's daughter. Quite frequently he is also painted holding a mirror in which the reflection of the Virgin is visible.

St. George of Cappadocia (second century) was born of Christian parents before the reign of Constantine. He suffered martyrdom at Diospolis, in Palestine. Many different legends are related about his life, and he has come to represent the triumph of right over oppression and wickedness. One story, recited in the Golden Legend, relates that a terrible dragon was infesting the country around Selena, in Lydia, making its lair in a marsh. In order to please the dragon, human sacrifices were offered to the beast, and lots were drawn to determine the victims. On one occasion, the lot fell to Cleodolinda, the daughter of the king. The maiden, dressed as a bride, was led to the marsh and offered to the dragon. St. George, a tribune of the Roman army, chanced to ride by on his charger at the fatal moment and, in the name of Christ, turned to help the princess. Making the sign of the Cross, he engaged

the dragon in mortal combat, He finally succeeded in pinning the dragon to the earth with his lance, whereupon he slew it with his sword. The king, and all his people, who had witnessed the struggle, were converted by this sign of the power of the Lord and were baptized into the Christian faith. St. George continued his journey to Palestine. There he defied the edict of the Emperor Diocletian against the Christians. He was seized and put to all manner of tortures, but was miraculously protected against injury. Finally he was beheaded.

St. George was one of the favorite subjects of the Renaissance artists, and pictures of him abound all over Italy. He is usually represented as a young knight clad in shining armor emblazoned with a red cross. Mounted on a charger, he is portrayed transfixing the dragon with his lance or in the act of slaying the dragon with his sword, the broken lance on the ground. St. George is the patron saint of England, and, in Italy, of the cities of Venice and Ferrara. He is also the patron saint of all soldiers and armorers. In his portrayal as patron saint, he is clad in armor and holds a shield, lance, or broken lance and sword.

St. Gregory (sixth century). One of the four Latin Fathers of the Church, Pope Gregory I, known as Gregory the Great, was born in Rome of noble parentage. He rose to be prefect of Rome.

After the death of his father he came under the influence of the Benedictine Order and gave up his political life for that of service to the Church. He converted his palace into a monastery and lived there for seven years as a monk Subsequently, he was made one of the deacons of Rome by Pope Benedict I. St. Gregory succeeded to the papacy after the death of Pelagius II in 590. He had a tremendous influence upon the affairs of the Church and upon the manners of his age. His breadth of activity and interest was remarkable. He worked to abolish slavery and to prevent war. He established the rule of celibacy for the clergy and made those special arrangements of church music that have come to be known as Gregorian chants. He was a constant writer on religious subjects.

In art, Gregory is portrayed wearing the tiara of the Pope and bearing the crosier with the double cross. His special attribute is the dove, which refers to the legend that the Holy Ghost came in the form of a dove to dictate the words upon which Gregory's writings were based. He sometimes carries a church to signify the importance of his work in establishing the foundations of the Church.

St. Helena (fourth century), the mother of the Roman Emperor, Constantine the Great, was converted to Christianity after the victory of Constantine

over his rival Maxentius. It was during this battle that Constantine is reported to have seen a vision of Christ bearing a banner inscribed with the Latin words, 'In hoc signo vinces' (By this sign shalt thou conquer). Constantine, adopting this message as his motto, became a Christian. As a token of her piety, St. Helena ordered a number of churches to be built and, at the age of eighty, undertook a religious pilgrimage to the Holy City of Jerusalem. There she was particularly interested in the Mount of Calvary, where Christ had been crucified, and caused various excavations to be made. She is said, as a result, have unearthed three crosses and the inscription, 'Jesus of Nazareth, King of the Jews,' which Pilate had commanded to be nailed upon the Cross of Christ. To determine which of the three crosses was that upon which the Saviour died, St. Helena caused a man who was very ill to be placed on each of the crosses in turn. When he touched the True Cross, he was miraculously cured. During later excavations, at St. Helena's direction, some of the nails used to affix Christ to the Cross were discovered. When unearthed, they were 'shining as gold.' Two of these nails she gave to her son, Constantine. He used one as an emblem on the bridle of his horse; he wore the other upon his helmet.

St. Helena is usually represented wearing a royal crown and bearing a cross, together with hammer and nails. Sometimes she is shown with a model of the Holy Sepulchre in her hands; often with the Cross borne by angels who are appearing to her in a vision.

St. James the Great, Apostle, brother of St. John, is reputed to have been closely related to Christ. The Gospels frequently mention Christ as calling aside Peter, James, and John, thus suggesting a more intimate relationship with these three Apostles. They were present at the Transfiguration and apart with Him during the Agony at Gethsemane.

One of the Epistles in the New Testament is ascribed to St. James. Nothing is recorded of him after Christ's Ascension, except the fact that Herod slew him with the sword. The legend of St. James the Great is a rich one, however, and, as the military patron saint of Spain, he became one of the most renowned saints in Christendom, his common name becoming Santiago. It is said that on one of his most famous pilgrimages he arrived at Compostella in Spain, where he was the first to establish the Christian religion. It was upon his return to Judea that he was beheaded. His body was subsequently taken back to Spain, where, during the Saracen invasion of that country, it was lost. Recovered about the year 800, it was taken to Compostella. So many miracles took place at that shrine that St. James has become the patron saint of Spain.

Because he is said to have liberated Spain from the Moors, in Spanish art he is

represented on horseback, bearing a banner. In Italy, he is usually portrayed with a pilgrim's staff, a scallop shell, or gourd, symbolic of his pilgrimage to Spain and, especially, to Compostella, a very famous goal of pilgrimages in the Middle Ages. As one of the Apostles, he sometimes bears a scroll in one hand with his text testifying to the Incarnation of Christ written upon it.

St. James the Less, Apostle. There is some question about the identity of James the Less. According to legend, he was a relative of Jesus and the first bishop of Jerusalem. His death occurred when, having survived being hurled from the roof of a temple, he was beaten to death by an enraged mob with a club or fuller's bat.
His attribute in painting is the club or bat which was the instrument of his martyrdom.

St. Jerome (fourth century), one of the four Latin Fathers of the Church, was born at Stridona in Dalmatia. As a young man he came to Rome to study, and was baptized there. His great contribution to the Church was a new translation of the Bible into Latin (the Vulgate). His life was divided between scholarship and ascetic practices. In Rome he was ordained a priest, but his biting tongue made him many enemies and he had to leave. By way of Antioch and Alexandria he reached Bethlehem, and remained there for the rest of his life.
St. Jerome was greatly aided by the arrival in Bethlehem of St. Paula and her daughter, St. Eustochium. After the death of her husband, St. Paula retired from Rome. Seeking the quiet of the religious life, she came to Bethlehem to settle near St. Jerome, who had been her confessor and director. Devoting her wealth to the Church, she erected a monastery for him and his followers, as well as a convent for women seeking the way of retirement. After her death, her daughter, St. Eustochium, carried on the work her mother had begun. It is said that they were tireless in their encouragement to St. Jerome as he engaged in the difficult task of translating the entire Bible into Latin. As Latin was the ordinary or vulgar speech of the common people, his work is known as the Vulgate.
An interesting legend is told that, while he was living at his monastery in Bethlehem, a lion, limping grievously, suddenly appeared. The other monks fled, but St. Jerome, in complete confidence, examined the lion's paw and removed from it a deeply embedded thorn. The lion, to show his gratitude, became the constant companion of the saint. But the troubles of the lion had not yet ended. The monks of the convent petitioned St. Jerome that the lion should work to earn his daily food, as did everyone else in the convent. St. Jerome agreed, and ordered the lion to act as a guard for the ass of the

convent on its trips to fetch wood. All went well for a time. One day the lion wandered off into the familiar desert, leaving the ass unguarded. Left alone, the ass was seized by robbers and sold to a caravan of merchants, who led it away. On his return, the lion could not find the ass, and went back to the convent alone, in great distress. The monks, seeing the lion's apparently guilty look, thought that he had eaten the ass. The lion was then ordered to do the work of the ass in atonement. The lion obeyed in perfect humility, but one day he saw the ass in a caravan, and triumphantly brought the whole caravan to the convent to prove his innocence.

In painting, St. Jerome is almost always accompanied by a lion. The saint is depicted as an old man, sometimes in the red hat and crimson robes of a cardinal, a contradiction explainable by the fact that in the early period of the Church, the priests of Rome had the functions that later fell to the cardinals. More often, St. Jerome is shown as a hermit in the desert, beating his breast with a stone and praying or writing, while a crucifix, a skull, and an owl are near by.

St. Joachim, the father of the Virgin, often appears in scenes of her life, such as have already been mentioned in connection with the life of Anna, his wife. (See The Virgin Mary, in Section VII.) His attributes are the lamb, lilies, and doves in a basket, in reference to his pious offerings at the temple.

St. John the Baptist, the son of Elisabeth and Zacharias, is considered to be the the last of the prophets of the Old Testament and the first of the saints of the New Testament. His story, of how he foretold the coming of Christ and baptized Him, and of how he was cast into prison by Herod and ultimately slain to please Salome, is familiar to all readers of the Bible. (See St. John the Baptist, in Section VI.)

In Renaissance art, there are innumerable paintings of John the Baptist, some devotional and others recounting his history and religious experiences. As patron saint of Florence, he is especially frequent in Florentine art. He is usually depicted as he was described by St. Matthew, who wrote, 'And the same John had his raiment of camel's hair, and a leathern girdle about his loins; and his meat was locusts and wild honey' (Matthew 3 : 4). He is often richly dressed, however, when he is represented in Paradise, standing or seated at the left hand of Christ. He often bears in his arms a lamb and a scroll bearing the words 'Ecce Agnus Dei' (Behold the Lamb of God) (John 1 : 36).

His attribute is the lamb. In addition, he is sometimes given a reed cross, or a banner with a reed cross. A dish or platter bearing his own head refers to his execution.

St. John, the Apostle and Evangelist, was the youngest of the twelve Apostles of Christ and the brother of St. James the Great. He is called 'the disciple whom Jesus loved,' and the gospel bearing his name refers to him as 'leaning on Jesus' breast' at the Last Supper. John was present at the Crucifixion, together with the three Marys. Jesus said to his mother, 'Woman, behold thy son!'; and to the disciple, 'Behold thy mother!' (John 19: 26, 27). Tradition says that from this time on the Virgin Mary lived with John, in fulfillment of Christ's words. After the Virgin Mary's death, St. John traveled about Judea preaching the gospel with St. Peter. He is said to have journeyed into Asia Minor, where he founded the Seven Churches referred to in Revelation. Eventually, John went to live at Ephesus, where he endured persecution at the hands of the Emperor Domitian, who, according to legend, twice had attempted taking his life. On one occasion, the emperor ordered him to drink a cup of poisoned wine; when John took up the cup to obey, the poison departed in the form of a snake. On another occasion, John was thrown into a cauldron of boiling oil, but emerged unhurt. He was then exiled to the island of Patmos, the place of his Revelation. He is supposed to have died a natural death at Ephesus at a very advanced age. St. John is, of course, best known for the version of the Gospel which he wrote, for the three Epistles, and for the Revelation which bears his name.

He appears sometimes as an Evangelist, sometimes as an Apostle. His principal attributes are the eagle, symbol of the highest inspiration, and the book. He is also on occasion seen with the cauldron of oil or the cup with a snake, in reference to the attempts upon his life.

St. John Gualbert of Florence (eleventh century) had a younger brother who was murdered on the eve of Good Friday. John pursued the assassin and would have slain him, but the man implored mercy in the name of Jesus Christ. John, in remembrance of Christ's sufferings, embraced the man instead of killing him. He then entered a near-by church to give thanks for having resisted the impulse to commit a crime and, as he prayed, the image of Christ on the crucifix appeared to incline its head toward him. This miracle led to John's forsaking the world and entering a Benedictine monastery. He later went to Vallombrosa, and lived as a solitary hermit. The fame of his holiness brought him many followers. To bring order into the community of his followers, John founded the Order of Vallombrosa in 1038 on rules similar to those of the Benedictines. When he died in 1073, twelve houses had been established and the Order had been approved by the Pope.

St. John Gualbert is painted in the gray habit of the Vallombrosans and is sometimes shown with a sword in his hand, or with a crucifix. In some representations the figure of Christ on the crucifix is bending towards him.

St. Joseph, husband of the Virgin Mary, was a carpenter of Nazareth. He frequently appears in paintings of the life of Christ, particularly in those of the birth of Jesus and in the other infancy narratives. (See The Virgin Mary, in Section VII; Jesus Christ, in Section VIII.)

He is frequently shown with a budded staff in his hand. This refers to the legend that, when the Virgin Mary was fourteen years old, each of her suitors left his staff at the temple, hoping for a sign to indicate which of them was most favored by God. In the morning, Joseph's staff was budding into leaf, and from it came a dove that flew up to Heaven. Other attributes of St. Joseph are a carpenter's plane, saw, and hatchet, and the lily, symbol of his purity. Often, in scenes of the Presentation, he carries two doves in a basket.

St. Jude, Apostle, is the reputed author of the last Epistle in the New Testament. Tradition says he was the brother of St. James the Less, and they are thought to have been relatives of the Virgin Mary. After the death of Christ, it is said that he traveled through Syria and Asia Minor with St. Simon Zelotes, preaching the gospel. In Persia, both were martyred for their faith, St. Jude being transfixed with a lance or beheaded with a halberd. For this reason, his attribute in art is the lance or the halberd.

St. Julian the Hospitator (ninth century) is a legendary figure about whom little is known. The story is that Julian was a nobleman who spent much of his time in hunting. One day a stag that he was pursuing was brought to bay. The stag turned to him and said, 'Thou that pursuest me to death shalt cause the death of thy father and mother.' Fearful that this prophecy might come true, Julian left home and journeyed into distant lands. There he met and married a beautiful girl named Basilissa. Julian's parents, overcome with grief at the loss of their son, set out in search of him. In due course, they found the place where Julian was living, but he was away from home. Basilissa, however, received them with joy and gave them her own bed in which to rest. Returning unexpectedly in the early morning, Julian was enraged to find two people in his wife's chamber and slew them both.

When he learned the truth, Julian, in remorse, swore never to rest until Christ had forgiven him. In search of forgiveness, he and his wife set out upon a pilgrimage. They came at last to a dangerous river, and there Julian built a hospital for the poor as well as a penitential cell for himself. He spent his time ferrying travelers across the river. One night, in the midst of a storm, Julian saw on the other side of the river a leper who appeared to be dying from exposure. At the risk of his life, Julian crossed the river, brought the sick man back, and laid him in his own bed to recover. In the morning the leper had been transformed into an angel. He told Julian that he was the Lord's

messenger sent to tell him that his penitence had been accepted. Soon after, well advanced in years, Julian and his wife found release from worldly cares in death.

Julian is generally painted as a huntsman with a stag by his side. Frequently, a river and a boat are shown in the background, in reference to his labors as a ferryman. Julian is the patron saint of travelers, ferrymen, and traveling minstrels.

St. Justina of Padua (fourth century), the daughter of noble parents of the Christian faith, was left an orphan at the age of sixteen. One day Justina was traveling to Padua when she was stopped on the bridge crossing the River Po by some soldiers of the Emperor Maximianus. They forced her to alight from her chariot and follow them to the local court of justice. Fearful for her innocence, Justina knelt upon the bridge and prayed God to preserve her from harm. It is said that the marks of her knees may still be seen in the stonework of the bridge. At her trial, the emperor ordered that she be stabbed in the throat with a sword.

Justina is represented holding the palm of martyrdom, with a unicorn, the emblem of purity, crouching at her feet; or with a sword piercing her throat, in reference to her martyrdom. She was frequently painted by artists of the Paduan and Venetian schools, and she is a patron saint of both Padua and Venice. It is sometimes difficult to distinguish St. Justina of Padua from St. Justina of Antioch, for both are given the same attributes.

St. Laurence (third century) was born at Huesca in Spain and studied at Saragossa, where he met Pope Sixtus II. Sixtus was so impressed with the young man that he took him back to Rome and made him an archdeacon of the Church. In this capacity, Laurence was in charge of all the treasures of the Church. When Sixtus was seized by the prefect of Rome and condemned to die because of his religion, Laurence sought to die with him. Sixtus instructed him, however, to follow in three days, using the interval to distribute the wealth of the Church to the poor. After the execution of Sixtus, the prefect of Rome demanded that Laurence deliver to him the Church's treasure. Laurence replied that he would show it to him in three days. By that time, Laurence had carried out the instructions of Sixtus and had gathered about him a great crowd of the poor and sick. Pointing to them, he told the prefect that these were indeed the treasures of the Church of Christ. Enraged at being thus outwitted, the prefect ordered Laurence to be executed by slow roasting on a gridiron. Defiant in the midst of his torment, Laurence shouted to the prefect, 'I am roasted on one side. Now turn me over and eat!'

St. Laurence is generally shown in the dress of a deacon, bearing a palm, the

symbol of his martyrdom. His special attribute is the gridiron upon which he was martyred. Sometimes, however, the gridiron is omitted and he carries in his hand a dish of gold and silver coins, in allusion to his distribution of the Church treasures. Occasionally he swings a censer or carries a cross; sometimes, he wears a tunic covered with flames.

St. Leonard (sixth century) is venerated throughout Europe as the patron saint of prisoners and captives. According to legend, Leonard was born in France, son of an official in the court of King Clovis. He was converted to Christianity and devoted himself to visiting prisoners. For many of them he interceded with the king, and paid their ransom himself. Later, Leonard abandoned the court to live as a hermit in a forest near Limoges. His death is said to have occurred in 546.
He is represented in painting as a deacon of the church, generally bearing broken fetters in his hand, or with prisoners kneeling at his feet.

St. Liberalis (fourth century) is primarily known as one of the patron saints of Treviso. He became famous for his zeal in converting many residents of that city to Christianity.
In art, he is generally represented as a knight in armor, leaning on a spear or holding a banner.

St. Longinus is the name given to the Roman centurion at Calvary. Tradition says it was he who pierced the side of Christ, and who cried out at His death, 'Truly this man was the Son of God' (Mark 15: 39). Legend continues that he was baptized by the Apostles and retired to Caesarea, where he lived many years and converted great numbers to the Christian faith. His death came because of his refusal to sacrifice to the false gods. Anxious for martyrdom, he told the blind governor who condemned him that his sight would be restored only by putting him to death. After Longinus was beheaded, the governor's sight was immediately restored and he was converted. Relics supposed to be those of Longinus were brought to Mantua; consequently he is a patron saint of that city.
Longinus is pictured at the Crucifixion in one of two ways. He is afoot, sometimes lance in hand, gazing up at Christ in adoration. More often he is on horseback, clad as a Roman soldier, looking up and holding his helmet in his hands.

Louis IX, King of France (thirteenth century), was said to know how to 'ally the majesty of the throne with the holiness of the Gospel.' Born in 1215, he was trained for his great responsibility by a holy mother, Blanche of

Castile. During an illness in 1244, Louis made a vow to go on a crusade. He returned to France bringing with him what were believed to be the crown of thorns and a part of the True Cross. On his second crusade, he contracted the plague and died.

His attributes are the crown of thorns, the cross, the kingly crown, the sword, and the fleur-de-lis.

St. Louis of Toulouse (thirteenth century) had a saintly heritage. St. Louis of France was his great-uncle and St. Elisabeth of Hungary was his aunt. At the age of fourteen, he was sent to the King of Aragon as a hostage for his father. Released after seven years of captivity, he was offered the throne of Naples. He refused, and, renouncing all his royal rights, he made his profession as a member of the Order of St. Francis. He was made Bishop of Toulouse and was loved throughout his diocese for his zeal, charity, and holiness. He died in 1297, when he was only twenty-four years old.

In Renaissance paintings, he is represented as a beardless youth of gentle face, generally in the costume of a bishop with the fleur-de-lis embroidered on his cope, or on some part of his dress. The crown and sceptre, which he renounced, lie at his feet.

St. Lucy (third century). According to legend, Lucy of Syracuse was the daughter of a noble lady, Eutychia, who suffered from a disease believed to be incurable. Lucy persuaded her mother to make a pilgrimage to the shrine of St. Agatha in Catania. There, St. Agatha appeared to Lucy in a vision and told her that her mother would be cured, but that she herself would suffer martyrdom. In gratitude for the healing of her mother, Lucy distributed all her wealth among the poor. This angered the young man to whom she was betrothed, and he denounced her to the authorities as being a Christian. When she persisted in her faith, soldiers were ordered to drag her away, but she could not be moved, even though she was bound with ropes and harnessed to a yoke of oxen. The governor then ordered her to be burned, but the flames did not touch her. Finally, one of the soldiers stabbed her in the neck with a poniard and killed her. Legend tells that one of her suitors was so smitten with the beauty of her eyes that he could find no rest. Fearing that her eyes were really causing harm to the young man, Lucy tore them from her head and sent them to him. He was overcome with remorse and so impressed with the courage which Lucy evidenced through her faith that he, too, became a Christian.

St. Lucy is sometimes represented with her eyes on a dish in her hand, or carried in some other manner. Other attributes of St. Lucy are a poniard and a wound in her neck, and a lamp, to suggest divine light and wisdom. As the

name Lucy suggests light, the eyes and the lamp might also be attributed to her for this reason.

St. Luke the Evangelist, born at Antioch in Syria, is well known to all readers of the Bible because of his Gospel and the book of The Acts of The Apostles. It is not known where Luke met Paul, but he became the constant companion of the famed Apostle and faithfully recorded the life of this great missionary. It is said that, after Paul's death, he continued preaching alone, and was crucified in Greece, although Greek tradition says that he died peacefully.
He is called 'the beloved physician' in reference to the medical profession, of which he was a practicing member. There is a legend to the effect that Luke was a painter, and that he did several portraits of the Virgin Mary and of Jesus. By showing these to his listeners, he is said to have made many converts to Christianity.
His most frequent attributes are the winged ox, presumably because in his Gospel he emphasizes the priesthood of Christ, and the ox is a symbol of sacrifice; the Gospel Book; and the portrait of the Virgin which he may be in the act of painting or holding in one hand. He is the patron saint of painters.

St. Margaret of Antioch (third century), the daughter of a pagan priest, is said to have been converted to Christianity by her nursemaid. One day the young girl was seen by the governor of Antioch, who was so struck by her beauty that he determined to marry her, but Margaret refused his offer of marriage, declaring that she was dedicated to Jesus Christ. The governor tried to shake her determination by torture, but Margaret stood firm. She was then dragged to a dungeon, where the Devil appeared to her as a dragon breathing fire, and sought to terrify her. Margaret fell upon her knees in prayer and made the sign of the Cross upon her breast. The dragon swallowed her, but the cross that Margaret had made grew larger and larger, until it split the body of the dragon in two, permitting Margaret to escape unharmed. Margaret's courage and constancy to her faith throughout her tortures so impressed the populace that thousands were converted to Christianity. To put a stop to this, the governor ordered that she be executed. On her way to the place of execution, St. Margaret, in memory of her escape from the body of the dragon, prayed that the memory of her might give help to those suffering the pains of childbirth. She has therefore become the patron saint of women in childbirth.
St. Margaret is invariably shown with a dragon which she is trampling under foot as she stands unharmed by his distended jaws. She often holds a cross and the crown and palm of martyrdom.

St. Mark the Evangelist is a familiar figure as the author of one of the Gospels. His early history is obscure, but we know that he was the traveling companion of Paul and Barnabas on the first of Paul's missionary journeys. Tradition says that, after leaving Paul, he journeyed to Rome with Peter and, as Peter's secretary, wrote his Gospel, the material being given to him directly by Peter. Mark's Gospel is probably the earliest in existence, and is accepted as such by scholars today.

According to legend, while he was preaching along the shores of the Adriatic, the vessel in which he was traveling was caught in a great storm and was driven into the coastal islands and lagoons. Here an angel appeared to Mark, saying, 'On this site, a great city will arise to your honor.' (Four hundred years later, the people of the mainland, fleeing before Attila, the Hun, sought refuge among the islands and there established the city of Venice.) St. Mark is said to have then departed for Libya, where for twelve years he preached the Gospel. He journeyed to Alexandria and founded the Christian Church in that city, which was also the place of his martyrdom. Several centuries after his death, his body was carried off by Venetian sailors, who brought it back to Venice. St. Mark became the patron saint of Venice, which adopted his emblem, the lion, as its own; therefore, both the saint and the lion are very frequently represented in Venetian art.

His almost invariable attribute is the winged lion, presumably because his Gospel emphasizes the royal dignity of Christ, the Lion of Judah. In his character of Evangelist and secretary of St. Peter, he is given a pen and the book of his Gospel.

St. Martha was the sister of **Mary** (sometimes identified with Mary Magdalene) and of Lazarus. The Gospel account represents Martha as one who devoted herself to domestic affairs and to the running of the home, while her sister was more inclined to sociability. When their brother, Lazarus, was taken ill, the two sisters sent word to Jesus, asking him to come to their aid. When Jesus arrived in Bethany, it was Martha who went out to meet Him. It would appear that she was already a disciple of Christ, for she said to Him, 'Lord, if thou hadst been here, my brother had not died. But I know, that even now, whatsoever thou wilt ask of God, God will give it thee.' And it was to Martha that Jesus then spoke His famous words, 'I am the resurrection, and the life: he that believeth in me, though he were dead, yet shall he live' (John 11: 21ff.). Some time later, before the feast of the Passover, Martha served Jesus a supper in their home at Bethany. It was on this occasion that Mary anointed the feet of Jesus. 'Then took Mary a pound of ointment of spikenard, very costly, and anointed the feet of Jesus, and wiped his feet with her hair: and the house was filled with the odour of the ointment' (John

12: 3). It is said that the influence of Martha led to the eventual conversion of Mary Magdalene. According to legend, after the death of the Saviour, Martha was with Mary Magdalene and Lazarus in an open boat which miraculously landed at Marseilles, France. In France she converted the people of Aix and delivered them from a fearful dragon that was laying waste the countryside.

St. Martha is usually shown with a ladle or skimmer in her hand, or with a large bunch of keys attached to her girdle, in token of her housewifely qualities. Sometimes, however, she is shown with a dragon at her feet, together with the holy water and asperges with which she conquered the monster.

St. Martin (fourth century) was born in Hungary, called Pannonia at that time, during the reign of Constantine the Great. He was converted to Christianity as a child and ran away to a monastery, but his father, who was a military tribune, insisted that the boy take up the life of a soldier. Martin joined the imperial cavalry and was stationed in France. In Amiens, one cold winter day, he chanced to pass a beggar clad in only a few rags and suffering from the bitter weather. Martin took off his cloak and, cutting it in two with his sword, gave half of it to the beggar. That night, Christ appeared to him in a vision, saying, 'What thou hast done for that poor man, thou hast done for me.' Martin then determined to devote his life to religion, and asked to be released from military service. When the emperor accused him of being afraid to meet the enemy, Martin declared that he would gladly face the enemy armed only with the Cross. Before his courage could be put to this test, word was received that the enemy was seeking peace. It was believed that St. Martin's faith in God brought about this surrender. He was, therefore, allowed to retire from the army, whereupon he went to live a life of seclusion, first on an island in the Tyrrhenian Sea, then at Liguge, near Poitiers, in France, where he founded a monastery believed to be the first in France. While at Liguge, he learned that he had been appointed Bishop of Tours. Anxious to continue his life of religious solitude, he hid from the emissaries who came to take him back to Tours. According to one legend, his hiding place was disclosed by the cackling of a goose, and he was compelled to accept his new responsibilities. Another tradition relates that in order to overcome his resistance, a citizen of Tours told him that his wife was dying and begged Martin to come and administer the Sacrament to her. Martin hurried to the city, and, upon the insistence of the people, was consecrated bishop. He remained Bishop of Tours for some thirty years. In Renaissance paintings he is often shown in the raiment of a bishop, sometimes with a goose. In other pictures, he is in military attire on horseback, dividing his cloak with his sword to cover a naked beggar.

St. Mary of Egypt (fifth century), according to legend, was an Egyptian girl of Alexandria who deliberately lived a life of sin. She joined a pilgrimage to Jerusalem, not for reasons of religious devotion but that she might seduce some of her fellow pilgrims. At Jerusalem, however, she had an impulse to enter a church with the others who had gone there to pray. A mysterious power prevented her from entering the church door, and she found that she was standing beside a statue of the Virgin. She was suddenly filled with remorse, and swore that she would sin no more. Purchasing three loaves of bread as her only source of sustenance, she went into the desert beyond the River Jordan, where she remained in solitude and prayer for many years. She was found there one day by a priest named Zosimus. She asked him to give her Holy Communion, but the priest was prevented from reaching her by the width of the River Jordan. Thereupon, Mary, aided by supernatural powers, passed dry-shod across the river and received her communion. Mary asked the priest to return at the same time the following year, that she might again receive the Sacrament. When he complied with her request, he found her dead, and written in the sand were these words: 'O Father Zosimus, bury the body of the poor sinner, Mary of Egypt. Give earth to earth and dust to dust, for Christ's sake.' Zosimus tried to bury her, but when his strength failed a lion appeared and helped to dig her grave with his paws.

Mary of Egypt is usually represented as a wasted old woman with long hair, holding three loaves of bread. Sometimes she has a lion beside her.

St. Mary Magdalene (sometimes identified with the sister of Martha and Lazarus) has come to be accepted as the great example of the penitent sinner, absolved from sin through faith in Christ. She was one of the women who accompanied Jesus on His last journey to Calvary, and who stood weeping at the foot of the Cross. With that other Mary, mother of St. James the Less, she witnessed the burial of Jesus. The third day after the Crucifixion, the two Marys appeared at the Holy Sepulchre with the spices and ointment with which to anoint the body of the Saviour. There they discovered that the stone closing the Sepulchre had been rolled away, and that the body of Christ had vanished. Mary was thus the first to bring the news of Christ's Resurrection to His disciples. Later, as she was standing weeping by the grave, Jesus appeared to her and gave her comfort.

According to an account that identifies her with the Mary who was sister of Martha and Lazarus, she was later set adrift in an open boat with her brother and sister and a number of other Christians. These victims of persecution were saved by a favorable wind which brought them into the harbor that is now Marseilles, France. There, Mary converted many people. Eventually, she retired into a desert near the city, where she remained in solitude for thirty

years. She had nothing to eat or drink, but, legend relates, she was refreshed by angels with celestial food.

Mary Magdalene was one of the favorite subjects of Renaissance painting, and pictures of her abound. Some are devotional, but many show scenes from the Gospel and from her legendary life. Her most common attribute is the alabaster box of ointment, in reference to her anointing the feet of Jesus: for she came to be regarded as the unnamed woman who anointed Jesus' feet, as St. Luke writes, 'And, behold, a woman in the city, which was a sinner, when she knew that Jesus sat at meat in the Pharisee's house, brought an alabaster box of ointment. And stood at his feet behind him weeping, and began to wash his feet with tears, and did wipe them with the hairs of her head, and kissed his feet, and anointed them with the ointment' (Luke 7: 37, 38). Sometimes she carries the box in her hand; other times it stands at her feet or is carried by an administering angel. She is often represented covered by her flowing hair, being carried by angels to receive refreshment in Heaven.

St. Matthew the Apostle and Evangelist is well known to all through his Gospel. Before he became one of Christ's disciples, he was a tax collector in the service of the Romans. The events of his life after the death of Christ are uncertain. He is supposed to have written his Gospel in Judea, and then to have preached in Ethiopia, where he died.

Matthew is portrayed in several ways. He is shown with a cherub, in human likeness, where he is pictured as recording the human ancestry of Christ. He appears with a winged man in reference to his detailed account of the Incarnation of Christ. He is also shown with a purse or a bag of money, in reference to his early profession, or with a book or pen, as writer of the Gospel. Sometimes an angel holds his inkhorn. An axe, the instrument of his martyrdom, is sometimes shown.

St. Monica (fourth century) is notable as the mother of St. Augustine and also because of her own saintly character. She devoted her whole life to her son, and, in his great book, 'Confessions,' St. Augustine pays magnificent tribute to his mother's sacrifices on his behalf. She followed St. Augustine to Italy; and, after he had been converted and baptized by St. Ambrose at Milan, she died at Ostia on the journey home to Africa.

She is represented in the black or gray habit of a nun or widow, and is often shown in paintings of her famous son.

St. Nicholas of Myra or Bari (fourth century) is regarded by historians as a purely legendary character who is supposed to have lived in the fourth

century. The universal tradition of Santa Claus (St. Claus), so loved by children, has its origin in the story of this saint. He was born in Asia Minor, of Christian parents, and very early dedicated his life to God. He was the nephew of the Archbishop of Myra, who, understanding the deep calling of Nicholas, ordained him to the priesthood. When his parents died, Nicholas distributed their great wealth among the poor.

Several stories of his life are related. One of the best known is, that hearing of a certain nobleman of the city who had lost all his money, Nicholas provided a dowry for each of his three daughters by throwing a bag of gold for each daughter through the nobleman's window at night. He was discovered while throwing the third bag, but begged the nobleman not to reveal the truth.

Another story of the saint tells of a voyage he took to the Holy Land during which his vessel was almost wrecked by the heavy seas. St. Nicholas rebuked the waves, and they subsided. He became the patron saint of sailors and travelers, and his image is to be found in almost every seaport throughout the world.

Returning from Palestine, Nicholas went to Myra. The archbishop of that seaport, who had succeeded Nicholas' uncle, had just died, and the local clergy had decided that the first priest to enter the church on the following morning should be made bishop. Early that morning, Nicholas went to the church to pray, and, as a result, was elected to the post of bishop.

One of the most famous legends of St. Nicholas tells of his visit to a certain inn, where he discovered that the wicked innkeeper was in the habit of stealing small children, killing them, and serving them to his guests as meat. Upon searching the establishment, Nicholas found the bodies of three children, hidden in a cask of brine. He made the sign of the Cross, and the three children were brought back to life. On the basis of this miracle, St. Nicholas was adopted as the protector and patron saint of little children.

Because the feast of the saint, December 6, falls near Christmas, and because his gift of the three purses was compared to the bringing of gifts to the Christ Child by the three Magi, the legend of St. Nicholas was gradually merged with the Christmas story, and he has become the familiar figure of Santa Claus.

St. Nicholas is usually represented as a bishop. His principal attribute is the three purses, or balls, in reference to his charity. He is often painted with an anchor or ship in the background, indicating his patronage of sailors. As the patron saint of children, he is sometimes shown with a small child kissing his hand. He is the chief patron saint of Russia.

St. Nicholas of Tolentino (thirteenth century) was born at St. Angelo-in-Pontara and became a friar of the Order of St. Augustine. Because his parents

had prayed to St. Nicholas of Myra for a son, he was given the saint's name. Nicholas was a man of great eloquence and saintly character. Many miracles are attributed to him.

Legend relates that, at his birth, a star flashed across the sky from his birthplace to Tolentino, where he was destined to spend much of his life. For this reason, he is frequently painted with a star on his breast. In recognition of the purity of his life, he is sometimes shown bearing a crucifix entwined with lilies. He is usually painted in the black habit of the Augustinian Order.

St. Onuphrius (fourth century) was a monk of Thebes, in Egypt, who lived in complete solitude in the desert for sixty years. According to legend, an angel brought him the Holy Eucharist each Sunday. He was eventually discovered by Paphnutius, the Bishop of Upper Thebes, who remained with him until he died. When Paphnutius found the saint, he was naked except for his long hair and a garland of leaves about his loins. Upon the death of Onuphrius, two lions appeared and dug his grave.

Onuphrius is represented as a wild, unkempt figure covered with hair and wearing a girdle of leaves. Frequently shown with him are the two lions who supposedly helped to bury him.

St. Paul the Apostle is the most widely known of the first-century followers of Jesus, owing to St. Luke's Acts of The Apostles and the many Epistles of St. Paul in the New Testament. He was born at Tarsus and was named Saul. His parents, though Jewish, were Roman citizens. He received careful instruction in Tarsus and was completing his studies at Jerusalem, under Gamaliel, when the first persecution of the Christians began. Saul officially witnessed the stoning of St. Stephen, the first deacon of the Church, and was on his way to Damascus with the commission to destroy the small community of Christians which had been formed there, when he was overcome by a great light from Heaven by which he was struck blind. He was felled to the earth and heard a voice saying, 'Saul, Saul, why persecutest thou me?' Saul cried out, 'Who art thou, Lord?' and the voice responded, 'I am Jesus whom thou persecutest' (Acts 9: 3ff.). Saul's companions led him into Damascus. There he was visited by Ananias, who, by the laying on of hands, restored his sight. Saul arose and was baptized, and his Christian name became Paul. After a period of retirement in the desert, Paul joined with other disciples of Christ to become the greatest missionary of the Christian faith. He made three great missionary journeys throughout Asia Minor and Greece. His carrying the message of Christianity to the non-Jewish world brought him his title, 'Missionary to the Gentiles.' Eventually he was arrested in Palestine and, as a Roman citizen, appealed for a hearing before

the Emperor Nero. He was sent to Rome and imprisoned. It was during his imprisonment that a number of his Epistles are supposed to have been written. Tradition says that Paul suffered martyrdom in Rome by the sword. St. Peter and St. Paul are considered to be the real founders of the Christian Church and, as such, are the subjects of innumerable religious paintings.
In art, St. Paul may be identified by the sword, with which he was beheaded, and the book or scroll of his Epistles.

St. Paul the Hermit (fourth century) is considered to be the earliest of those who lived the life of the solitary hermit. As a young man, he lived in the city of Thebes, in Egypt. During the persecution of the Christians under the Emperor Decius, he sought refuge in the desert country. Living in a cave near a date tree and a well, he remained in the desert for ninety-eight years. Legend relates that during this time a raven came to him each day, bringing him half a loaf of bread. He was finally discovered in his desert solitude by St. Anthony Abbot, who lived with him until his death, when two lions came to help Anthony bury the body of the old man.
In Renaissance painting, Paul is represented as a very old man, with long white hair and a beard, clad only in palm leaves. The particular attributes by which he may be recognized are the raven with the loaf of bread, a palm tree, and the lions that helped St. Anthony Abbot bury St. Paul.

St. Peter the Apostle was a fisherman in Galilee and the brother of Andrew. He, together with James and John, shared an inner intimacy with Christ. Peter's position among the Apostles seems to have been that of spokesman. St. Matthew, in his Gospel, relates how Peter and Andrew were called to the apostolate: 'And Jesus, walking by the sea of Galilee, saw two brethren, Simon called Peter, and Andrew his brother, casting a net into the sea: for they were fishers. And he said unto them, Follow me, and I will make you fishers of men. And they straightway left their nets, and followed him' (Matthew 4: 18ff.). From the time of his calling, Peter is frequently mentioned in the Gospels. At Caesarea, it was Peter who answered Christ's question, '. . . whom say ye that I am,' by giving the great declaration, 'Thou art the Christ, the Son of the living God,' to which Jesus replied, 'Thou art Peter, and upon this rock I will build my church; and the gates of hell shall not prevail against it. And I will give unto thee the keys of the kingdom of heaven' (Matthew 16: 15ff.). In the scriptural accounts of the Passion, Peter's vow of loyalty followed closely by his denial and deep repentance are familiar to all. The life of Peter after the Ascension of Christ is related in The Acts of The Apostles. Peter carried the word of the Saviour throughout Asia

Minor, centering his activities around Antioch. Subsequently, he came to Rome, where, it is believed, he formed the first Christian community there. Tradition says that St. Peter carried on his work in Rome for some twenty-five years, until he was accused of having cast a spell over one of the favorites of the emperor. At the pleas of his Christian followers, the Apostle agreed to flee the city, but on his way he saw a vision of Christ. Peter asked, 'Lord, whither goest thou?' (Domine, quo vadis?), to which Jesus answered, 'To Rome, to be crucified anew.' Taking this as a sign, Peter returned to Rome, where he was arrested and imprisoned. He was eventually scourged and crucified head downward. This was done at his own wish, for he did not consider himself worthy to die in the same manner as Christ.

In most paintings of St. Peter, he is shown holding the keys to Heaven. Sometimes he holds a fish, to show he is the fisherman of souls. The cock is occasionally shown near by in reference to his denial. His mantle is bright yellow, symbolic of Revealed Faith.

St. Peter Martyr (thirteenth century) is considered to be the most important saint of the Dominican Order, after St. Dominic. Born in Verona, Peter joined the Dominican Order upon hearing St. Dominic preach. He became a powerful preacher and was appointed Inquisitor-General by Pope Gregory IX. In this office he undertook to suppress heresy, acting so severely that the wrath of the people was raised against him. As a consequence, he was assassinated while on his way from Como to Milan.

Paintings of him generally represent him in the habit of the Dominican Order with a bleeding wound in his head. He is shown bearing the palm; and often a sword or a knife, the instrument of his martyrdom, is in his head or his hand.

St. Petronius (fifth century), one of the patron saints of Bologna, was born of noble Roman parents. He was converted to Christianity, entered the priesthood, and eventually became Bishop of Bologna. It was he who built the famous Church of Santo Stefano in that city.

He is customarily shown in the vestments of a bishop, bearing a model of the city of Bologna in his hand.

St. Philip, Apostle, appears infrequently in the Gospel narratives. He is associated chiefly with the account of the Feeding of the Five Thousand (John 6: 5), and as being present at the gathering of the disciples of Christ in Jerusalem after the Ascension (Acts 1: 13). Philip's later life is unknown, but he is supposed to have carried the Gospel to Scythia, where he remained for many years. There, according to legend, in the city of Hierapolis, he found

the people worshiping a great serpent. Aided by the cross, Philip caused the
serpent to disappear, but it left behind such a hideous stench that many people
died, among them the son of the king. Again aided by the cross, Philip
brought the youth back to life. The priests of the serpent were enraged
by the overthrow of their god. Seizing Philip, they put him to death.
St. Philip is usually represented bearing a cross of the Latin type fastened to
the top of a staff or reed, an allusion to his martyrdom. Sometimes the Tau
cross is substituted for the Latin cross. The dragon may appear in remem-
brance of the miracle performed by St. Philip at Hierapolis.

St. Remigius (Remy) (fifth century) was elected Bishop of Rheims at the
age of twenty-two. He was not only a man of great knowledge and brilliance
but was well known and greatly admired for his sanctity. The Frankish King,
Clovis, regarded him with great respect and afforded him constant protec-
tion in his work for the Church. In 496, as Clovis was facing a crushing de-
feat in battle, he sought the help of the God of his Christian queen, Clothild.
The tide of battle turned and a victory was won. Fulfilling his promise,
Clovis was brought to St. Remigius by Clothild. He was prepared for
baptism and the ceremony was performed on Easter Even, 496. The conver-
sion of the king greatly aided the work of St. Remigius. He directed a great
deal of his activity against the Arians, and his gentleness of character and his
wisdom of argument won many converts from this heresy. St. Remigius
has been called the Founder of the Church of God in France. He died after
having served as Bishop of Rheims for seventy-two years.

St. Reparata (third century), one of the patron saints of Florence, was a
child of noble birth who lived in Caesarea, in Palestine. As a Christian, she
was martyred at the age of twelve during the persecutions of the Emperor
Decius. Legend relates that, after being tortured, she was killed by a stroke of
the sword. As she died, her soul was seen rising to Heaven in the form of a
dove.
She is almost always represented with her spirit, in the form of a dove, flying
from her mouth.

St. Roch (fourteenth century), the patron saint of those suffering from the
plague, was born at Montpellier, in France. Because he had a birth mark in
the shape of a cross, St. Roch believed he was consecrated to a religious life.
After the death of his parents, he disposed of all his worldly goods and started
on a pilgrimage to Rome. At the town of Aquapendente, he found the
populace stricken by the plague. St. Roch immediately devoted himself to
the care of the sick, and his nursing was so effective that many recovered. As

a result of this experience, St. Roch came to believe that he had a special mission to help those stricken by the plague. He went from place to place, wherever the plague was raging, to aid its victims. After many years of this service, he was stricken by the plague in the town of Piacenza. Alone, he withdrew into the woods to die. His faithful dog refused to abandon him, and daily brought him a loaf of bread. At length, he recovered sufficiently to return to his native town of Montpellier. His illness had so changed him that no one recognized him. He was arrested as a spy and was brought before the magistrate, who happened to be his uncle. Not believing his story, his uncle sentenced him to prison. One morning, five years later, he was found dead in his prison cell, which was flooded with a heavenly light. Beside him was written this inscription: 'All those who are stricken by the plague and pray for help through the intercession of Roch, the servant of God, shall be healed.' Many years later, the citizens of Venice succeeded in stealing his body and removing it to their city. The Franciscan monks built the Church of San Rocco as a shrine for the relics of the saint.

In Renaissance painting, St. Roch is usually shown in the habit of a pilgrim, with cockleshell, wallet, and staff, lifting his robe to exhibit a plague spot on his thigh. He is generally accompanied by his faithful dog.

St. Romuald (eleventh century), a citizen of Ravenna, joined the Order of St. Benedict to atone for his father's murder of a near relative. While in the monastery, he had a vision of St. Apollinaris, who told him to found a new Order in the service of God. Romuald, a man of great asceticism, was shocked at the laxity of many of those who professed to be living the religious life. None of the existing Orders was willing to accept the severity of the rule that Romuald wished to impose. So, in the year 975, he founded the Order of Camaldoli, whose members were vowed to perpetual silence and solitude. According to legend, when Romuald was looking for a place to build his monastery, he dreamed that he saw a ladder stretching from earth to Heaven, on which men in white raiment were ascending. Taking this as a sign, he decreed that the monks of his new Order should be dressed in white robes.

In paintings, his most common attribute is the ladder to Heaven. Sometimes he is shown with the Devil under his feet. He is usually depicted as an old man with a long beard and clad in the white habit of the Camaldoli Order.

St. Scholastica (sixth century) was the twin sister of St. Benedict. Like her brother, she dedicated her life to religion, and eventually founded a community of Benedictine nuns. It is said that at the time of her death her brother was praying in his cell. There, in a vision, he saw the soul of his sister

in the likeness of a dove, ascending to Heaven. Thereupon, he announced her death to his monks and instructed that her body be brought to his abbey, where it was buried in a grave that he had prepared for himself.

St. Scholastica is the chief female saint of the Benedictine Order. She is generally represented holding a lily or a crucifix, with the dove of the legend either at her feet, pressed to her bosom, or flying toward Heaven.

St. Sebastian (third century) was a young nobleman of Narbonne, in Gaul, and commander of a company of the Praetorian Guard, the special bodyguard of the Roman emperors. His secret belief in Christ was revealed when he encouraged two of his fellow officers, who were being tortured for their belief, to die rather than renounce their faith. Hearing of this, the Emperor Diocletian urged Sebastian to abandon his faith in Christ and return to the worship of the Roman gods. When Sebastian refused, Diocletian ordered that he be bound to a stake and shot to death with arrows. The order was carried out, and Sebastian was left for dead. The mother of one of his martyred friends discovered, however, that he was still alive. She dressed his wounds and, after they had healed, advised him to escape from Rome. Contrary to her advice, Sebastian determined to come forth openly and declare his faith. He stood on the steps of the emperor's palace, pleading for those who had been condemned, and reproaching the emperor for his intolerance. When Diocletian saw him, he was amazed and demanded, 'Art thou not Sebastian?' To this the youth replied, 'I am indeed Sebastian whom God hath delivered from thy hands that I might testify to the faith of Jesus Christ and plead for His servants.' Diocletian then ordered that he should be taken to the arena and beaten to death with clubs. In order that his friends might not find it, Sebastian's body was thrown into the great sewer of Rome, but it was discovered and was buried in the catacombs at the feet of St. Peter and St. Paul.

Sebastian is always shown as a young man whose body is transfixed by arrows. Often he is bound to a tree or stake. In ancient times, the plague was believed to have been brought by Apollo's arrows. Therefore, St. Sebastian became one of the chief saints invoked against that dread disease.

St. Simon Zelotes, Apostle, is reputed to have been one of the shepherds to whom angels revealed the birth of Christ. After the Crucifixion, tradition says, he and St. Jude preached the gospel throughout Syria and Mesopotamia, and both were martyred in Persia. The instrument of their martyrdom is not known, and traditions vary. According to one legend, St. Simon was crucified; another relates that he was put to death by being sawed asunder. His attribute in art is a large saw or a cross.

St. Stephen (first century) was the first Christian deacon and the first martyr for the Faith. His story is told in the sixth and seventh chapters of The Acts of The Apostles, where it is stated that 'Stephen, full of faith and power, did great wonders and miracles among the people.' But those of the old faith in Jerusalem were angered by Stephen's words and by his influence over the people. They had him arrested and brought before the council, where, on the testimony of false witnesses, he was accused of having spoken blasphemous words against Moses and against God. In reply, Stephen preached his famous sermon (Acts 7: 2–53), which so aroused the authorities that he was taken out of the city and stoned to death. Saul, who later became the Apostle Paul, was present as a witness, and consented to Stephen's death. As he died, Stephen knelt down and cried, 'Lord, lay not this sin to their charge.' Legend states that four hundred years after his death, a priest in Palestine by the name of Lucian had a vision in which the resting place of Stephen's body was revealed. As a result, the relics of the saint were taken up and eventually reburied in Rome beside the relics of St. Laurence. It is said that when the tomb of St. Laurence was opened to receive the body of St. Stephen, St. Laurence moved to one side and gave his hand to St. Stephen. This is the origin of the title of 'the courteous Spaniard' which has been given to St. Laurence.

St. Stephen is represented as a young man in the costume of a deacon who bears the palm of martyrdom. His particular attributes are the stones which were the instruments of his martyrdom. Because of the legend of his burial, St. Stephen and St. Laurence are often portrayed together.

St. Sylvester (fourth century) became the Bishop of Rome in the year 314, during the reign of the Emperor Constantine. Many legends are told of Sylvester, the most important being the story of his converting Constantine to Christianity. It is said that, while stricken with leprosy, Constantine was visited in a vision by St. Peter and St. Paul, who told him to send for Sylvester. Recognizing the saints from pictures that Sylvester showed him, he accepted Sylvester's care. Sylvester took him to a pool and baptized him, whereupon the emperor was at once cured of his sickness. He then issued an order that Jesus Christ should be worshiped as the only true God throughout Rome. Another version of this legend places Constantine's baptism by Sylvester at the end of his life, when, in remorse for his many cruelties, he was cleansed of the leprosy of his sins by the waters of baptism. In a dispute with a group of learned doctors and magicians, Sylvester is said to have restored a dead bull to life, as proof that Christ was the God of Life.

St. Sylvester is generally represented in pontifical robes, wearing the mitre and the triple tiara, and bearing the crosier and a book. His particular attribute

is the bull, which lies at his feet. Sometimes he is shown with a dragon, as a symbol that it was during his pontificate that the power of the pagan religions was broken in the Roman Empire.

St. Thecla (first century), according to legend, was a young woman of Iconium who chanced to live in a house directly opposite that in which the Apostle Paul had his lodging. Sitting at her open window, she heard St. Paul preaching the word of Christ and thus became converted to Christianity. She became such a devoted follower of Paul that her rejected lover, Thamyrus, complained to the local governor. When he had Paul driven from the city, Thecla followed him.

She survived many tortures, including the flames of fire and the wild beasts of the arena. In later life she retired to a mountain in Iconium, where she became famous for her powers of healing. The local doctors were jealous of her and, believing that her healing powers were derived from her chastity, they plotted to have her kidnaped and defiled. As St. Thecla fled, a rock opened to receive her, leaving only a piece of her veil in the hands of her pursuers.

In art, she is generally portrayed wearing a loose mantle of dark brown or gray, and holding the palm. Occasionally wild beasts appear with her.

St. Thomas, Apostle, one of Christ's disciples, has often been called 'doubting Thomas' because he refused to believe in the Resurrection of Christ until convinced by sight and touch. 'Except I shall see in his hands the print of the nails, and put my fingers in the print of the nails, and thrust my hand in his side, I will not believe' (John 20: 25). In tradition, he has a similar role, doubting the Assumption of the Virgin. As Christ overcame Thomas' doubt by inviting him to thrust his hands in His side, the Virgin is said to have convinced Thomas by lowering her girdle to him from Heaven.

This doubt of Thomas does not mean that he did not possess great courage. When Christ insisted on returning to Judea in spite of the threats of the Jews to kill Him, it was Thomas who said to the other disciples, 'Let us also go that we may die with Him.' In the spreading of the gospel by the Apostles, Thomas is said to have gone to the east as far as India, where he established the Christian Church. Legend recounts how he was asked by Gondophorus, King of the Indies, to build him a magnificent palace, but Thomas used the money given him for this purpose to distribute among the poor. The king was enraged and vowed vengeance. It so happened however, that his brother, Gad, had just died. When Gad arrived in Heaven, he was asked by the angels where he would like to live. He pointed to a magnificent palace that stood near by, but the angels told him that he could not inhabit it, for it

was the palace that a Christian had built in Heaven for his brother, Gondophorus. When Gad appeared to Gondophorus in a vision and told him this, the king set St. Thomas free. The Apostle then explained to the king that, by faith and charity in this world, it was possible to build up a store of wealth in Heaven. Because of this legend, the usual attribute of St. Thomas in art is the builder's rule or square.

St. Thomas Aquinas (thirteenth century) was sent as a boy to the Benedictine school at Monte Cassino, but he later went to Naples, where, much against the wishes of his family, he joined the Order of St. Dominic. At this time, his manner was so heavy and apprently dull that his companions nicknamed him 'the dumb ox.' His tutor, however, was more perceptive and declared, 'You may call him a dull ox, but he will give such a bellow in learning as will astonish the world.' Thomas, in fact, soon became an outstanding theologian and teacher. He became a professor at the University of Naples, where he based his teaching of Christian doctrine on the philosophy of Aristotle.

He spent his life lecturing, writing, and dealing with Church affairs. His major work, 'Summa Theologica,' is still the basis of much of the Roman Catholic doctrine. Thomas Aquinas has been called 'the most saintly of the learned and the most learned of the saints.'

In painting, his most common attributes are the ox, for which he was nicknamed; the sun, which appears on his breast; the chalice, because of his Eucharistic writings. He is generally represented in the Benedictine habit and carries a book or books, symbolizing his great learning.

St. Ursula (fifth century) was born in Brittany, and was the daughter of the Christian king, Theonestus. According to legend, she was endowed with great beauty and high intelligence. She had many suitors, but refused to marry until Agrippus, King of England, sent ambassadors to ask her hand in marriage to his only son, Conon. Ursula told the ambassadors that she would marry Conon, but only on three conditions. First, she insisted that she must have ten noble virgins as her companions, and that each of these must have a thousand maidens as attendants. She also required a thousand handmaidens for herself. Second, she insisted that before she was married, she should be allowed three years in which to visit the shrines of the Christian saints. Third, she insisted that Prince Conon and all his court must become Christians, for she refused to marry a heathen.

These conditions were so extreme that Ursula believed they would be refused, but her beauty and wisdom had so impressed the ambassadors that Conon and his father accepted them all. Eleven thousand maidens were

gathered together to form Ursula's retinue, and Conon himself decided to join her on her pilgrimage to Rome. On their return journey, they found the city of Cologne being besieged by the Huns. These heathen savages fell upon Ursula's party and slew them all. The leader of the Huns offered to spare Ursula if she would become his bride. When she refused, he drew his bow and drove three arrows through her body.

Ursula is generally represented as a crowned princess with an arrow, which is her attribute, and she is holding a pilgrim's staff surmounted by a white banner with a red cross. She is often surrounded by her many attendants who always accompany her.

St. Veronica. The Apocryphal Gospels of Nicodemus tell the legend of St. Veronica. When Jesus was on His way to be crucified, she took pity on His sufferings and wiped the sweat from His brows with her veil, or handkerchief. Miraculously, the cloth retained the likness of the Saviour.

In art, her attribute is the 'veil of Veronica,' Veronica's napkin, which bears the picture of Christ, wearing a crown of thorns. She appears in many pictures of the Road to Calvary.

St. Vincent (fourth century) was a deacon of Saragossa, in Spain. During the reign of the Emperor Diocletian, Vincent was persecuted by the proconsul Dacian and was subjected to the most terrible tortures. Dacian, having tried in vain to shake St. Vincent's faith, then sought to tempt him by kindness and luxury. He prepared a fine bed of down, strewn with roses, upon which Vincent was lain. But Vincent had no sooner been placed upon the bed than he commended his spirit to God, and died. Dacian ordered the body to be thrown to wild animals, so that it might be devoured, but a raven came and protected it from all attacks. The body was then taken out to sea in a boat and thrown overboard, with a millstone tied round its neck. It was miraculously washed ashore, and the waves of the sea hollowed a tomb for St. Vincent in the sands. Many years later, his body was discovered and buried in Valencia.

In painting, St. Vincent is represented as a beautiful young man, dressed in the habit of a deacon. He carries the palm of martyrdom, but his special attributes are two crows which accompanied the vessel that brought the relics of the saint from Cape St. Vincent to Lisbon, where they now lie.

In reference to his martyrdom, he may have as attributes a whip, a chain, a grill with iron hooks, or a millstone.

St. Zeno (fourth century). According to legend, Zeno was a fisherman of Verona who became bishop. He was famous for his wisdom and kindness.

He is said to have saved the city of Pistoia from destruction by flood by creating an exit for the waters of the two rivers, the Arno and Ombrone, through what is now known as the Gonfolina Pass.

St. Zeno is generally painted in the costume of a bishop, with a fish hanging from his crosier. He is the patron saint of Verona.

St. Zenobius (fourth century). Born in Florence of noble birth, Zenobius was converted to Christianity by one of his tutors. He became a priest, and a friend of St. Ambrose of Milan, who recommended him to Pope Damasus I. After the death of that Pope, Zenobius returned to Florence, where he was chosen bishop. Many legends are told of the ability of Zenobius to restore the dead to life.

For this reason, he is frequently portrayed with a dead child or young man in his arms. Legend also states that after his death, when his body was being borne to the cathedral for burial, it chanced to touch a withered elm that stood by the wayside. Forthwith, the dead tree burst into leaf. The flowering tree is therefore another attribute of Zenobius.

Radiances, Letters, Colors, and Numbers

A number of symbols have been used to suggest the divine nature or holiness of the persons portrayed in paintings of religious subjects. These symbols are used almost universally in representations of God, Christ, the Holy Ghost, the Virgin Mary, and the saints.

Aureole. The aureole is the symbol of divinity, therefore, of supreme power. Its use has been reserved for the representation of Divinity: the Father, the Son, and the Holy Ghost; or such symbols that represent the Persons of the Trinity. This use has been extended only to representations of the Blessed Virgin.

The aureole consists of a field of radiance and splendor which encircles the whole body and appears to emerge from it. In some cases, the aureole follows the form of the body and clings closely to it, appearing as a fringe of light; in other instances, it is removed from the body and is composed of many luminous rays issuing from a central point. The aureole often appears to end in, or to consist of, pointed flames. It may be shaded off in the colors of the rainbow. The early aureoles were white, but by the Renaissance, gold was generally used to give the impression of light. A blue aureole, indicating celestial glory, is occasionally seen.

The Mandorla or **Almond.** This aureole obtained the Italian name *mandorla* from its almond shape. In the mandorla, the extended rays of the aureole are enclosed in an almond-shaped framework that surrounds the body of the person depicted. On rare occasions the mandorla may be composed of seven doves, indicating the seven gifts of the Holy Ghost. More rarely, a grouping of angels will be portrayed within the framework of the mandorla. The mandorla is frequently given to Christ in pictures of the Last Judgment, and, on certain occasions, to the Virgin Mary, as in representations of the Assumption.

Halo or **Nimbus.** The halo, or nimbus, is a zone of light, generally represented as a circle, square, or triangle. It is placed behind the heads of divine or sacred personages to identify their great dignity.

The nimbus takes a variety of forms, depending upon the persons depicted. In portrayals of God the Father, of Christ, and of the Holy Ghost, the Trinity is often symbolized by three rays of light issuing from the head to form a rayed nimbus. The cross within a circle, the cruciform nimbus, refers to redemption through the Cross and is, therefore, used only in portrayals of Christ. The triangular nimbus is sometimes used in pictures of God the Father, and refers to the Trinity. The nimbus of the Virgin Mary is always circular and is often elaborately decorated. The nimbus of saints, or of other sacred persons, is usually circular in form without much ornamentation.

A nimbus in the form of a square is used to distinguish living persons, such as donors, from the saints. The square has always been considered inferior to the circle, and hence was employed to symbolize the earth, whereas the circle expresses Heaven or eternal existence. The many-sided nimbus, usually hexagonal, is used in portrayals of persons imagined to represent the virtues or other allegorical figures.

Glory. The glory is a luminous glow that combines the nimbus surrounding the head and the aureole surrounding the body. It expresses the most exalted state of divinity and is, therefore, the attribute of God, the Supreme Lord of Heaven, and of Christ as Judge.

Letters. Various letters were used from early Christian times to identify Christ, or to stress the identity of some individual or object with Christ.

A and W: Alpha and Omega, the first and the last letters in the Greek alphabet, are frequently used on a plaque, shield, book, or elsewhere, as the symbol of God the Son. This usage is based upon Revelation 1: 8, which reads: 'I am Alpha and Omega, the beginning and the ending, saith the Lord . . .'

T: This single Greek letter is explained as representing the first letter of the Greek word Theos, meaning 'God.' The single letter T is used as an attribute of St. Anthony Abbot, generally being placed upon his left shoulder.

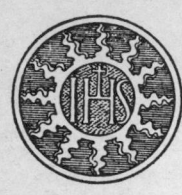

I H S, I H C: These letters are the first three letters of Ihsus, or Ihcuc, the name of Jesus in Greek. The S and the C are variant forms in the Greek alphabet. They have often been confused with the Latin phrase, 'In hoc signo.' This refers to the legend that Constantine, on the eve of battle and before his conversion, had a vision. In this vision he beheld a banner on which these words were inscribed: 'In hoc signo vinces' (In this sign you will conquer). After victory in the battle, he is said to have embraced the Christian religion. Furthermore, these letters are sometimes misinterpreted as being an abbreviation of the Latin phrase, 'Iesus Hominum Salvator (Jesus Saviour of Men).

This monogram, inscribed in a sun, is the sign that appeared to St. Bernardino of Siena, and which that saint is often depicted carrying in his hand.

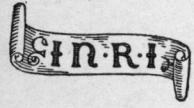

I N R I: These represent the four initial letters of the Latin words, 'Jesus Nazarenus Rex Judaeorum,' meaning 'Jesus of Nazareth, King of the Jews.' According to St. John 19: 19, after Christ had been crucified, 'Pilate wrote a title, and put it on the cross. And the writing was, Jesus of Nazareth, the King of the Jews.' St. John goes on to say that this sign was written in Hebrew, Greek, and Latin.

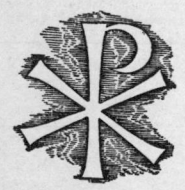

Monograms. A monogram is a character composed of two or more letters. The nature of the letters, together with various possible arrangements, may produce a beautiful and symbolic design. Frequently the letters are interwoven or combined with other symbols to represent God, or the Persons of the Godhead. By far the most common are the monograms representing Christ.

XP: The two Greek letters Chi and Rho, which most frequently appear in a monogram, are the first two letters of the Greek word for Christ, ΧΡΙΣΤΟΣ. The combination of these two letters readily gives the form of a cross. Furthermore, as Rho resembles 'p' and Chi is similar to 'x', the monogram could be read as the Latin word pax, meaning peace.

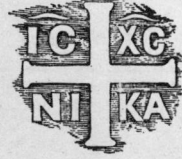

IC XC NIKA was the ancient monogram symbolizing Christ the Conqueror. I and C are the first and last letters of the Greek word Ihcuc (Jesus); X and C are the first and last letters of Xpictoc (Christ); Nika is the Greek word for conqueror.

Colors. *Black*: Black, as a symbol of death and of the underworld, was familiar before the days of Christianity. It was a pagan custom to sacrifice a black animal to propitiate the gods of the nether world.

In Christian symbolism, black is the color of the Prince of Darkness, and, in the Middle Ages, it was associated with witchcraft, the 'black art.' In general, black suggests mourning, sickness, negation, and death. Black and white together, however, symbolize humility and purity of life. In this sense black, or black and white, was used as the color of the habits of certain religious orders, such as the Augustinians, the original Benedictines, and the Dominicans. Black, as the traditional color of mourning, is the liturgical color for Good Friday, the day of Christ's Crucifixion.

Blue: Blue, the color of the sky, symbolizes Heaven and heavenly love. It is the color of truth, because blue always appears in the sky after the clouds are dispelled, suggesting the unveiling of truth. In paintings, both Christ and the Virgin Mary wear mantles of blue; Christ during His ministry on earth, and the Virgin when holding the Christ Child or shown with Him. In the Church, blue has become the traditional color of the Virgin, and is used on days commemorating events in her life.

Brown: Brown is the color of spiritual death and degradation, and also of renunciation of the world. In this sense, it has been adopted by the Franciscan and the Capuchin Orders as the color of their habits.

Gold: see *Yellow*.

Gray: Gray, the color of ashes, signifies mourning and humility. It is sometimes used as the Lenten color. Because gray symbolizes the death of the body and the immortality of the spirit, Christ is sometimes shown wearing gray in paintings of the Last Judgment. Gray is the color of the habit of the Vallombrosian Order of Benedictines.

Green: Green is the color of vegetation and of spring, and therefore symbolizes the triumph of spring over winter, or of life over death. Being a mixture of yellow and blue, it also suggests charity and the regeneration of the soul through good works. In pagan rites of initiation, green was the color of water; and it is as the symbol of spiritual initiation that St. John the Evangelist sometimes wears a green mantle.

Green is the color of the Epiphany season in the Church, marking

the Visitation of the Magi, and the initiation rites in the life of Christ.

Purple: Purple has always been associated with royalty, and is the accepted sign of imperial power. As such, it is sometimes used as a symbol of God the Father. Purple is also the color of sorrow and penitence. It is the liturgical color for Advent and Lent, the Church's seasons of preparation and penitence, when men are anticipating the joyous festivals of Christmas and Easter.

Red: Red is the color of blood, which is associated with the emotions, and is, therefore, symbolic of both love and hate. Red, the color of sovereign power among the Romans, has a similar meaning in the dress of the cardinals. St. John the Evangelist is clad in red to suggest his love of action. Red is the Church's color for martyred saints, because many of the early Christians suffered martyrdom in the Roman persecutions, or at the hands of the barbarians, rather than deny their faith in Christ. In a different sense, because red is the color of fire, it is used during the Church's season of Pentecost, which commemorates the coming of the Holy Ghost.

Violet: Violet symbolizes love and truth, or passion and suffering. It is the color worn by such penitents as Mary Magdalene, and sometimes is worn by the Virgin Mary after the Crucifixion.

White: White has always been accepted as symbolic of innocence of soul, of purity, and of holiness of life. Several references to white as the color of purity and innocence are found in the Bible. For example, 'Wash me, and I shall be whiter than snow' (Psalm 51 : 7). Christ in the Transfiguration is clad in a garment 'as white as the light' (Matthew 17: 2). In describing the angel of the Lord who rolled back the stone from the door of Christ's sepulchre, St. Matthew wrote, 'His countenance was like lightning, and his raiment white as snow' (Matthew 28: 3). White is worn by Christ after His Resurrection. It is also worn by the Virgin Mary in paintings of the Immaculate Conception, of her Presentation in the Temple, and, in general, in scenes prior to the Annunciation. The Roman vestal virgins wore white as a symbol of innocence and purity, and this custom has been perpetuated in the dress of brides, in the garments of those receiving their first communion, and in the garb for baptism. In the Early Christian period the clergy wore white, and this color has remained in liturgical use for Christmas, Easter, and Ascension. White is the color of light, and is sometimes represented by silver.

Yellow: The color yellow may have either of two opposed symbolic meanings, depending on the way in which it is used. A golden yellow is the emblem of the sun, and of divinity. The backgrounds of many Renaissance paintings glow with a golden yellow, symbolizing the sacredness of that which is depicted. Both St. Joseph and St. Peter are sometimes painted in yellow dress. St. Peter wears a yellow mantle because yellow is the symbol of revealed truth. On the other hand, yellow is sometimes used to suggest infernal light, degradation, jealousy, treason, and deceit. Thus, the traitor Judas is frequently painted in a garment of dingy yellow. In the Middle Ages heretics were obliged to wear yellow. In periods of plague, yellow crosses were used to identify contagious areas, and this use led to the custom of using yellow to indicate contagion.

Geometrical Figures. *Circle*: The circle, or ring, has been universally accepted as the symbol of eternity and never-ending existence. As the monogram of God, it represents not only the perfection of God but the everlasting God, 'Who was in the beginning, is now, and ever shall be, world without end.' (See Ring, in Section XIV).

Triangle: The equilateral triangle is the symbol of the Trinity, suggesting three equal parts joined into one. The triangular nimbus is used only in representations of God the Father, or of the Trinity.
The triangle with three circles is the monogram of the Trinity: the Three Persons in the One God: the Father, the Son, and the Holy Ghost.

Square: The square, in contrast with the circle, is the emblem of the earth, and of earthly existence. In this sense it is used in painting as the nimbus of living persons. (See Halo or Nimbus.)

Pentagram: A pentagram is a five-pointed, star-shaped figure made by extending the sides of a regular pentagon until they meet. This geometrical figure has long had symbolic significance, having first been used by followers of Pythagoras, the Greek philosopher, mathematician, and religious reformer; and later by the magicians of the Middle Ages. In the secular sense, the pentagram was used as a protection against the evils of sorcery. In Christian symbolism, the figure suggests the five wounds suffered by Christ upon the Cross.

Numbers. *One* is the symbol of unity.

Two suggests the two natures of Christ, the human and the divine.

Three was called by Pythagoras the number of completion, expressive of a beginning, a middle, and an end. In Christian symbolism, three became the divine number suggesting the Trinity, and also the three days that Christ spent in the tomb.

Four is ordinarily used to suggest the four Evangelists.

Five is symbolic of the wounds of Christ.

Six is the number of creation, and perfection, symbolizing divine power, majesty, wisdom, love, mercy, and justice.

Seven is the number of charity, grace, and the Holy Spirit. It was also used by the early writers as the number of completion and perfection. Many instances of this use appear in Biblical writings. When the friends of Job came to comfort him, they 'sat down with him upon the ground for seven days and seven nights' (Job 2 : 13). Jacob, as a sign of perfect submission, bowed seven times before his brother. Again, there is reference to the sevenfold gifts of the Holy Spirit, the seven deadly sins, and the seven joys and the seven sorrows of the Virgin.

Eight is the number of Resurrection, for it was on the eighth day after His Entry into Jerusalem that Christ rose from the grave. Many baptismal fonts are octagonal in shape.

Nine is the angelic number, for the Bible refers to the nine choirs of angels.

Ten is the number of the Ten Commandments.

Twelve, as the number of the Apostles, has always been a favorite number in Christian symbolism. In a more extended meaning, it is occasionally used to represent the entire Church.

Thirteen is the number of faithlessness and betrayal. At the Last Supper there were thirteen persons at the table: Jesus and the twelve Apostles, including Judas, who had already agreed to betray his Master.

Forty is symbolic of a period of probation or trial. The Israelites wandered for forty years in the wilderness and, for a similar period of time were in bondage to the Philistines. Moses remained for forty days on Mount Sinai. The rain of the Flood lasted for forty days and forty nights. After Christ's baptism, He was forty days in the wilderness, being tempted by the Devil. The

forty days of Lent commemorate this event. Forty is sometimes used as the symbol of the Church Militant.

One hundred is the number of plenitude.

One thousand was once regarded as the number signifying eternity, since the names of numbers which exceed one thousand were merely additions to, and multiplications of it.

SECTION XII

Religious Dress

Types of Religious Dress. The three orders of ministers in the medieval Church, namely, bishops, priests, and deacons, may be distinguished by the particular vestments and clothing they wear. Those in holy orders who do not belong to one of the religious communities are known as the secular clergy. In Renaissance art, it is usually members of the hierarchy, namely, bishops, cardinals, and the Pope, whom we find portrayed.

All seculars, regardless of their rank, wear a cassock which is a close-fitting, long-sleeved garment reaching to the ankles. Traditionally, it has thirty-three buttons, which are symbolical of the number of years of Christ's earthly life.

The regular clergy, as distinct from the secular, are those in holy orders who are joined under the common rule of the religious order to which they belong. They can be distinguished in two ways: first, by the color of the habit which is peculiar to the religious order of which they are members; and second, by the tonsure, or cut of the hair, which in Renaissance times was common to all those in monastic orders. The shape of the tonsure was often a distinguishing mark of the particular monastic order. The dress of the regulars is called a habit. Usually, it is a long, loose gown, gathered about the waist by a leather belt or rope girdle, with wide sleeves and a hood. The hood, which is the most distinctive feature, is known as the cowl and may be drawn over the head. Some habits include a scapular and a mantle. The religious order of the wearer may be identified by the color of the habit. Women also enter the religious life. Like the men, they live a communal life under the vows of poverty, chastity, and

obedience. Their order is distinguishable by the habit which they wear. Though they take the monastic vows, they are not admitted to holy orders.

Liturgical Vestments. When celebrating Mass, the priest wears over his cassock, or habit, the following vestments: amice, alb, stole, cincture, maniple, and chasuble. Bishops, and other members of the hierarchy, also wear the rochet under the alb, liturgical sandals and stockings, pontifical gloves and ring, pectoral cross, and mitre, and they carry the pastoral staff.

Alb. The alb is a white linen tunic reaching to the feet. It alludes to the robe of mockery with which Herod caused Christ to be clothed, and symbolizes chastity, purity, and the eternal joy of those who have been redeemed by the Blood of the Saviour. In the Middle Ages, embroidery was on the sleeves, chest, and at the hem of the alb to symbolize the five wounds of Christ.

Amice. The amice is the first vestment the priest puts on when vesting for Mass. It is an oblong piece of white linen upon which a cross is sewn or embroidered. It is an allusion to the cloth that covered the face of Christ during the mocking by the soldiers.

Biretta. The biretta is a stiff, square hat with three or four ridges on the top. It may have a pompon attached at the center. It is worn by secular priests and by members of the hierarchy. The color of the biretta may distinguish the ecclesiastical rank of the wearer: in general, black is worn by priests, purple by bishops, and scarlet by cardinals. Distinguished from the biretta is the cardinal's hat, having a broad brim, low crown, and two cords with fifteen tassels each. Its color is always red.

In Renaissance painting, St. Jerome is sometimes depicted wearing the cardinal's red hat and robe, even though the ecclesiastical rank of cardinal was not known in his day. St. Bonaventura is upon occasion distinguished by a cardinal's hat hanging on a tree or lying on the ground beside him.

Cassock. The cassock is the everyday dress of the clergy, and signifies their devotion to Christ and the Church. In general the distinguishing colors of the cassock are white for the Pope, scarlet or red for cardinals, purple for bishops, and black for

priests. However, several variations of these colors may occur. When a member of a religious order is raised to the hierarchy, he lays aside his habit and assumes a cassock. The color of the habit of his order, however, is retained in this cassock.

Chasuble. The chasuble is the last liturgical garment with which the celebrant is vested. It is the outer garment covering the other vestments, and the Latin origin of its name, *casula* (little house), aptly describes it. The chasuble may be white, red, rose, green, violet, black, gold, or silver, depending on the season of the Church's year or the feast that is being observed. It usually has a cross embroidered on the back, which is an allusion to the Passion of Christ. Symbolically, this vestment alludes to the purple dress that Pilate ordered to be placed on Christ as 'King of the Jews.' It also recalls Christ's seamless garment for which the soldiers, on Calvary, cast lots. Because the chasuble covers the other vestments, its symbolic meaning is Christian charity and protection; charity being the virtue that should supersede all others.

Cope. The cope, the richest and most magnificent of ecclesiastical vestments, is a large cape fashioned in the form of a half circle. A highly decorative deep collar, suspended from the shoulders, ornaments its back. The color of the cope is that of the Church's season. It is worn in processions and in services of great solemnity. Its symbolic meaning is innocence, purity, and dignity.

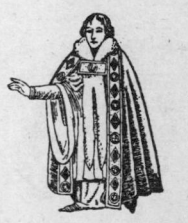

Cord. The cord, or cincture, is a linen rope (although it may be of wool or silk(worn around the waist, over the alb and the crossed stole of the celebrant. It is an allusion to the rope with which Christ was bound to the pillar during the Flagellation. Its symbolic meaning is chastity, temperance, and self-restraint.

Dalmatic. The dalmatic is the traditional liturgical vestment of the deacon. It is a long-sleeved outer tunic which the deacon wears over the alb. Bishops and abbots may wear it under the chasuble at Solemn Pontifical Masses, and in Renaissance paintings bishops and abbots are often shown wearing both vestments. Its shape, which is the form of a cross, refers to the Passion of Christ. It symbolizes joy, salvation, and justice. The dalmatic is one of the attributes of St. Stephen and St. Laurence.

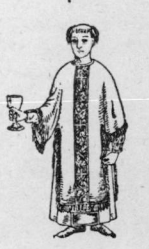

Maniple. The maniple is a narrow strip or band of silk worn over the alb on the left arm by the celebrant of the Mass. It is of the same material and color as the chasuble and stole. It is an allusion to the rope with which Christ was bound and led to Calvary, and symbolizes good works, vigilance, and penitence.

Mantelletta. The mantelletta is a knee-length, sleeveless outer vestment, open in the front, worn by cardinals, archbishops, and bishops. Its color is determined by the ecclesiastical rank of the wearer. Cardinals wear a red mantelletta; bishops, a purple one. The vestment is worn as a sign of limited jurisdiction or authority.

Mitre. The mitre in its modern form is a tall head-dress with the top cleft crosswise, its outline resembling a pointed arch. It is a liturgical hat, and is worn by the Pope, cardinals, archbishops, and bishops and, with special permission, by some abbots. It is symbolic of their authority.

Mitres may be inlaid with precious stones, embroidered with orphreys, or unadorned and made with white linen or silk. Abbots wear only this latter type, except by special privilege. The mitre is reminiscent of the pointed hat worn by the Jewish high priest as a symbol of authority, but it was not derived directly from that. The two horns of the mitre are an allusion to the two rays of light that issued from the head of Moses when he received the Ten Commandments. They are also symbolic of the Old and New Testaments. Attached to the back of the mitre, and falling over the shoulders of the wearer, are two flaps, or fanons, which are symbolic of the spirit and the letter of the Testaments. Three mitres are given as an attribute to both St. Bernard and St. Bernardino, in token of the three bishoprics that each man refused.

Morse (Brooch). The morse, or brooch, is a clasp used to fasten the front of the cope.

Mozzetta. The mozzetta is an elbow-length cape with an ornamental hood. It is a non-liturgical garment, and is not worn to administer the Sacraments. It is worn by the Pope, by cardinals when not in Rome, and by archbishops, bishops, and abbots within the limits of their jurisdiction.

Pallium. The pallium is a narrow band of white wool worn around the shoulders. It has two short pendants, one hanging down the front, the other down the back, and is ornamented with six black crosses. It is a symbol of the papal authority, and may be given by the Pope to archbishops to indicate their participation in his authority. Its Y shape is symbolic of the Crucifixion.

Ring. The ring worn by members of the hierarchy symbolizes not only spiritual marriage with the Church but also the ecclesiastical office of the wearer.

The papal ring is known as the Fisherman's Ring because it bears the image of St. Peter fishing. It is of plain gold. It is put on the finger of a new Pope at the time of his election. Since it bears his name, it is broken at his death. The Pope always wears a cameo; the privilege of wearing a carved gem is reserved for him.

The cardinal's ring is a sapphire, which he receives from the Pope at the time of his elevation. On the inside of this ring is engraved the coat of arms of the Pope who bestows it.

A bishop also wears a gemmed ring, and he may choose any stone he wishes except a sapphire, which is reserved for the exclusive use of cardinals.

Abbots and abbesses may also wear very simple gemmed rings. A plain metal band, or a band in the form of a cross, may be worn by a nun to symbolize her marriage with Christ. This is represented pictorially in the many paintings of the Mystic Marriage of St. Catherine of Alexandria.

A ring is also used liturgically, and when it serves this function it is known as the Pontifical Ring. Such a ring is ornamented with a beautiful, large stone, and its band must be of a size which can easily fit over a gloved finger.

Rochet. The rochet is a knee-length, pleated tunic, of white linen with tight sleeves. The bottom, shoulder pieces, and ends of the sleeves are ornamented with lace lined with silk of a color that distinguishes the ecclesiastical rank of the wearer.

Scapular. The scapular, meaning shoulder, is a narrow length of cloth placed over the shoulders and extending to the hem of the garment, both in the front and in the back. It is a part of most monastic habits, and probably developed from some kind of

large apron put on to protect the clothing. It is symbolic of the yoke of Christ.

Skull-Cap (Zucchetto). The skull-cap is close-fitting and rimless. As with other ecclesiastical garments, its color is in accord with the rank of the wearer.

Stole. The stole is a narrow, embroidered vestment worn about the neck. When used as one of the Mass vestments, it is crossed over the breast and made secure by the cord. Its color matches that of the chasuble and maniple. It may have three crosses, one on each end and one in the middle. When worn for other liturgical offices it is not crossed. The deacon wears a broad stole over his left shoulder, across the breast, and fastened at the waist. The stole is a sign of priestly dignity and power. It symbolizes the yoke of Christ and the Christian duty of working loyally for His Kingdom, and the hope of immortality.

Surplice. The surplice is a knee-length, white linen tunic. Its large flowing sleeves and hem are usually trimmed with lace. Worn over the cassock, it is used during the administration of the Sacraments and for various other liturgical purposes. It is symbolic of man renewed in justice and in the holiness of truth.

Tiara. The tiara, which is a circular headpiece consisting of three crowns, one above the other, surmounted by a cross, is worn only by the Pope. It has a long history, but was first known in its present form in 1315. Its three crowns have numerous interpretations: they are symbolic of the Trinity, and also allude to the three estates of the Kingdom of God. In art, the tiara is an attribute of St. Gregory and St. Sylvester.

Tonsure. Tonsure was the custom of shaving the hair from the top of the head. This practice, during the Renaissance and in the early days of the Church, was adopted by the secular clergy and the monastic orders. It has a triple symbolism: the remembrance of the crown of thorns; the rejection of temporal things; and a reminder of the perfect life.

Tunicle. The tunicle is a short dalmatic worn by the sub-deacon at High Mass. It is the symbol of joy and contentment of heart.

Veil. The veil, as a religious garment, is the outer covering of the headdress of a nun. It is symbolic of modesty and renunciation of the world.

Wimple. The wimple is a linen covering around the head, neck, and cheeks of a nun.

SECTION XIII

Religious Objects

Altar. The Christian altar is a table of stone or wood, and is usually beautifully carved. Situated in the center of the sanctuary, it is the chief focal point within the church. Liturgically, the altar faces the east and Jerusalem, the Holy Land of Christ's Passion and Death. This position is traditional and has scriptural authority in Ezekiel 43 : 4, 'And the glory of the Lord came into the house by the way of the gate whose prospect is toward the east.' The altar, or holy table, symbolizes the presence of Christ in the Sacrament of the Eucharist.

Altar Cloth. The altar cloth is of pure white linen, covering the top of the altar and extending downward on both sides. It is symbolic of the shroud that covered Christ.

Altarpiece. The altarpiece is a panel or panels attached to, or placed immediately behind, the altar. It takes many forms: a largen (single panel); the more common triptych (triple panel); or polyptych (numerous panels); and it is richly ornamented. The central panel usually depicts the Crucifixion, although it may portray some other great event in the life of Christ. Often, the central panel is a representation of the Virgin and Child. The side panels portray events associated with Christ or the Virgin, or with the saints to whom the particular church or chapel is dedicated. These side panels are often hinged, so that they can be closed for penitential seasons or opened on special occasions.

Ampulla. The ampulla is the vessel that contains the holy oil. The blessed oils are used in the Sacraments of Holy Baptism, Confirmation, Holy Orders, and Unction. They are also used in the ceremony of Coronation. The holy oil is symbolic of consecration.

Asperges (Aspergillum). Asperges (thou shalt sprinkle) is the first word of the anthem, 'Asperges me, Domine, hyssopo,' which has come to designate the rite of sprinkling the altar, clergy, and people with holy water. It symbolizes the purification from and the expulsion of evil. 'Purge me with hyssop, and I shall be clean: wash me, and I shall be whiter than snow' (Psalm 51: 7). Asperges has come to be used to designate the rite itself, as well as the aspergillum, which is used by the priest in performing the rite. The aspergillum is a brush, or a perforated globe holding a sponge, on a short handle. From its use, the aspergillum has acquired a very special significance as an instrument with which to exorcize evil. As such, it occurs as an attribute of St. Anthony Abbot, St. Benedict, St. Martha, and the other saints famed for their contests with the Devil.

Bells in church towers and spires summon the faithful to worship. The sanctus bell at the altar announces the coming of Christ in the Eucharist. St. Anthony Abbot is frequently portrayed with a bell attached to his crutch as a warning to demons.

Candle. Candles play a great and varied role in churches, and according to their use and numbers the teaching of the Church is expressed symbolically. Examples of this are the six lights on the altar, representing the Church's constant round of prayer; the sanctuary lamp; the Eucharistic candles, symbolizing the coming of Christ in Communion; the Paschal candle, symbolical of the risen Christ during the Easter season. Candles are also symbolical when used in groupings: three candles represent the Trinity,or seven candles signify the Seven Sacraments. The Bishop's Candle is used when the bishop is pontificating, or is the celebrant of the Mass. The use of candles for devotional purposes, at shrines and in processions, is universal and frequently seen in Renaissance art. The candlestick, because of the symbolism attached to the candle, is usually a work of artistic beauty.

Cathedral. A cathedral is the official seat of a bishop, and is, therefore, the principal church of a diocese. It takes its name from the cathedra, or official chair or throne of the bishop, which is placed in the sanctuary.

Censer. A censer is the vessel in which incense is burned. It is cup-shaped, with a pierced cover, and is suspended by chains. In the Old Testament, the censer symbolized the pleas of the worshiper that his prayer would be acceptable to God. 'Let my prayer be set forth before thee as incense; and the lifting up of my hands as the evening sacrifice' (Psalm 141: 2). In Christian symbolism, the smoke of the incense symbolizes the prayers of the faithful ascending to Heaven. The censer is an attribute of St. Laurence and St. Stephen.

Chalice. A chalice is the cup from which the consecrated wine and water of the Eucharist are partaken at Holy Communion. It refers to the Last Supper and the sacrifice of Christ upon the Cross. 'And he took the cup, and when he had given thanks, he gave it to them: and they all drank of it. And he said unto them, This is my blood of the new testament, which is shed for many' (Mark 14: 23, 24). Thus, the chalice is a symbol of the Christian faith. Its significance goes back to the Old Testament, where an allusion to the Eucharist may be found in Psalm 116: 13, 'I will take the cup of salvation . . .' Also St. Paul conveys this idea in I Corinthians 10: 16, 'The cup of blessing which we bless, is it not the communion of the blood of Christ?' The chalice with a serpent is the attribute of St. John the Evangelist. The chalice and wafer are attributes of St. Barbara; the broken chalice, of St. Donatus.

Church. In Christian symbolism, the church has several meanings. In its basic sense, it means the House of God. It may also be used to signify the Body of Christ. Sometimes, the church is alluded to as the Ark, and in this sense means the salvation of all its members. In painting, a church placed in the hands of a saint signifies that he was the founder of a particular church or was its first bishop. In the hands of St. Jerome and St. Gregory, however, the church signifies no particular building, but the Church in general, of which they were great supporters and among the primitive fathers.

Ciborium. The ciborium has two meanings. It is either a canopy erected over the altar and supported by four pillars, an allusion to the Ark of the Covenant, or it is a receptacle for the Reserved Host. In the latter sense, it symbolizes the Eucharist and the Last Supper.

Corporal. The corporal is a white linen cloth laid on the altar, upon which the elements of bread and wine are consecrated. At certain times during the service these elements may be covered with the corporal.

Crosier. The ancestor of the crosier is generally supposed to be the shepherd's crook; however, it may also be a descendant of the walking staff common in the days of the Apostles. Now, greatly enriched since its humbler days, it is the pastoral staff of a bishop, archbishop, abbot, or abbess. It is still common practice for an abbot's staff to bear a white pendant veil. The pennanted staff often appears in paintings. It is the symbol of authority and jurisdiction. The crosier bearing a double cross is the attribute of St. Gregory, and also of St. Sylvester. St. Zeno carries a crosier with a fish.

The crosier is regarded as the symbol of mercy, firmness, and the correction of vices.

Cross. The cross is one of the oldest and most universal of all symbols. It is, of course, the perfect symbol of Christ because of His sacrifice upon the Cross. In a broader sense, however, the cross has become the mark or sign of the Christian religion, the emblem of atonement, and the symbol of salvation and redemption through Christianity.

There are many and varied forms of the cross. In Christian art, two major types, known respectively as the Latin cross and the Greek cross, are most commonly found.

The Latin cross has a longer upright than crossbar. The intersection of the two is usually such that the upper and the two horizontal arms are all of about equal length, but the lower arm is conspicuously longer. This cross is used to symbolize the Passion of Christ or the Atonement. Five red marks or jewels are sometimes placed on the face of the cross to represent the five wounds Christ suffered while being crucified. In addition, Christ's crown of thorns is frequently shown with the cross or

hanging upon it. Tradition says that Christ was crucified on a Latin cross.

The Latin cross fastened to the top of a staff or reed is the attribute of St. Philip, who is also sometimes represented with a plain Latin cross in his hand or with a Tau cross on the end of his staff. The Latin cross, alone or in combination with other pictorial elements, is used as an attribute of numerous other saints. The plain Latin cross is borne by St. Reparata and St. Margaret. John the Baptist frequently bears a cross made of reeds. St. Helena is depicted with a cross with hammer and nails or with a cross borne by angels. St. Anthony of Padua has a flowered cross, while St. Catherine of Siena is given a cross with a lily. St. George of Cappadocia and St. Ursula are painted with a banner on which there is a red cross.

The Greek cross has four equal arms. This cross is used more often to suggest the Church of Christ than to symbolize Christ and His sacrifice for mankind.

Another well-known form of the cross is the St. Andrew cross, which consists of crossed arms which are not at right angles to each other, but diagonally placed in the shape of an X. The origin of this form is attributed to St. Andrew, who, when condemned to be crucified, requested that he be nailed to a cross of a different form than that upon which Christ was sacrificed. In true humility, St. Andrew believed that, even in martyrdom, he was unworthy to approach the likeness of his Redeemer. The St. Andrew cross has, therefore, come to be a symbol of humility in suffering.

An older form of the cross is the Egyptian or Tau cross, which consists of three arms only, arranged in the shape of the letter T. This is known as the Old Testament cross. Tradition says that it was upon such a cross that Moses lifted up the serpent in the wilderness, foreshadowing the lifting up of Christ upon His Cross (John 3 : 14). The Tau cross is occasionally one of the attributes of St. Philip because, according to one version of his martyrdom, he was crucified on a cross of this type. It is also one of the attributes of St. Anthony Abbot.

Two adaptations of the cross, known as Ecclesiastical crosses, are used to distinguish different ranks in the hierarchy of the Church. The double cross, that is, a cross with two crossbars, is used to signify patriarchs and archbishops, while the triple cross, with three crossbars, is used exclusively by the Pope.

Crown. The crown, from very early days, has been the mark of victory or distinction. From this, it came to be accepted as the mark of royalty. In Christian art, the crown, when on the head of the Madonna, indicates that she is the Queen of Heaven. When the crown is used as the attribute of a martyr, it signifies victory over sin and death, or denotes that the saint was of royal blood. The crown is sometimes merely a circlet, but it may be a chaplet of flowers or a magnificent circle of gold and jewels.

The Crown of Thorns is one of the emblems of the Passion and the Crucifixion of Christ. 'And the soldiers . . . clothed him with purple and platted a crown of thorns, and put it about his head, and began to salute him, Hail King of the Jews!' (Mark 15: 16–18). Christ is usually pictured wearing the Crown of Thorns from this moment until He was taken down from the Cross. The tonsure of the monk, originally the sign of dedication to Divine service, is a reverential imitation of Christ's sacrificial Crown of Thorns.

The crown in various forms is used as an attribute of certain saints. The triple crown, for example, is an attribute of St. Elisabeth of Hungary. St. Catherine of Alexandria is given the royal crown because of her rank. St. Catherine of Siena wears the crown of thorns because of her stigmata. St. Louis of France has the crown of thorns, as well as the kingly crown, to commemorate his discovery of the Crown of Thorns in the Holy Land. St. Louis of Toulouse is painted with a royal crown and sceptre at his feet in token of his refusal of the royal succession. St. Cecilia is painted with a crown of roses. St. Veronica and St. Mary Magdalene are sometimes accorded the crown of thorns. The Pope wears a triple crown as an emblem of his triple royalty. (See Tiara, in Section XII.)

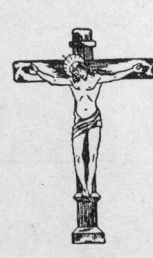

Crucifix (Rood). The crucifix is a representation of Christ on the Cross. From the word *rood*, the alternate English name for crucifix, comes the designation of the screen at the entrance of the sanctuary of a church as the rood screen, for it was customary to erect a great crucifix upon it. A number of saints, including St. Anthony of Padua, are sometimes painted with a small crucifix in their hands. One of the attributes of St. Nicholas of Tolentino is a crucifix decorated with lilies. St. John Gualbert is sometimes painted kneeling before a large crucifix with the head of Christ bending toward him.

Cruet. The cruet is a small vessel that contains the wine or water of the Eucharist. It is symbolic of redemption.

Cup. The cup is the symbol of Christ's Agony in the Garden of Gethsemane. This is based on Christ's own words, when, in His prayer to God, He said, 'O my Father, if this cup may not pass away from me, except I drink it, thy will be done' (Matthew 26; 42). Knowing that He had been betrayed by Judas and that His supreme sacrifice upon the Cross lay before Him, Christ thus accepted the burden which God had laid upon Him. (See Chalice.)

Dossal. The dossal is a richly embroidered hanging placed behind the altar. It is usually a brocade of embroidered needlework on a cloth of gold. If the dossal is extended so that the sides of the altar are included, these extensions are known as riddles. (See altarpiece.)

Ewer and Basin. The ewer and basin are used for the washing of the celebrant's hands at the Eucharist, and at certain special offices of the Church. This washing of the hands is a symbolic act of innocency and purity. It refers to the act of Pilate when the multitude demanded that he condemn Jesus to death. 'When Pilate saw that he could prevail nothing, but that rather a tumult was made, he took water, and washed his hands before the multitude, saying, I am innocent of the blood of this just person . . .' (Matthew 27: 24). In paintings of the Virgin Mary, the ewer is symbolic of purity.

Frontal. The frontal is a decorative piece, usually movable, covering the front of the altar. This oblong panel was often richly figured with paintings or sculptural reliefs.
In the Renaissance, the frontal was often of silk or brocade, frequently embroidered, and in the color of the Church season or feast.

Host. The Host is the flat, round piece of unleavened bread which the celebrant consecrates at the Eucharist, or Mass. Its name is derived from the Latin word *hostia*, meaning victim or sacrifice. As such, and especially when shown with the chalice, it symbolizes the Sacrifice of Christ upon the Cross.

Monstrance. The monstrance, originally any receptacle in which sacred relics were exposed, is also a transparent container in which the consecrated Host is viewed. Its name is derived from the Latin word *monstro*, meaning show.

Pall. The pall is a white linen cloth used to cover the chalice. It symbolizes the linen in which the body of Christ was enshrouded.

Paten. The paten is a shallow plate for the bread of the Eucharist. It symbolizes the dish used at the Last Supper.

Purificator. The purificator is a white linen cloth used to cleanse the chalice after the celebration of the Eucharist.

Pyx. The word pyx is derived from the Latin word *pyxis*, meaning box. In earlier times the term was applied to all vessels used to hold the Eucharist. In ordinary usage it now refers to the vessel in which the Host is carried to the sick. In Christian art, the pyx is an attribute of St. Clare of Assisi, who, according to legend, placed a pyx containing the Host on the threshold of her convent, whereupon the infidels who were besieging it threw down their weapons and fled.

Reliquary. The reliquary is a container for keeping or exhibiting a relic or relics. It may be of any form and material, but is often shaped in the form of the relic it contains.

Rosary. The rosary is a form of devotion to the Virgin Mary. This devotion consists of a series of meditations and prayers centering about events in the life of Christ and of the Virgin. These meditations are known as mysteries, and are divided into three series: the Joyful, the Sorrowful, and the Glorious. The prayers of the rosary are counted on a string of beads. The rosary may be represented as a wreath of roses in which the color of the flowers, white, red, and yellow or gold, represents the mysteries.
The rosary is an attribute of St. Dominic, who instituted the devotion of the rosary. It is also sometimes used as an attribute of St. Catherine of Siena, one of the great Dominican saints.

Tabernacle. The tabernacle is first mentioned in Exodus as a

tent carried by the Israelites during their wanderings in the wilderness. It was used as the place of sacrifice and worship. In Christian usage, it denotes the receptacle in which is placed the pyx, or ciborium, containing the consecrated elements of the Eucharist. Three tabernacles are symbolic of the Transfiguration.

Throne (Cathedra). The official throne or chair of the bishop, properly called a 'cathedra,' is a symbol of episcopal dignity which goes back to the very early days of the Church. It is located on the gospel, or left, side of the sanctuary, though in former times its position was behind the altar. This location is still retained in the Church of St. Peter in Rome. The cathedra was the chair of the teacher in ancient times, and from this it derives its name. The Bishop's church, which is the principal church of a diocese, is called a cathedral. This name originates from the fact that the cathedra (Bishop's throne) is located there as the symbol of his authority and jurisdiction.

SECTION XIV

Artifacts

Anchor. The anchor is the Christian symbol for hope and steadfastness. This symbolic meaning rests on the Epistle to the Hebrews 6: 19, which refers to the everlasting virtue of God's counsel in these words, 'Which hope we have as an anchor of the soul, both sure and steadfast. . .' The symbol was frequently used in this sense in the catacombs of ancient Rome, and was carved on old Christian gems.
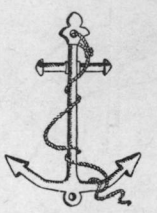
The anchor is the attribute of St. Clement, who was condemned to be cast into the sea bound to an anchor, and of St. Nicholas of Myra, patron saint of seamen.

Armor. Armor is the symbol of chivalry. The warrior saints, of whom St. George is outstanding, are frequently shown in armor, as is the Archangel Michael. Armor also suggests the Christian faith as protection against evil. 'Put on the whole armour of God,' says St. Paul in his Epistle to the Ephesians, 'that

ye may be able to stand against the wiles of the devil . . . having on the breastplate of righteousness . . . the shield of faith . . . the helmet of salvation, and the sword of the Spirit, which is the word of God' (Ephesians 6: 11ff.).

Arrow. The arrow is generally used to suggest a spiritual weapon, dedicated to the service of God. The arrow is an instrument of war and death figures in the portrayals of many saints. St. Sebastian is usually depicted with his body pierced by arrows. St. Ursula is said to have survived torture by arrows. The arrow was also a symbol of the plague, and because St. Sebastian survived his ordeal of being shot by arrows, he became one of the patron saints of all victims of the plague.

Balls. Three balls, or purses, are one of the attributes of St. Nicholas of Myra, representing the three gifts of money which according to legend, the saint threw into the window of the impoverished man with three marriageable daughters, to provide them with dowries.

Banner. The banner, usually with a cross, is the symbol of victory. This alludes to the Emperor Constantine, who, seeing a cross in the clouds and thereupon being converted to Christianity, included it in the design of his flag. In Christian art, the Lamb of God often bears a banner with a cross symbolizing the victory over death won by the martyrdom of Christ. Christ Himself carries a banner only when rising from the grave, in the Descent into Hell, and in the Appearances on earth after the Resurrection and before the Ascension. St. John the Baptist is often represented with a banner, inscribed either with a cross or with the Latin words *Ecce Agnus Dei* (Behold, the Lamb of God). It is also the attribute of military saints and of those who carried the gospel to foreign lands. A banner with a red cross is the attribute of St. George of Cappadocia and of St. Ansanus. St. Reparata and St. Ursula are the only female saints to whom a banner is attributed.

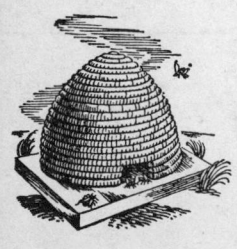

Beehive. The beehive has been used to symbolize great eloquence, as is suggested by the expression, 'honeyed words.' The beehive was given as an attribute to both St. Bernard of Clairvaux and St. Ambrose because 'their eloquence was a sweet as honey.' (See Bee, in Section I.)

Book. The book, when used as a symbol in Renaissance painting, had a number of meanings, depending upon the person shown.

The book in the hands of the Evangelists and Apostles represents the New Testament. In the hand of St. Stephen, it represents the Old Testament. In the hand of any other saint, it generally means that the saint was famous for his learning or his writings. It is so used in paintings of St. Catherine of Alexandria, the Doctors of the Church, St. Thomas Aquinas, and St. Bernard of Clairvaux. In paintings concerned with monastic orders, the book, accompanied by a pen or inkhorn, indicates that the individual was an author, and the book is sometimes lettered with the title of his work. The open book, in the hand of a founder of an Order, is the symbol of his rule and is often lettered with the first sentence of the rule of the Order.

A book with Alpha and Omega is an attribute of Christ. The sealed book is often placed in the hand of the Virgin Mary, in reference to the allusion of Psalm 139: 16, '. . . in thy book all my members were written. . .' St. Augustine is frequently portrayed with book and pen, attributes sometimes given to the four Evangelists. St. Anthony of Padua is often shown with a book pierced by a sword.

Bow. The bow is the symbol of war and of worldly power: 'Behold,' said the Lord to the Prophet Jeremiah, 'I will break the bow of Elam, the chief of their might' (Jeremiah 49: 35).

Box of Ointment. The box of ointment is most commonly used in Renaissance art as an attribute of St. Mary Magdalene. This refers, on the one hand, to the scene in the house of Lazarus after the conversion of Mary: 'Then took Mary a pound of ointment of spikenard, very costly, and anointed the feet of Jesus, and wiped his feet with her hair . . .' (John 12: 3).

It also refers to the scene at the sepulchre, after the Crucifixion: 'And when the sabbath was past, Mary Magdalene, and Mary the mother of James, and Salome, had brought sweet spices, that they might come and anoint him' (Mark 16: 1).

The box of ointment is also used as an attribute of the brothers St. Cosmas and St. Damian, who, as physicians, are depicted holding a small box of ointment in one hand and a lancet, or some other surgical instrument, in the other.

Bread. Bread has always been a symbol of the means of sustaining life, hence the phrase: 'Bread is the staff of life.' In the Old Testament bread was the symbol of God's providence, care, and nurture of His people. He sent manna to the children of Israel in the wilderness. 'And when the children of Israel saw it, they said one to another, It is manna: for they wist not what it was. And Moses said unto them, This is the bread which the Lord hath given you to eat' (Exodus 16: 15). Christ gave new meaning to this symbolism when He said, '. . . I am the bread of life: he that cometh to me shall never hunger . . .' (John 6: 35). At the Last Supper, Christ used bread as the symbol of His sacrifice upon the Cross. 'And he took bread, and gave thanks and brake it, and gave unto them, saying, This is my body which is given for you: This do in remembrance of me' (Luke 22: 19).

Three loaves of bread are given to St. Mary of Egypt as an attribute, for she went forth into the desert to a life of solitude and prayer, bearing with her three loaves of bread. A raven bearing a loaf of bread is one of the attributes of St. Paul the Hermit, for the raven brought him bread during his many years in the wilderness. A loaf of bread is also used occasionally as an attribute of St. Dominic, on the basis of the legend of his obtaining bread for his monastery by divine intervention.

Cauldron of Oil. A cauldron is used as an attribute of St. John the Evangelist, who, according to legend, was hurled into a cauldron of boiling oil, but was miraculously saved from death.

Cloak or Coat. A cloak divided into halves by a sword is an attribute of St. Martin, who , in the midst of winter, befriended a poor man by giving him half of his own cloak. (See Robe.)

Club (Bat). The club is one of the symbols of the betrayal of Christ. The club, or bat, is also the attribute of St. James the Less, for it was the instrument of his martyrdom. According to tradition, he was thrown to the ground from the top of the temple, but not being killed by the fall, he was afterward slain with a club, or a fuller's bat, as he rose to his knees to pray.

Coins. Thirty pieces of silver represent one of the symbols of the Passion, in reference to the betrayal of Christ by Judas Iscariot. 'Judas Iscariot went unto the chief priests and said unto them,

What will ye give me, and I will deliver him unto you? And they covenanted with him for thirty pieces of silver' (Matthew 26: 14, 15).

St. Laurence is sometimes shown bearing in his hand a dish of gold and silver coins. This refers to his distribution of the wealth of the Church to the poor at the behest of Pope Sixtus II.

Comb. An iron comb is one of the attributes of St. Blaise, for, upon order of the Emperor Licinius, he was tortured by having his flesh torn by combs of iron, similar to the combs used for the carding of wool.

Crutch. Crutches are frequently used as an attribute of St. Anthony to signify his age and feebleness after many years spent as a hermit in the desert. A bell is sometimes suspended from his crutch to symbolize his power to exorcize evil spirits.

Dagger. A dagger is one of the attributes of St. Lucy, who suffered martyrdom by being stabbed in the neck with a poniard.

Dice. Dice are sometimes used as a symbol of the Passion, referring to the incident of the soldiers who, after the Crucifixion, cast lots for Christ's coat. 'Now the coat was without seam, woven from the top throughout. They said therefore among themselves, Let us not rend it, but cast lots for it, whose it shall be' (John 19: 23, 24).

Dish. Apart from the paten, the dish itself is not a symbol used in Christian art, but a dish sometimes appears as part of a symbol or attribute. (See Paten, in Section XIII.)

Dish Bearing Head: This is one of the attributes of St. John the Baptist. It refers to the slaying of John at the request of Salome.

Dish Bearing Eyes: According to legend, a suitor of St. Lucy was so moved by the beauty of her eyes that he left her no peace and complained that her beautiful eyes were a torture to him. Upon hearing this, St. Lucy tore out her eyes and sent them to the suitor on a dish. The dish bearing eyes has, therefore, come to be an attribute of St. Lucy.

Dish or Basket Bearing Roses: An attribute of St. Dorothea, who, at the place of her execution, received a gift of roses and apples from an angelic messenger.

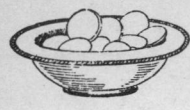

Dish Bearing Money: This has come to be an attribute of St. Laurence, who was commanded by Sixtus, Bishop of Rome, to distribute the treasures of the Church to the poor.

Dish Bearing Female Breasts: This is an attribute of St. Agatha, who, as a part of her martyrdom, had her breasts torn by shears, or pincers.

Fetters (Chains). Fetters are one of the symbols of the Passion, referring to the Flagellation of Christ by the soldiers. St. Leonard is usually depicted bearing in his hand some broken fetters, symbolic of his work on behalf of the prisoners of King Clovis of France, to whose court the saint was attached.

Gate. The gate has a number of symbolic meanings in Christian art. The gate may signify death and departure from life in this world. '. . . consider my trouble which I suffer of them that hate me, thou that liftest me up from the gates of death' (Psalm 9: 13). It may also represent the entrance into the heavenly Paradise. 'Lift up your heads, O ye gates; and be ye lift up, ye everlasting doors . . .' (Psalm 24: 7). The gate carries both of these meanings in scenes of the Expulsion of Adam and Eve from the Garden of Eden. It also appears as the dividing barrier between the righteous and the damned in scenes of the Last Judgment. A gate is always a central feature in representations of the Descent into Hell. Christ has broken through it and its fragments lie strewn at His feet. The Vigin Mary is sometimes referred to as the Closed Gate, in reference to her unblemished virginity.

Girdle (Cincture). The girdle, or cincture, was worn over the other clothing and, in ancient costume, served as purse, protection, and ornament. Many symbolical meanings were attached to it. Christ used it to symbolize preparation for any service that God might require of His children. 'Let your loins be girded about, and your lights burning' (Luke 12: 35). St. Paul called the girdle the symbol of truth in the Christian's armor. 'Stand therefore, having your loins girt about with truth . . .' (Ephesians 6: 14). When worn by the prophets, the girdle is the symbol of humility and contempt of the world, and is made of leather. The girdle of the monks, signifying their vows of poverty, chastity, and obedience, was probably developed from the prophetic meaning. The girdle is also symbolic of chastity. The Biblical

origin of this meaning lies in the ancient practice of virtuous women, of making very beautiful girdles which became symbolic of their virtue and chastity (Proverbs 31).

The girdle, as an attribute of the Virgin Mary, signifies chastity. It also refers to the legend that she lowered her girdle from the sky to convince the unbelieving St. Thomas that she had actually ascended to Heaven.

Glass. Glass, being clear and transparent, is a symbol of purity. In this sense, it is often depicted in scenes from the life of the Virgin. In pictures of the Annunciation of the Virgin, the lily is often placed in a vase of transparent glass. It is also symbolic of the Immaculate Conception. In pictures of the Creation, God is sometimes shown holding a crystal ball, symbolic of the divine world of light before the creation of the earth.

A crystal glass containing a serpent, or a broken crystal glass, is sometimes used as an attribute of St. Benedict, with reference to his miraculous escape from death by poisoning.

Globe. The globe is a symbol of power. As such, it is frequently shown as an attribute of God the Father. In the hands of Christ, the globe is an emblem of His sovereignty. In the hands of a man, the globe is the symbol of imperial dignity.

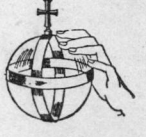

Gridiron. The gridiron is frequently used as an attribute of St. Laurence, who is said to have been tortured by being roasted upon a gridiron.

Halberd. The halberd is the attribute of St. Jude, who, on his travels with St. Simon, is said to have been killed with a halberd.

Hammer. The hammer was used to nail Christ to the Cross, and so it is one of the instruments of the Passion and is a symbol of the Crucifixion.

Harp. The harp is recognized as the attribute of King David. 'And David and all Israel played before God with all their might, and with singing, and with harps . . .' (I Chronicles 13: 8). The harp has come to be the symbol of the Book of Psalms and of all songs and music in honor of God.

The harp as an instrument of divine music is referred to in

Revelation 5: 8, which describes the twenty-four elders who surround the Throne of God as 'having every one of them harps.' St. Augustine, in his sermons, explains the Ten Commandments in terms of the ten strings of David's harp.

Hatchet (Axe). The hatchet, or axe, is a symbol of destruction. The hatchet is also used as the attribute of several Biblical characters. It is an emblem of St. John the Baptist. In preaching to the people of Judea, he declared, 'And now also the axe is laid unto the root of the trees: therefore every tree which bringeth not forth good fruit is hewn down (Matthew 3: 10).
It is also an emblem of Joseph, in allusion to his trade as a carpenter. Since both St. Matthew and St. Matthias suffered martyrdom by beheading, the axe is one of their attributes.

Key. Jesus said to St. Peter, according to St. Matthew 16: 19, 'And I will give unto thee the keys of the kingdom of heaven: and whatsoever thou shalt bind on earth shall be bound in heaven . . .' Thus, St. Peter is regarded as the guardian of the Gate of Heaven and his attribute is a key, or a bunch of keys. St. Martha, as patroness of feminine discretion and good housekeeping, is also frequently depicted with a large bunch of keys hanging from her girdle.

Knife. A knife is most frequently shown as an instrument of martyrdom. St. Bartholomew is always shown with a large knife of a peculiar shape, and sometimes with a piece of human skin over his arm, which refers to his having been flayed alive. St. Peter Martyr is also given a knife, either in his head or in his hand, because it was also the instrument of his martyrdom.

Ladder. The ladder is one of the instruments of the Passion and is frequently shown in scenes of the Descent from the Cross. It also refers to the vision of Jacob: 'And he dreamed, and behold a ladder set up on the earth, and the top of it reached to heaven: and behold the angels of God ascending and descending on it' (Genesis 28: 12). In paintings of the patriarchs, the ladder is used as an attribute of St. Benedict, who, in a vision, saw the brethren of his Order ascend to Heaven on a ladder.

Lamp. The lamp, because of the light it sheds, is used as a symbol

of wisdom and piety. The Bible describes the Word of God as a lamp unto the faithful. In the parable of the wise and foolish virgins, a lighted lamp is used to indicate the wise ones. It is in this sense that the lamp has been given as an attribute to several saints, notably St. Lucy. The use of the lamp with St. Lucy refers to her vision of St. Agatha, who appeared to her and said, 'Lucy, that art indeed a light.'

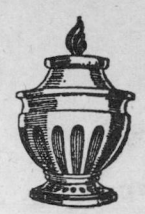

Lance. The lance, used to pierce the side of Christ on the Cross, is a symbol of the Passion. St. George of Cappadocia is frequently shown bearing in one hand a lance, often broken, because, according to legend, his lance being broken, he slew the dragon with his sword. The lance, or javelin, is also the attribute of St. Thomas, since it was the instrument of his martyrdom.

Millstone. The millstone is used as an attribute for St. Florian and St. Vincent, because each was martyred by being thrown into the water with a millstone tied to his neck.

Mirror. A mirror bearing the image of the Virgin is one of the attributes of St. Geminianus. The spotless mirror is a symbol of the Virgin Mary.

Money. Two hands filled with money are sometimes used as a symbol of the Passion, in allusion to the betrayal by Judas. A bag of money is an attribute of St. Matthew the Apostle, who was a publican (tax collector) before he was converted to Christianity. Three bags of money are one of the attributes of St. Nicholas of Myra. A dish with money, or bags of money, may be used to identify St. Laurence, who distributed the treasures of the Church to the poor. Other saints notable for their charity may also be represented giving money to the poor. Among them is St. Elisabeth of Hungary.

Mortar and Pestle. The mortar and pestle, instruments used by the apothecary in preparing medicines, are often attributes of the two physician saints, Cosmas and Damian.

Musical Instruments. Musical instruments, in addition to being one of the attributes of St. Cecilia, are frequently represented in the hands of angels shown in scenes of the Virgin and

Child. Choirs of angels are portrayed playing musical instruments to symbolize their eternal praise to God.

Nails. Nails, because of their use in the Crucifixion of Christ, are a symbol of the Passion. Early crucifixes show four nails piercing each of the hands and feet of Christ. On most crucifixes, there are only three nails, both feet being pierced by one nail. The number three was preferred when the nails were painted separately as instruments of the Passion, perhaps with symbolic reference to the Trinity.

Organ. The organ is used to symbolize the praise that the Church is continually offering to the glory of God. It is an attribute of St. Cecilia, the patron saint of music. She is said to have invented the organ, in order that she might pour forth the flood of harmony with which her soul was filled.

Painting. A painting of the Virgin is one of the attributes given to St. Luke, who is often shown painting her portrait.

Pen. The pen alone, or sometimes with an inkhorn, is given as an attribute to the Evangelists and Doctors of the Church. Notable among those to whom this attribute is applied are St. Augustine, St. Bernard, St. Mark, and St. Matthew.

Pillar. The pillar to which Christ was bound during the Flagellation is used as one of the emblems of the Passion. The pillar is an attribute of Samson, who died tearing down the pillars of the palace of the Philistines. St. Sebastian is usually shown bound to a pillar, his body pierced with arrows.

Pincers (Shears). Pincers are an attribute of St. Agatha, who had her breasts torn with shears, or pincers. They are also an attribute of St. Apollonia of Alexandria, who, as a part of her martyrdom, is said to have had her teeth pulled out with pincers.

Plane. The carpenter's plane is an attribute of St. Joseph, who followed the carpenter's trade in the village of Nazareth.

Ring. The ring, or circlet, has been universally accepted as the symbol of eternity and never-ending existence. It is also the

symbol of eternal union. The ring of a bishop suggests his union with the Church. Marriage rings are symbols of permanent union. Two rings linked, or two circles one above the other, are emblematic of the earth and sky. Three rings linked together signify the Holy Trinity.

The bridal ring is the attribute of St. Catherine of Siena, who dedicated herself to a religious life and prayed that Christ would be her Bridegroom.

Robe. The scarlet or purple robe is one of the emblems of Christ's suffering, while he was in the common hall, and is, therefore, one of the symbols of the Passion. 'Then the soldiers of the governor took Jesus into the common hall, and gathered unto him the whole band of soldiers. And they stripped him, and put on him a scarlet robe . . . And after that they had mocked him, they took the robe off from him, and put his own raiment on him, and led him away to crucify him' (Matthew 27: 27–31). The seamless robe is also one of the symbols of the Passion. 'Then the soldiers, when they had crucified Jesus, took his garments, . . . and also his coat: now the coat was without seam, woven from the top throughout . . . They said . . . Let us not rend it, but cast lots for it. . .' (John 19: 23, 24).

Rope. The rope is one of the symbols of the betrayal of Jesus by Judas, for, according to John 18: 12, 'Then the band and the captain and officers of the Jews took Jesus, and bound him, and led him away to Annas first; for he was father-in-law to Caiaphas, which was the high priest that same year.' St. John is the only one of the Evangelists to mention that Jesus was bound on this occasion, but Matthew and Mark mention that He was bound when taken to Pilate the next morning. According to tradition, it was with a rope that Judas hanged himself after the betrayal, in desperate repentance for his awful deed.

Rule. A carpenter's rule is one of the customary attributes of the Apostle Thomas, builder of the heavenly palace of Gondophorus.

Saw. The carpenter's saw, together with a plane and hatchet, is commonly used as an attribute of St. Joseph, who was a carpenter by trade. The saw is also the attribute of St. Simon Zelotes, who, according to legend, was martyred by being

sawed asunder. It is also an attribute of certain sacred persons, notably St. Euphemia and Isaiah.

Scales. The Archangel Michael is frequently portrayed bearing a pair of scales, for one of his responsibilities is to weigh the souls of the departed. In general, the scales symbolize equality and justice.

Sceptre. The sceptre, or wand, carried in the hand is the symbol of authority. It is borne by princes of this earth and by the archangels, notably Gabriel.

Scourge. The scourge is one of the symbols of the Passion. It is sometimes shown in combination with the pillar to which Christ was bound. In general, the scourge in the hands of a saint or at his feet suggests the penance which he inflicted on himself. In the hand of St. Ambrose, however, it is an allusion to his work in driving the Arians out of Italy.

Scroll. A scroll, or rolled manuscript, is sometimes used in place of a book to suggest the gifts of an individual as a writer. This is particularly true of St. James the Great, who is frequently portrayed bearing a scroll in one hand. Scrolls, as the ancient type of book, are more often given to the Old Testament authors.

Scythe. The scythe, like the sickle, symbolizes the cutting off of the strand of life and is, consequently, used as the attribute of Death. Death is frequently portrayed as a skeleton with a scythe in hand.

Seal. The seal is the mark, or signature, of God. 'And I saw another angel ascending from the east, having the seal of the living God; and he cried with a loud voice to the four angels, to whom it was given to hurt the earth and the sea, saying, Hurt not the earth, neither the sea, nor the trees, till we have sealed the servants of our God in their foreheads' (Revelation 7: 2, 3). This was known as the seal of the living God.

Ship. Through a number of different associations, the ship came to have a special meaning as symbolic of the Church of Christ. The ark of Noah, which floated safely in the midst of the deluge

while everything else was overwhelmed, was an obvious symbol for the Church. St. Ambrose, in his writings, compares the Church to a ship, and the Cross to a ship's mast. The miracle of the Sea of Galilee, when Christ calmed the waves and saved the vessel of the Apostles from disaster, likewise served to give the ship a symbolic religious meaning.

The ship is also the attribute of a few saints. The best known are St. Vincent and St. Nicholas of Myra. In paintings of St. Julian, a boat is frequently shown in the background, referring to his self-imposed task as a ferryman.

Spear. The spear, because it was used to pierce the side of Christ on the Cross, is one of the symbols of the Passion.

Sponge. The sponge is one of the emblems of the Crucifixion. This meaning is drawn from the scriptural story of the Crucifixion. 'And straightway one of them ran, and took a spunge, and filled it with vinegar, and put it on a reed, and gave him to drink' (Matthew 27: 48).

Staff. The pilgrim's staff is used alone and in combination with various other objects as an attribute of numerous saints who have been noteworthy for their travels and pilgrimages. The pilgrim's staff, together with a scroll and a scallop shell, are the customary attributes of St. James the Great.

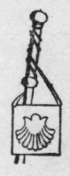

The palm tree staff is always the attribute of St. Christopher, a man of great strength, who tore up a palm tree by the roots for his staff. After he had carried Christ, in the semblance of a child, across the river, he was told: 'Plant thy staff in the ground and it shall put forth leaves and fruit.' When this miracle took place, St. Christopher was converted to Christianity.

Other saints commonly given a pilgrim's staff as an attribute include St. John the Bapist and St. Jerome, St. Philip the Apostle is given a staff with a cross. St. Ursula frequently bears a staff with a banner on which the cross is inscribed. St. Roch is sometimes shown with a staff, cockleshell, and wallet.

Stake. The stake, as the instrument of those who were tortured by fire, is used as an attribute of St. Dorothea, who was burned at the stake, and of St. Agnes, who was miraculously saved from a similar death.

Surgical Instruments. These instruments are attributes of St. Cosmas and St. Damian, the physician brothers, who are customarily shown holding a lancet, or some other surgical instrument, in one hand. (See Box of Ointment and Mortar.)

Sword. The sword is used as an attribute of numerous saints who, according to tradition, suffered martyrdom at the sword's edge. Among these are St. Paul, who was beheaded; St. Euphemia, who was similarly beheaded after lions had refused to destroy her: St. Agnes, who met her fate in similar fashion; and St. Peter Martyr, who was assassinated. St. Justina is sometimes shown with a sword piercing her breast. The Archangel Michael is given the sword of the warrior, as is St. George of Cappadocia. St. John Gualbert is sometimes portrayed with a sword in hand, referring to his pursuit of the assassin of his brother. St. Martin is shown with a sword and the cloak which he divided, in order that he might share its warmth with a beggar.

Torch. The torch is one of the emblems of the Betrayal, and, therefore, of the Passion. This meaning is based upon John 18: 3, which describes the betrayal by Judas: 'Judas then, having received a band of men and officers from the chief priests and Pharisees, cometh thither with lanterns and torches and weapons.'
Christ as the Light of the World was sometimes portrayed by the torch in scenes of the Nativity.
The torch is also used as an attribute of certain martyrs. St. Dorothea, as an example, is sometimes shown with a torch at her side, for she was burned at the stake. A dog with a flaming torch in its mouth is an attribute of St. Dominic.

Towel. A spotless towel is a symbol of purity, and is sometimes used as an attribute of the Virgin Mary. A towel with a pitcher is sometimes employed as a symbol of the Passion, in reference to Pilate's washing his hands. (See Ewer and Basin, in Section XIII.)

Tower. The tower, generally with three windows, is the customary attribute of St. Barbara. This is an allusion to the legend that when her tower was being built she instructed that it should have three windows instead of two, the three windows signifying the Trinity.

Vase. A vase holding a lily is one of the most frequently depicted objects in paintings of the Annunciation. The vase is very often of transparent glass; for glass, being clear and translucent, symbolizes the perfect purity of the Virgin.
In a general sense, the empty vase symbolizes the body separated from the soul. A vase with birds on its rim, quenching their thirst, is a symbol of eternal bliss.

Veil. The veil, because it conceals the wearer, symbolizes modesty and chastity. The veil with the head of Christ depicted on it is the attribute of St. Veronica. This refers to a passage in the Apocryphal Gospel of Nicodemus, which relates that Veronica dried the sweat from the face of Christ on His way to Calvary with her veil, and that the imprint of His face remained on it. It is also an attribute of St. Agatha, with reference to the legend that her veil stayed a flow of lava from Mt. Etna which had menaced the city of Catania.

Wheel. Rotating force is the symbol of divine power; hence the wheel, burning or otherwise, carries this meaning. It appears in the Expulsion of Adam and Eve from the Garden of Eden. The Throne of God is often shown borne upon flaming wheels with eyes and wings, an allusion to the vision of Ezekiel (Ezekiel 1 : 1–28). The wheel is the special attribute of St. Catherine of Alexandria, who was tortured upon the wheel.

Winepress. The winepress is the symbol of the wrath of God. It takes this meaning from the passage in Isaiah 63 : 3, 'I have trodden the winepress alone; and of the people there was none with me; for I will tread them in mine anger and trample them in my fury. . .'

List of Plates

75. Fra Angelico: *The Healing of Palladia by SS. Cosmas and Damian*. National Gallery of Art, Washington
76. Lippo Vanni: *St. Dominic*. University of Miama, Miami, Florida
77. Lippo Vanni: *St. Elizabeth of Hungary*. University of Miami, Miami, Florida
78. Vittore Crivelli: *St. Francis*. El Paso Art Museum, El Paso, Texas
79. Francesco Pesellino: *The Crucifixion with St. Jerome and St. Francis*. National Gallery of Art, Washington
80. Giovanni Antonio Bazzi, called Sodoma: *St. George and the Dragon*. National Gallery of Art, Washington
81. Sebastiano Ricci: *The Finding of the True Cross*. National Gallery of Art, Washington
82. Simone Martini and Assistants: *St. James the Great*. National Gallery of Art, Washington
83. Master of St. Francis, 13th Century: *St. James the Less*. National Gallery of Art, Washington
84. Giovanni Battista Cima da Conegliano: *St. Jerome in the Wilderness*. National Gallery of Art, Washington
85. Francisco Zurbaran: *St. Jerome, St. Paula and St. Eustochium*. National Gallery of Art, Washington
86. Piero di Cosimo: *St. John the Evangelist*. Honolulu Academy of Arts, Honolulu, Hawaii
87. Andrea Bregno: *St. Jude*. Marble relief. The William Rockhill Nelson Gallery of Art, Kansas City, Missouri
88. Bernardo Strozzi: *St. Lawrence giving the Treasures of the Church to the Poor*. Portland Art Museum, Portland, Oregon
89. Bramantino: *The Raising of Lazarus*. Kress Collection, New York
90. Francesco del Cossa: *St. Lucy*. National Gallery of Art, Washington
91. Giovanni di Paolo: *St. Luke the Evangelist*. Seattle Art Museum, Seattle, Washington
92. Girolamo di Benvenuto: *St. Margaret of Antioch*. The Isaac Delgado Museum of Art, New Orleans, Louisiana
93. Franco-Rhenish Master, about 1440: *The Mass of St. Martin of Tours*. Art Museum, Allentown, Pennsylvania
94. Simone Martini and Assistants: *St. Matthew*. National Gallery of Art, Washington
95. Vincenzo Foppa: *St. Paul the Apostle*. The Isaac Delgado Museum of Art, New Orleans, Louisiana
96. Pietro Candido: *A Scene from the Life of St. Nicholas*. Columbia Museum of Art, Columbia, South Carolina
97. Sebastiano Ricci: *The Death of St. Paul the Hermit*. University of Kansas, Lawrence, Kansas
98. Marco Zoppo: *St. Peter*. National Gallery of Art, Washington
99. Andrea Bregno: *St. Philip*. Marble relief. The William Rockhill Nelson Gallery of Art, Kansas City, Missouri
100. The Master of St. Gilles, late 15th Century: *The Conversion of an Arian by St. Remy*. National Gallery of Art, Washington
101. Master of St. Gilles: *The Baptism of Clovis*. National Gallery of Art, Washington
102. Attributed to Lorenzo Costa: *St. Roch and St. Julian*. Atlanta Art Association Galleries, Atlanta, Georgia
103. Amico Aspertini: *St. Sebastian*. National Gallery of Art, Washington
104. Vittore Carpaccio: *St. Stephen and St. Peter Martyr*. Philbrook Art Center, Tulsa, Oklahoma
105. Master of Fucecchio: *Madonna and Child between St. Stephen and St. Lawrence*. Bucknell University, Lewisburg, Pennsylvania
106. Simone Martini and Assistants: *St. Simon*. National Gallery of Art, Washington
107. Simone Martini and Assistants: *St. Thaddeus*. National Gallery of Art, Washington
108. Benozzo Gozzoli: *St. Ursula with Angels and Donor*. National Gallery of Art, Washington
109. Master of the St. Lucy Legend and Assistant: *Angels with Musical Instruments*. Detail from 'Mary, Queen of Heaven'. National Gallery of Art, Washington
110. Paolo Veronese: *Sacra Conversazione*. The Isaac Delgado Museum of Art, New Orleans, Louisiana
111. Master of Flémalle and Assistants: *Madonna and Child in the Enclosed Garden, with S. Catherine of Alexandria, John the Baptist, Barbara and Anthony Abbot*. National Gallery of Art, Washington
112. Biagio d'Antonio da Firenze: *Adoration of the Child with Saints and Donors*. The Philbrook Art Center, Tulsa, Oklahoma

Index of Names and Subjects

Plate references follow the text references and are indicated by italicized type.